NATIONAL GEOGRAPHIC

STUNNING PHOTOGRAPHS

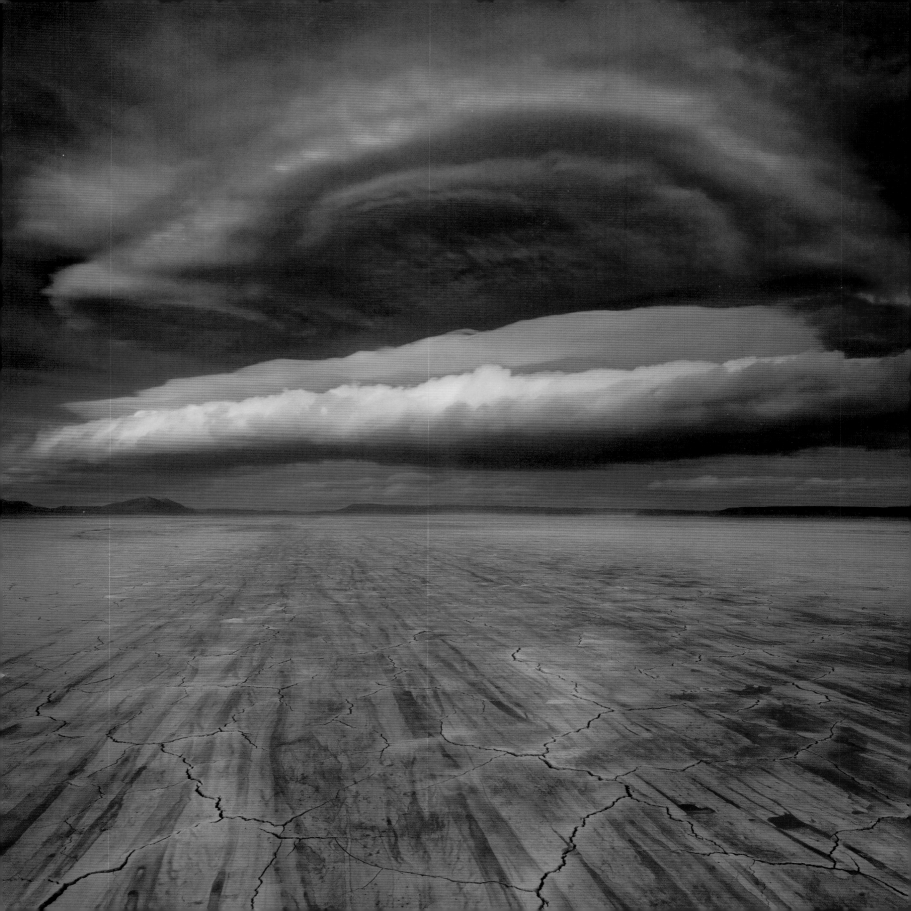

NATIONAL
GEOGRAPHIC

STUNNING
PHOTOGRAPHS

Annie Griffiths

National Geographic
Washington, D.C.

Photography is a way of feeling, of touching, of loving. What you have caught on film is captured forever . . . it remembers little things, long after you have forgotten everything.

~ Aaron Siskind

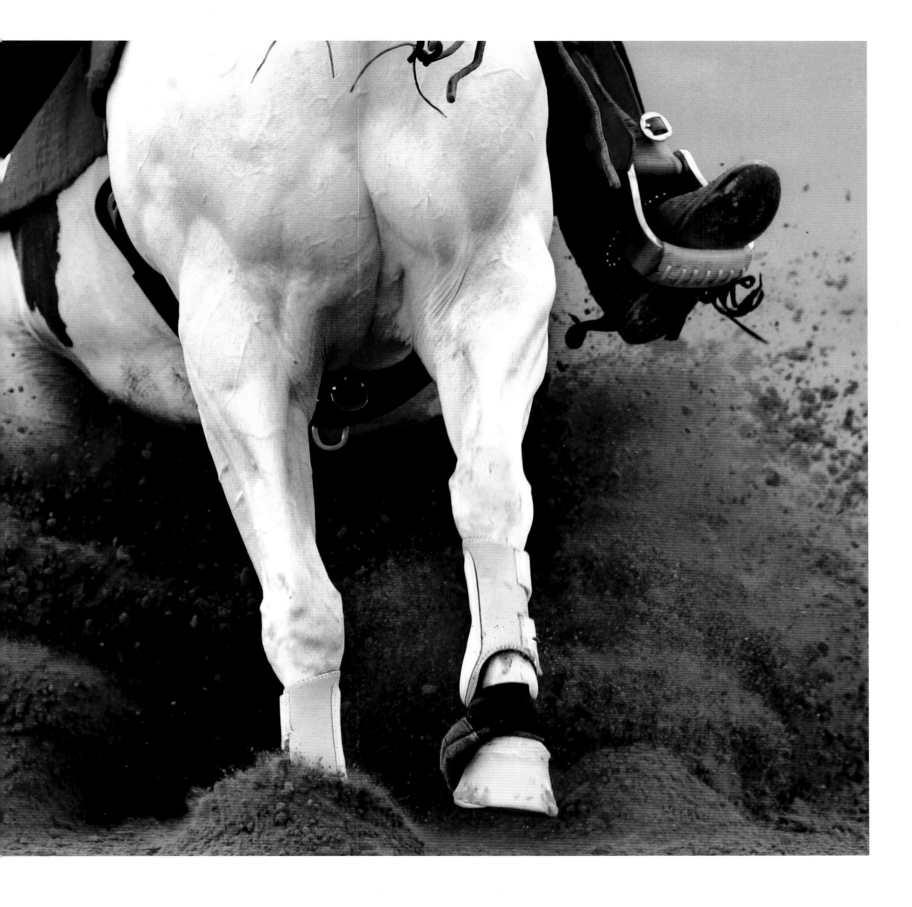

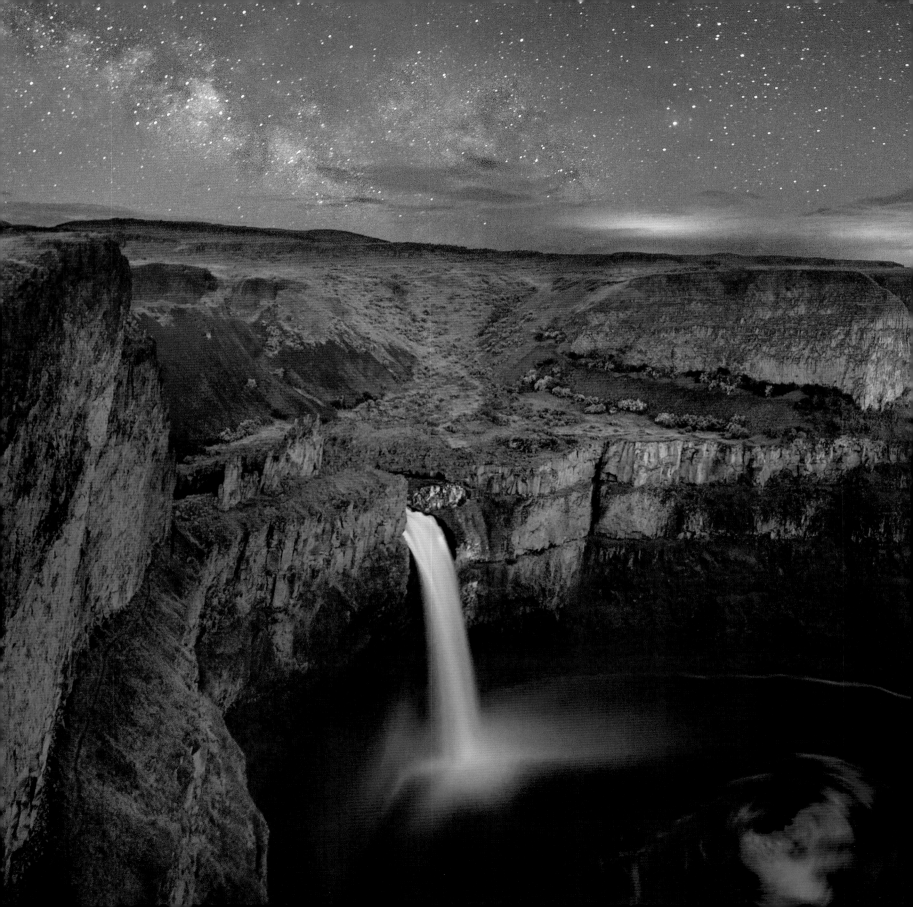

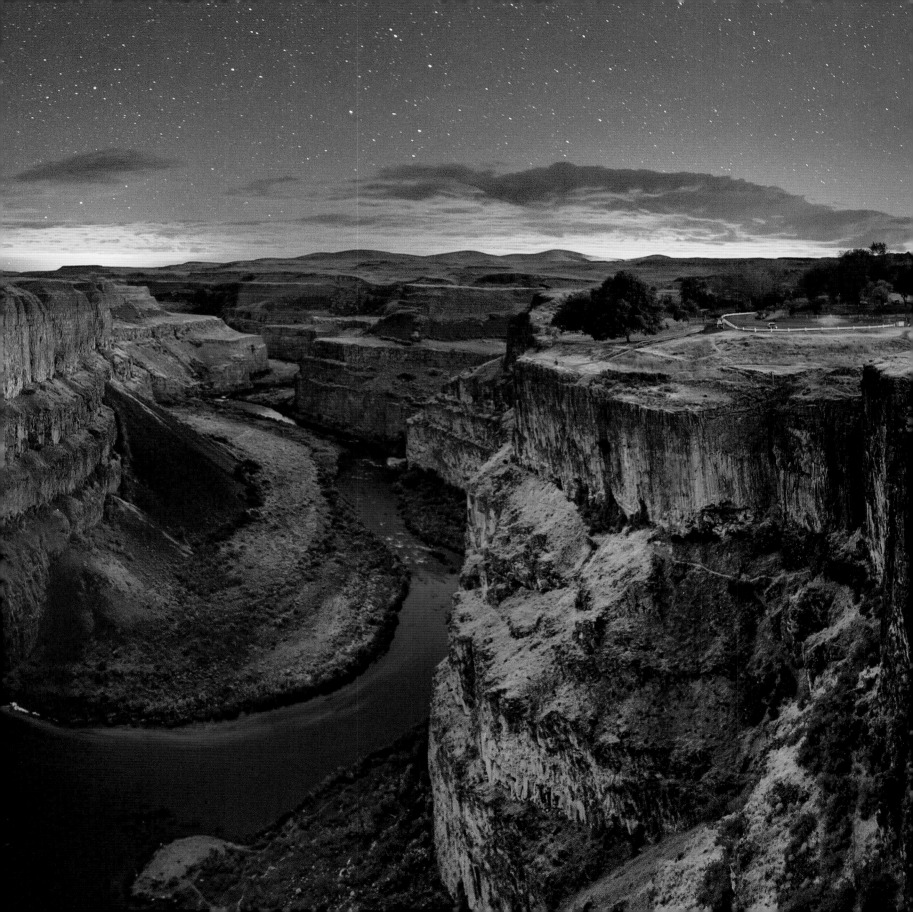

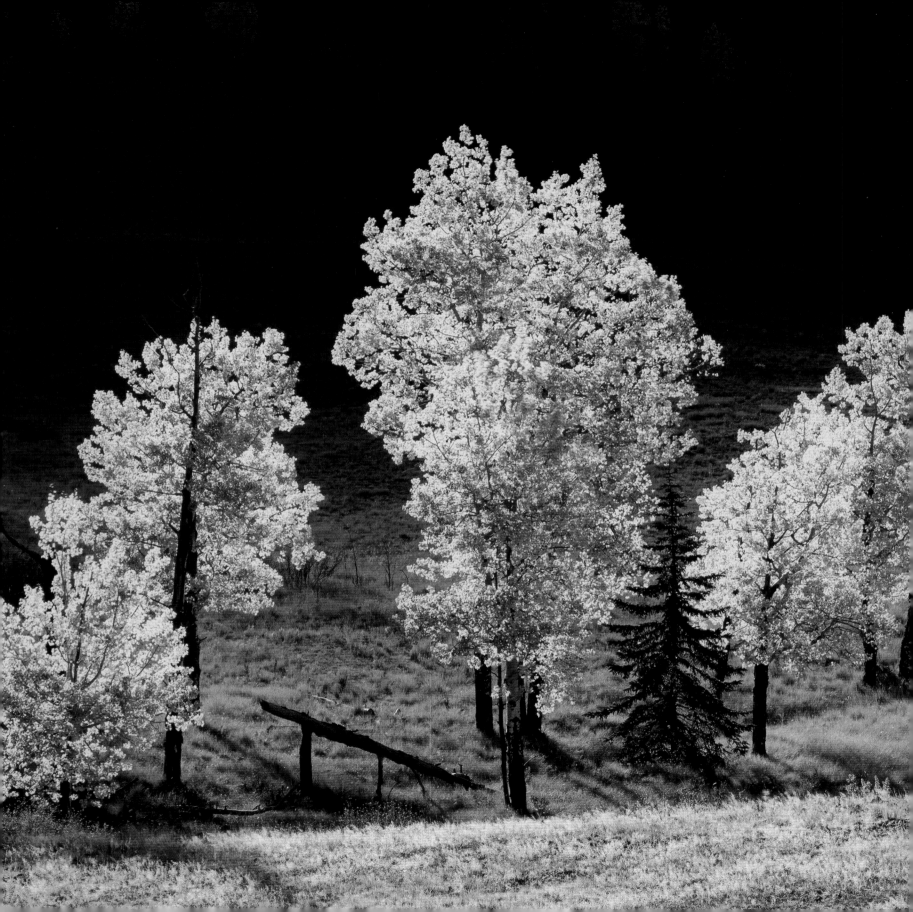

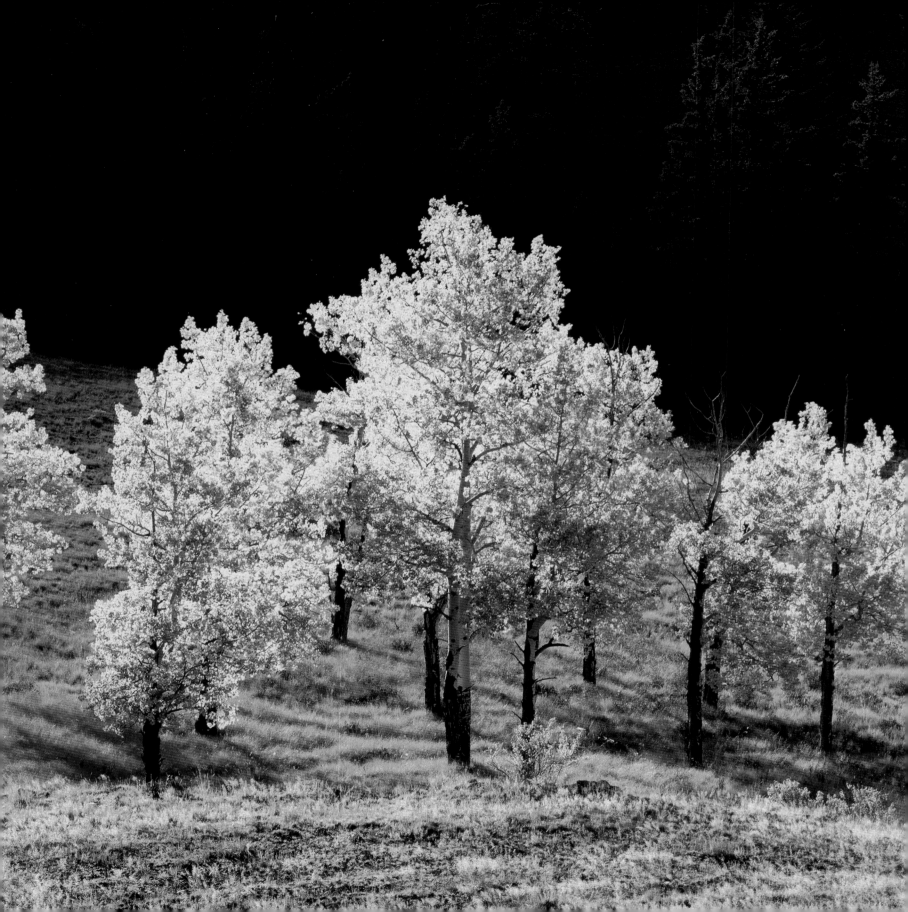

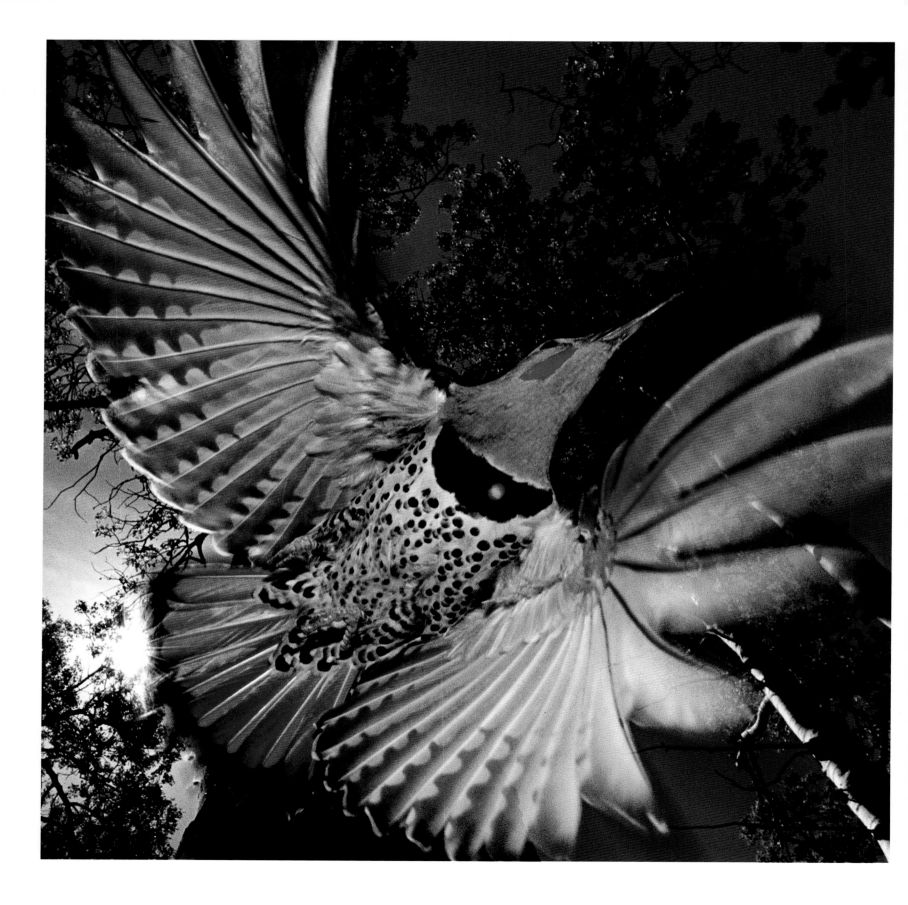

Contents

∽

Introduction 14

Mystery 22

Harmony 82

Wit 152

Discovery 214

Energy 278

Intimacy 332

MICHAEL QUINTON United States Displaying its dazzling plumage, a red-shafted northern flicker takes flight.

preceding pages (2–9) MARC ADAMUS Alvord Desert, Oregon Low-lying storm clouds turn florid in the sunset. ROLF VENNENBERND Aachen, Germany A horse and rider come to a sliding stop during a reining contest. JESSE L. SUMMERS Palouse Falls, Washington A star-spangled sky crowns a rugged canyon and waterfall.

CARR CLIFTON Durango, Colorado Autumn aspen trees gild the San Juan Mountains.

following pages (12–21) SERGEI REOUTOV Socotra, Yemen Immense sand dunes dwarf a solitary camel. BONNIE STEWART Mandalay, Myanmar An exuberant young monk leaps with joy. FRANS LANTING Antarctica Chinstrap penguins rest in a thicket of iceberg spires.

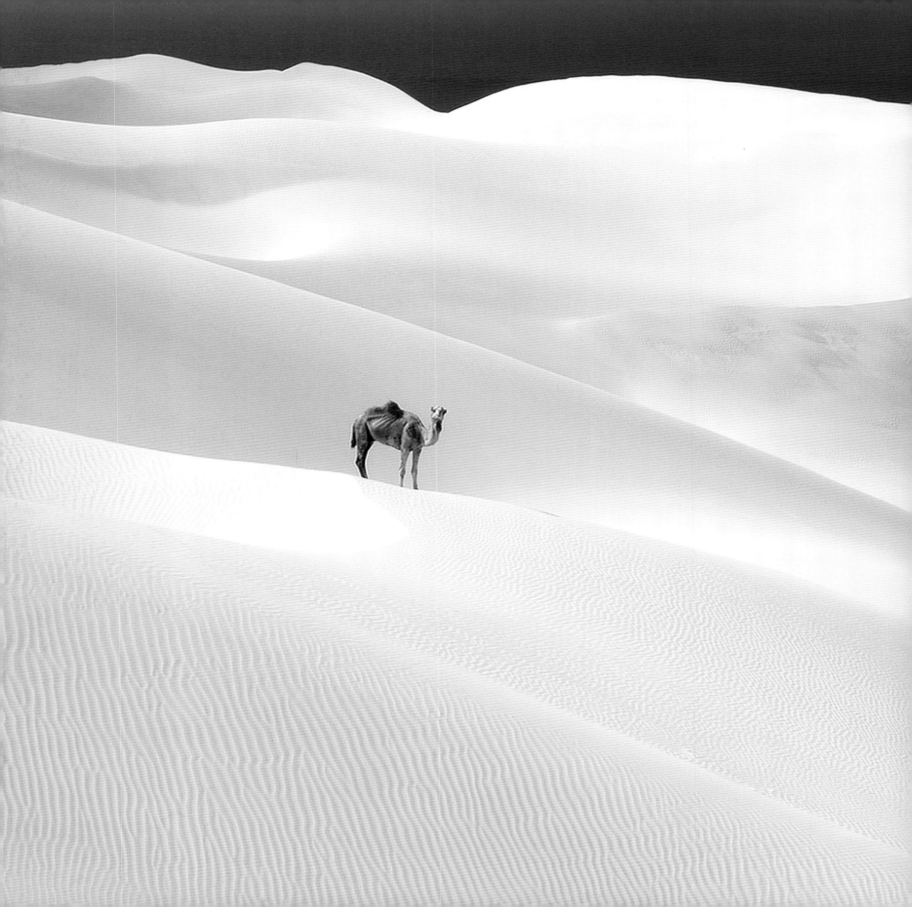

Introduction

When I was seven years old, I received a gift that would forever change my life. My mother took me to get a pair of little-girl eyeglasses, shaped like blue butterfly wings and festooned with rhinestones. I had never seen anything quite so beautiful. The glasses themselves seemed an extraordinary gift—but on the drive home the true miracle occurred, as my world suddenly and literally came into focus. My sight had been fuzzy for so long that I had no memory of the world in detail. I'd seen trees the way that children draw them: as big balls of green with broad, brown trunks. For the first time, I could see individual leaves and delicate branches. I saw blades of grass and the airy seedpods of dandelions. I pressed my nose to the window in rapt silence. At seven years old, I felt reborn. 	Although I went on to curse my poor eyesight for much of my life, I now know that those blurry years before the world was clear instilled in me an appreciation for seeing that would eventually lead me to photography. 	As with all senses, the gift of sight is something that we mostly take for granted as we navigate our lives. The art of seeing, however, is earned through paying attention, to light and pattern and gesture. Visual acuity is like a muscle that becomes stronger with use. 	A stunning image is one that makes the viewer halt, look again, and connect on an emotional level. This connection can vary from jaw-dropping amazement to amused surprise or sudden empathy at the new vision of a universal truth. 	Visually, the world is a chaotic jumble. In navigating that jumble, the photographer learns to *trust* that his eye is leading him somewhere. It may be a shard of light, a compelling face, or a play of color. Photographers learn to follow their visual radar and strip away every element that distracts as they move toward the final composition. 	Photography is not passive. It's a hunt.

It's a seduction. It's a dance. The photographer holds his breath. He waits, believing that something magical will happen. If he follows a single drop descending a steamy window, a vision will appear. If he pays attention to a shaft of light across the room, a composition will emerge. If he patiently anticipates the climax of a scene, an intimate moment will be revealed. It's an intense, full-bodied pursuit of something new and something wonderful. ✺ My favorite days as a photographer are those when the shooting is so all-consuming that I lose myself in the choreography of the moment. I may be literally chasing a picture for hours. It's only when the dream dissolves and the scene falls apart that I return to my body and realize that I am spent. My eyes sting, my bladder is bursting, and my nose has been so flattened by my Nikon that I look like a proboscis monkey. It's better than sex. ✺ So what is it that makes an image indelible? There are, of course, photographs that are universally stunning, that humble with the grandeur and energy of something truly remarkable, frozen in time. Other photographs are imbued with atmosphere or mystery that haunts us long after we first see them. There are witty images that surprise and delight, as the familiar is translated into something fresh and remarkable. Some photographs are so intimate that they take our breath away or move us to tears. There are images that answer questions, and others that move us to ask more. A photograph can ignite the imagination or make us laugh out loud. Most importantly in this frenetic world, a single stunning image can make us stop and feel and consider. ✺ It's telling that even in the Internet age, the still image has become more popular than ever. The very first photo was taken fewer than 200 years ago. Since then, more than four trillion have been shot, the vast majority since the onset of digital photography. Three hundred million photos are uploaded to Facebook every day. Photographs have become an essential part of our cyber lives. ✺ The explosion of shared photographs can

be overwhelming at times, but the popularity of websites and smartphone applications has allowed stunning images and creative talent to find an audience. The ability to instantly view our photos encourages amateurs and pros alike to experiment, learn from their mistakes immediately, and try again. This has led to an exciting era of creativity and growth, as everyone feels freer to push the envelope. The world may be drowning in quantity, but quality still prevails. ❧ The photographic journey is long and winding. Those who are drawn to it know the breathless beginnings as they cross the threshold from aimlessly snapping pictures to the pursuit of more meaningful images. Most start with still subjects, as they navigate the mysteries of focus, exposure, and composition. There is the early thrill of capturing details of a flower or the wild colors of a blazing sunset. Then comes the quickening. Through conscious, artful choices, a simple flower becomes *our* flower. A sunset is more than color; it's an invitation to compose a thoughtful photograph. We capture people or places we love, and learn that loving them is not enough to make a photograph work. We tiptoe into the world of pleasing light, expressions caught, and striking composition. We turn to favorite images again and again, and delight in the emergence of our own vision. ❧ Light becomes the first editor of what should be photographed, and how. Its quality makes or breaks an image. Photographers know that nearly anything can come to life in interesting light, but even the loveliest scene can fall apart without it. Light ignites or softens or blesses. It defines the mood of a photograph, and that mood sets the stage for the entire composition. ❧ Composition is the architecture of the photograph. It is the chosen frame within which the image succeeds or fails. It's also the one element that the photographer can completely control. Yet composition is often an afterthought. ❧ One of the prices paid for instant and "deletable" pictures is a frenetic firing of shots. Artistic

choices are delayed until long after the moment has passed, in the mistaken hope that somehow in the rapid-fire effort, the moment will be caught. The joy of the hunt for stunning images has become a massacre. We shoot and do not see. A confident hunter anticipates the key moment, quiets his breath, aims, and shoots. Likewise, the hallmark of a good photographer is that most images are thoughtfully composed in camera—not cropped into submission later on. When a photographer wishes to go beyond personal vision to the world of communication, the key is content. The content of a photograph is its message. It moves beyond the architecture and appeal to purposeful communication. Photojournalists are in the business of delivering information and stories with pictures. They want the viewer to learn as well as to see. The most difficult element to capture in a photograph is a moment of true revelation; when the tear falls, the hands touch, the grin erupts, the volcano sleeps, the spirit is revealed. Capturing these moments requires passion and patience in equal parts. In the words of master photographer Minor White: "No matter how slow the film, Spirit always stands still long enough for the photographer it has chosen." Photography has become one of our most profound instruments of communication. The ability to share photographs is a powerful global tool that has unmasked horror, toppled governments, and lifted causes. Viewers are roused to anger or compassion or laughter and understanding. Photography shows us the size of the universe, the bounty of the sea, the intricacy of a butterfly wing. *National Geographic* magazine published its first pictures in 1889, and launched a sensation. The indelible images that followed over the next hundred years took readers inside, below, above, and beyond. Four hundred pages of that journey have been collected here, drawn from the simply stunning photographic collection of National Geographic. Enjoy every moment.

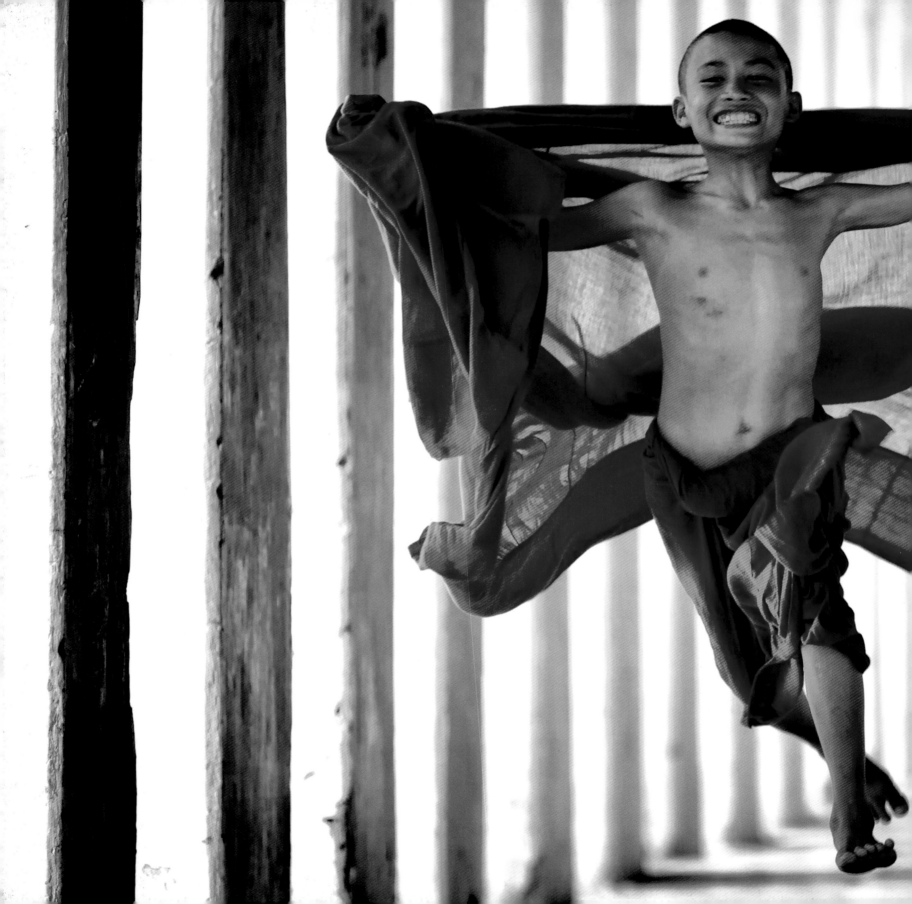

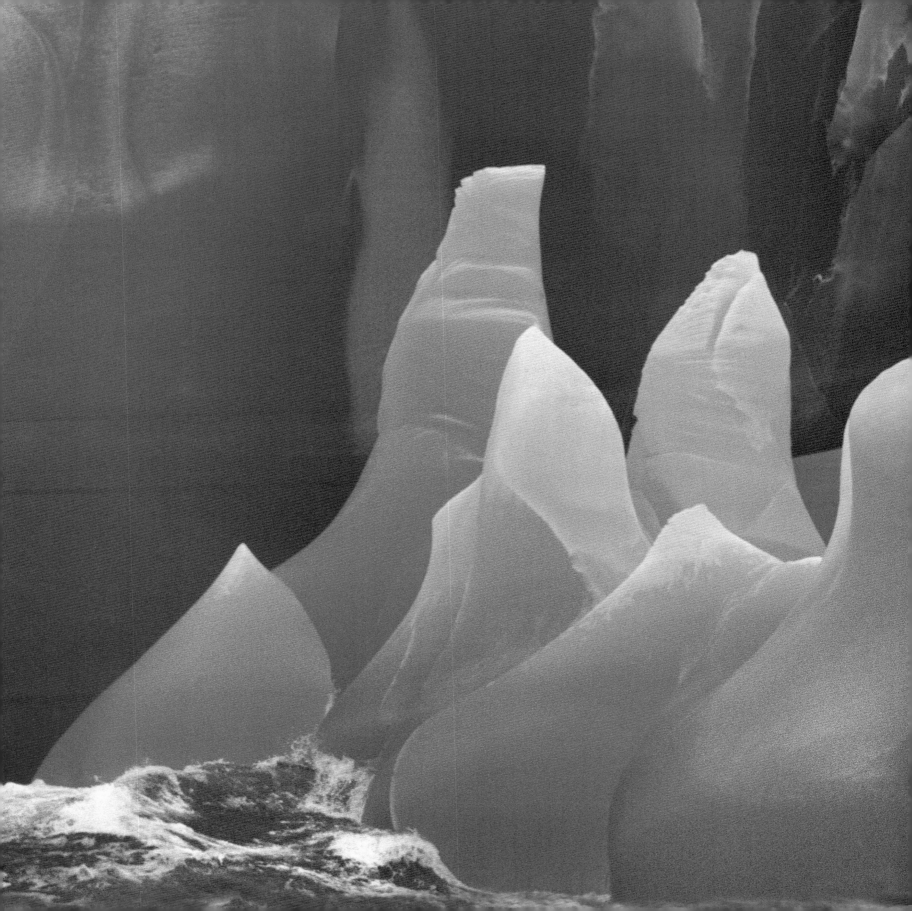

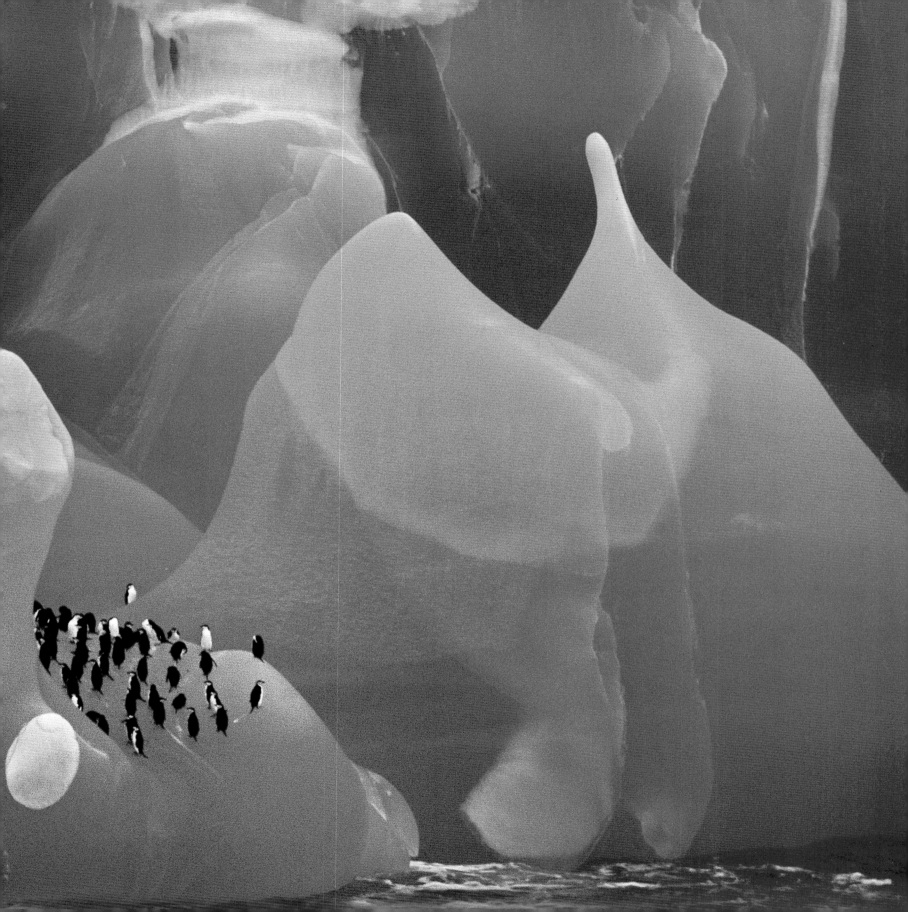

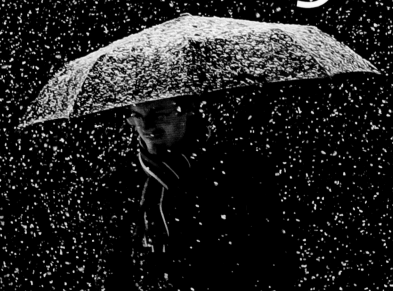

Mystery

There is a province in which the photograph tells us nothing more than what we see with our own eyes, but there is another in which it proves how little our eyes permit us to see.

~ Dorothea Lange

Mystery

We are drawn to mystery like moths to a flame. We are haunted and seduced by images that ignite humanity's primal fire: curiosity. A mysterious photograph asks more questions than it answers. Much the way we strain to *hear* a whisper, we strain to *see* something more. We can't see clearly, so we can't look away. In the flood of imagery that sweeps through our daily lives, mysterious photographs cause us to halt and reexamine. Visual riddles arouse suspense because of facts concealed or imagined. They invite interpretation and interaction. Deconstructing these images draws not only on what is seen but on the viewer's life experience and expectations. When visual clues run out, imagination takes over. Visions that appear angelic to one may appear demonic to another. Mist may soothe or agitate. A shadow may be seen as immaterial or a portent. Some see a sunrise, others a sunset. The quality of light dictates mood in most compelling photographs, and is key in arousing curiosity. Smoke and mist and dusk arouse visceral responses as light reveals only pieces of a scene. Sun shines selectively in a mysterious photograph, leaving the viewer to imagine what lurks in the fog, what causes this pattern, or silhouette or wondrous phenomenon. Like the "Mona Lisa," some images can be so enigmatic and unsettling that there is no real resolution. Viewers must be content with personal interpretation of what the subject is thinking or where the moment is leading. Other photographs are riddles that are meant to be solved, and revelation often elicits a physical response—it's a reflection, it's a tunnel, it's a snake! When presented with a visual conundrum, we are delighted to discover that what had appeared to be abstract is actually the view from a satellite or a microscope. Mystery solved. Some photographs document events so fantastical that

they humble us: the murmuration of starlings, the pulsing sorcery of the aurora borealis, or the undulating scenes beneath polar ice. In a world where we sometimes feel that we have seen it all, new and mysterious wonders are still captured and shared through photographs. ✿ Since its inception, photography has been a means of solving mysteries, by illuminating what most could never be fortunate enough to witness. Photographs have provided proof that the Earth is round, the continents have shifted, the species has evolved. ✿ The advent of digital photography has made it possible for photographers to capture images in lower and lower light, revealing sights previously unseen in astonishing detail. The Milky Way, once a blurry vision in a lucky exposure, is now quite easy to capture, even with a simple camera. Astronauts, scientists, and even soldiers are now shooting in the dark and bringing back astonishing images. ✿ Endlessly curious, photographers have harnessed technology to regularly take cameras where they have never gone before: inside the human body. We are mystified at the beauty of bacteria, and shiver at the sight of a bed bug magnified 10,000 times. These images explode mysteries, expand scientific knowledge, and save lives. ✿ Perhaps the greatest achievement in photographic revelation has been the Hubble Space Telescope. Hubble images have solved mysteries as profound as the age of the universe and the existence of dark energy. It is most astonishing to realize that, within our lifetime, this telescope has created a photo archive of cosmic events that predate the very invention of photography by hundreds of thousands of years. ✿ Whether through microscopic detail or cosmic wonder, mysterious photographs light the imagination. They challenge us to halt in our daily lives and consider something new or uncomfortable or unclear. Most important, these images make us want to know more.

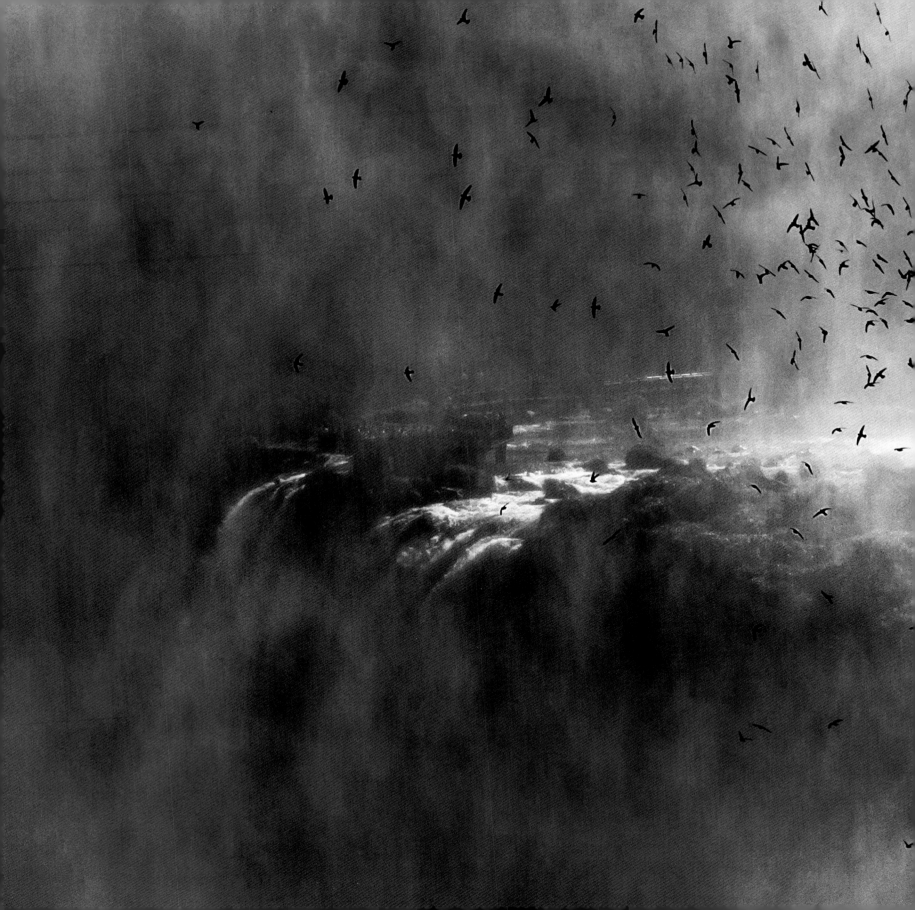

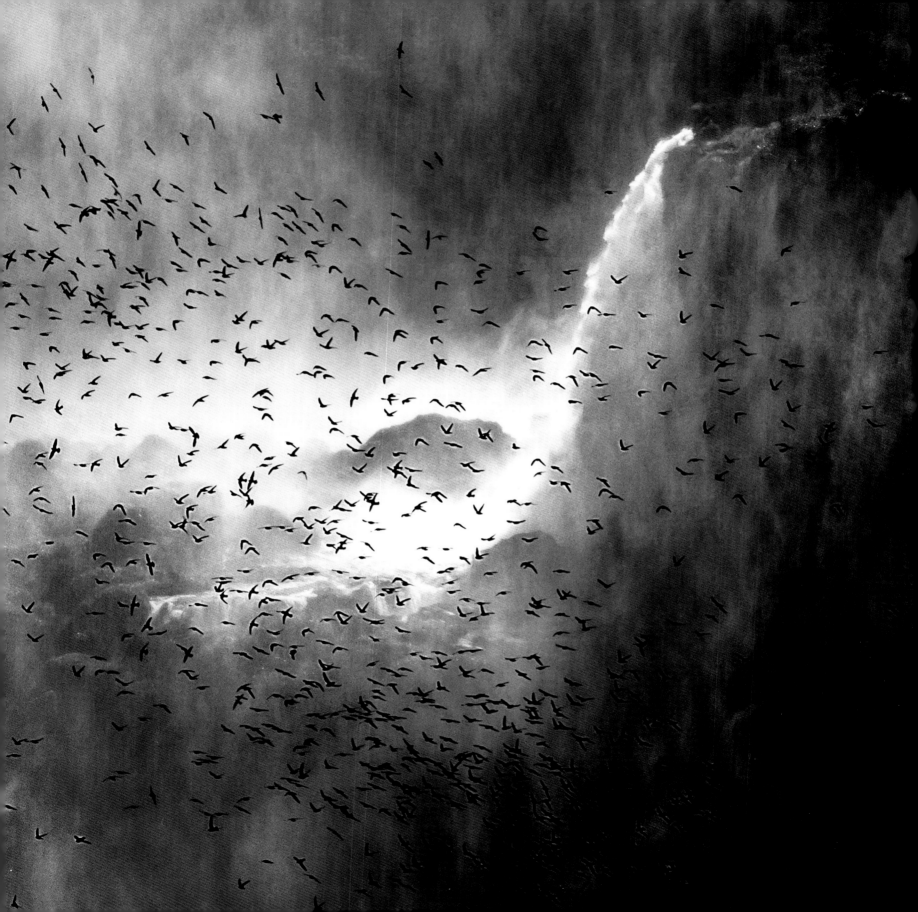

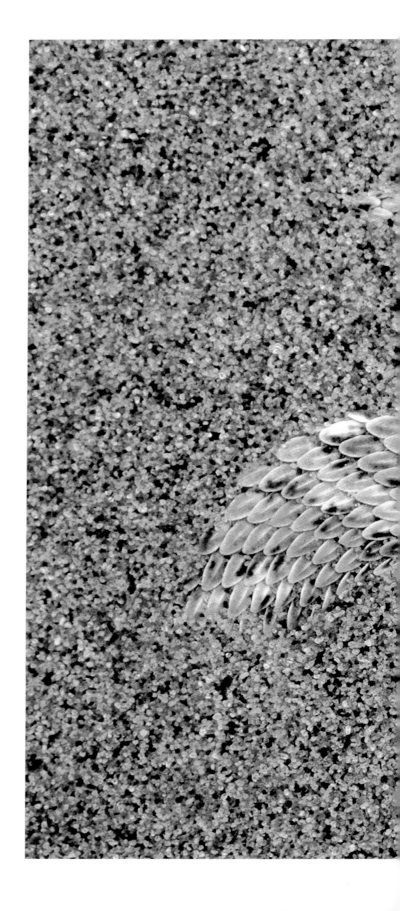

THOMAS DRESSLER
Namib Desert, Namibia
Waiting for prey, a Peringuey's adder
burrows into sand, leaving only its eyes
and tail exposed.

preceding pages

JOSEP LAGO
Barcelona, Spain
An umbrella shields a man from heavy
snow flurries.

FRANCESCO FILIPPO PELLEGRINI
Misiones, Argentina
A flock of swifts flies through the spray
of majestic Iguazú Falls.

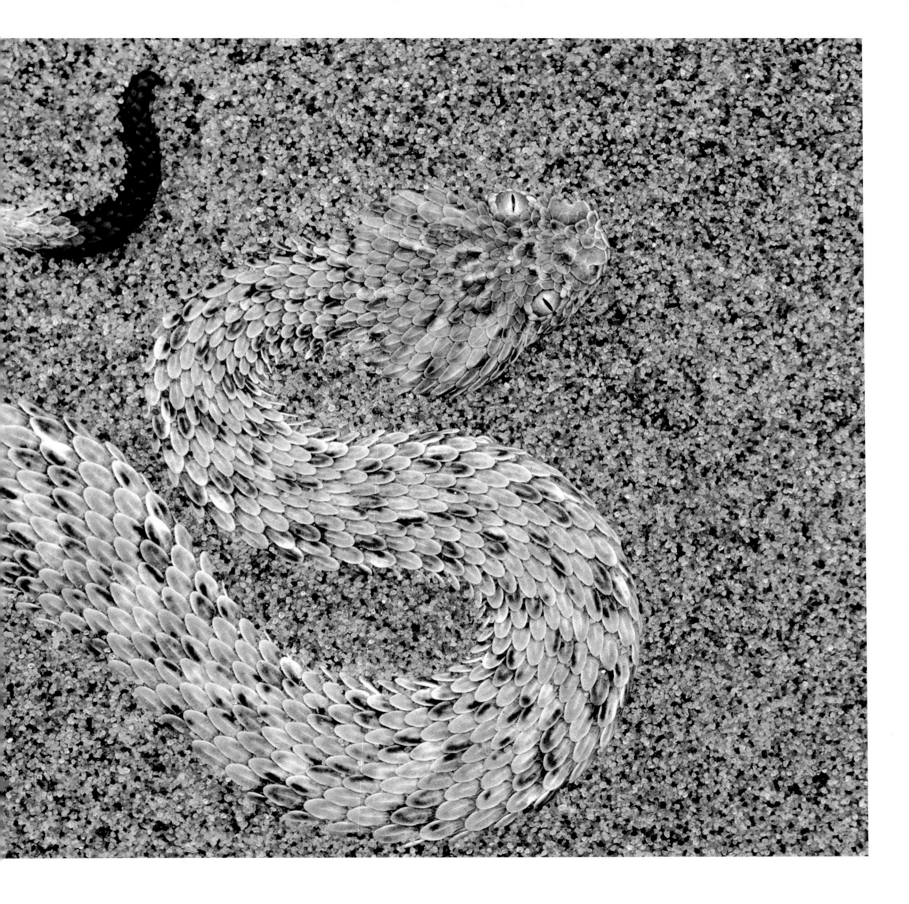

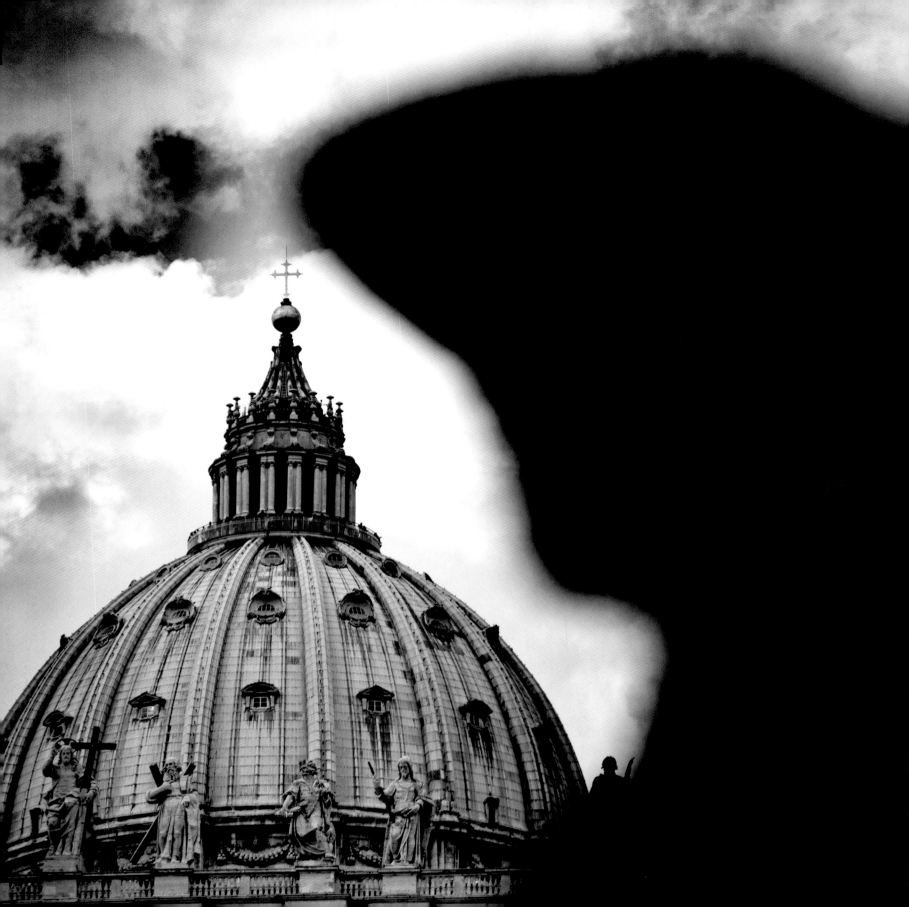

ANTONIO GIBOTTA
Rome, Italy
A visitor wearing a hat pauses near
St. Peter's Basilica in Vatican City.

following pages

THOMAS J. ABERCROMBIE
Kabul, Afghanistan
A woman shrouded in a chadri carries
a pair of caged goldfinches on her head.

DO DO
Beijing, China
The camera transforms farm fields into
an artful landscape.

Every branch of human knowledge, if traced up to its source and final principles, vanishes into mystery.

~ Arthur Machen

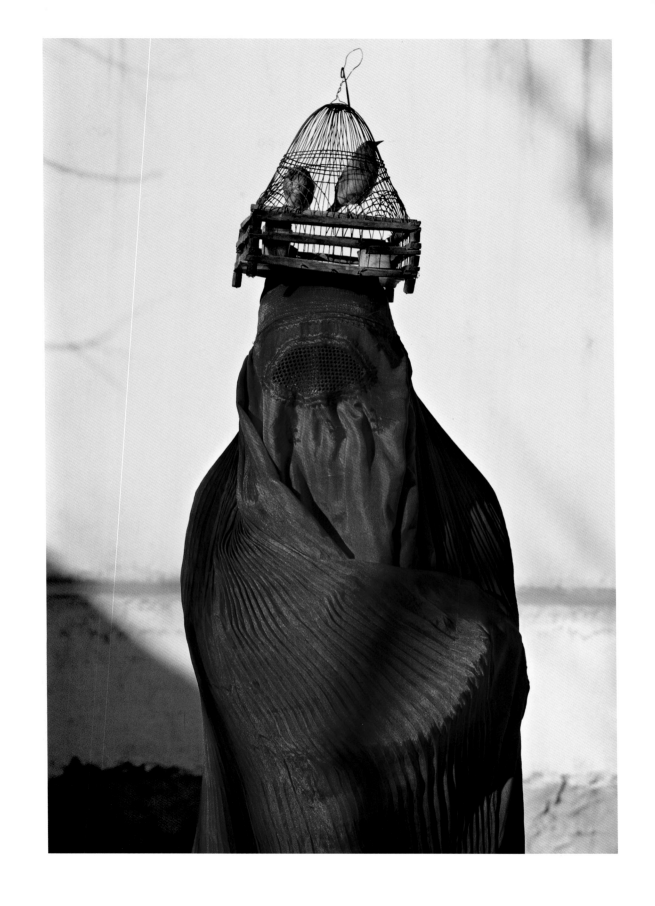

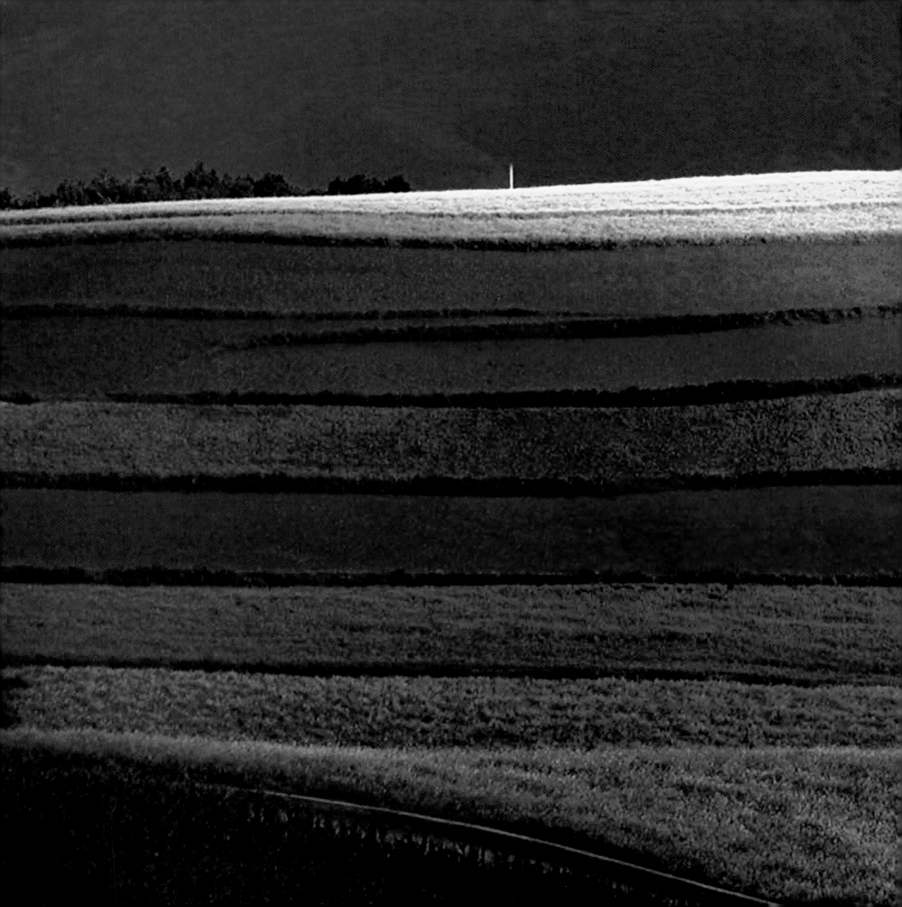

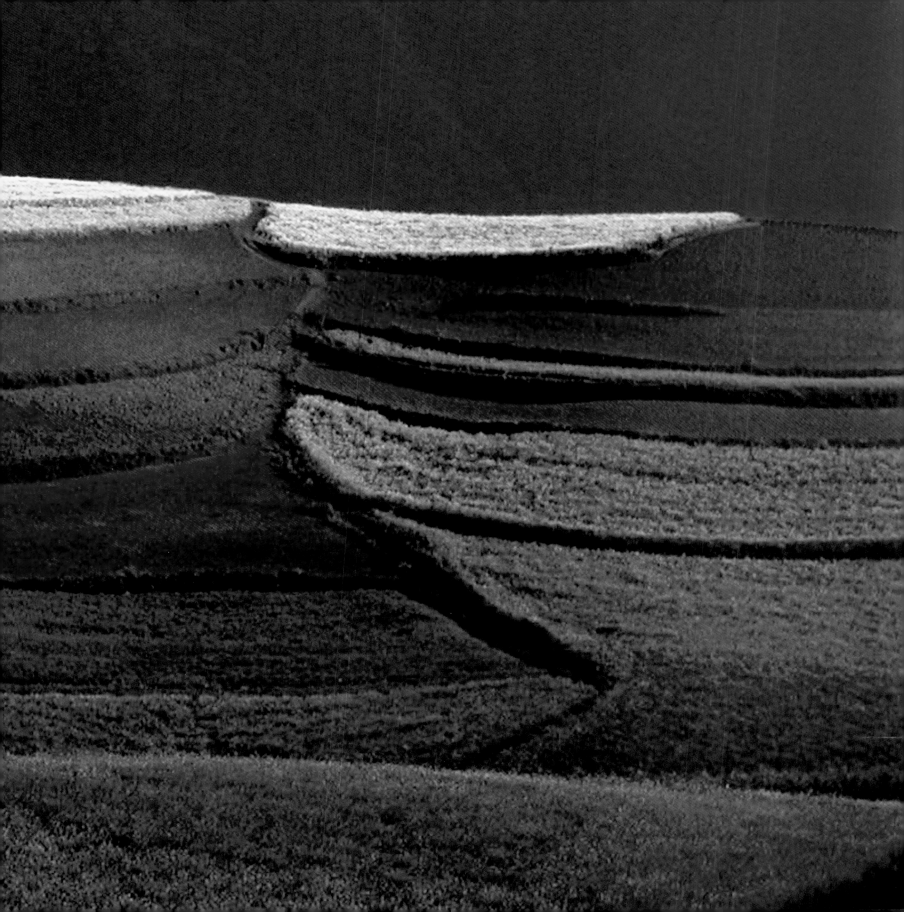

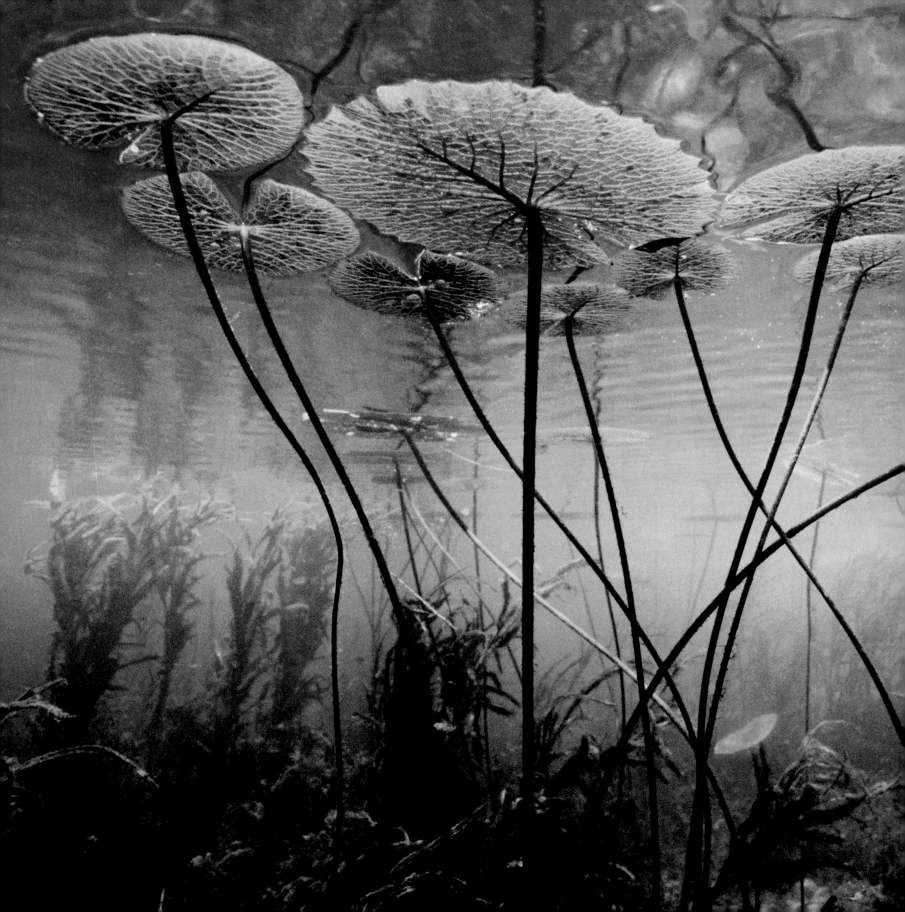

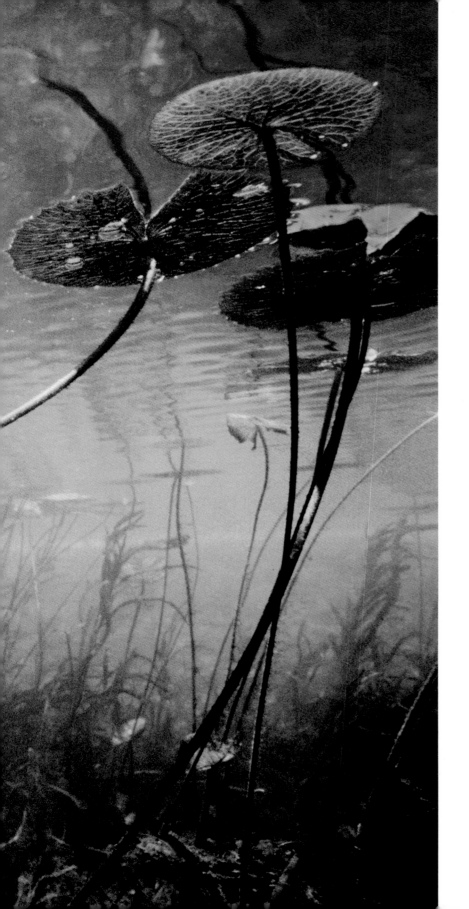

FRANS LANTING
Okavango Delta, Botswana
Water lilies rise to the surface of
a river delta.

37

Martin Oeggerli

I am a science photographer and my passion
is to explore invisibly small things. To capture
the morphology of Venus flytrap pollen grains,
I used a scanning electron microscope. Flower-
ing plants are the dominant plants on Earth
and much of their evolutionary success is
based on structures invisible to the naked eye.
Collecting and analyzing the details helps us
to understand "the mystery of all mysteries,"
as Charles Darwin liked to say.

MARTIN OEGGERLI
Switzerland
Magnification reveals the beauty of
Venus flytrap pollen grains.

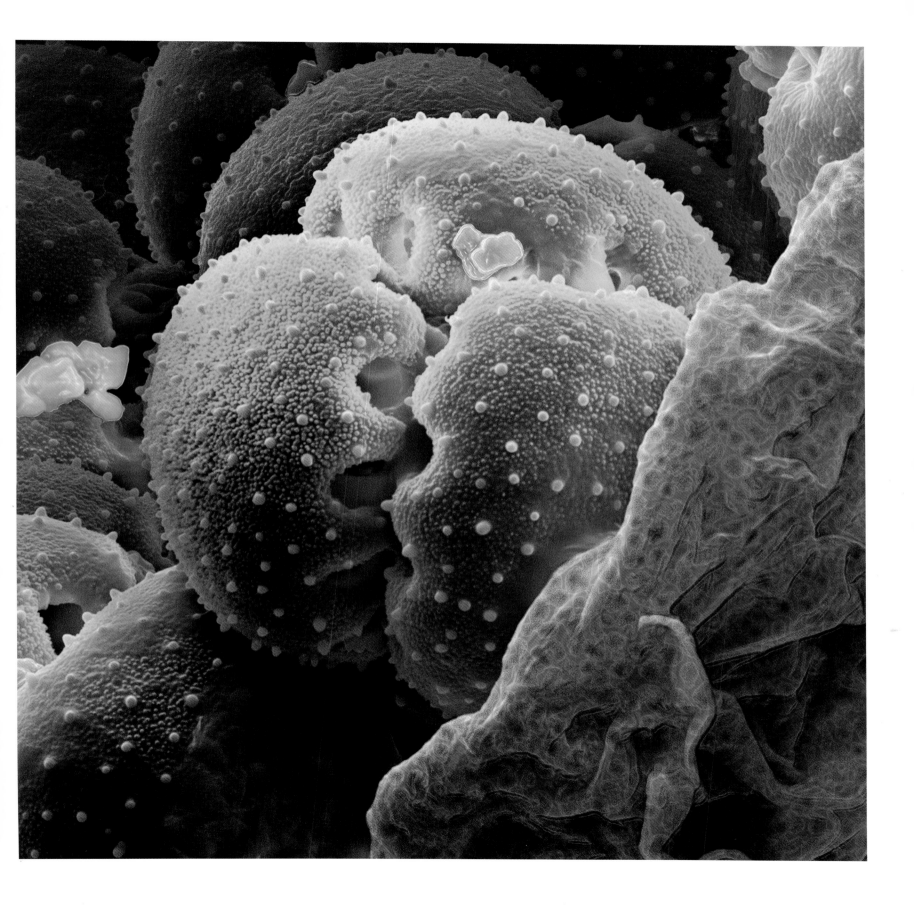

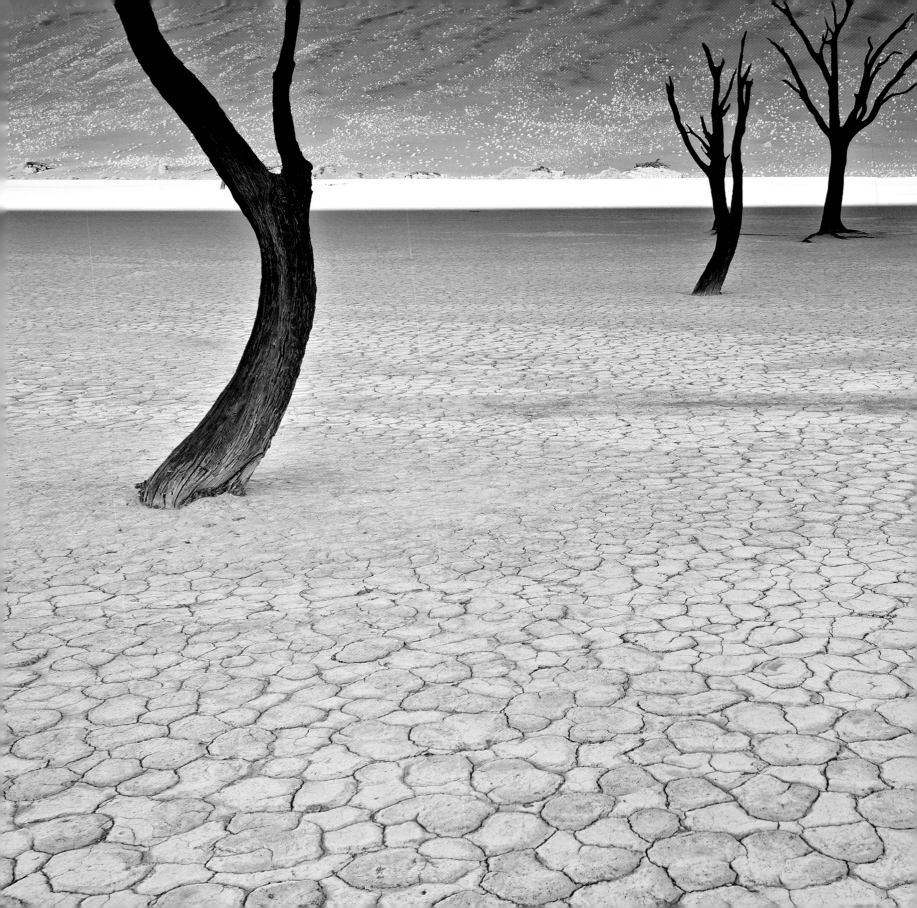

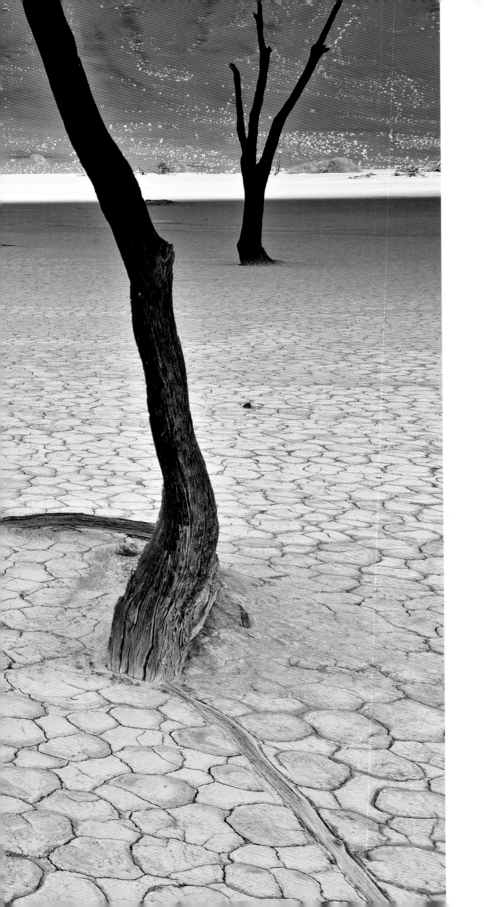

FRANS LANTING
Namib-Naukluft National Park,
Namibia
Skeletal trunks of camel thorn trees dot
a parched landscape.

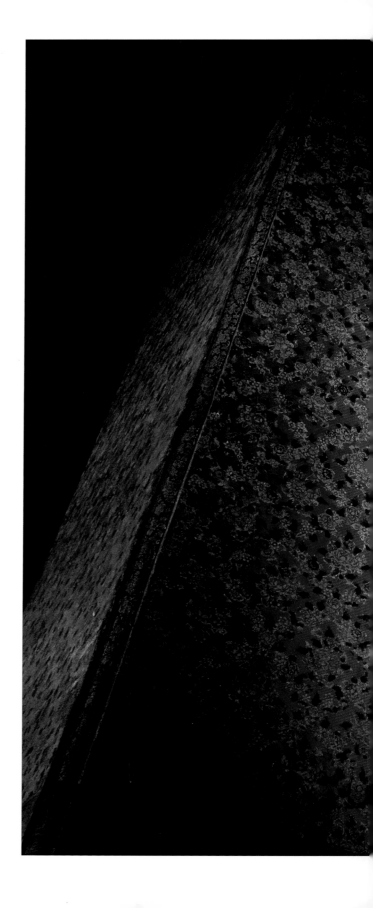

RICK WIANECKI
Bangkok, Thailand
Ornate pillars frame the face of a
reclining Buddha at Wat Pho temple.

following pages
ALEX SABERI
London, England
Deer gather in Richmond Park on
a misty morning.

MICHAEL NICHOLS
San Diego, California
A white rhinoceros at a safari park
strolls at twilight.

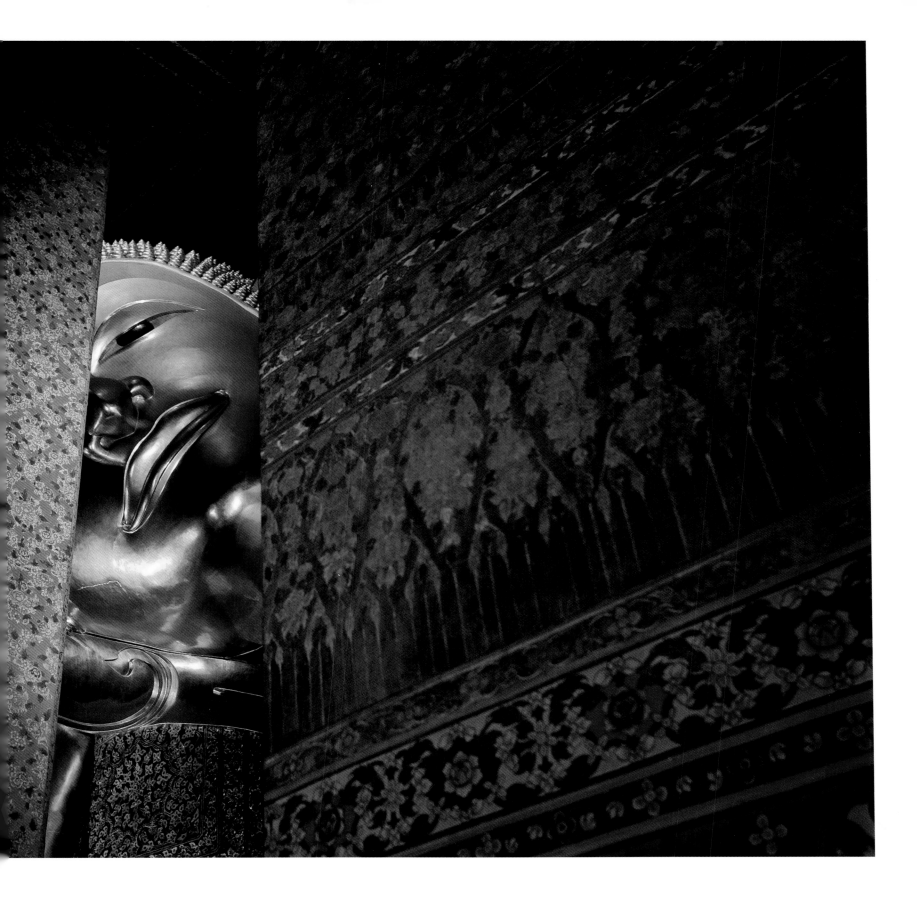

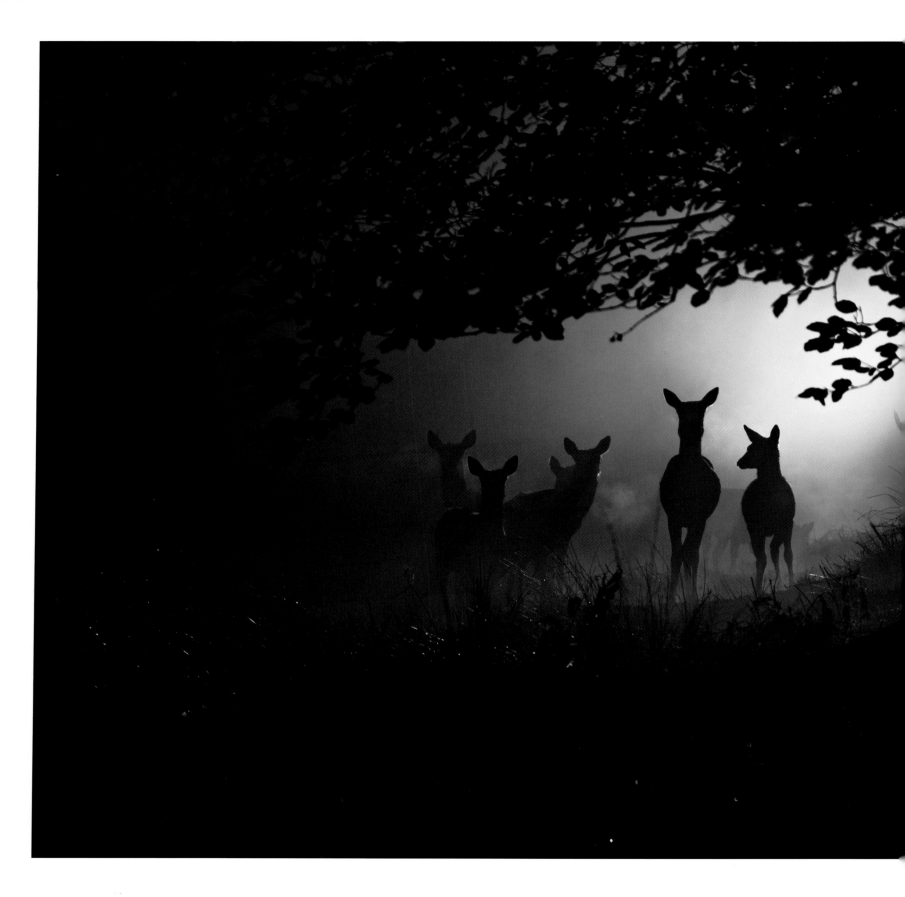

Light makes
photography.
Embrace light.
Admire it. Love it . . .
and you will
know the key to
photography.

~ George Eastman

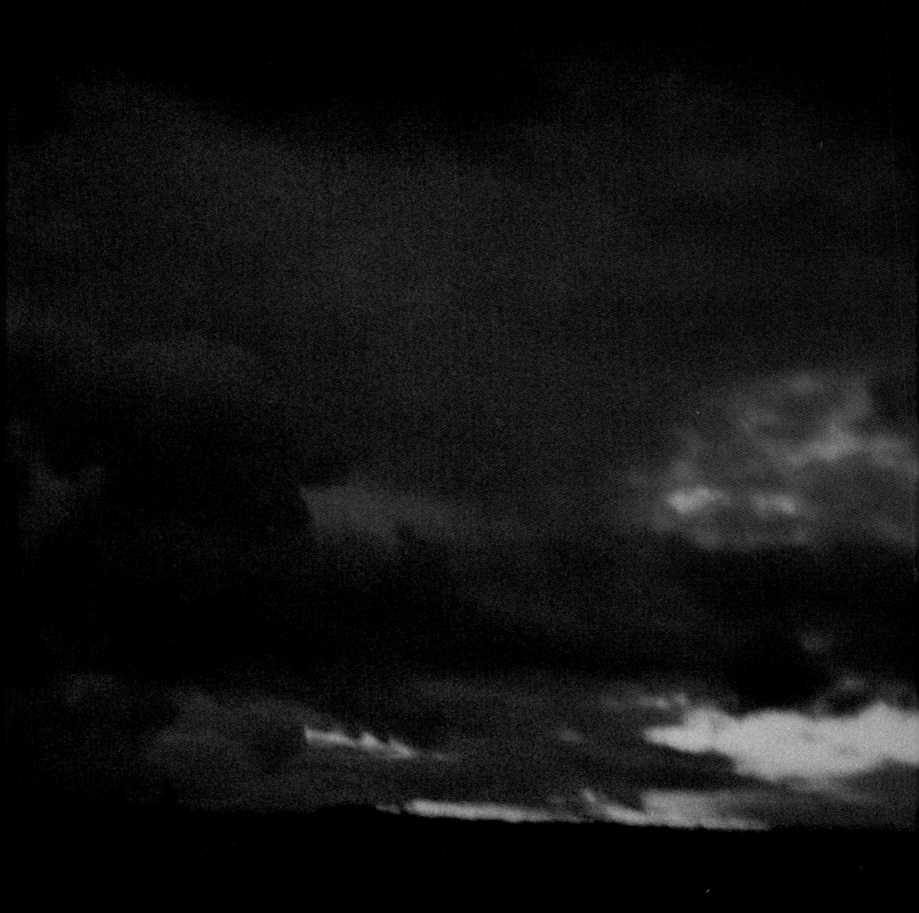

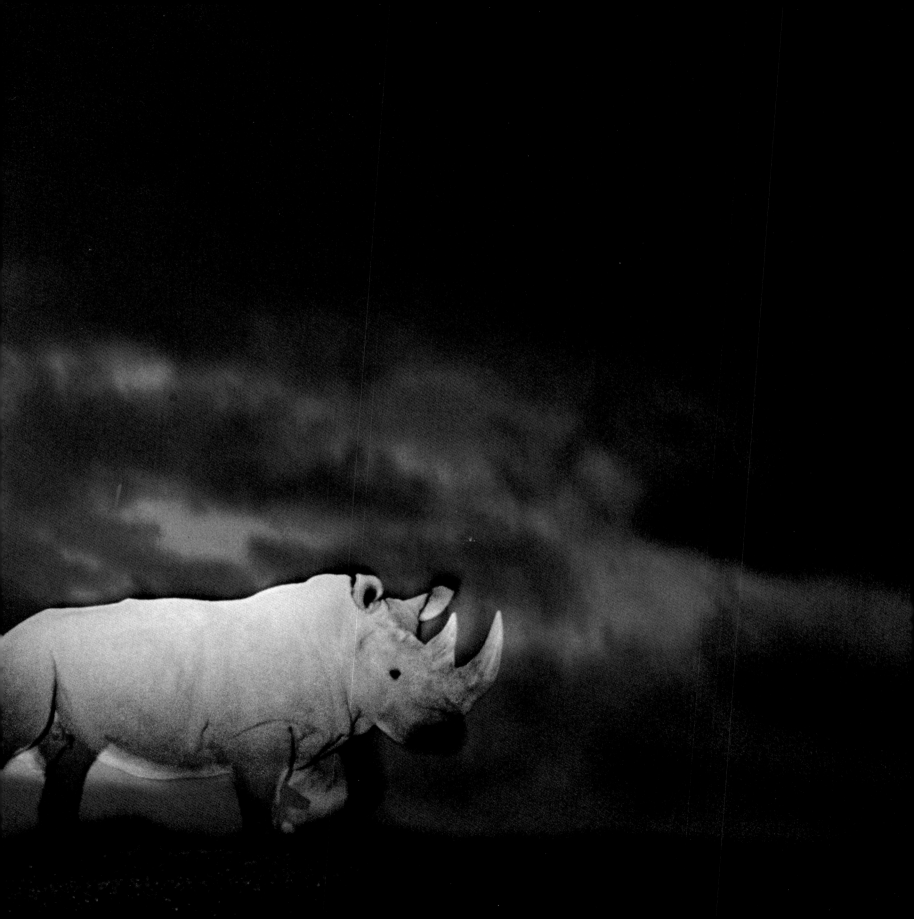

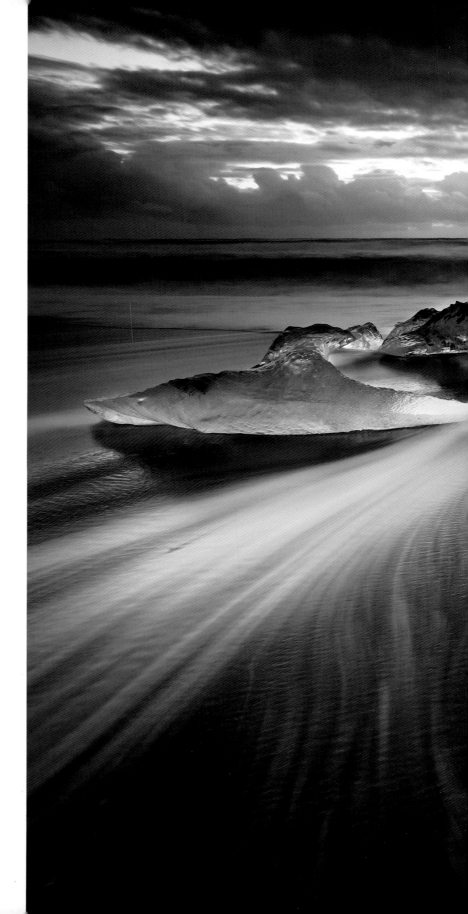

EREZ MAROM
Jokulsarlon Beach, Iceland
Water eddies around iceberg calves
washed up on a black-sand beach.

following pages

KIRK THOMPSON
Fox River Grove, Illinois
Head half-submerged, a young girl takes
her portrait underwater.

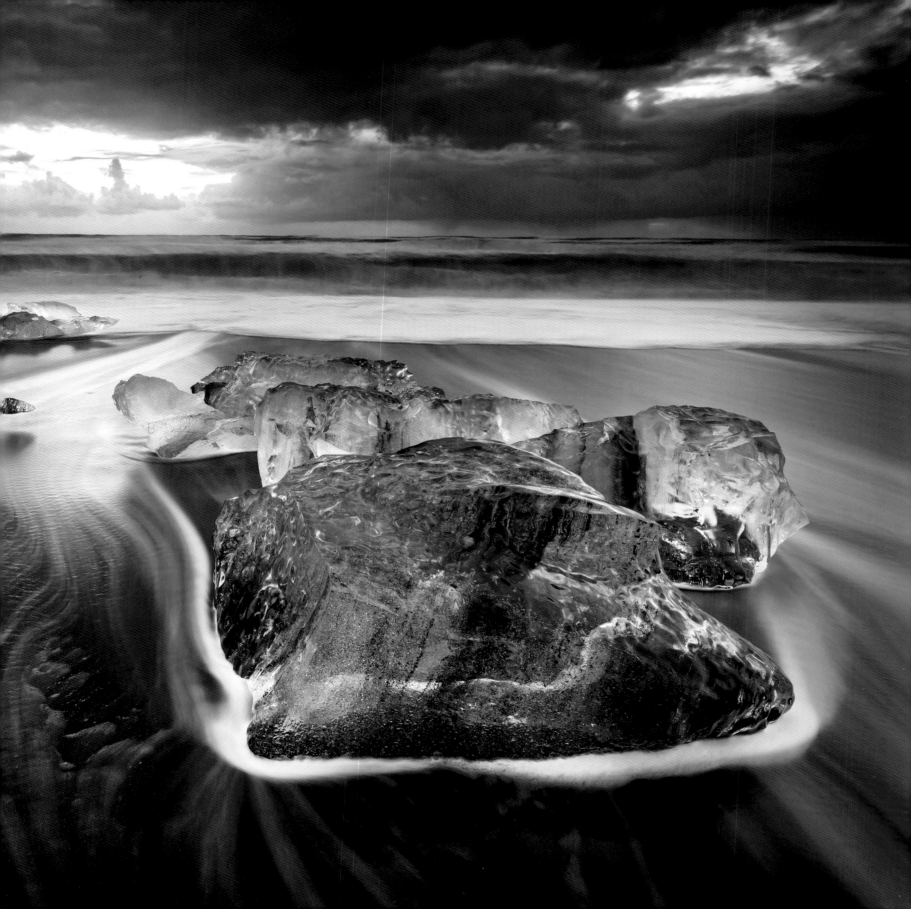

You cannot
depend on
your eyes if your
imagination is
out of focus.

~ Mark Twain

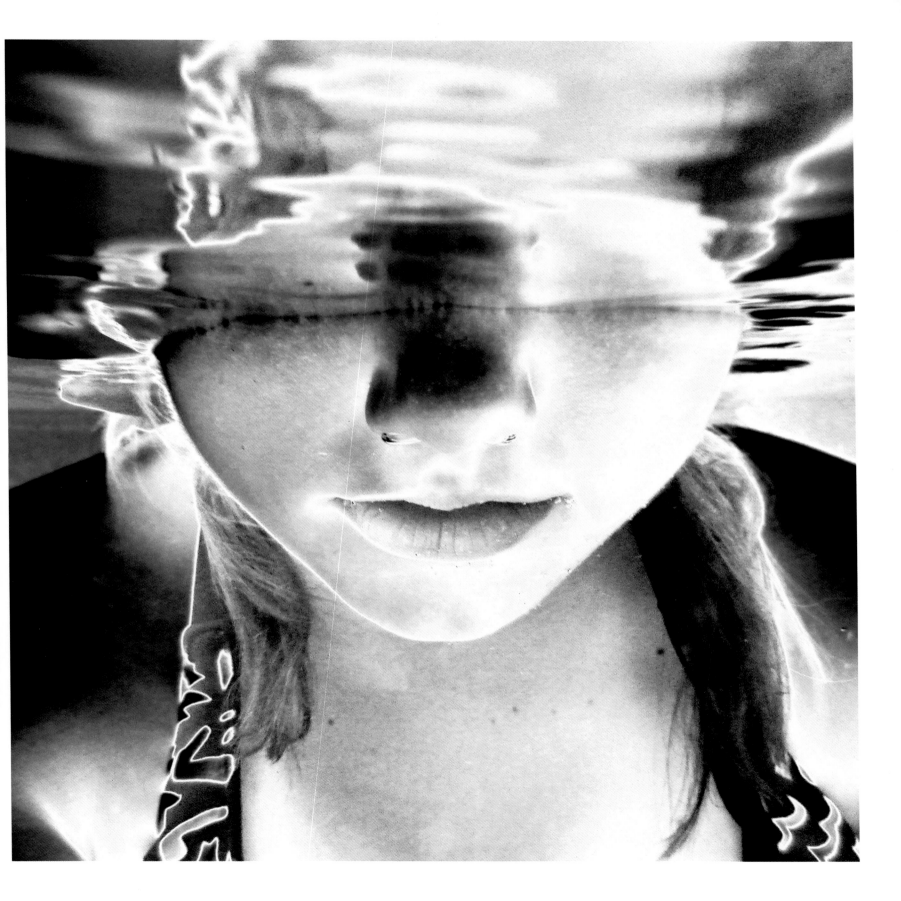

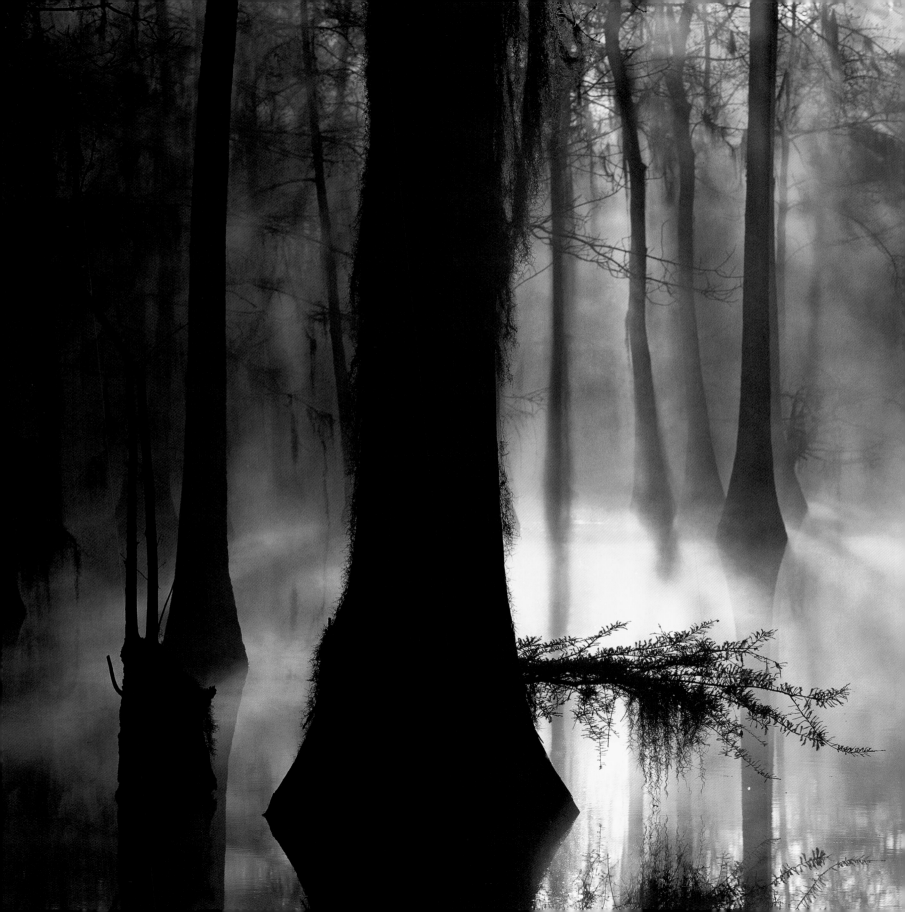

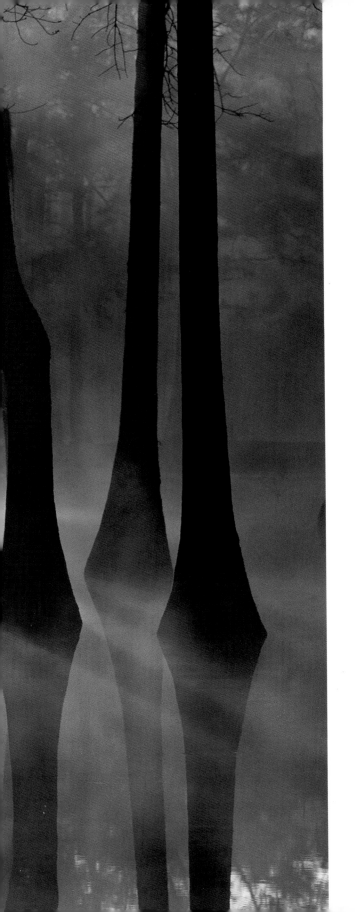

TIM FITZHARRIS
Lake Fausse Pointe State Park,
Louisiana
Dawn breaks over a bald cypress grove.

following pages
TSUNEAKI HIRAMATSU
Near Okayama, Japan
Thousands of dancing fireflies illuminate
a forest.

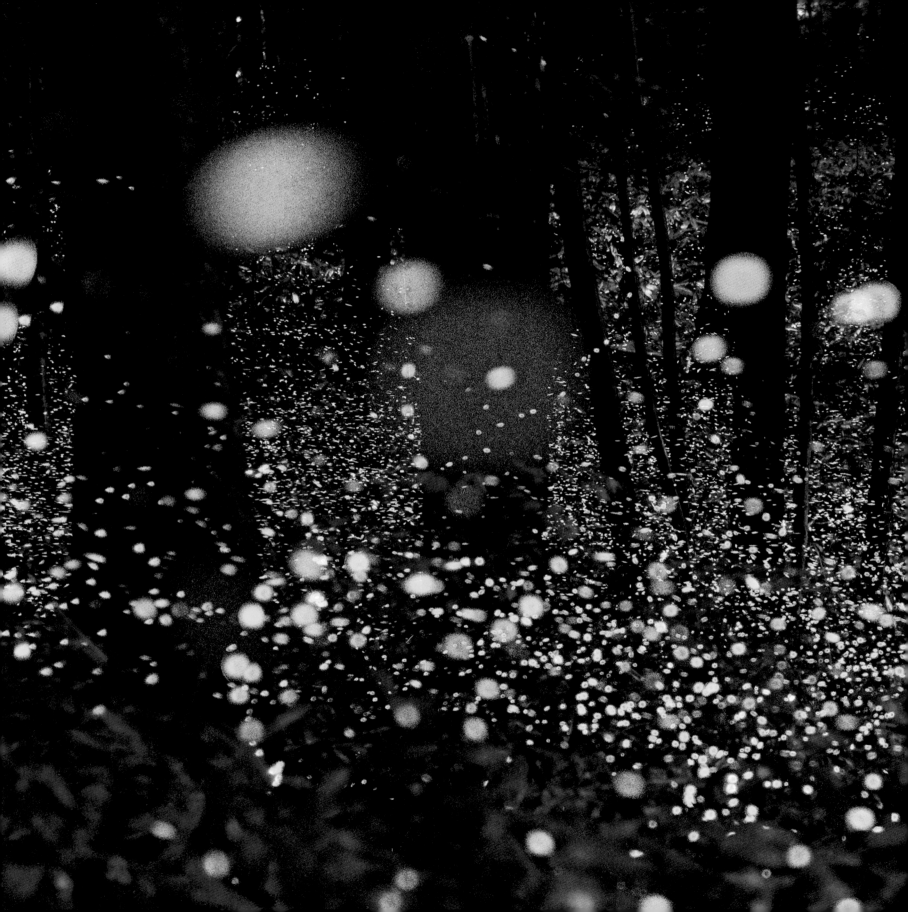

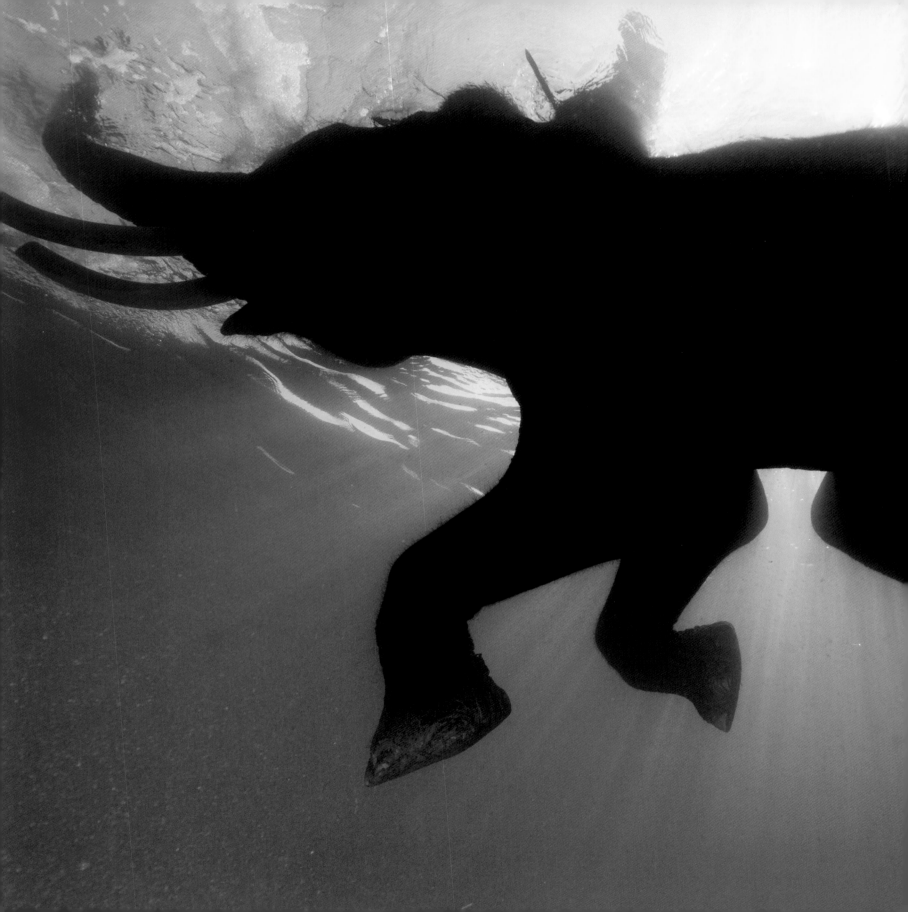

CESARE NALDI
Andaman Islands, India
An elephant swims underwater using
his trunk as a snorkel.

following page
KRISTIN JÓNSDÓTTIR
Skorradalur, Iceland
Water mirrors dazzling emerald green
northern lights.

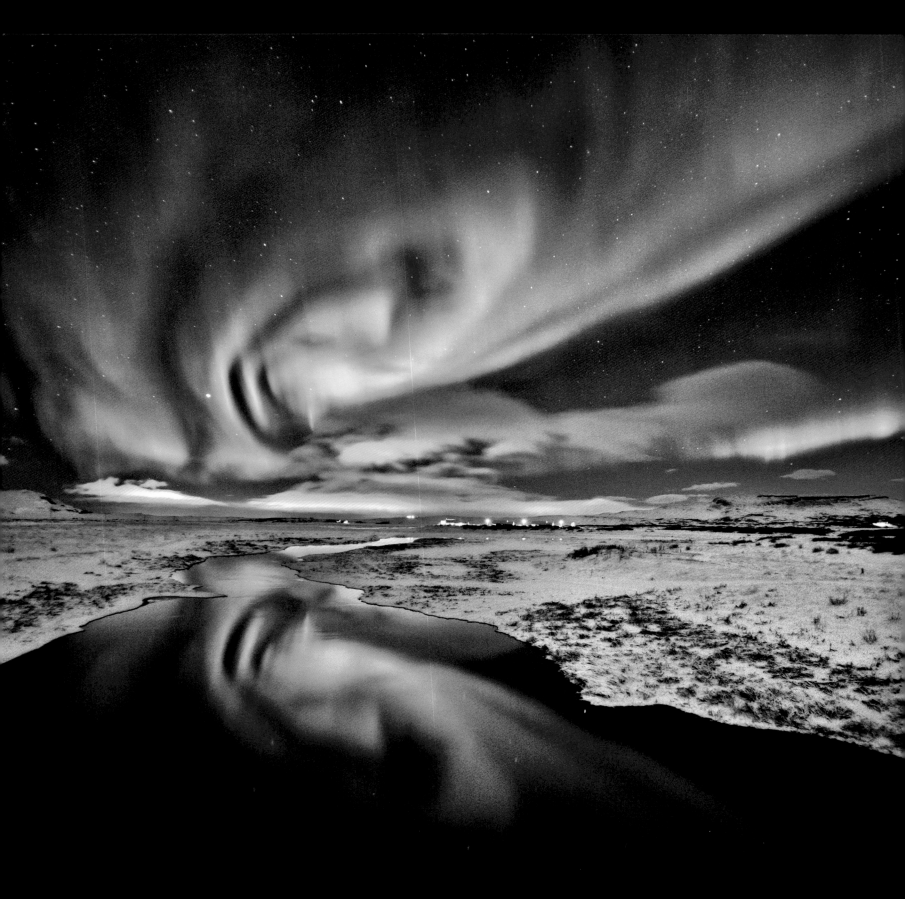

Beauty paints and when it painted most, I shot.

~ Ernst Haas

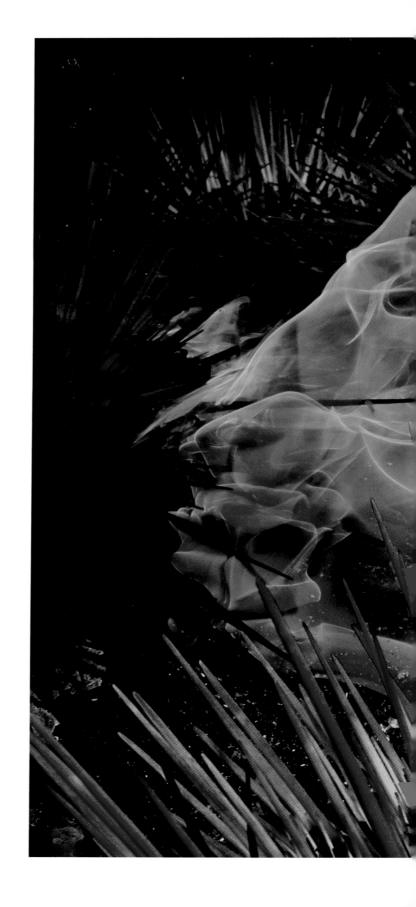

PAUL NICKLEN
Vancouver Island, British Columbia,
Canada
A nontoxic dye marks currents flowing
through a sea urchin colony.

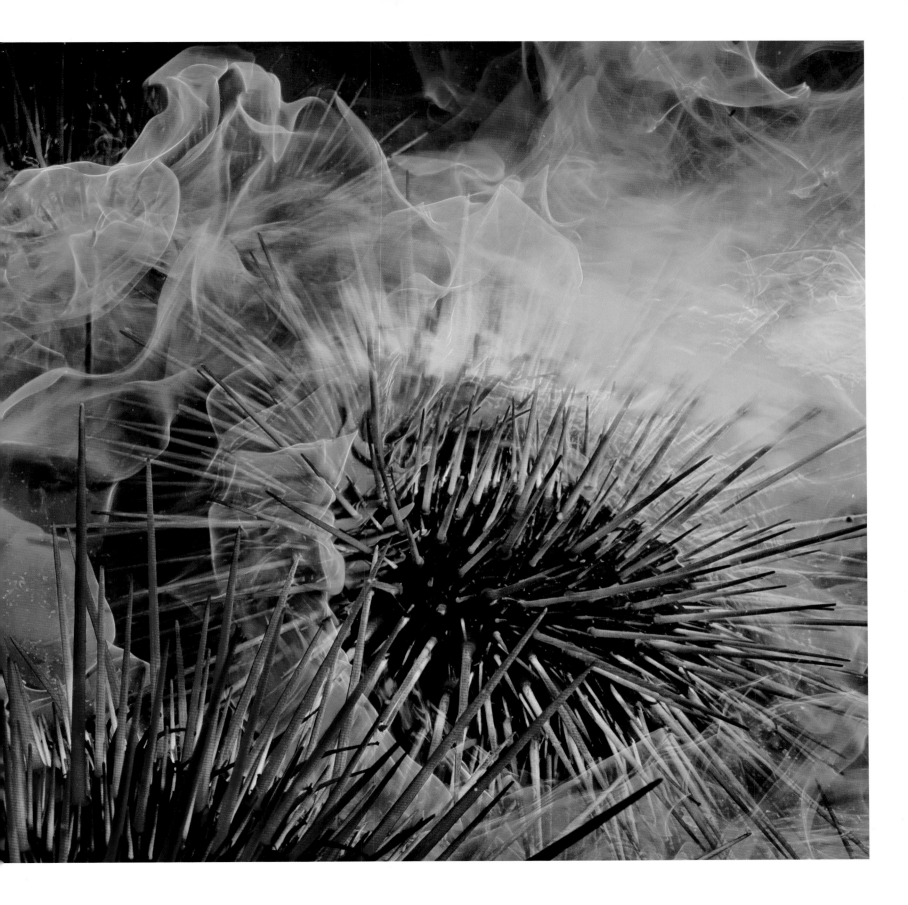

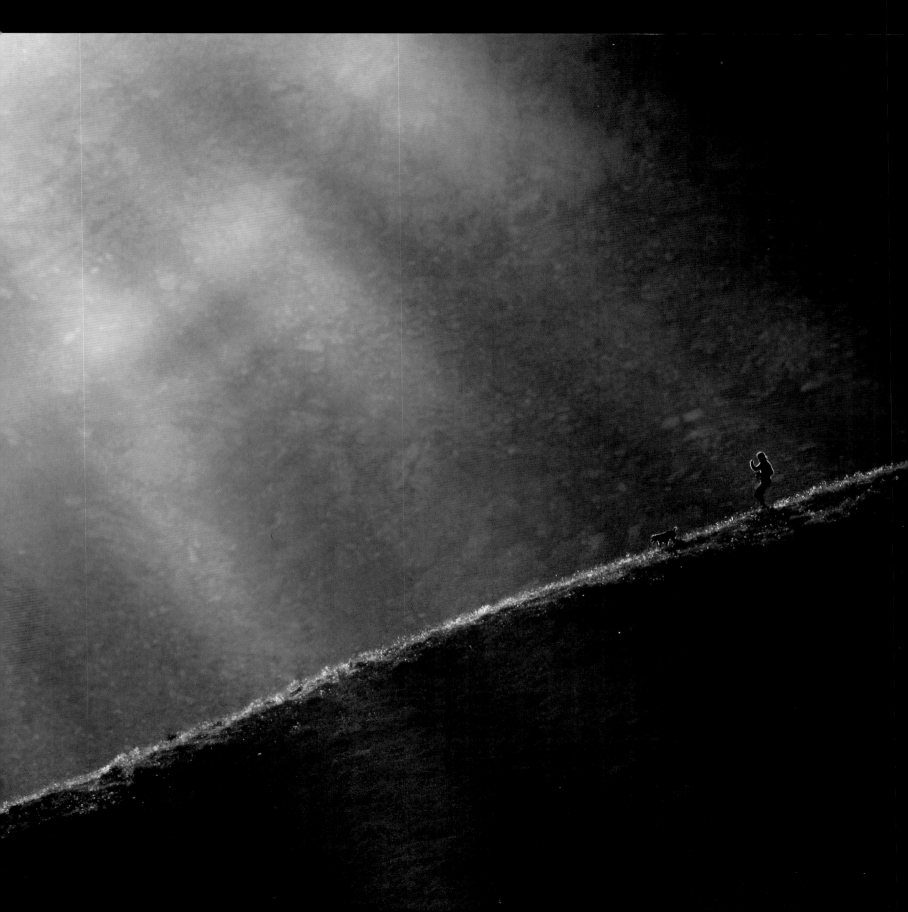

Christiane Biederbick

I am drawn to colors and light always. The day I took this picture, I was high in the Alps of Italy. Suddenly I heard my friend Hanna and our loyal dog, Orfeo, running down a distant hill. Orfeo was barking and Hanna was shouting, so I looked for them through the zoom lens. I saw their shapes—light and wonderful—and followed them with my camera.

When they arrived they were breathless, and scared, and Hanna told me that they were running from an angry goat that was chasing them down the mountain. I call that day the goat day.

CHRISTIANE BIEDERBICK
Aosta Valley, Italy
Sunrays beam down on a woman running down a hill.

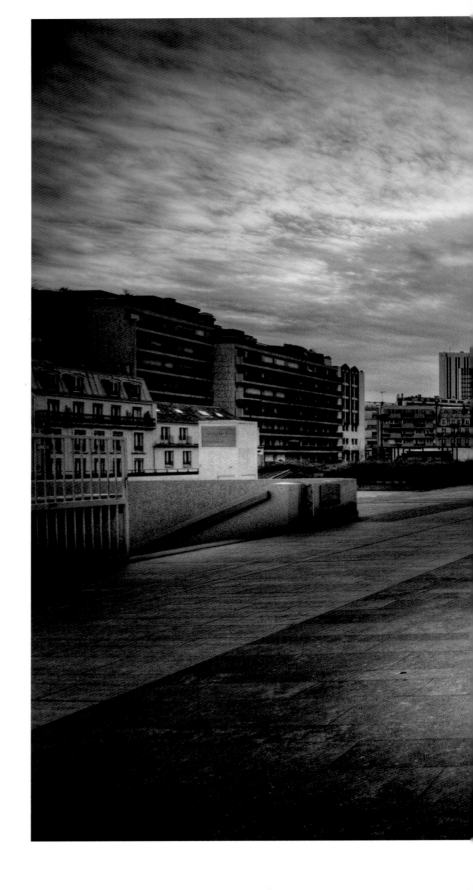

LAURENT HUNZIKER

Paris, France

A saffron-robed monk walks through
a deserted plaza in Montparnasse.

following pages

NATE PERKES

Donnelly, Idaho

A rising sun glows through trees in the
morning fog over Cascade Lake.

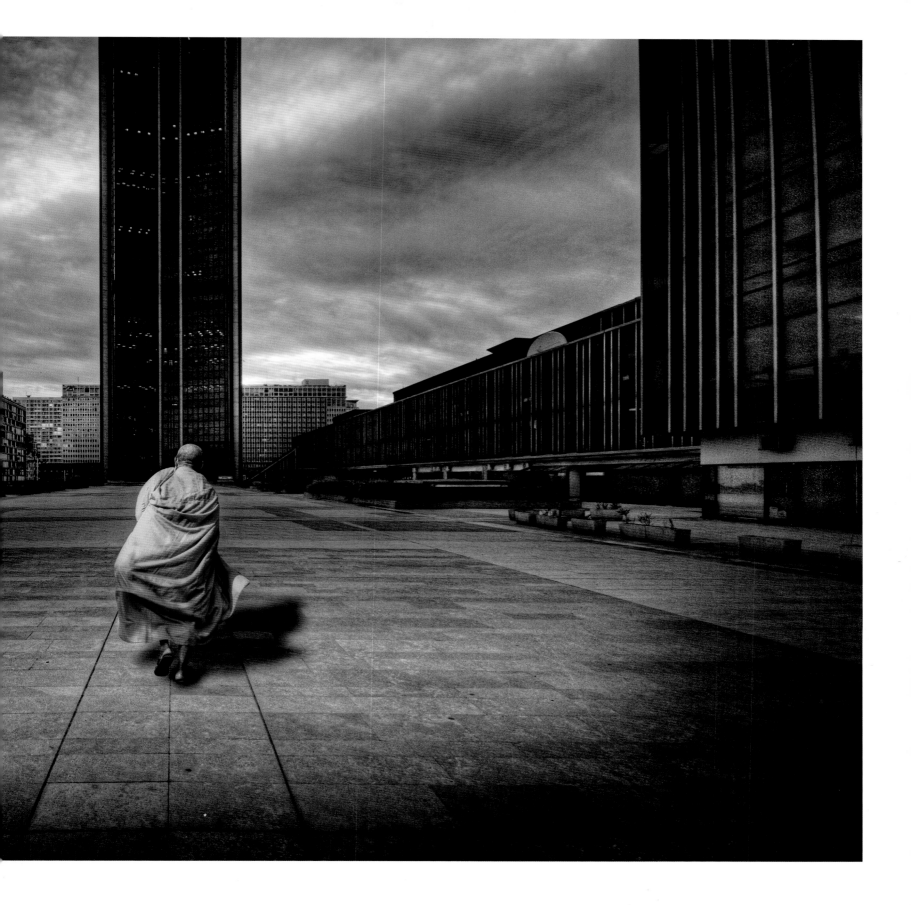

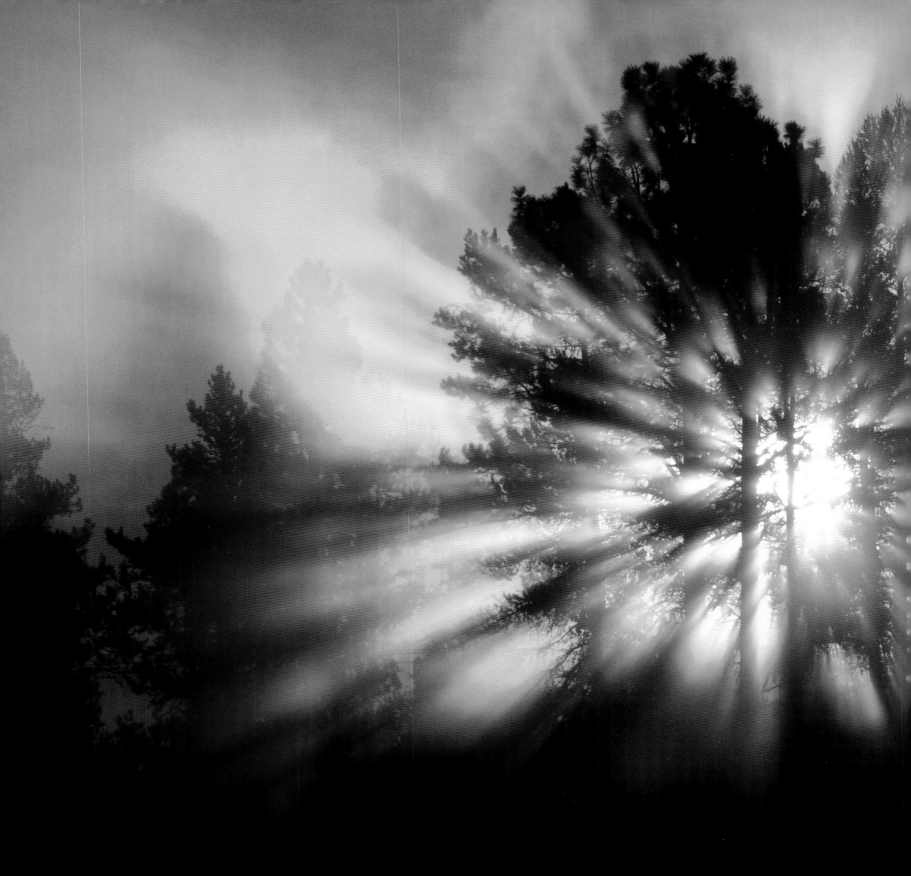

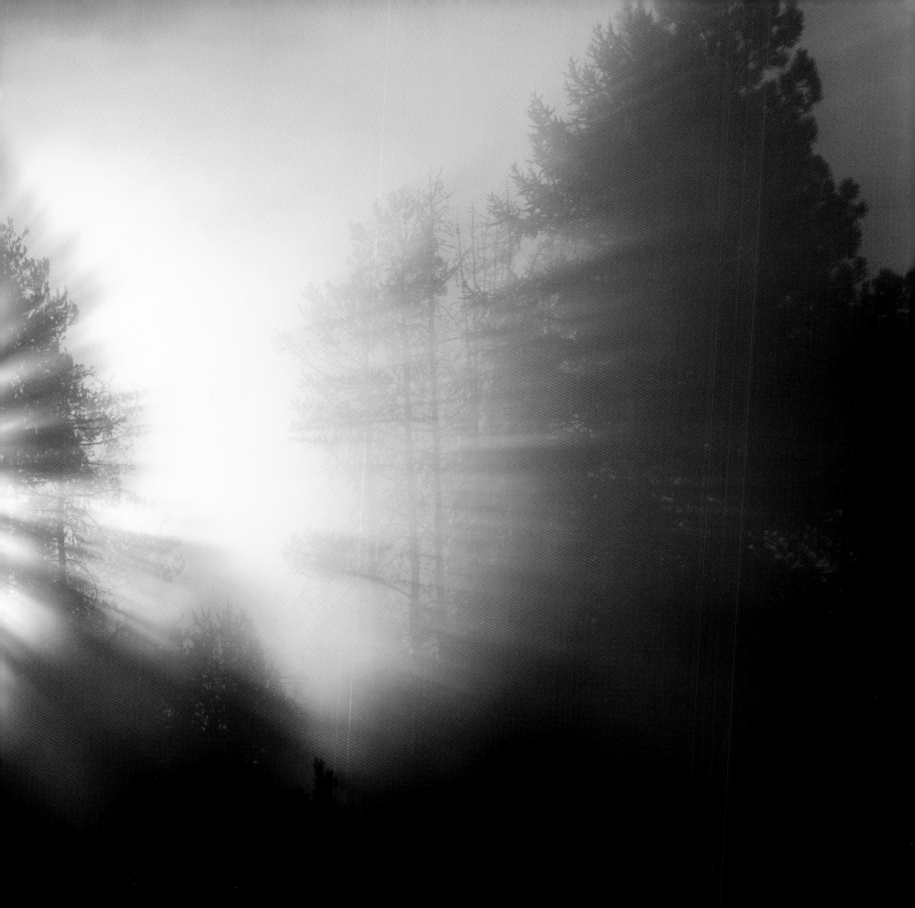

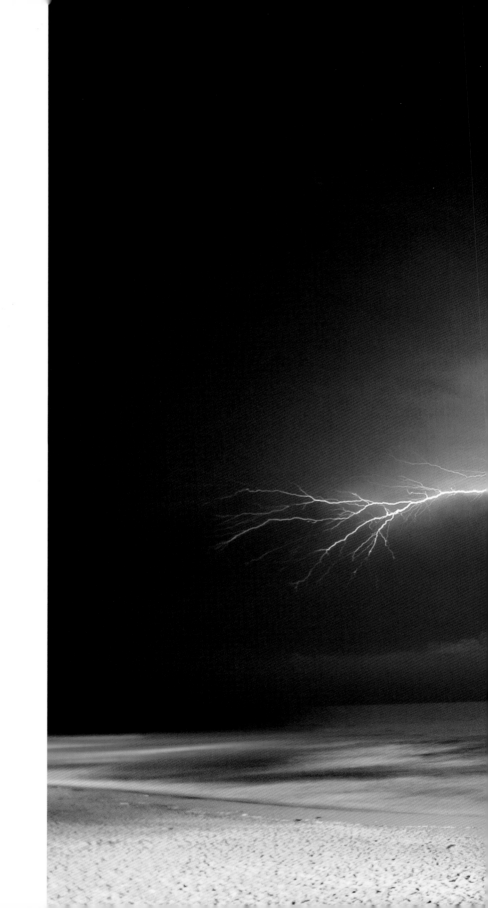

AMIRALI SHARIFI

Mahmood Abad, Iran

A distant lightning bolt splits the night
sky over the Caspian Sea.

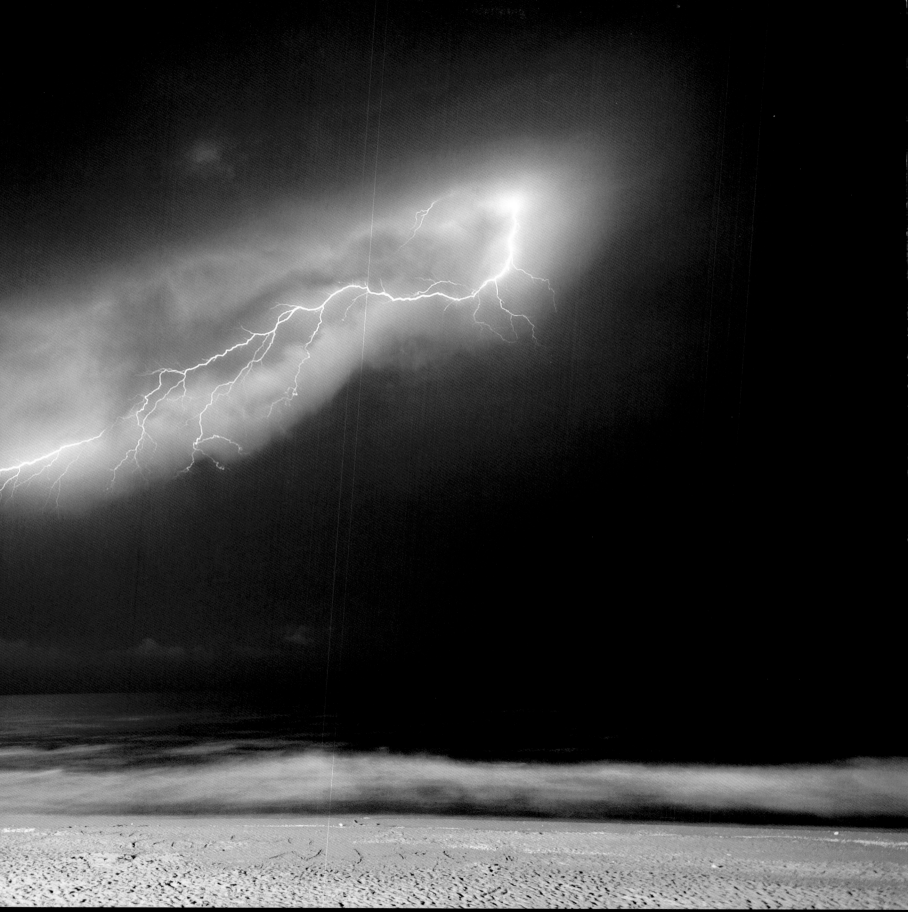

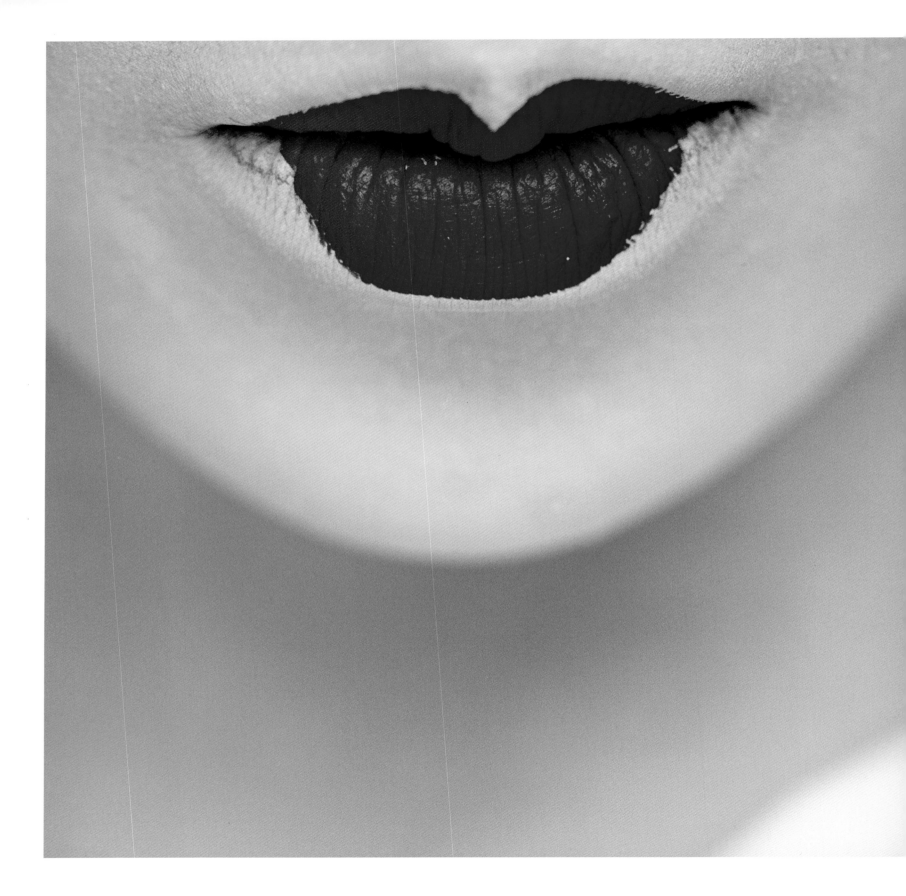

Jodi Cobb

Mystery is a great motivator in my career. I always want to know what's around the next corner. This picture was made for a self-initiated project on the geisha of Japan. I was granted 24 hours inside their very secret world. After applying her makeup behind a screen, the anonymous geisha stepped out and a shaft of light came through the window. It was the reflection from a car outside. I was able to make four frames before the light was gone.

JODI COBB
Kyoto, Japan
A geisha's painted smile accentuates her alabaster makeup.

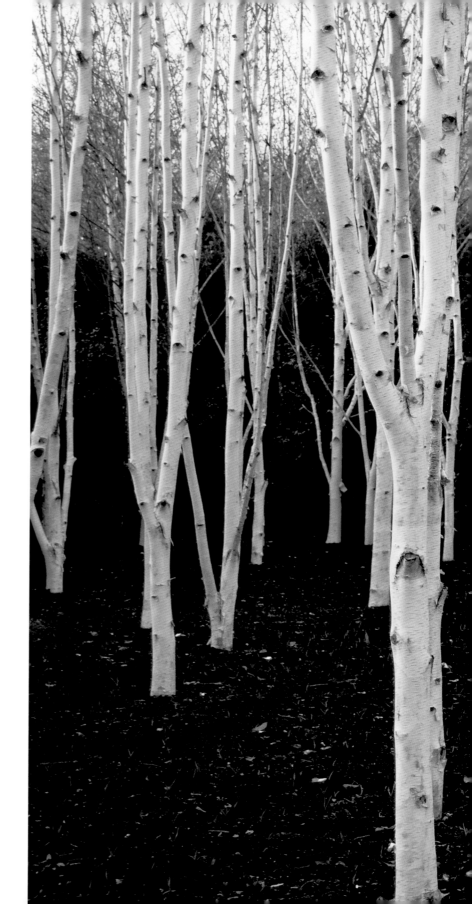

STAMEN STANEV

Cambridge, England

A grove of white Himalayan birch
marks the end of Anglesey Abbey's
garden walk.

following pages

ROBERT B. HAAS

Ciudad Guayana, Venezuela

Egrets fly above a sandbank in the
Orinoco River.

BOZA IVANOVIC

Los Angeles, California

A lion at the zoo displays a seemingly
pensive pose.

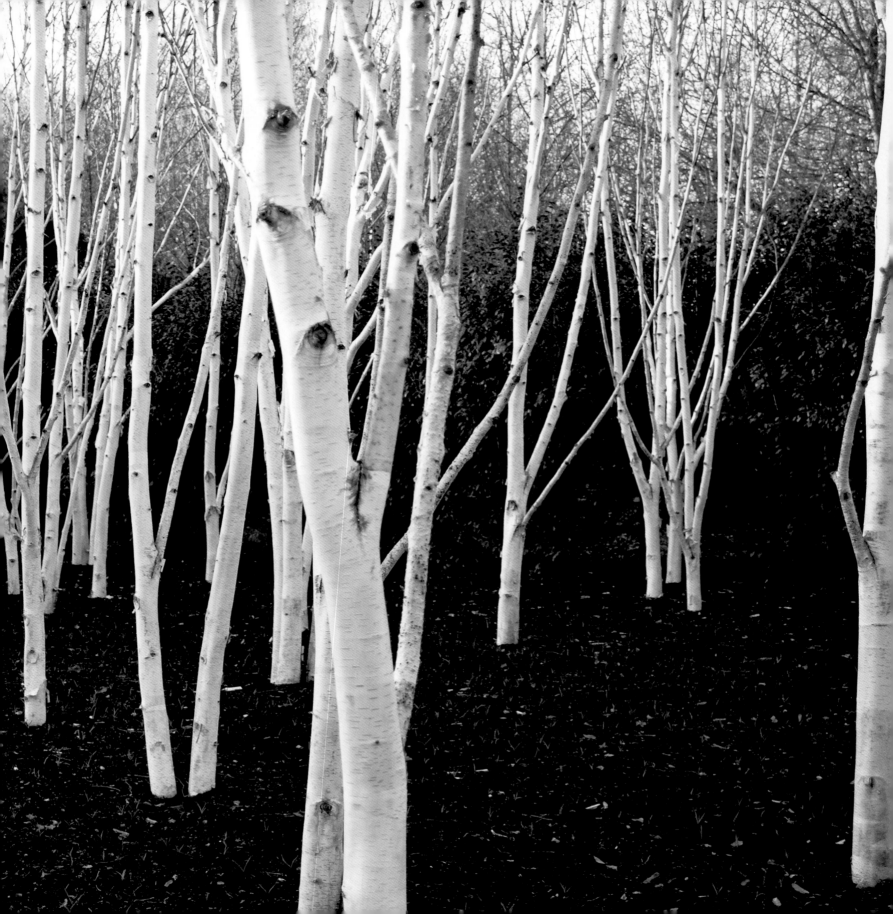

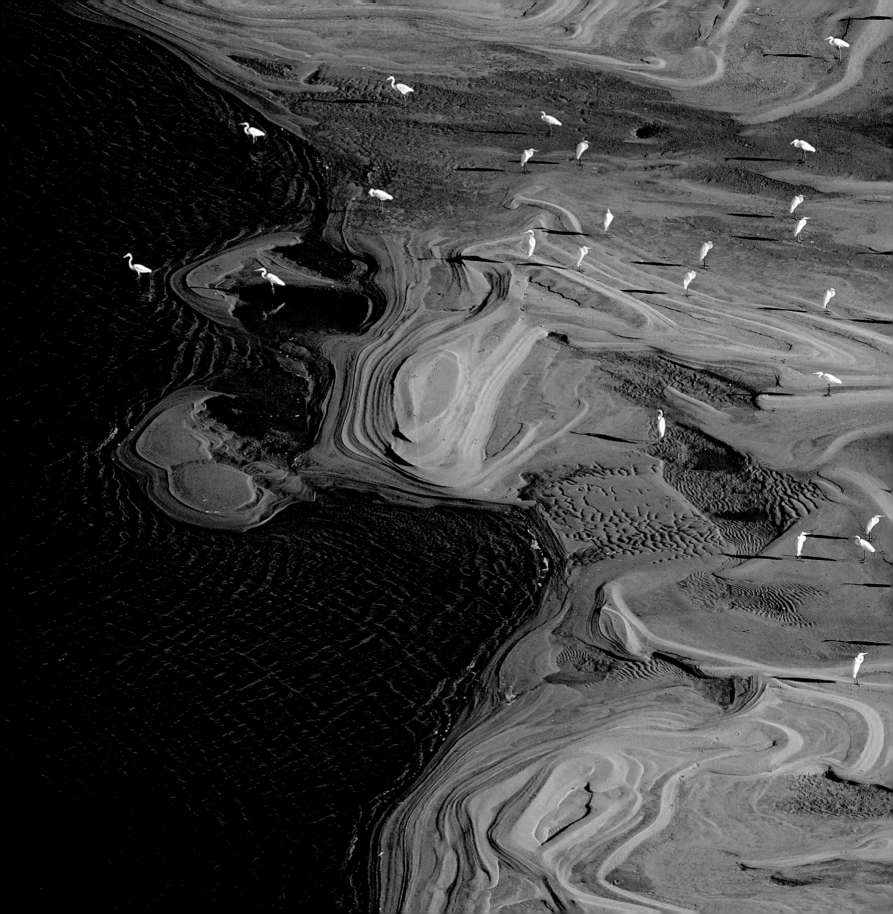

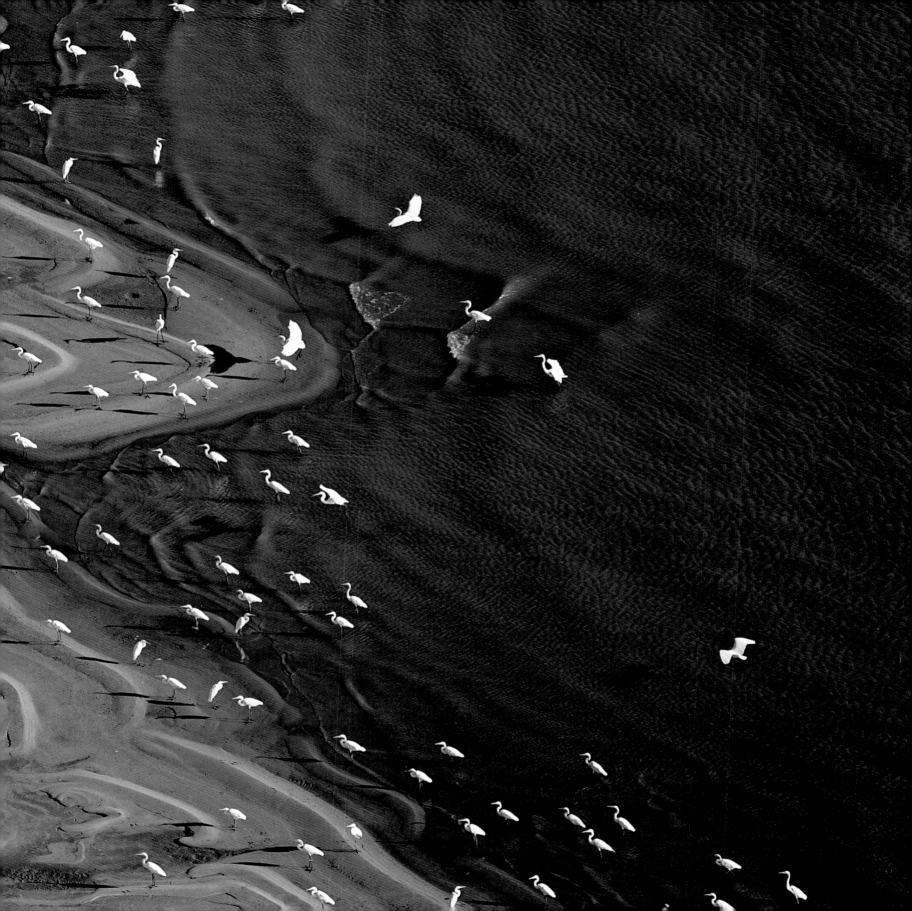

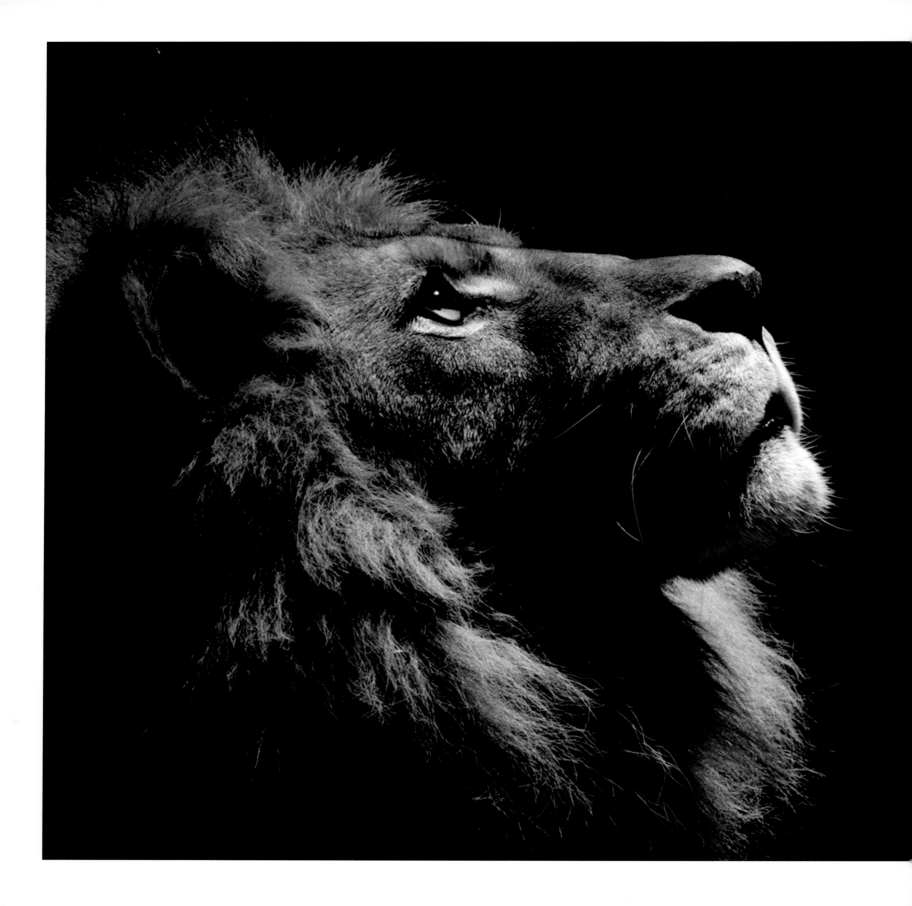

There is no greater mystery to me than that of light traveling through darkness.

~ Alexander Volkov

MARSEL VAN OOSTEN
Namib-Naukluft National Park,
Namibia
Mist and light enhance the mystery
of ancient camel thorn trees.

following pages
RÉKA ZSIRMON
Danube River, Hungary
A flock of great egrets crowds the
Danube's tidal region.

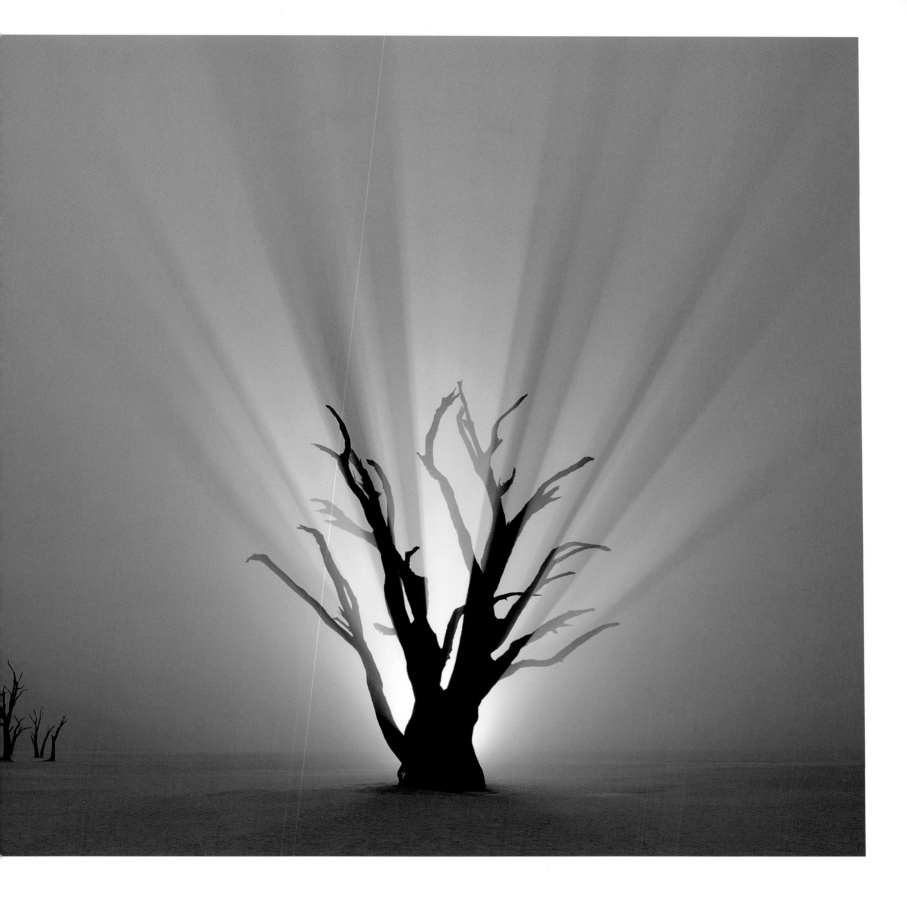

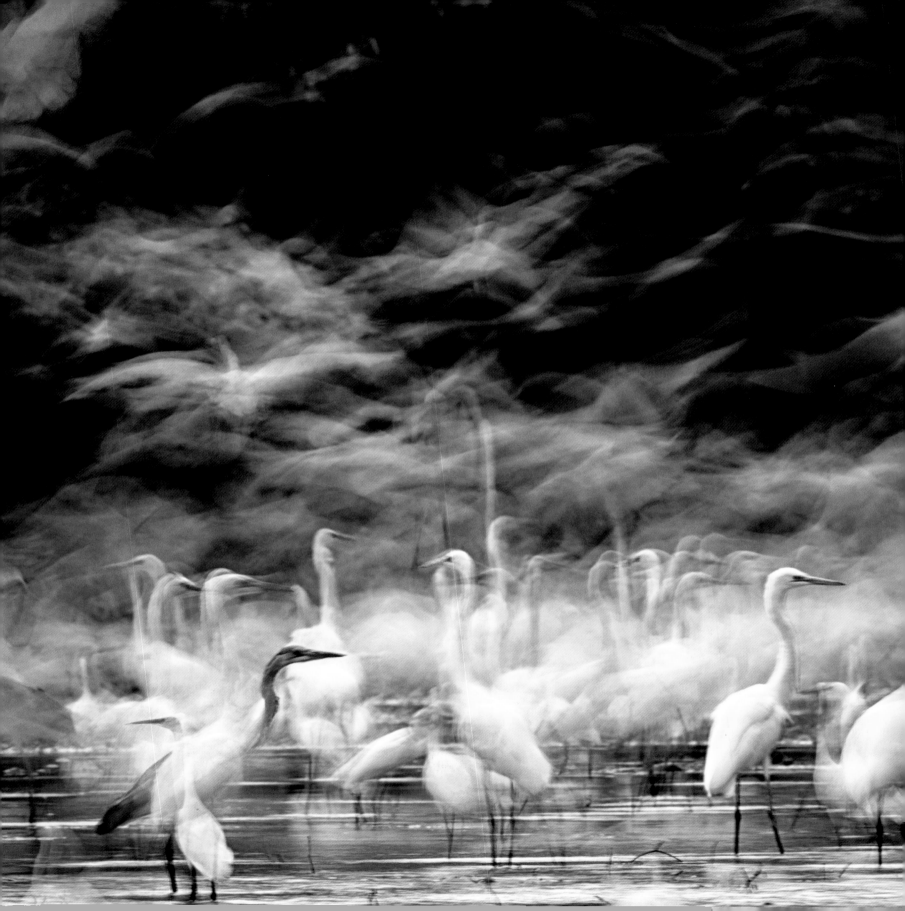

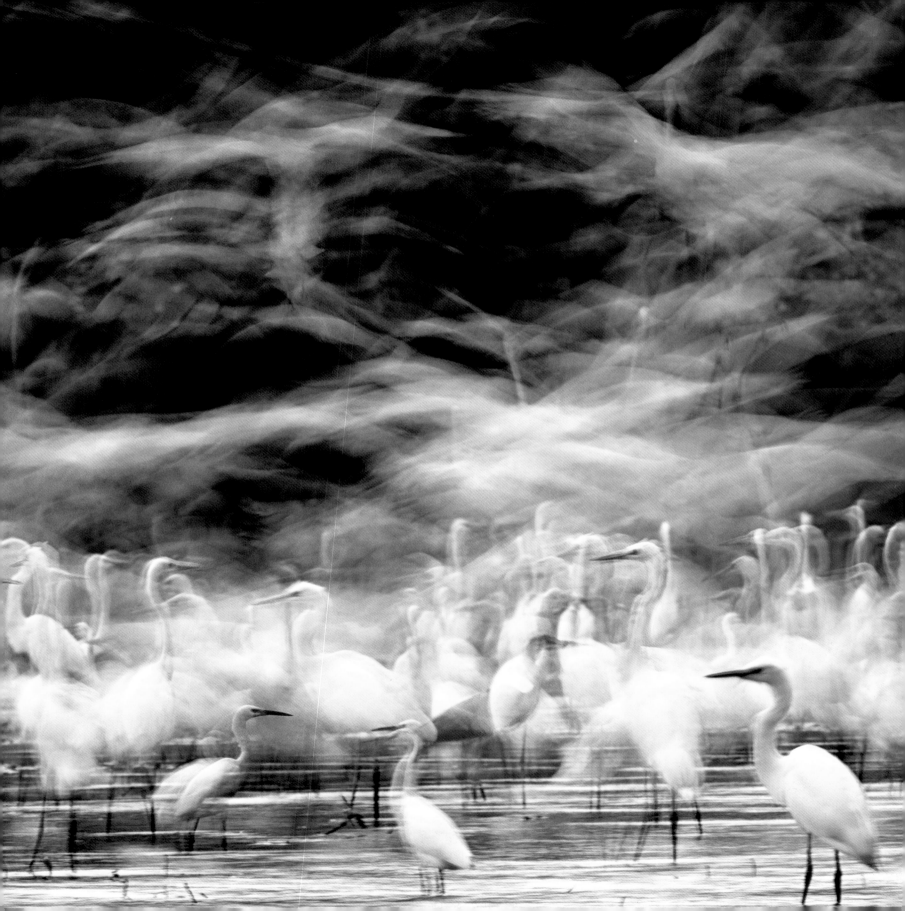

Harmony

When words become unclear, I shall focus with photographs. When images become inadequate, I shall be content with silence.

~ Ansel Adams

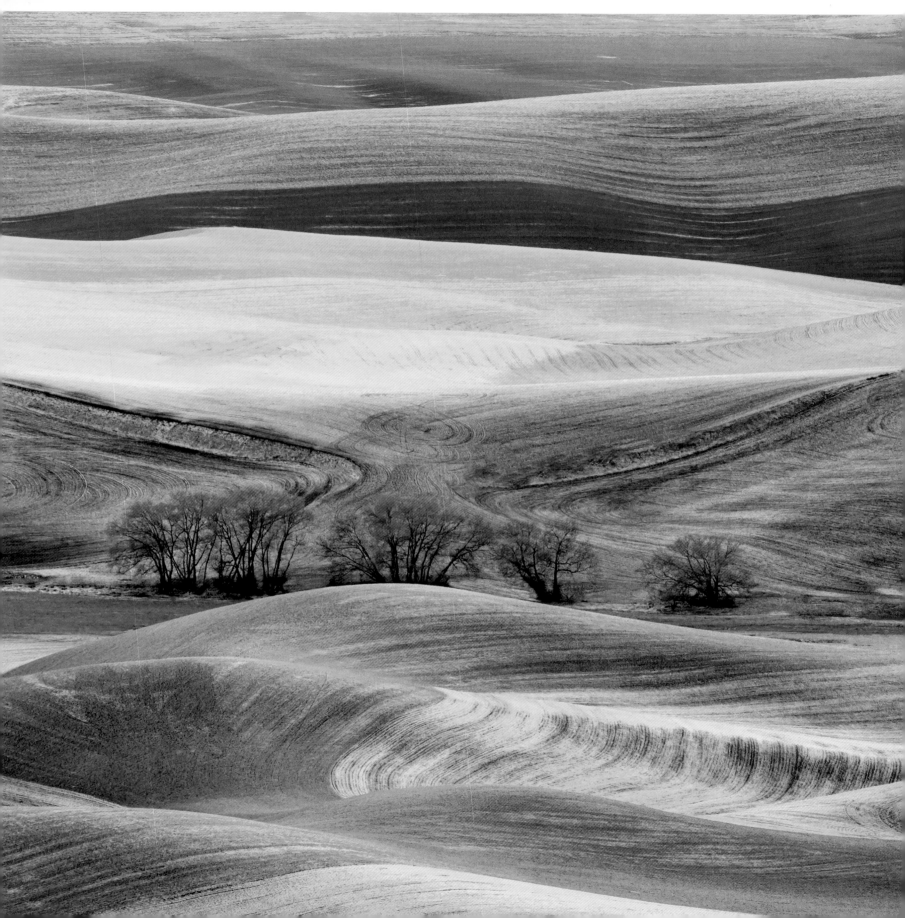

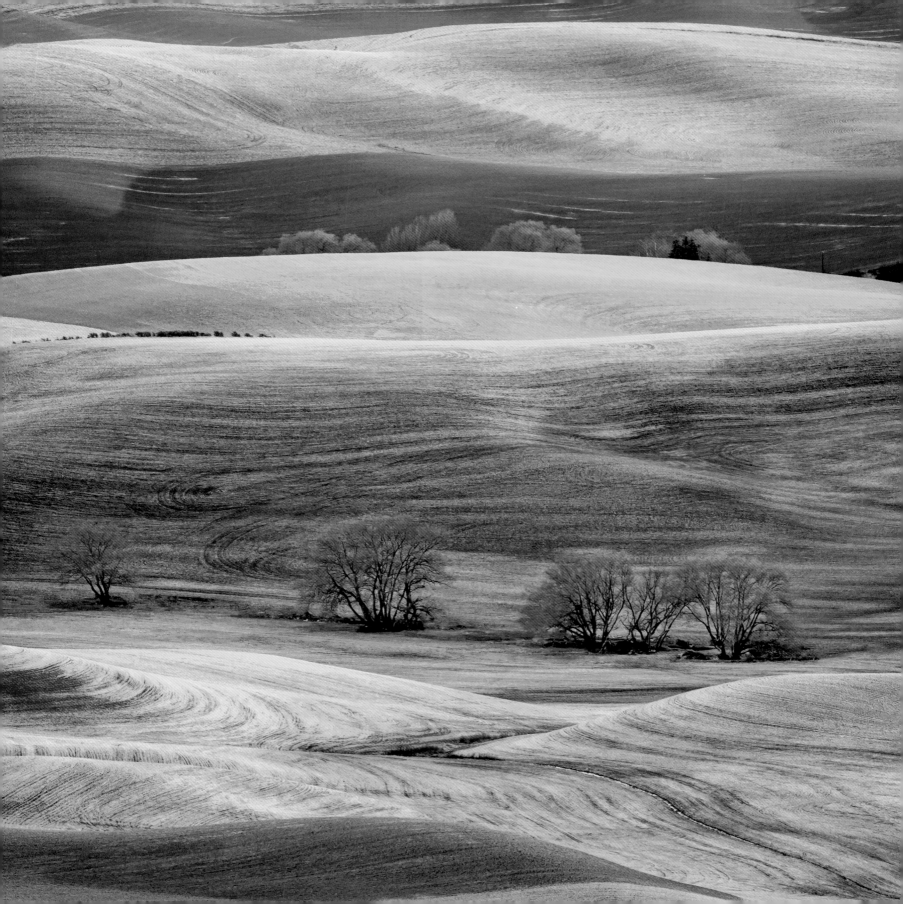

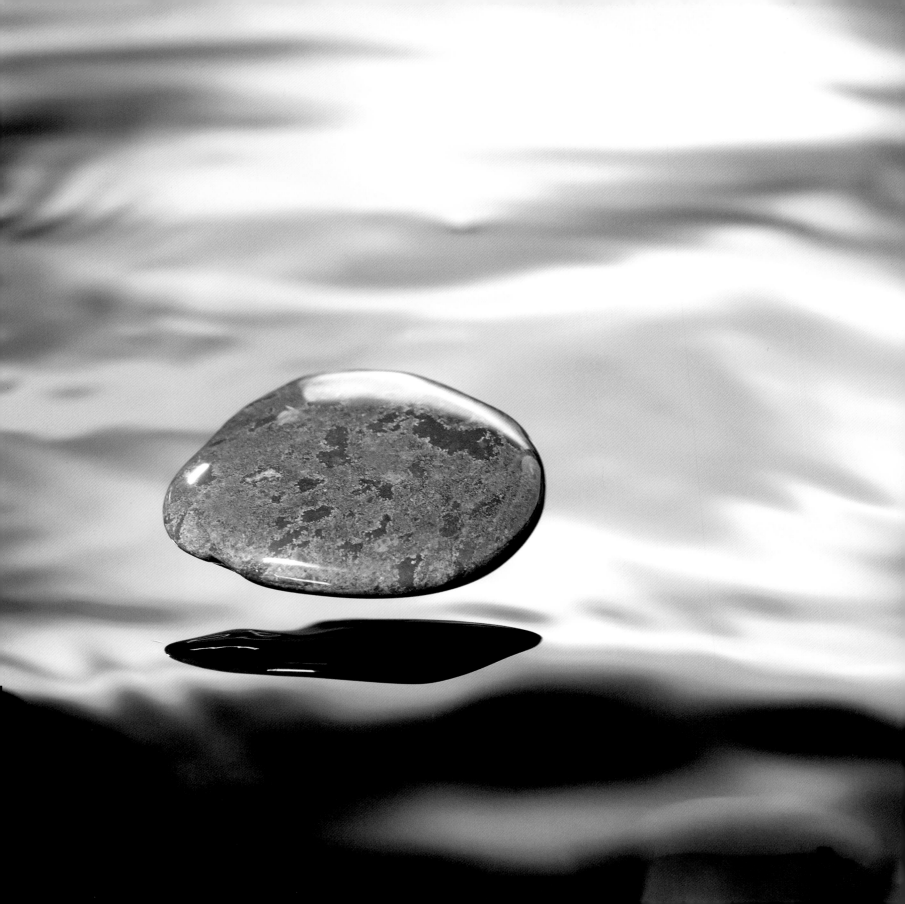

MICHAEL DURHAM
Oregon
A skipping stone hovers above the surface of water.

preceding pages
ANNIE GRIFFITHS
Minnesota
Morning sunlight burns through fog over a forest.

CHIP PHILLIPS
The Palouse, Washington
Melting spring snow exposes patches of a wheat field.

following page
JESSI RINGER
Knoxville, Tennessee
A newborn naps in a sunny window.

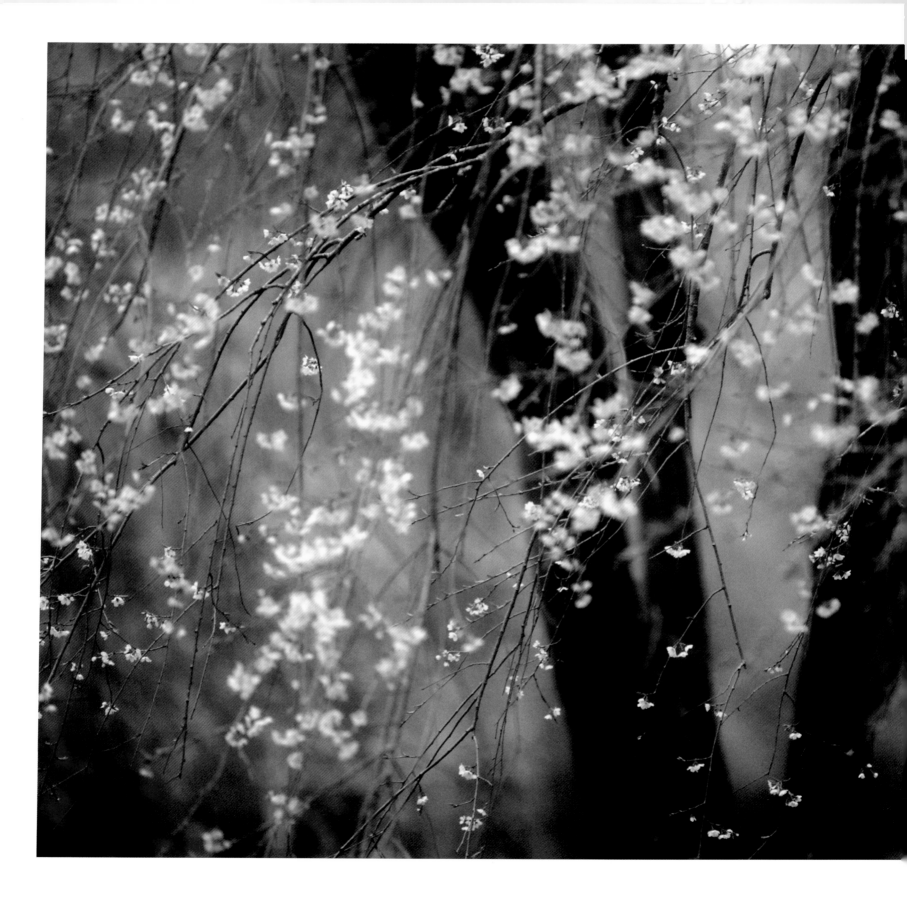

HIDEYUKI KATAGIRI
Japan
Delicate petals cascade down a cherry blossom tree.

following pages
BRIAN SKERRY
Matura Beach, Trinidad
A newborn leatherback turtle scuttles to the sea.

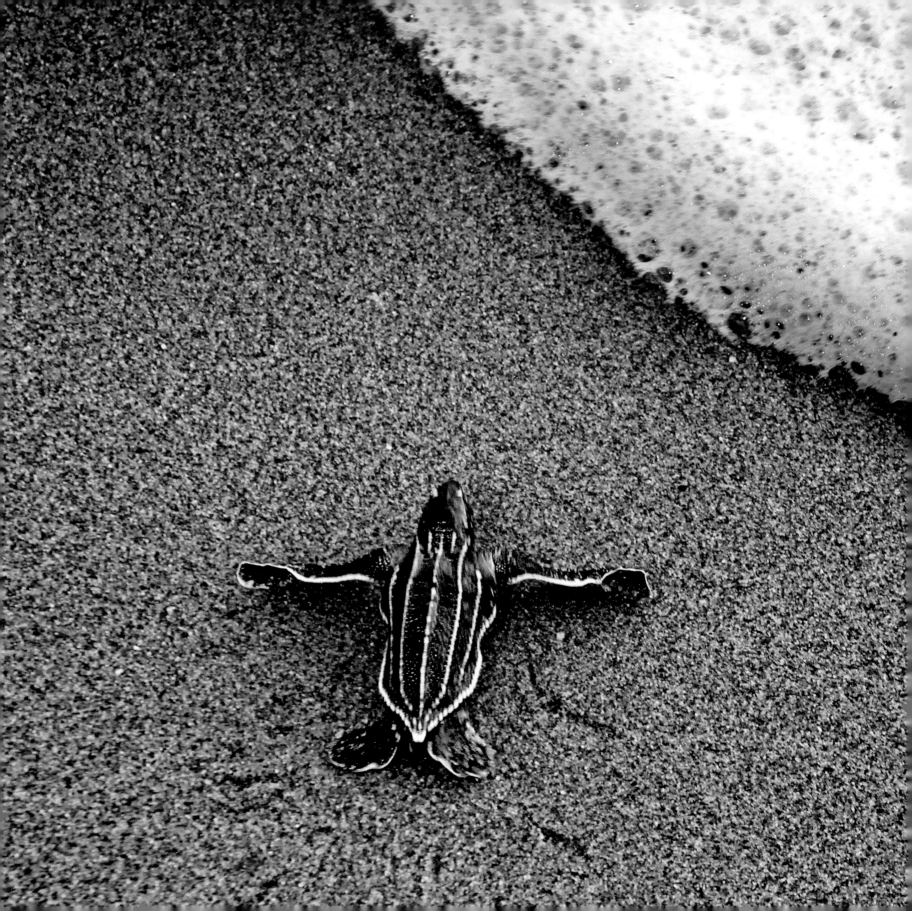

Marc Adamus

I am nomadic by nature and travel continuously the entire year. Most of my journeys are long, solo treks deep into the wilderness. I'm inspired by new landscapes. Every photograph is a fusion of my creative vision with a personal experience that will never happen again.

MARC ADAMUS
Death Valley, California
Sunset illuminates sculpted sand dunes.

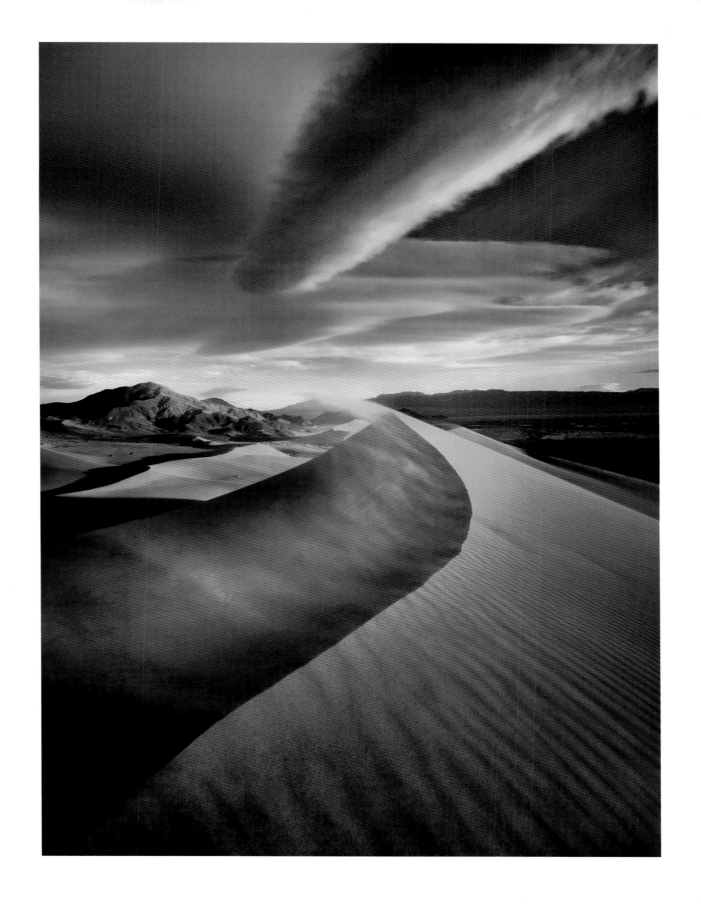

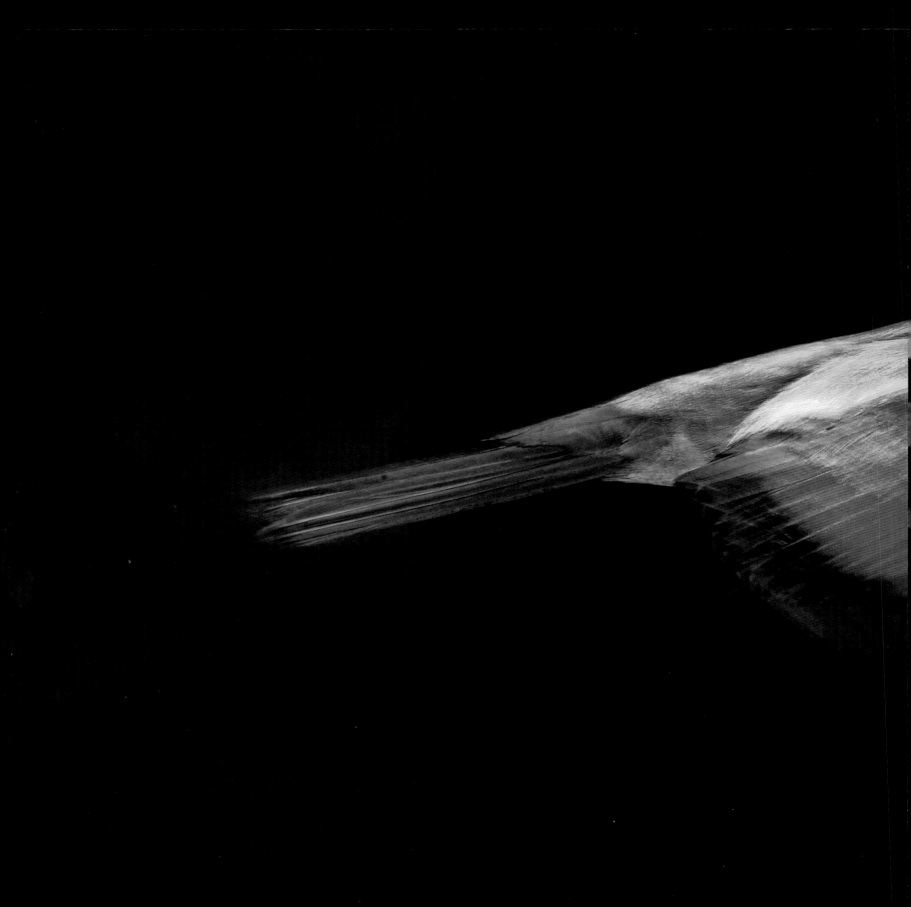

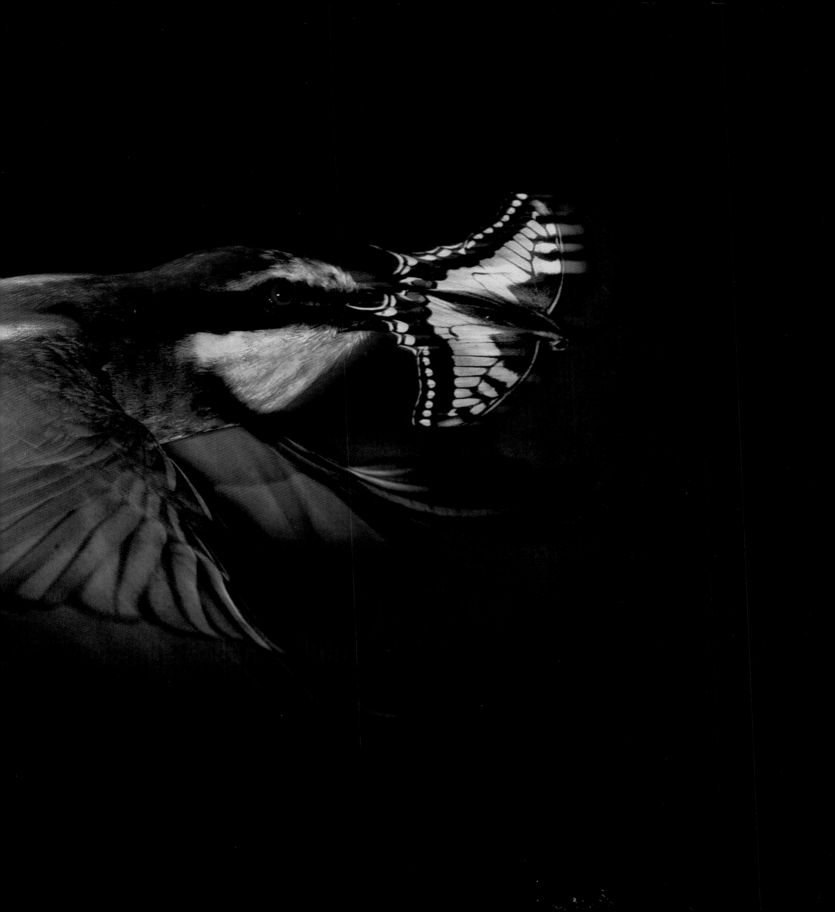

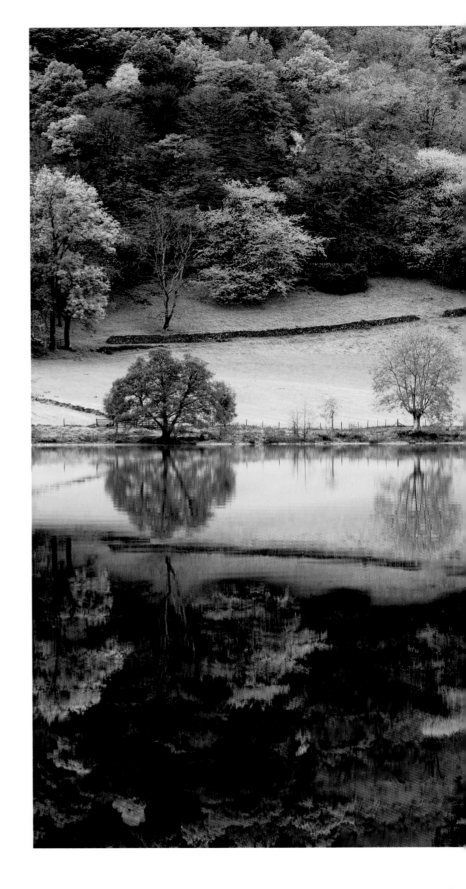

DAVID CLAPP

Grasmere, England

A still pond reflects the Lake District's autumn splendor.

preceding pages

JOE PETERSBURGER

Sáránd, Hungary

A bee-eater plucks a butterfly from the air.

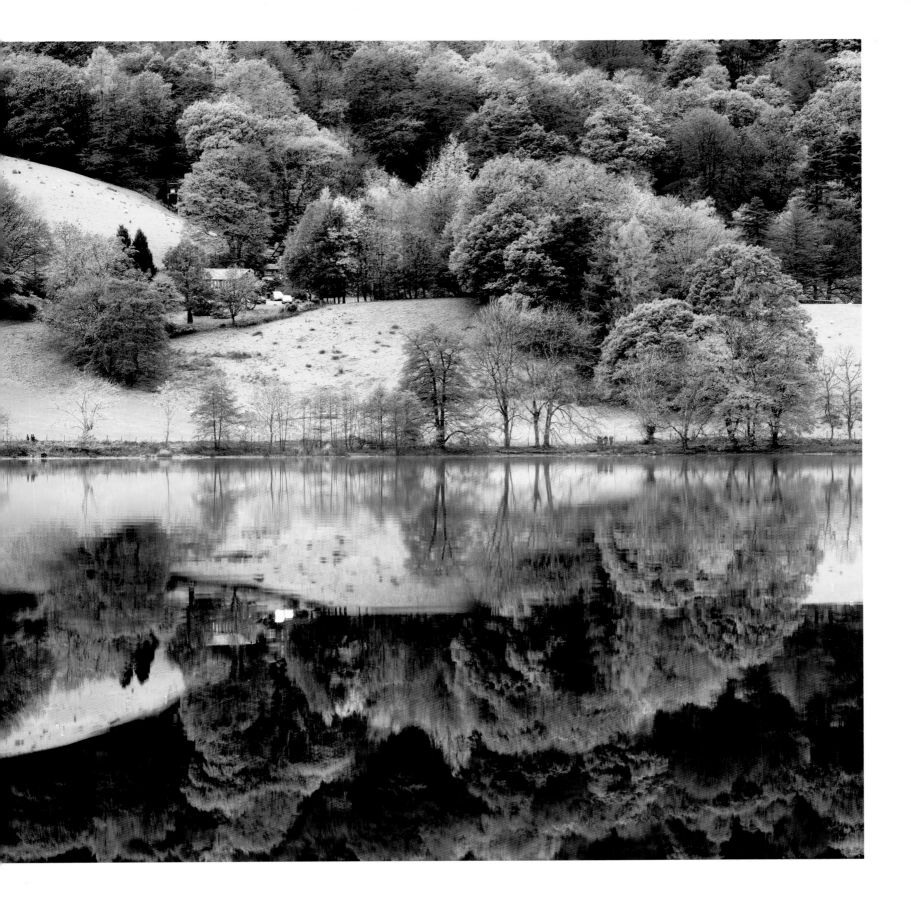

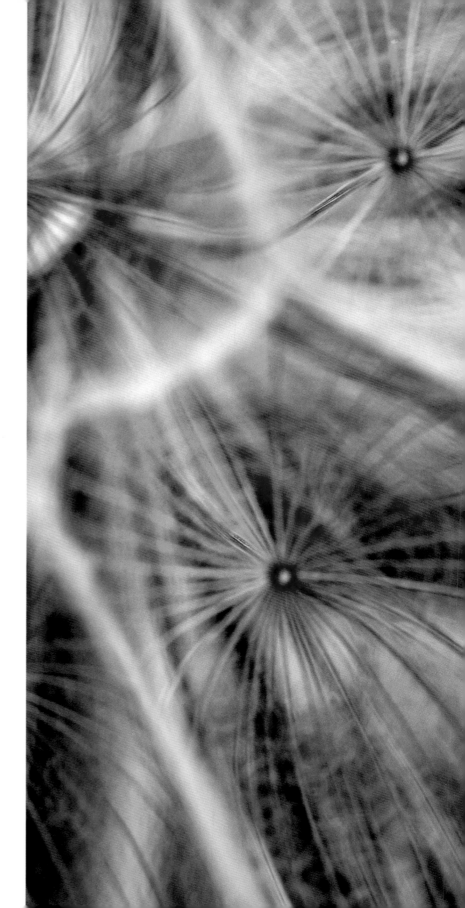

MELANIE LAWSON
Bend, Oregon
A close-up reveals the symmetry
of dandelion seed heads.

following page
DAVID DOUBILET
St. John, Virgin Islands
A hibiscus blossom floats on
swirling water.

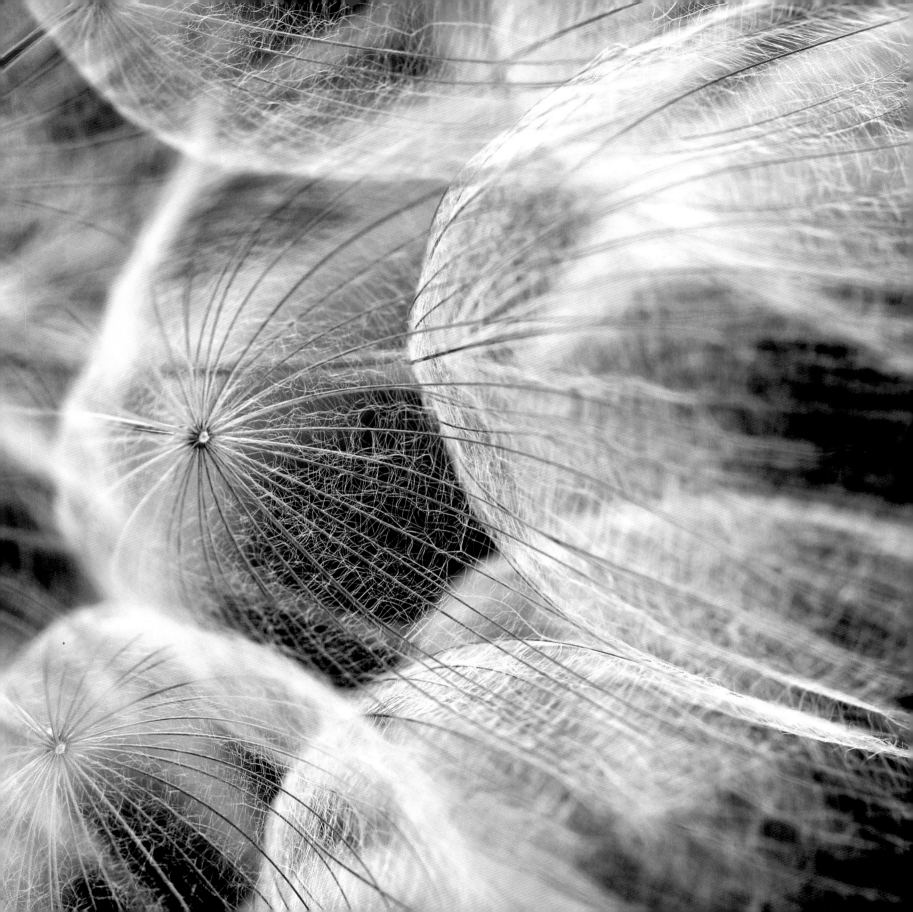

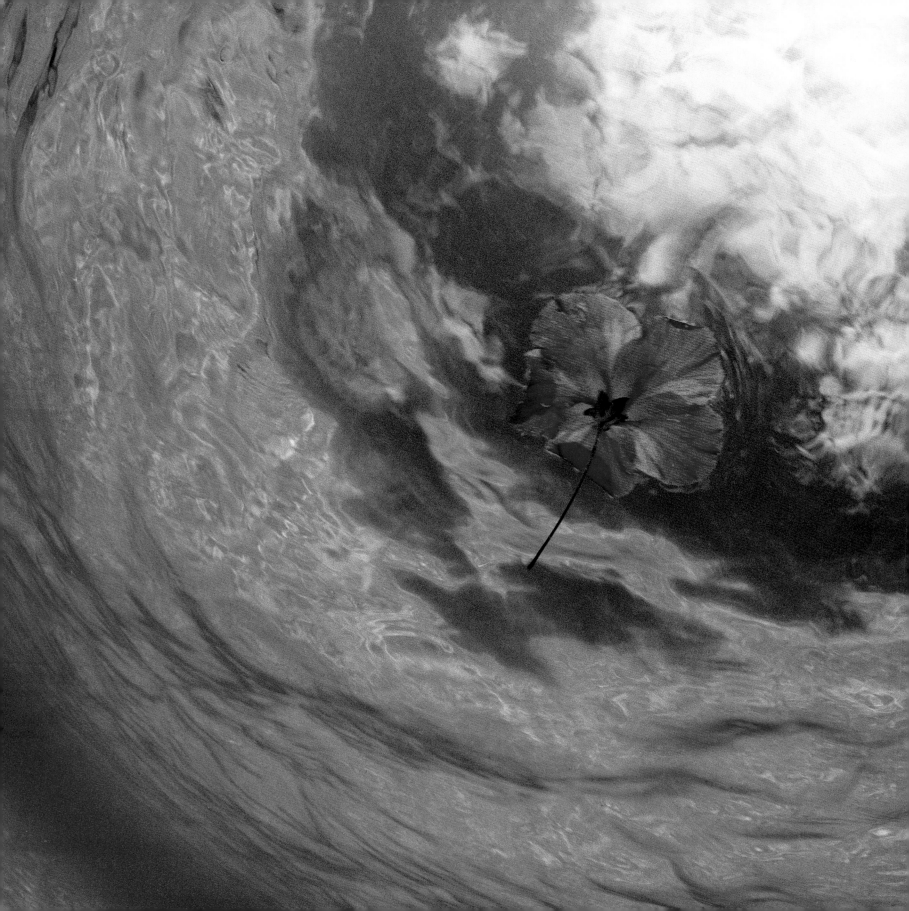

It is only when we are aware of the earth and of the earth as poetry that we truly live.

~ Henry Beston

LOGAN STEC

Cup Lake, Washington

A sheet of ice thaws in an
alpine wilderness.

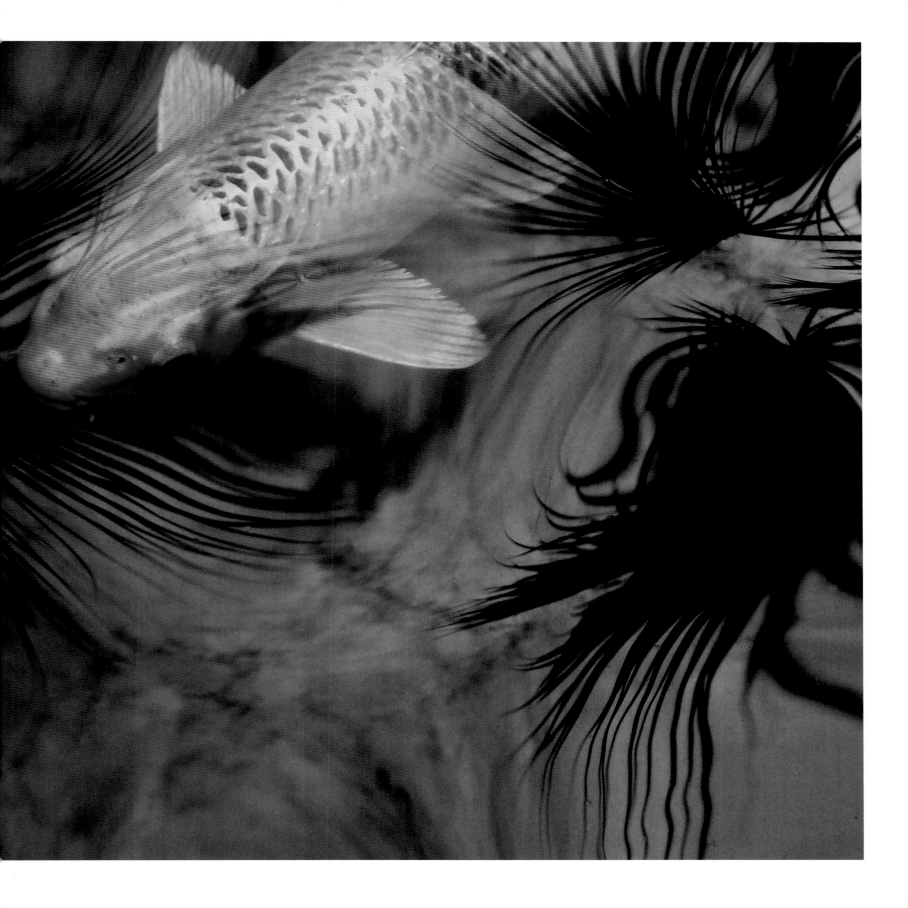

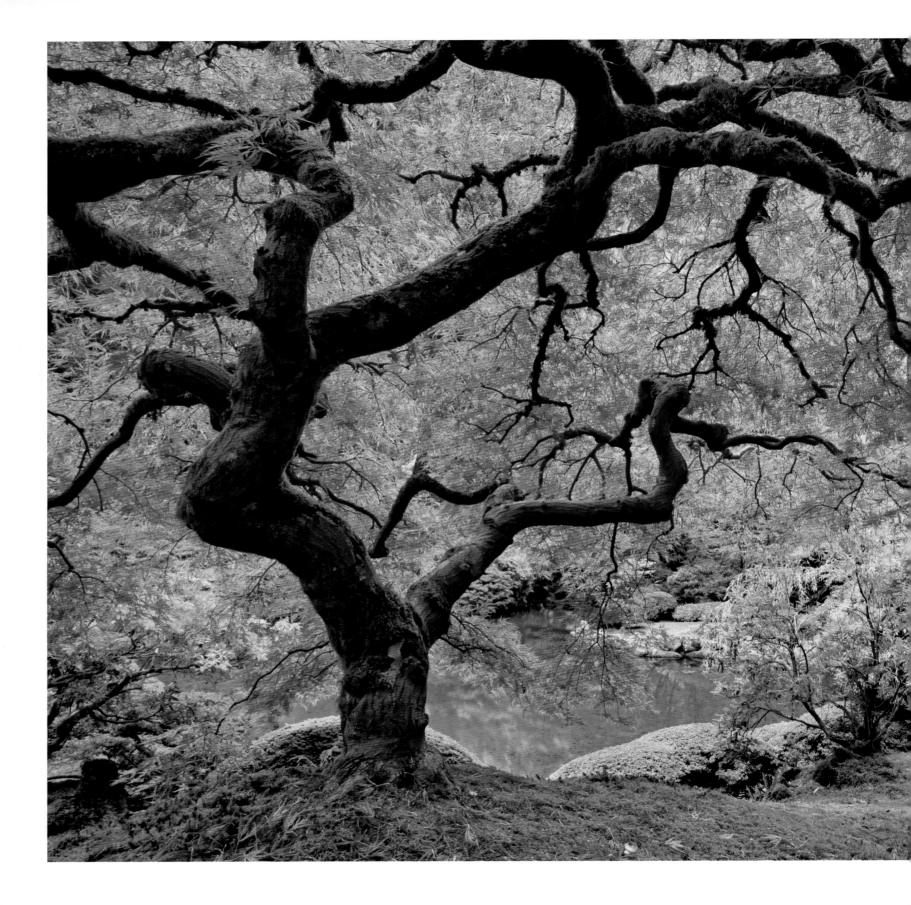

DON PAULSON
Portland, Oregon
A large Japanese maple shades a garden.

following pages
DAVID EDWARDS
Grand Canyon, Arizona
Storm clouds pour rain in the canyon.

JAMES FORTE
Baja California, Mexico
A finback whale ascends to the surface
of the Sea of Cortés.

Photography takes an instant out of time, altering life by holding it still.

~ Dorothea Lange

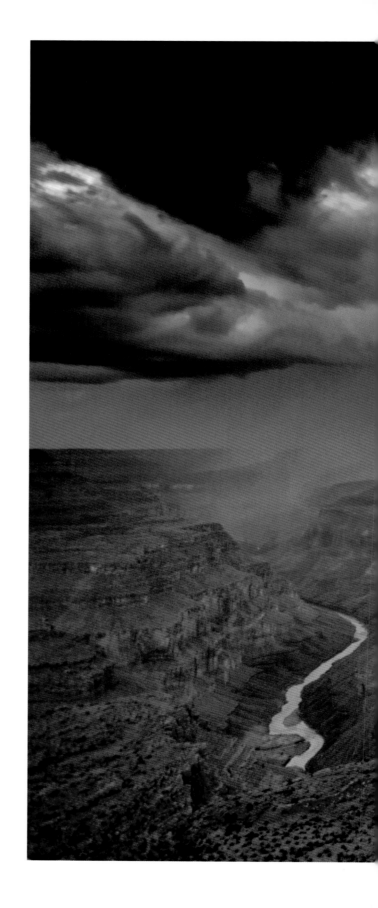

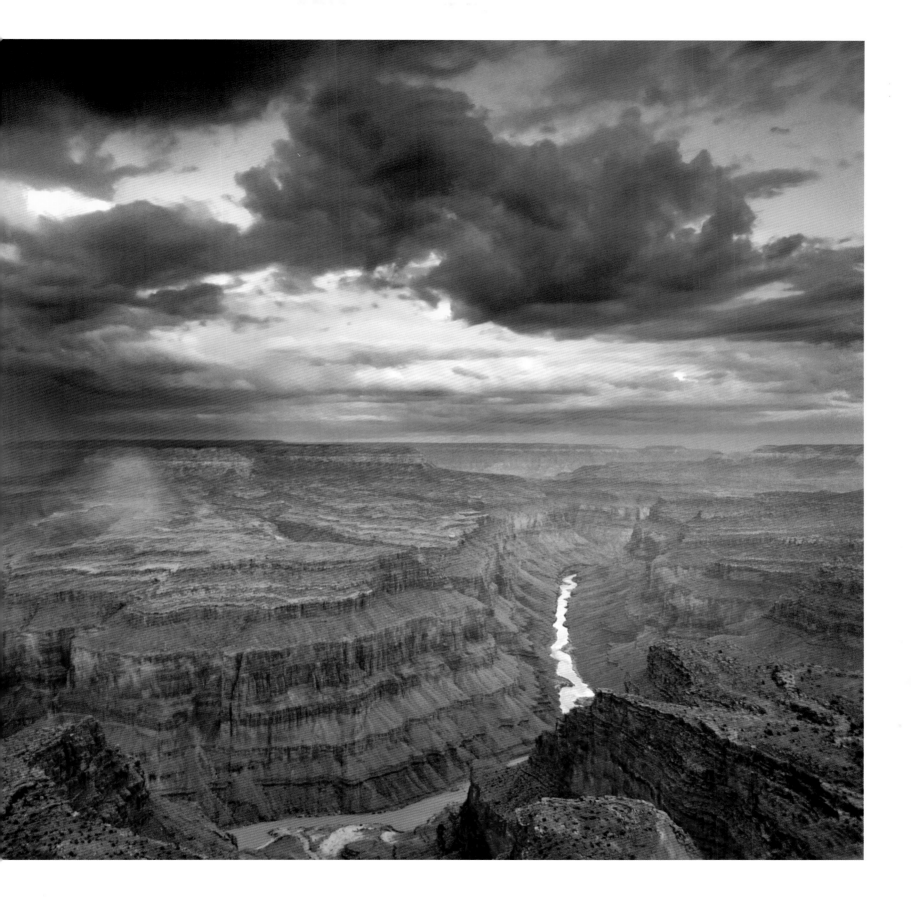

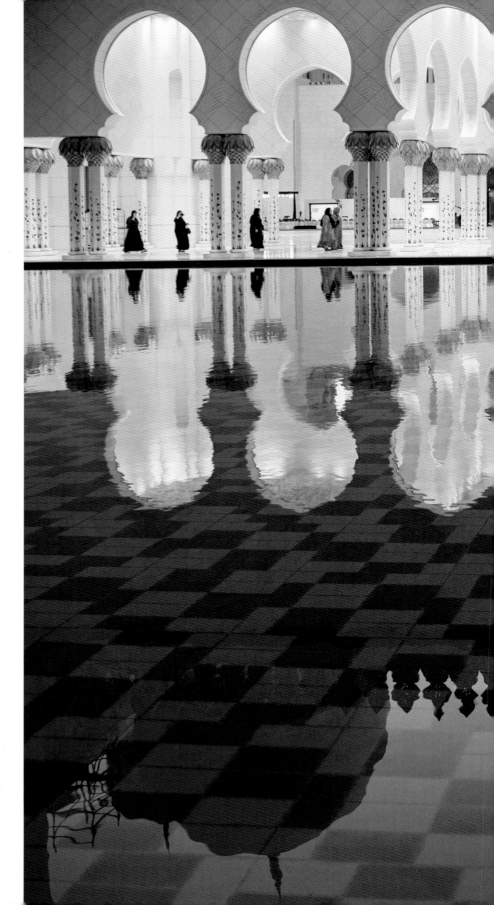

DHAFER AL-SHEHRI
Abu Dhabi, United Arab Emirates
A fountain pool mirrors the grandeur
of the Sheikh Zayed Grand Mosque.

following pages

AMNON EICHELBERG
Iceland
Seljalandsfoss plunges 200 feet into
a moss-fringed pool.

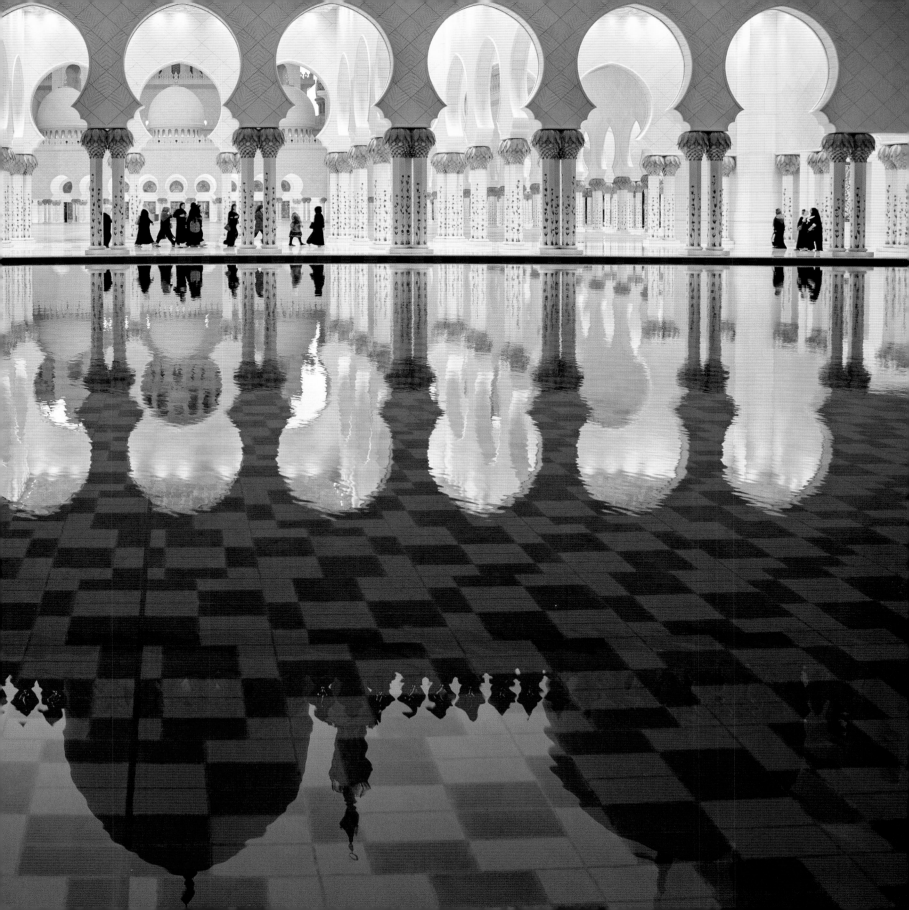

Happiness is
not a matter of
intensity but
of balance, order,
rhythm and
harmony.

~ Thomas Merton

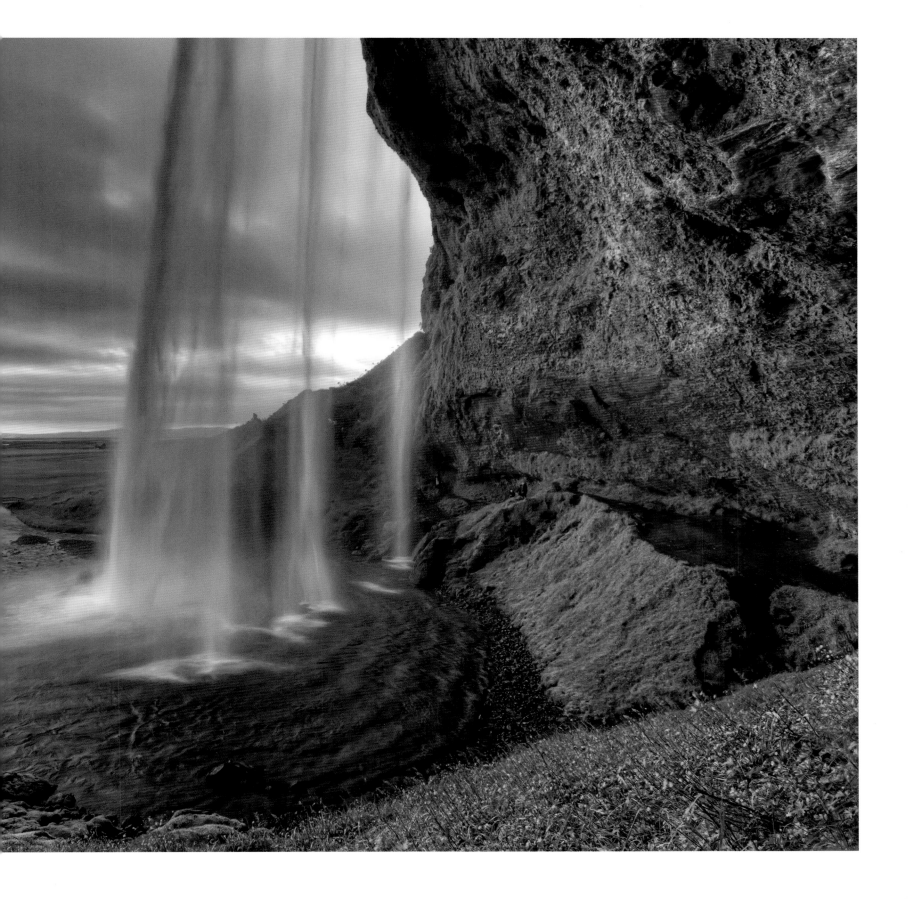

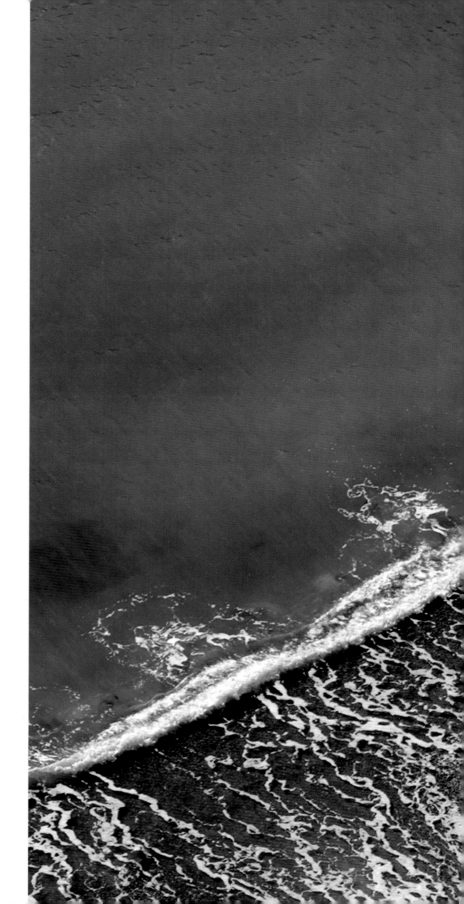

STANISLAV SHMELEV
Dorset County, England
Furrows in the sand create unusual
patterns along the Jurassic coastline.

following pages

DAVID MAITLAND
Wiltshire, England
A few poppy blossoms persevere
among a stand of dead stems.

124

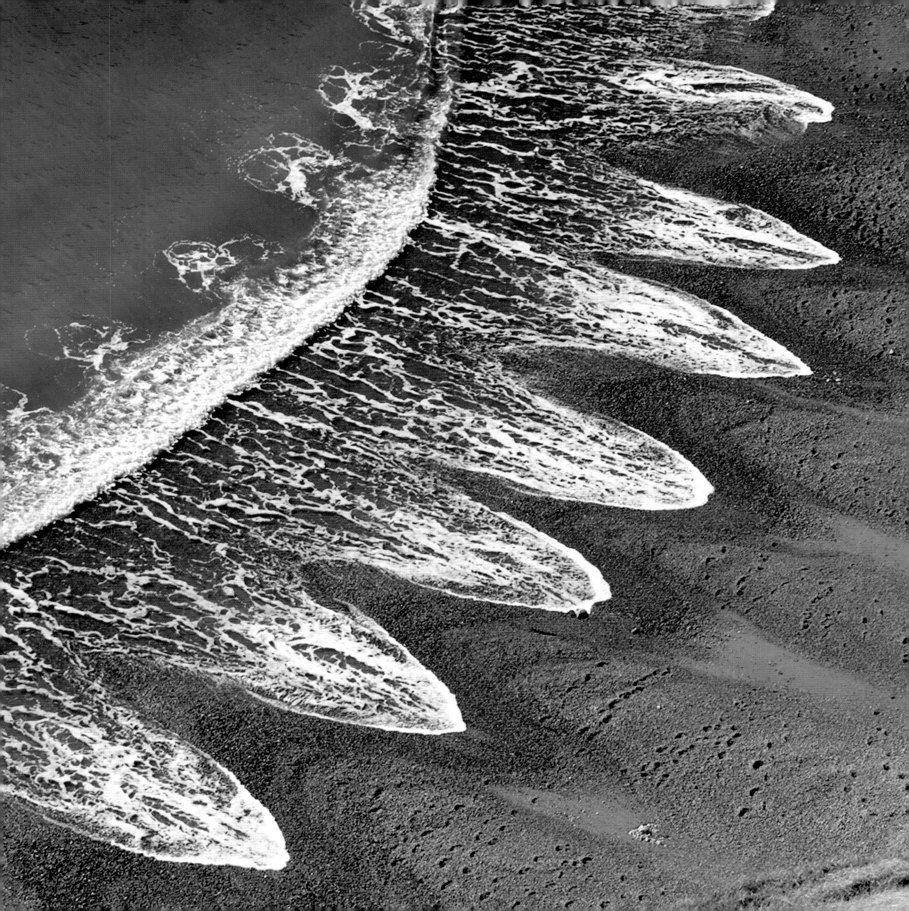

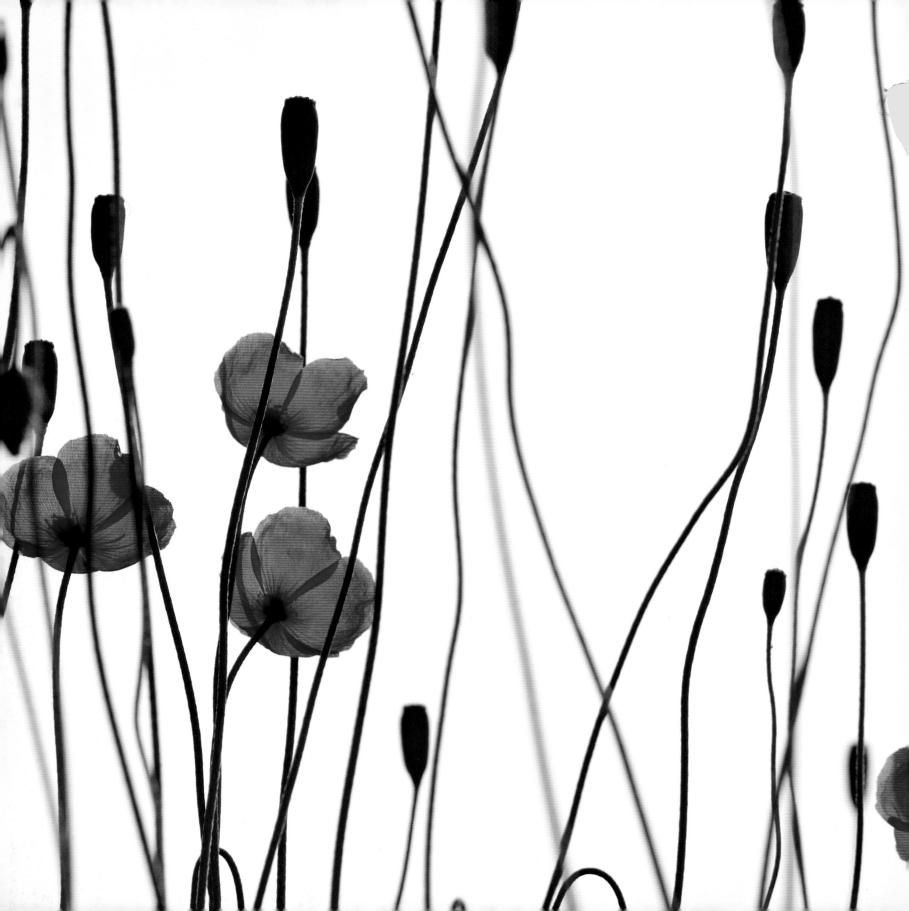

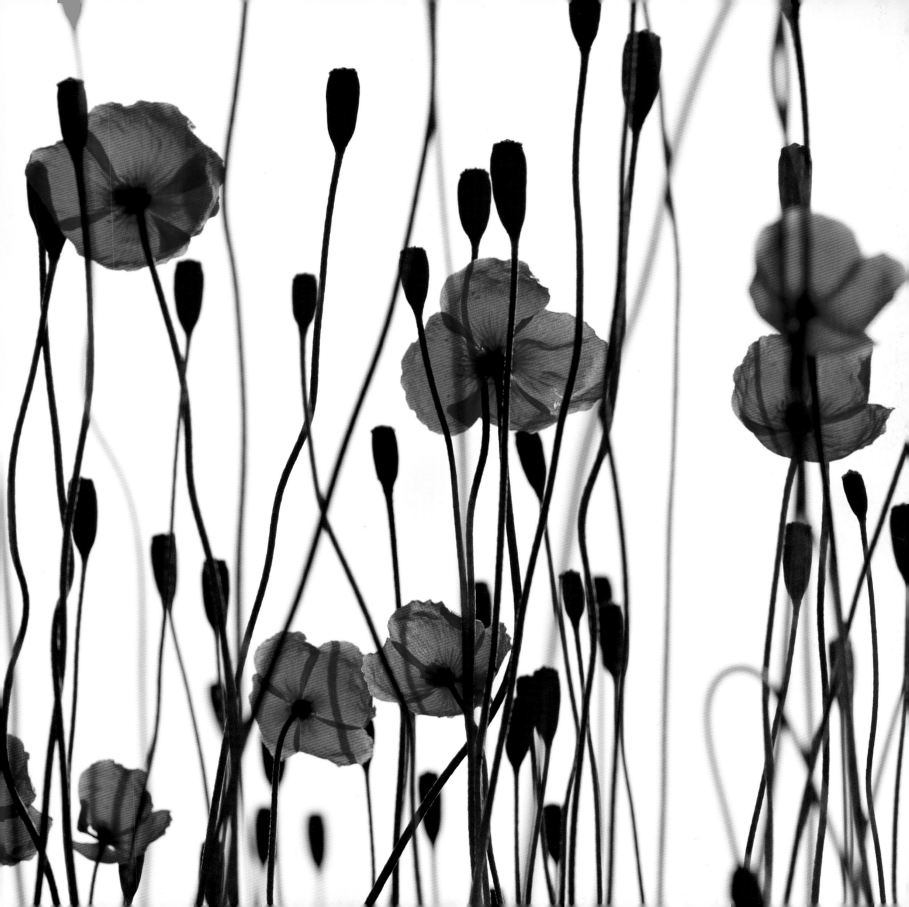

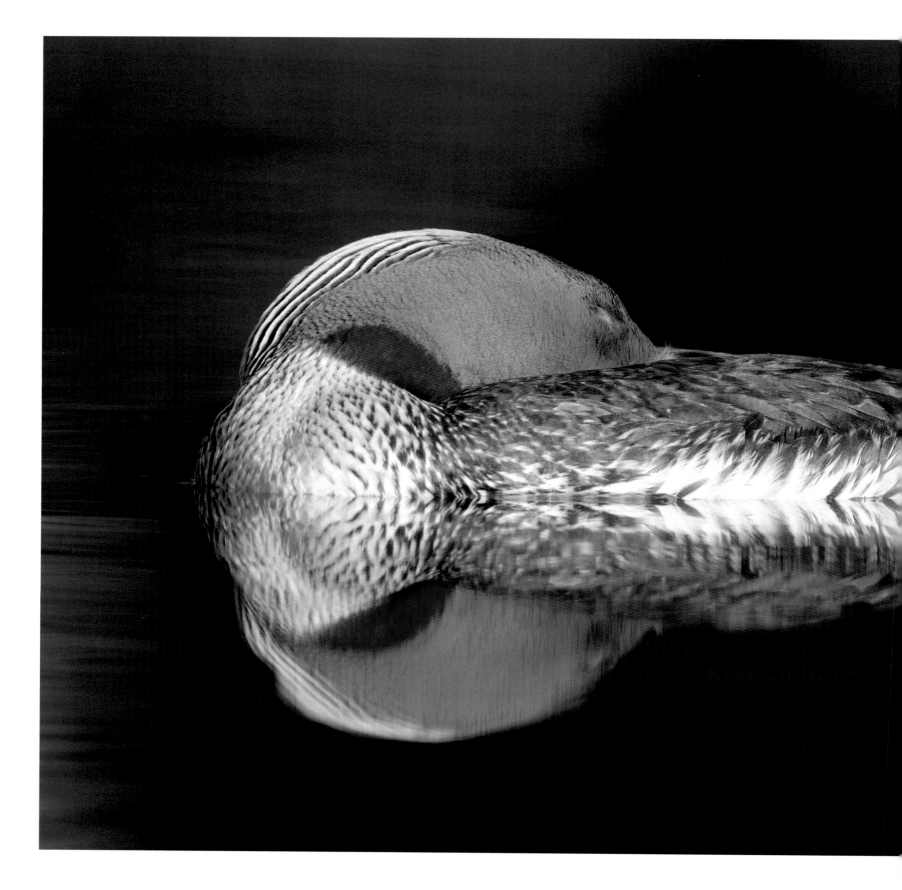

MICHAEL QUINTON
Alaska
Head tucked, a red-throated loon sleeps
on water.

MARC ADAMUS
Capitol Reef National Park, Utah
A tree grows inside a remote canyon.

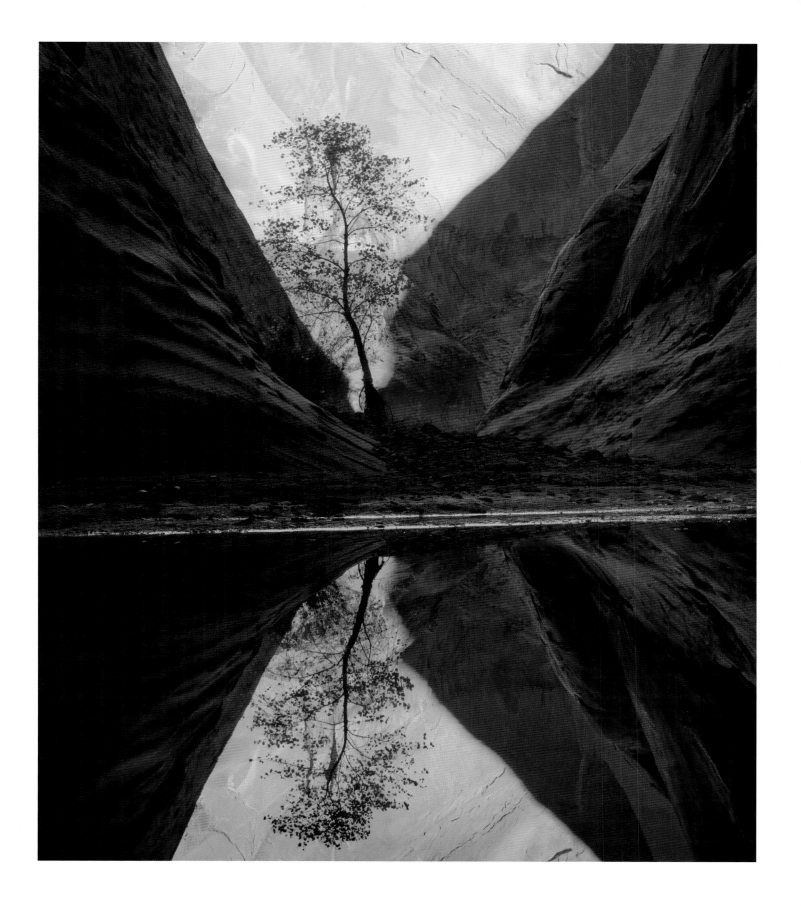

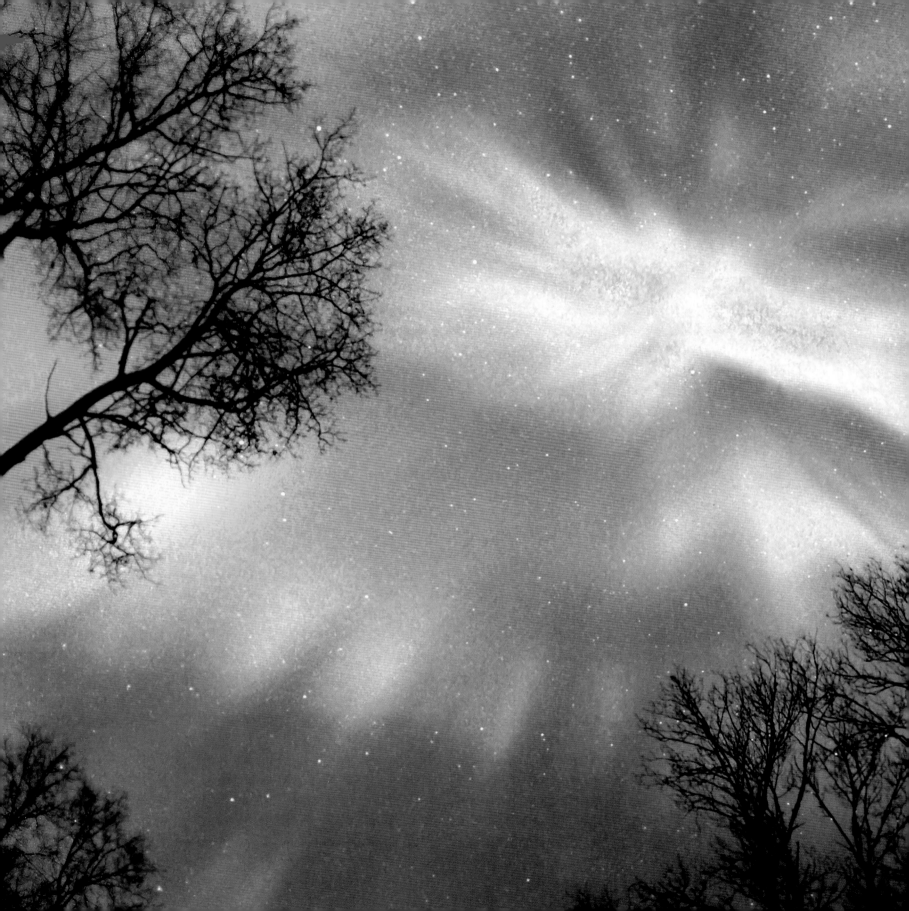

Jim Brandenburg

I have always had a reverence for nature, perhaps because I grew up among people who worked the land. For me, the act of photographing is like meditation.

This photograph was made near the Boundary Waters Canoe Area Wilderness on a cold January evening. No photograph can truly replicate the pulsing phenomenon of an aurora. It is a miracle of color constantly in motion and, in a long exposure, the camera actually records more than the eye can see.

JIM BRANDENBURG
Northern Minnesota
An aurora borealis shimmers above the treetops.

133

GORDON ESLER

London, England

A couple braves a snowstorm outside
the Old Royal Naval College along
the River Thames.

following pages

KENT SHIRAISHI

Biei, Japan

Snow falls on tree skeletons in
a picturesque blue pond.

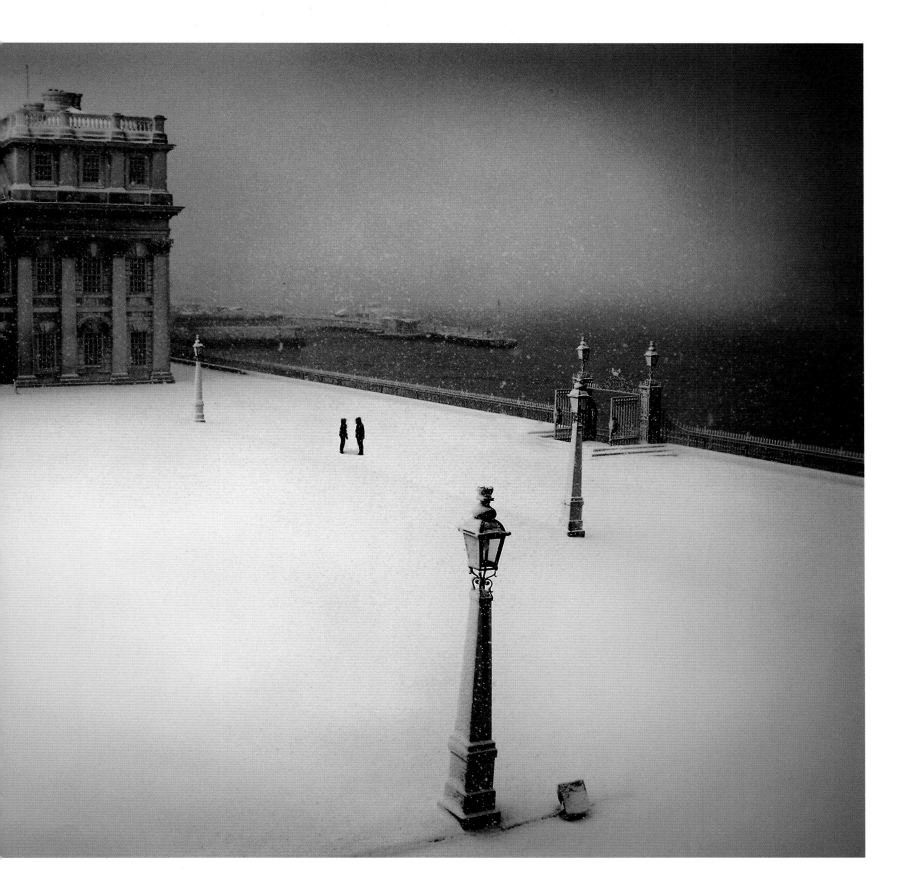

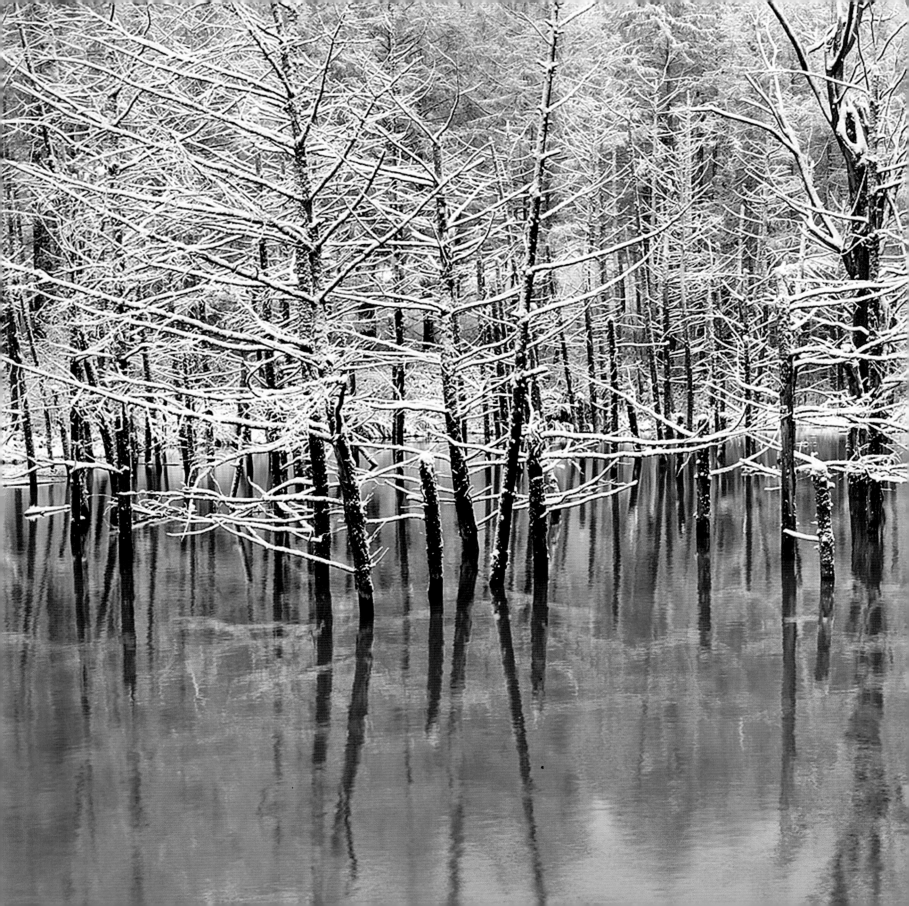

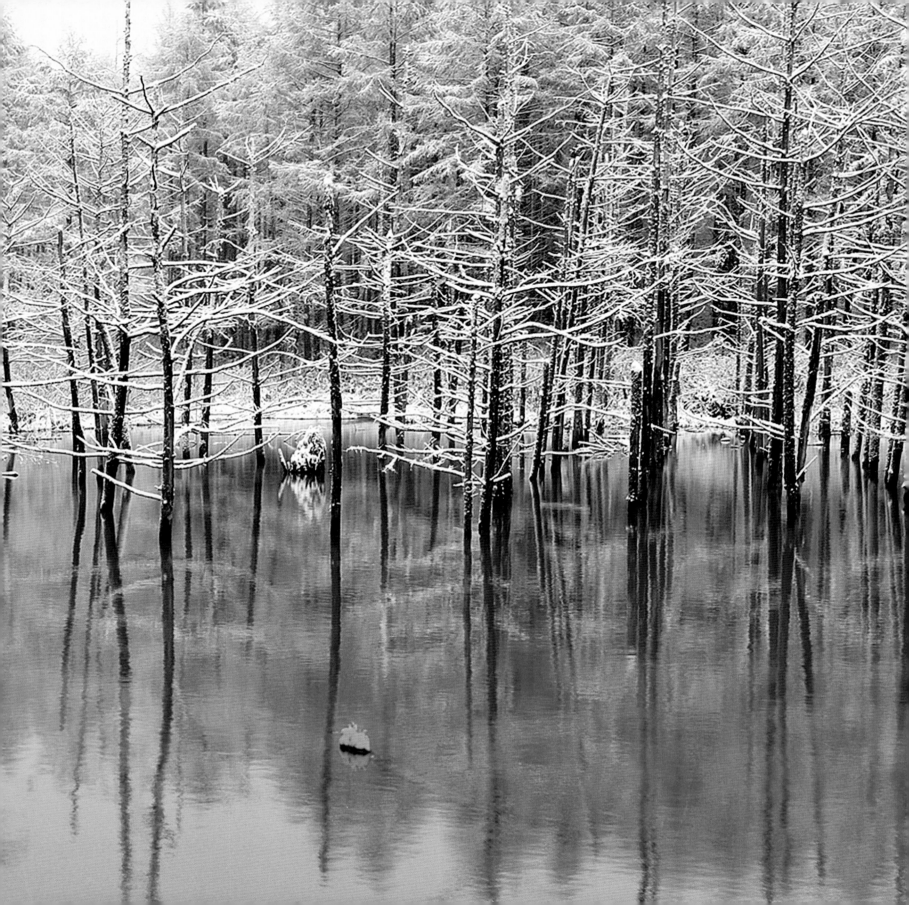

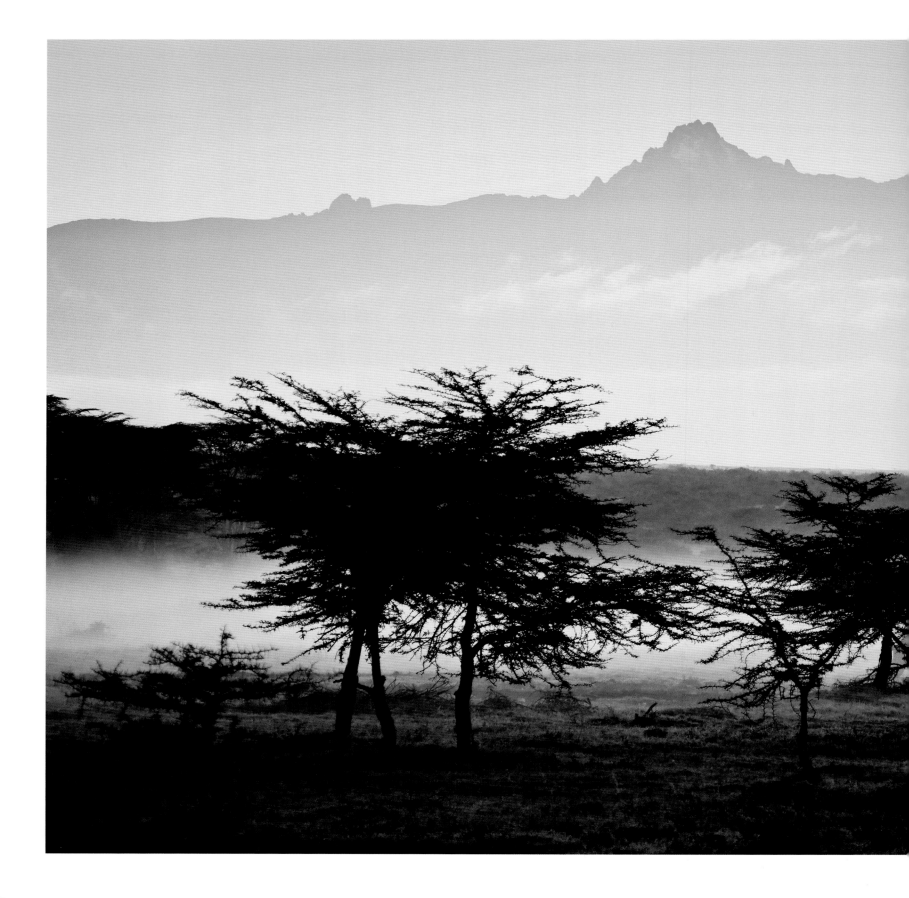

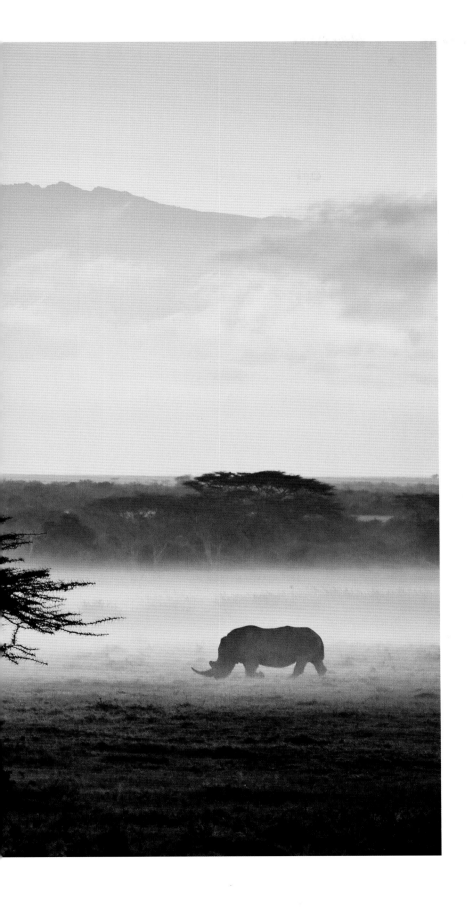

ROBIN MOORE
Solio Game Reserve, Kenya
Rhinos forage in the mist as dawn breaks over Mount Kenya.

following pages
MICHAEL MELFORD
Kamchatka, Russia
A storm billows toward a flower-covered tundra.

139

There is so much
in the world for us
all if we only have
the eyes to see it.

~ L. M. Montgomery

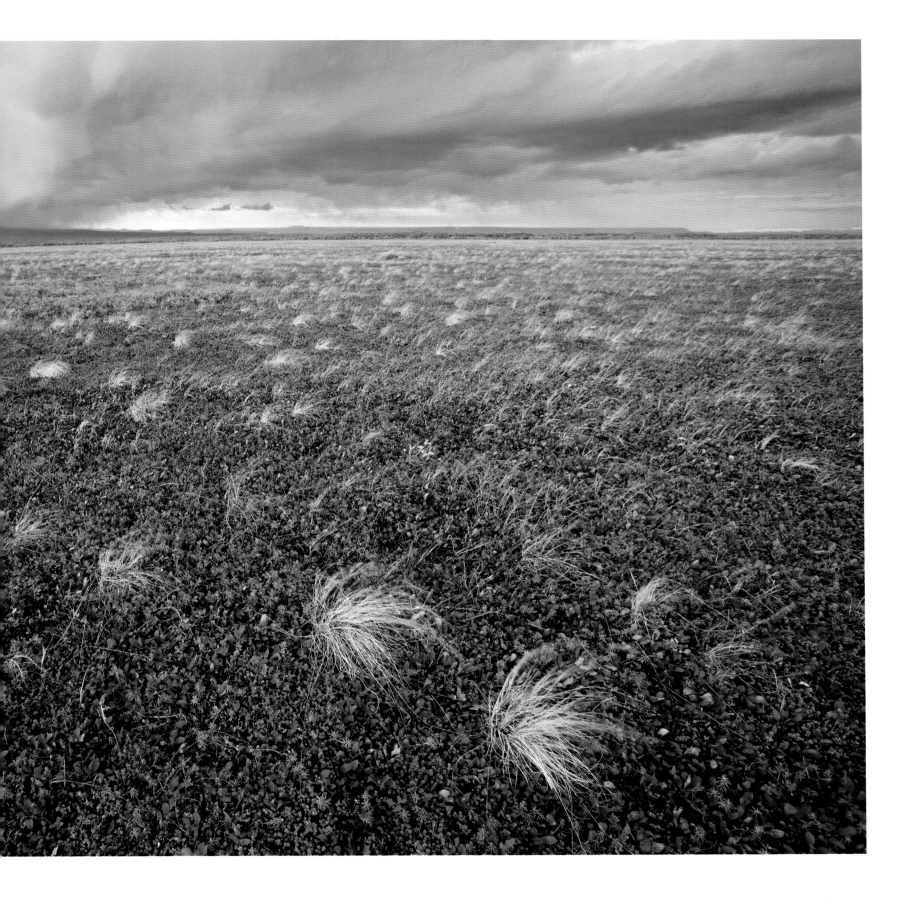

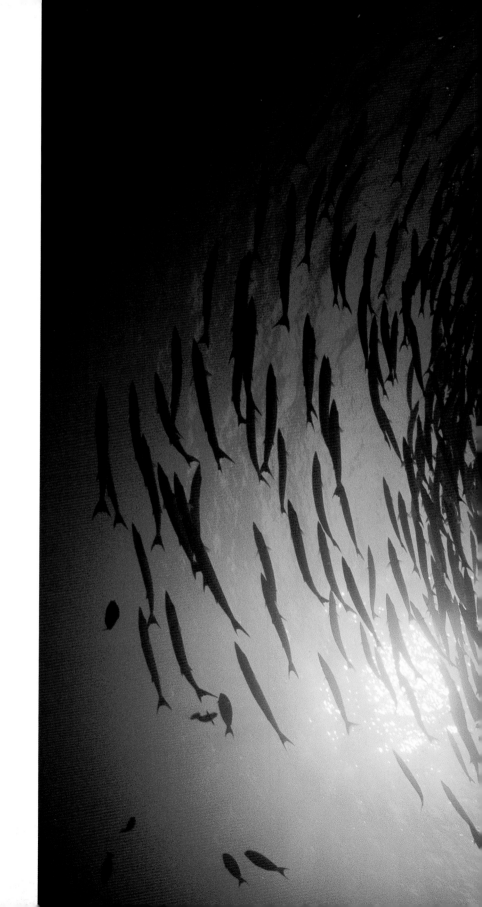

DAVID DOUBILET
Bismarck Sea, near Papua New Guinea
A school of barracuda encircle a diver.

following pages
MUHAMMAD NIAZI
Islamabad, Pakistan
Carvings decorate Pakistan's petal-
shaped national monument.

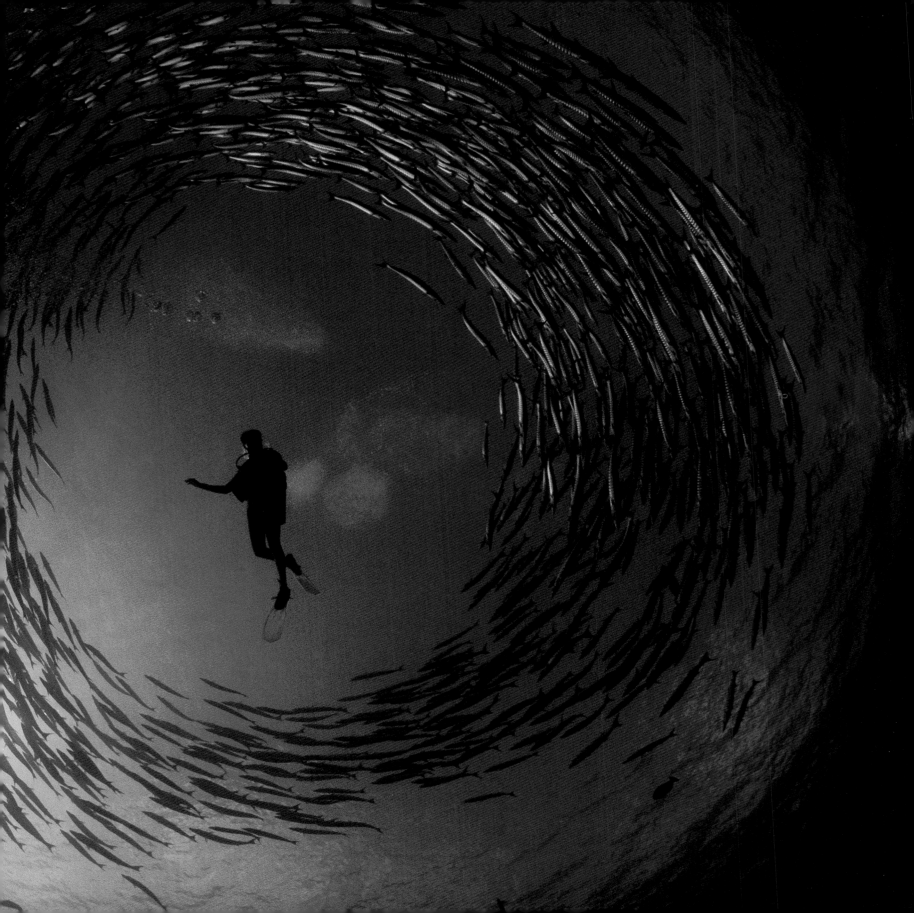

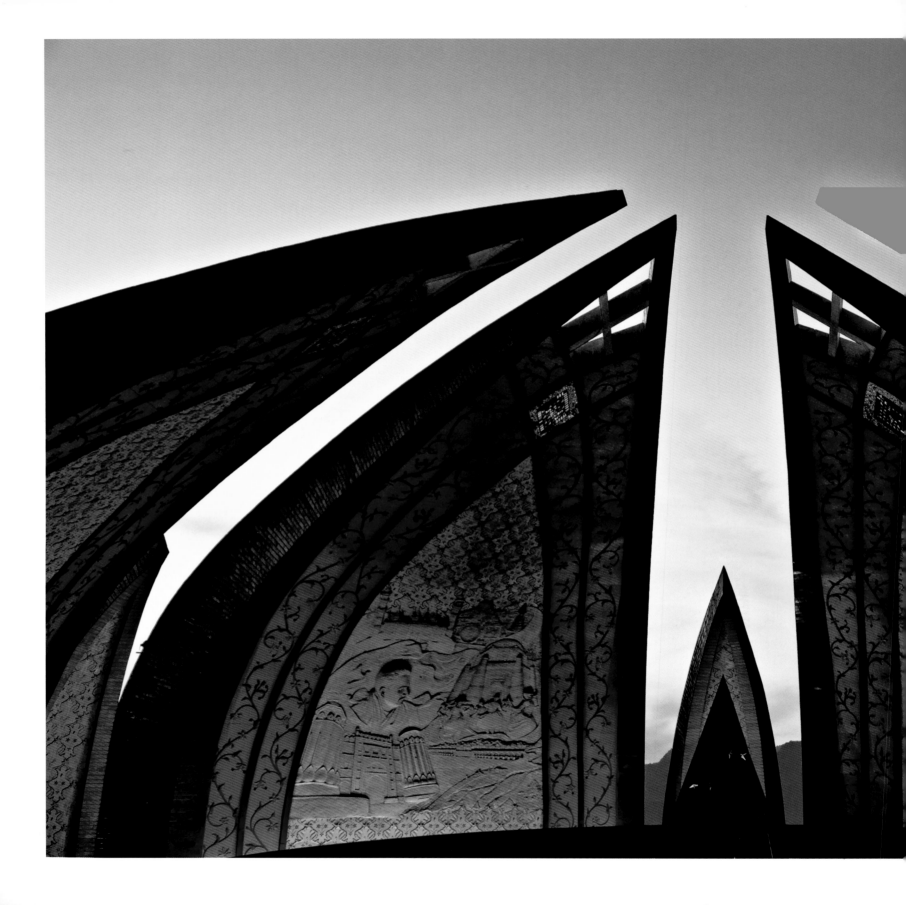

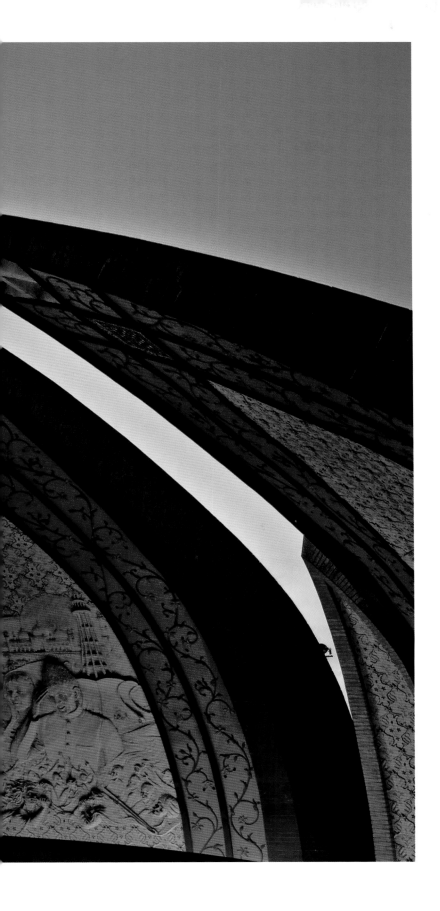

The hidden
harmony is
better than
the obvious.

~ Pablo Picasso

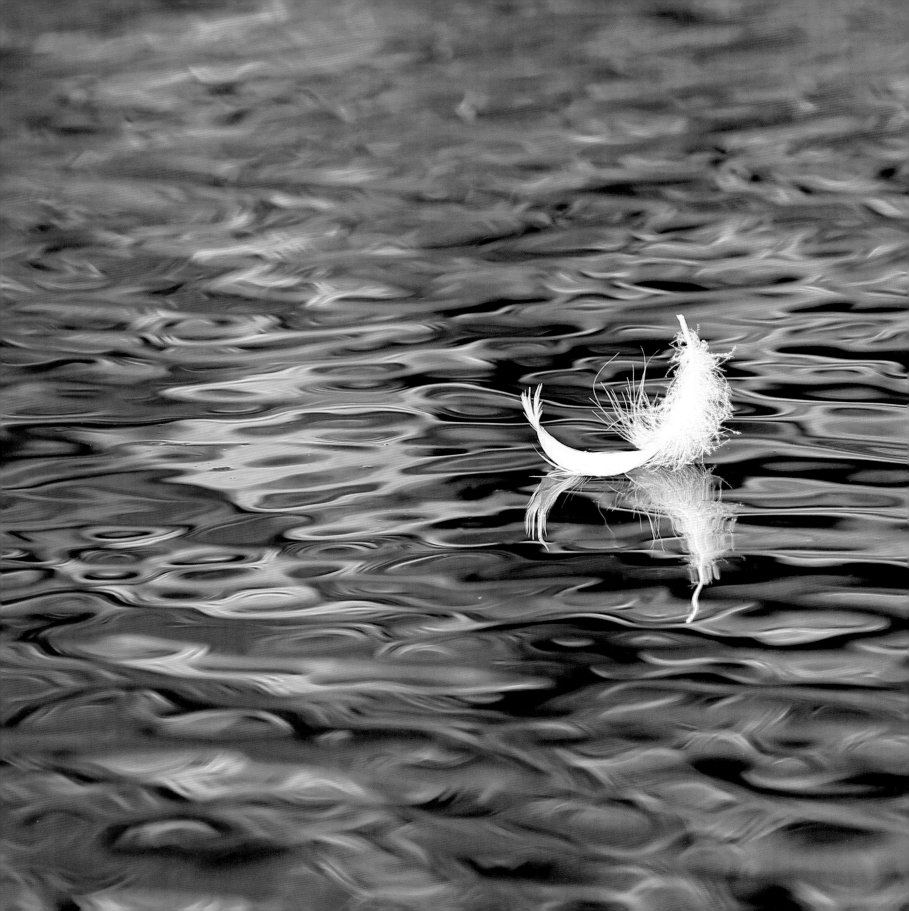

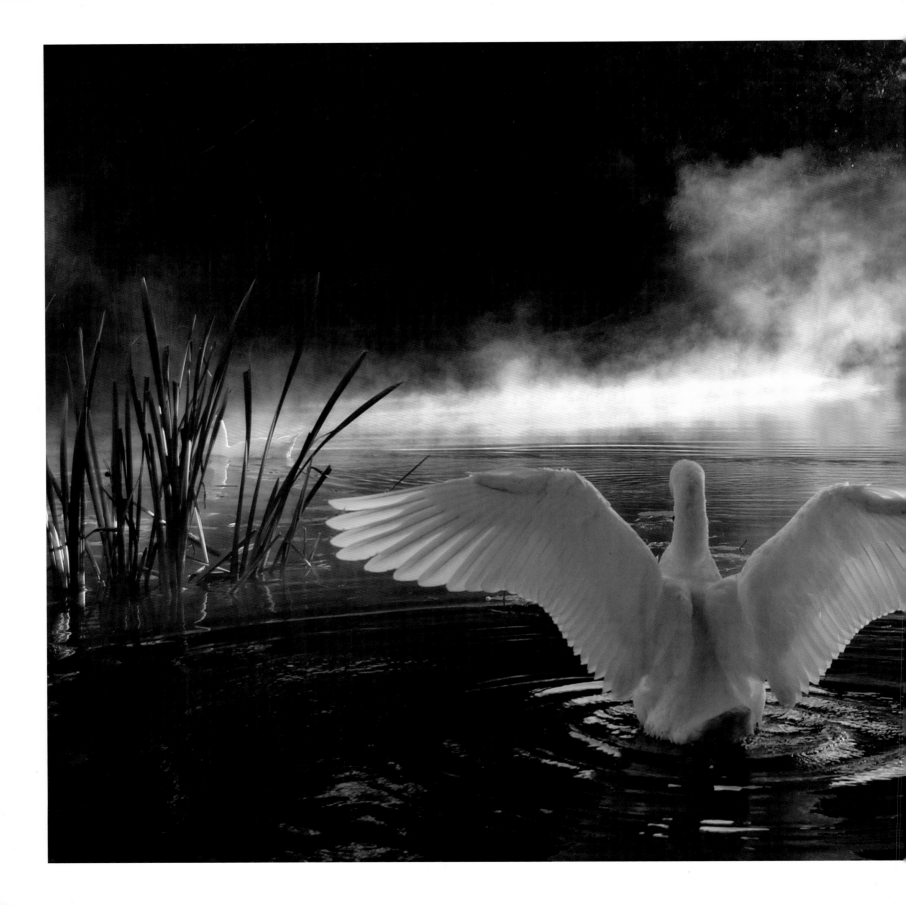

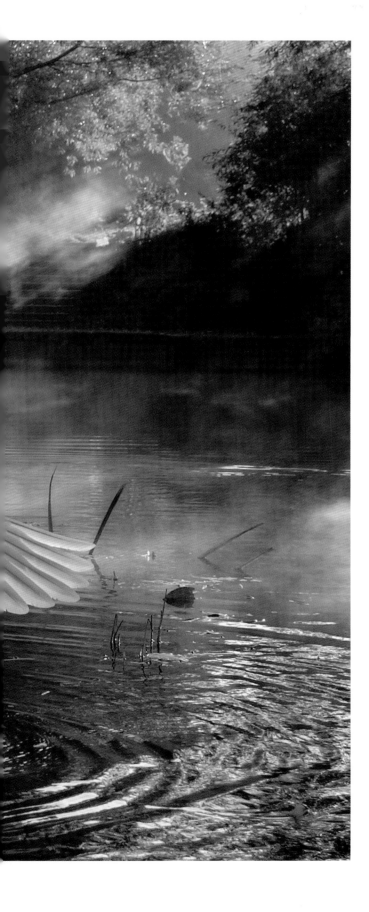

JASON WICKENS
Worcester, England
A swan bathes in the River Avon as
the sky begins to lighten.

preceding pages
VERONIKA KOLEV
Moscow, Russia
A swan feather sails across a lake
reflecting fall foliage.

following pages
ANTONY SPENCER
Somerset, England
The sun rises over a field of lavender.

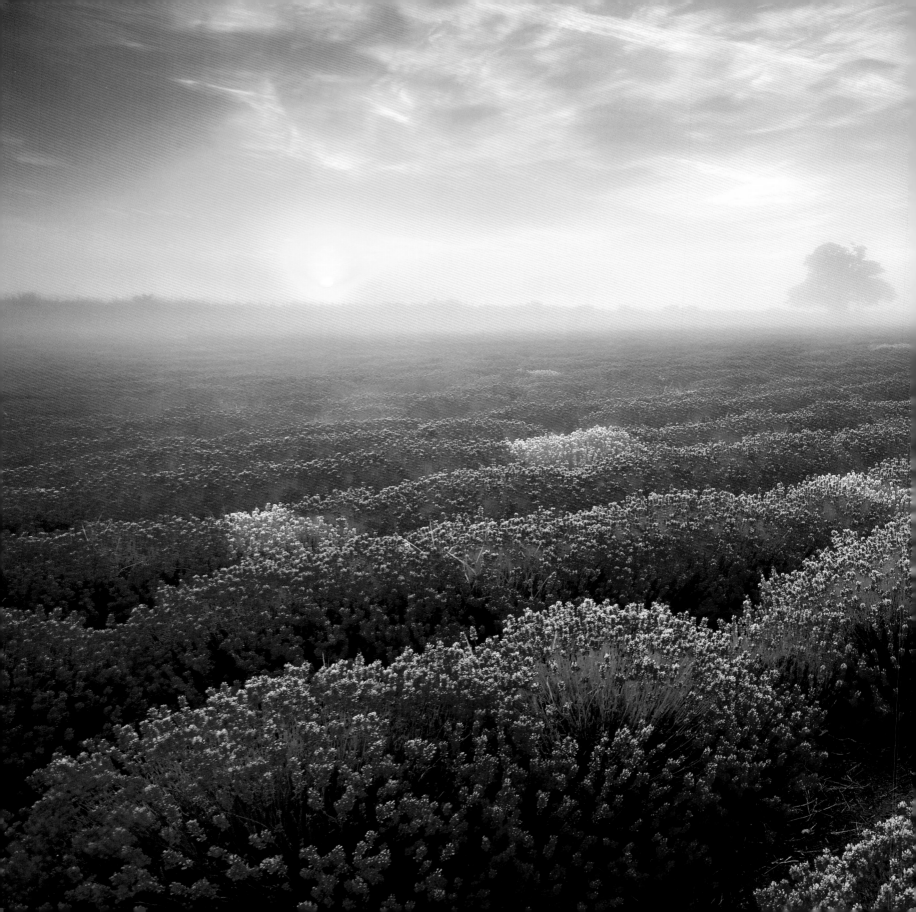

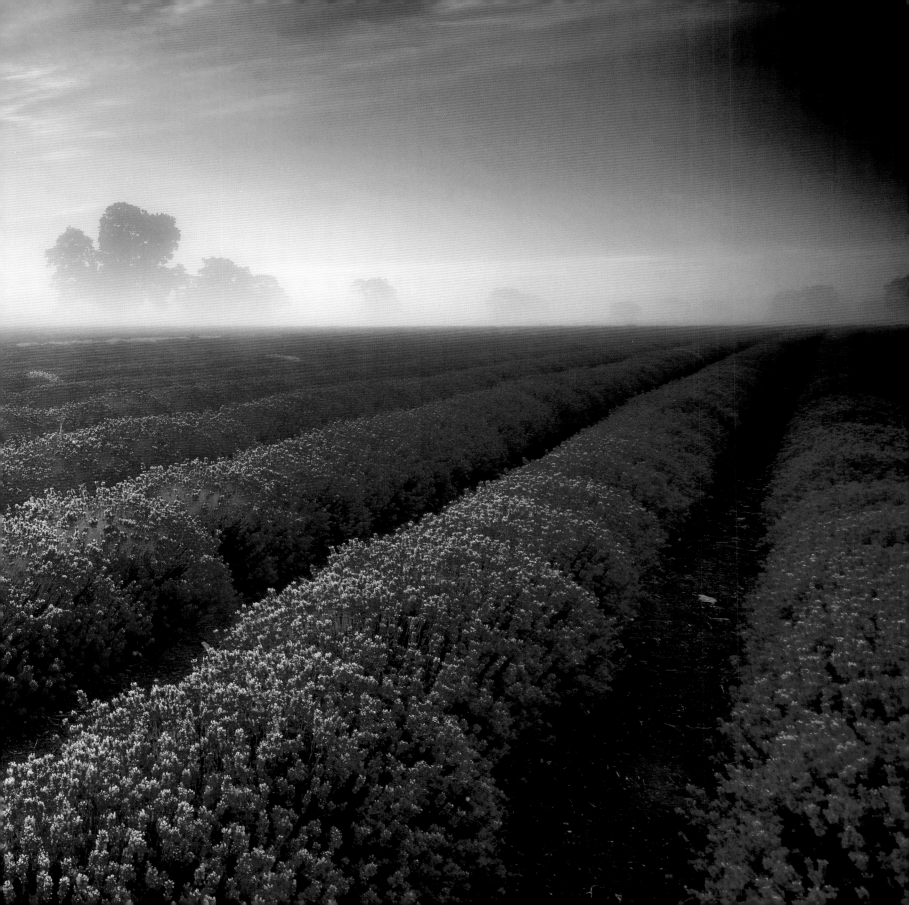

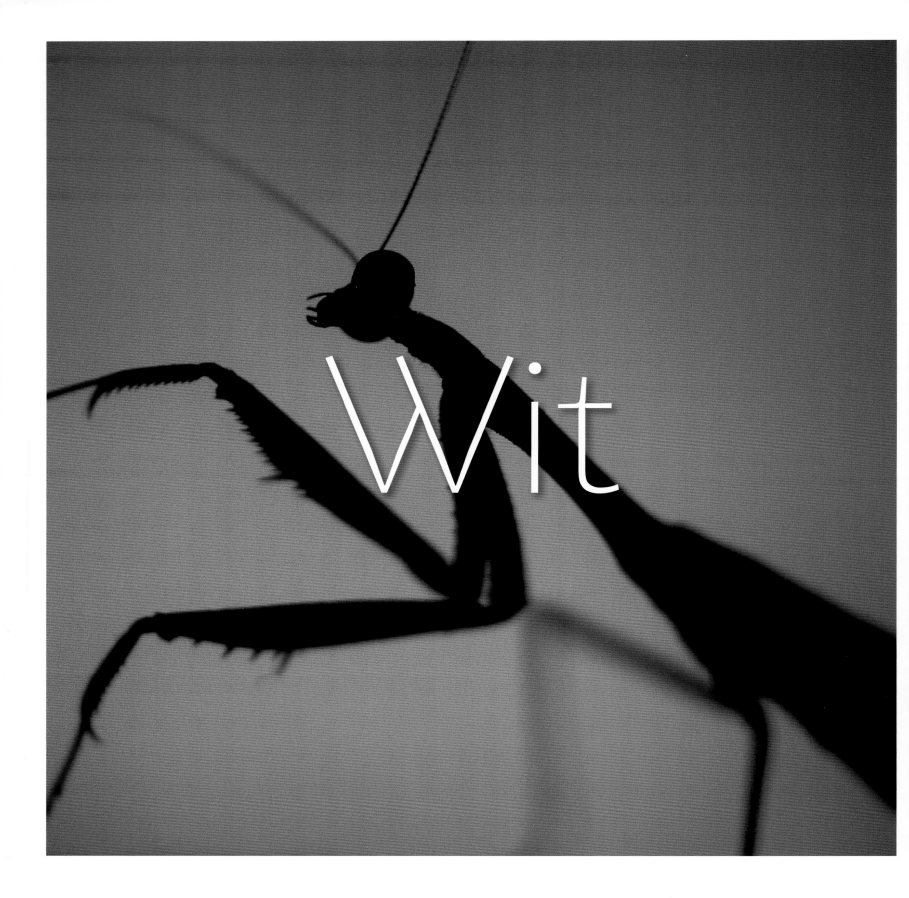

Wit

Wit makes its own welcome, and levels all distinctions. No dignity, no learning, no force of character, can make any stand against good wit.

~ Ralph Waldo Emerson

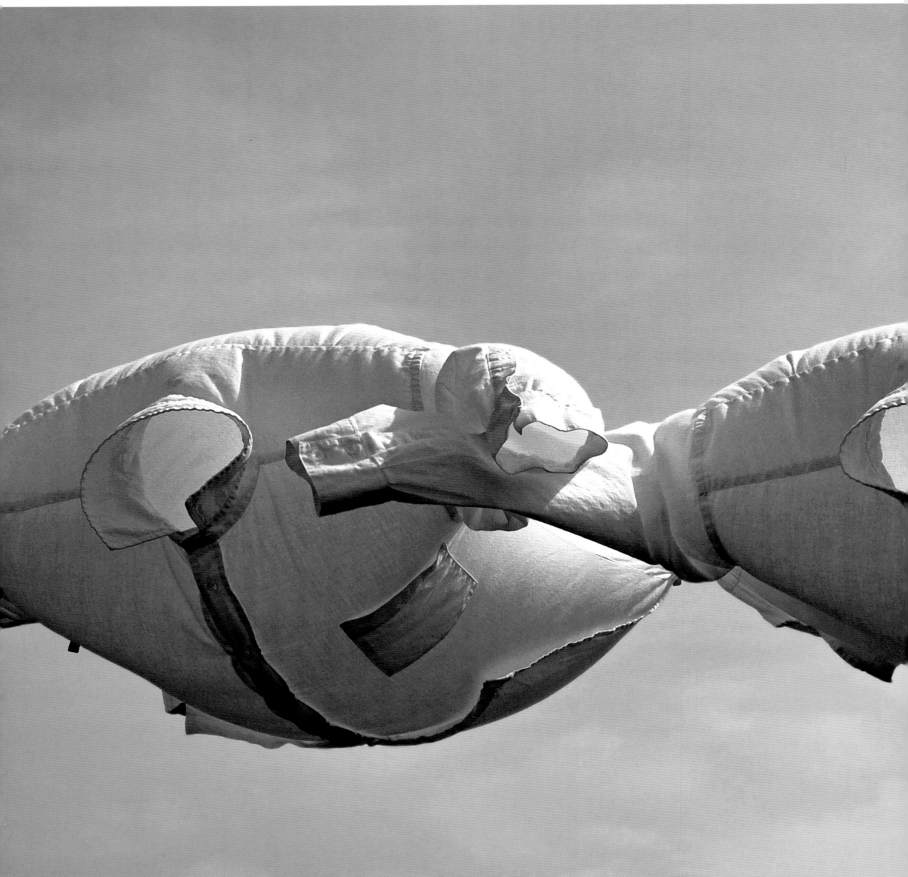

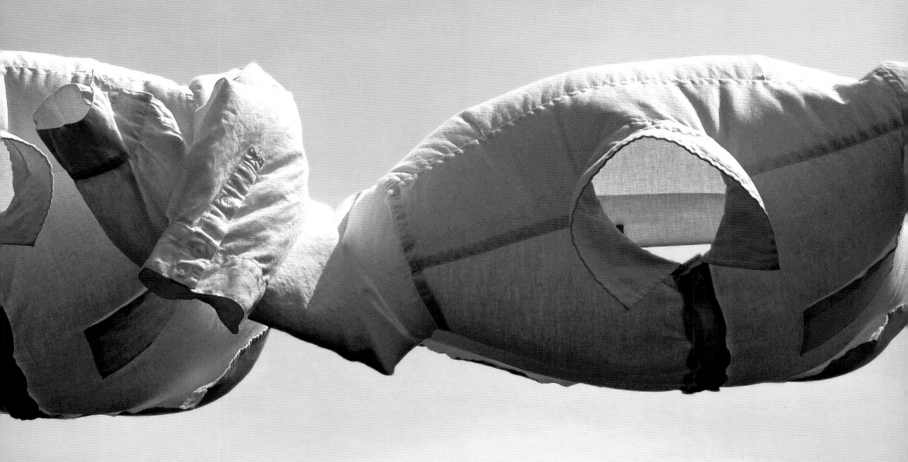

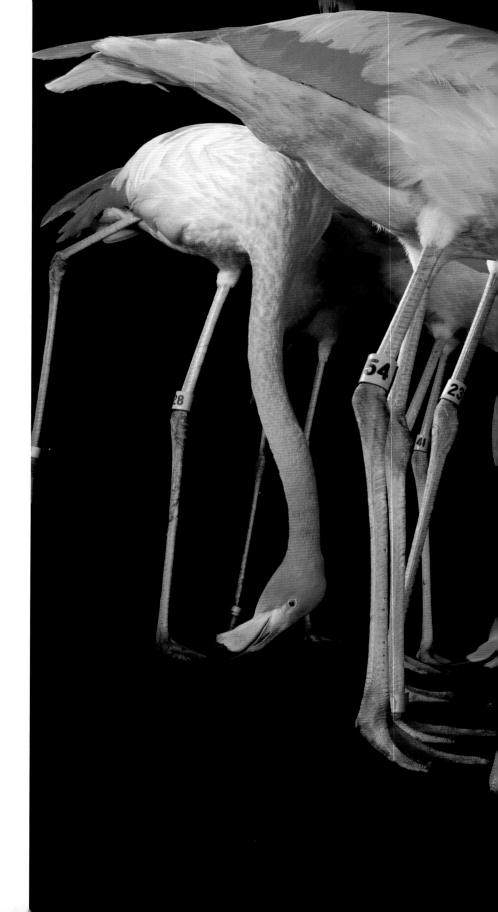

JOEL SARTORE
Lincoln, Nebraska
A black background highlights flamingos'
upside-down bill feeding position.

preceding pages
YANG HAITAO
China
Lamplight silhouettes a mantis.

ROBERT F. BERGMANN
County Clare, Ireland
Three shirts dance in the wind.

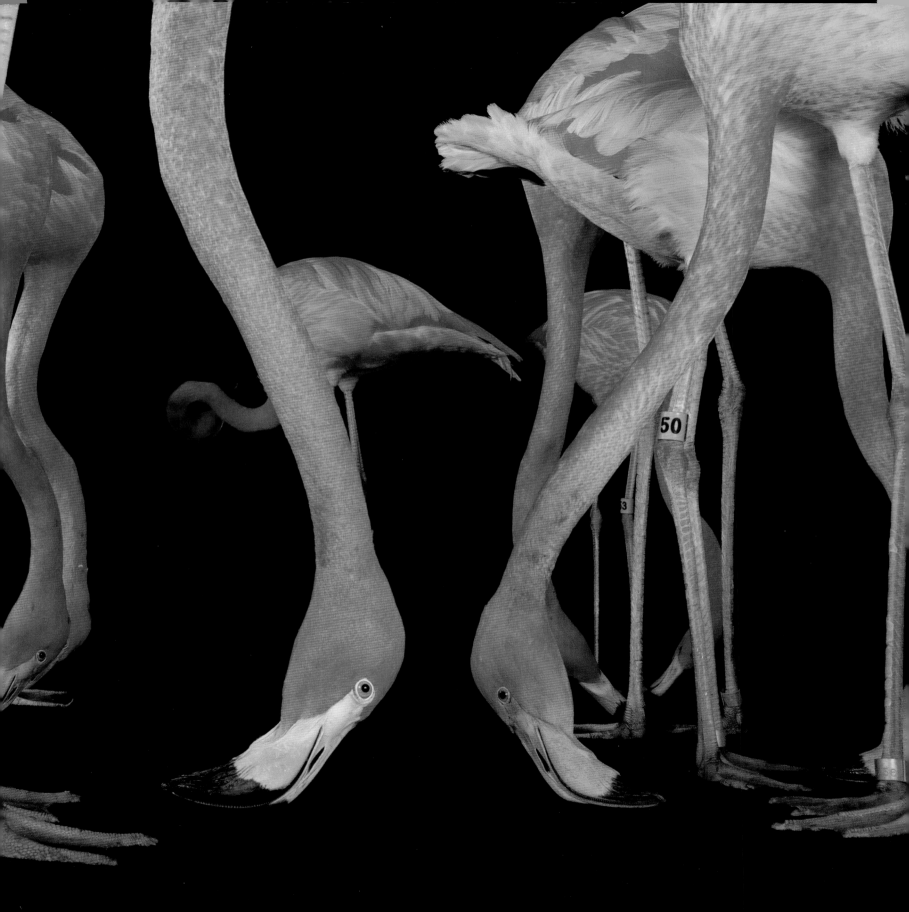

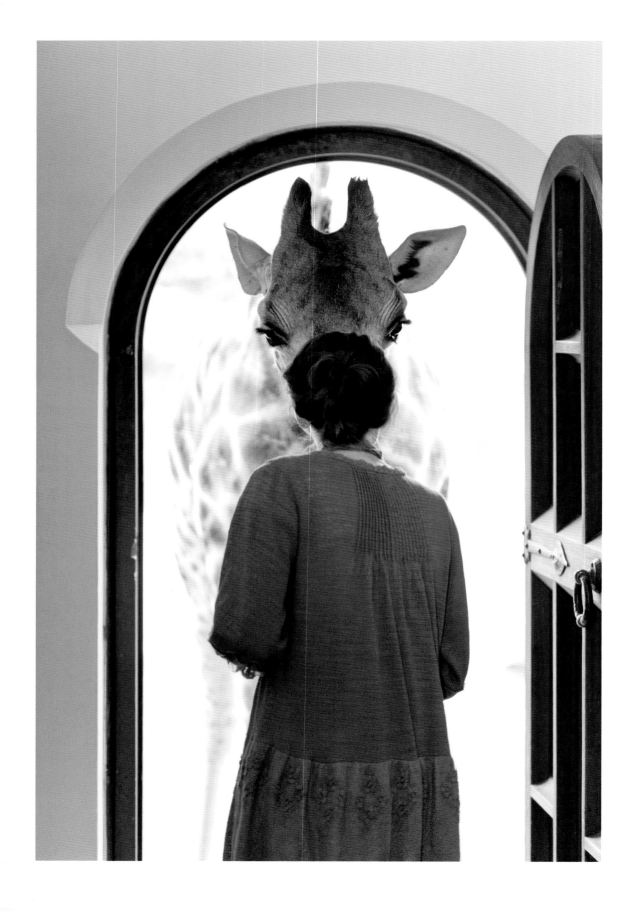

Robin Moore

On the outskirts of Nairobi, a herd of endangered Rothschild's giraffes live near a lodge called Giraffe Manor. The animals are free roaming, but some have become regular visitors to the lodge. My first morning there, a giraffe with big, doughy eyes stuck its head through the window while I was eating breakfast.

This shot was not planned. The manager opened the door, and there was the giraffe. The picture looks as if she is welcoming a guest, but it was actually the giraffe that bent down to greet her.

ROBIN MOORE
Nairobi, Kenya
A woman greets a giraffe at the door of a safari lodge.

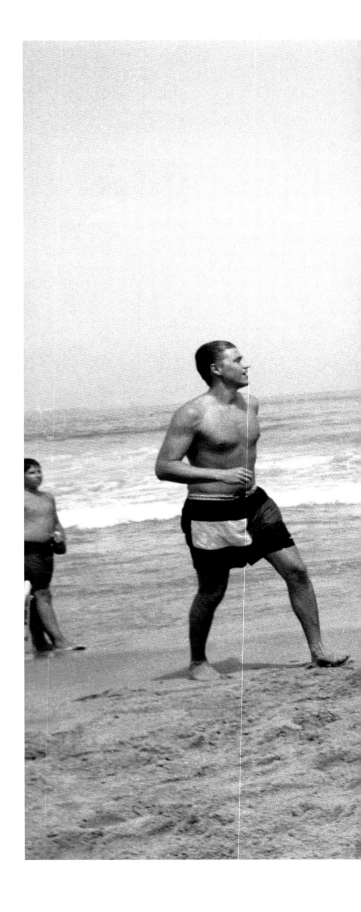

TINO SORIANO
Algeciras, Spain
A soccer player heads the ball.

following pages
ANNIE GRIFFITHS
Chapel Hill, North Carolina
Pregnant women exercise in
a swimming pool.

HEIDI AND HANS-JÜRGEN KOCH
Halle-Wittenberg, Germany
A golden hamster pauses in its
odyssey through a labyrinth at
Martin Luther University.

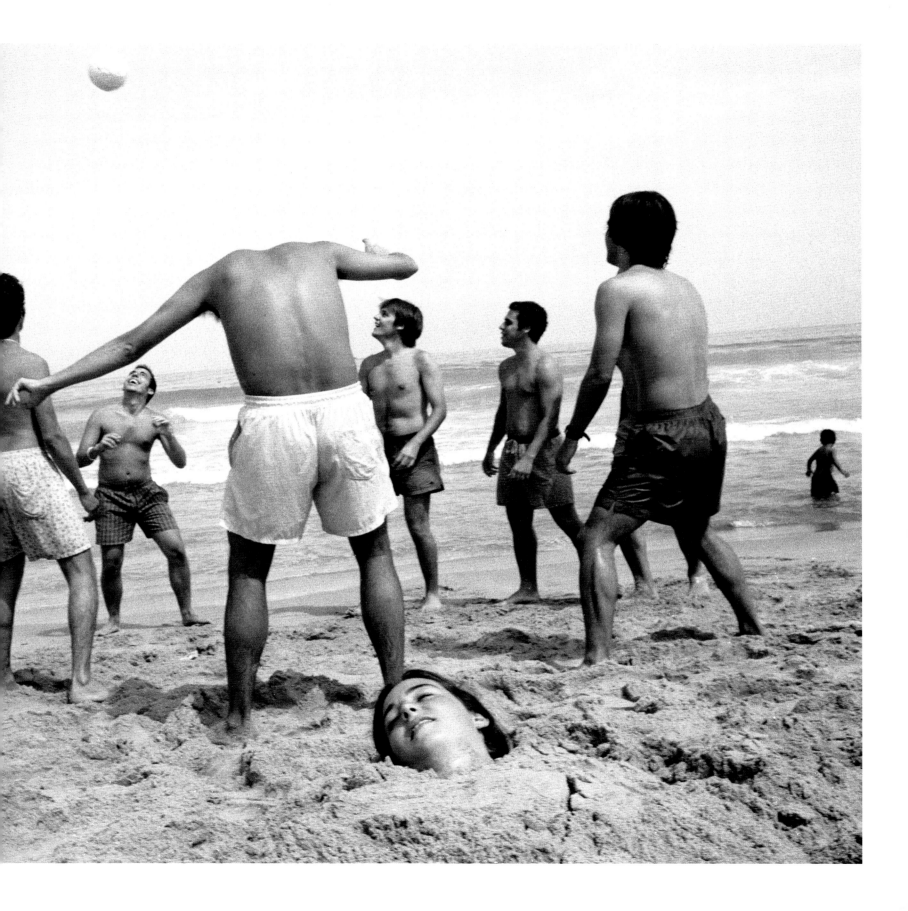

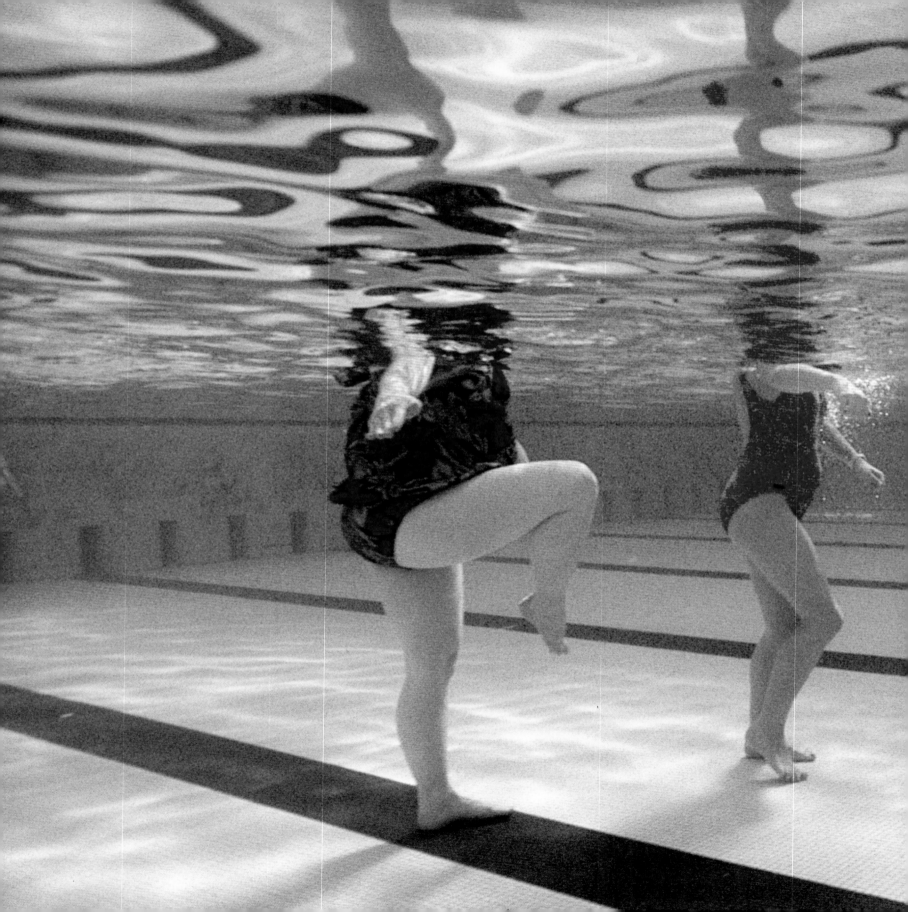

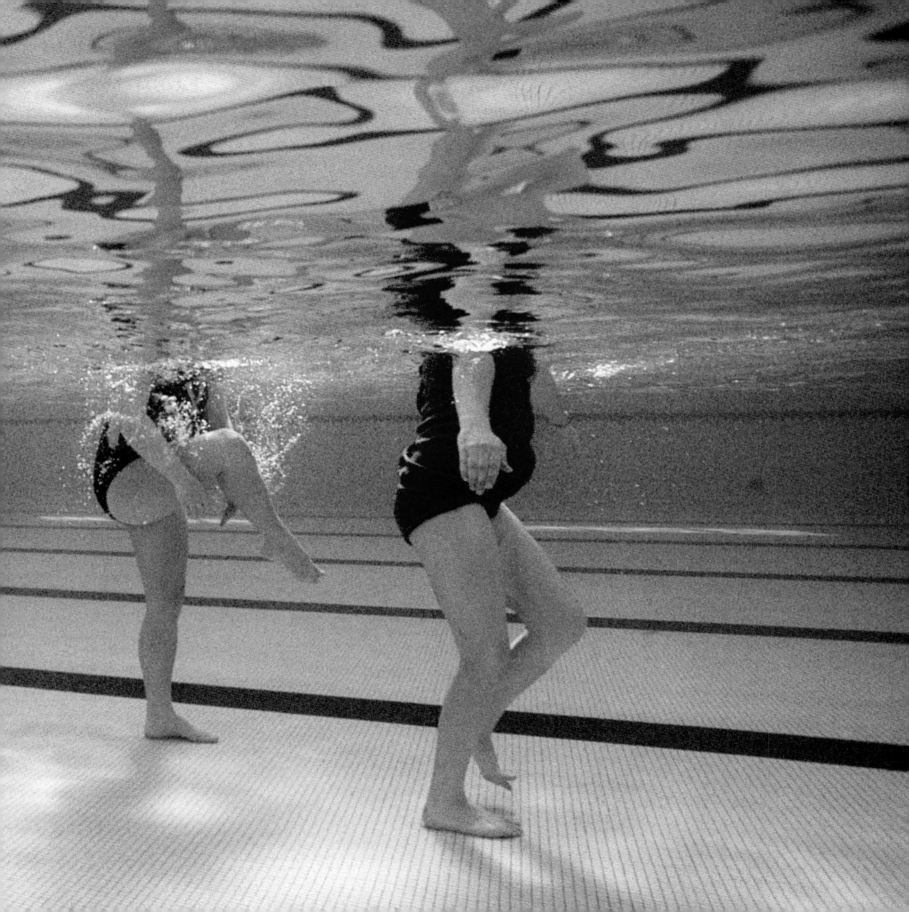

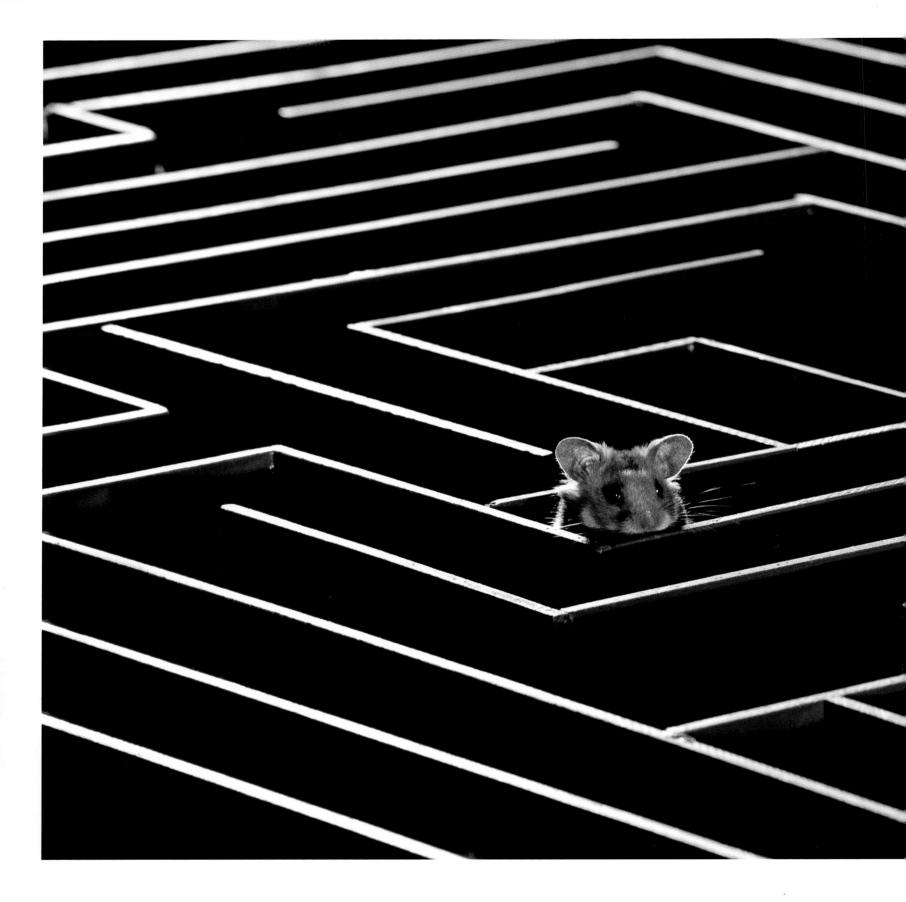

Humor is
emotional chaos
remembered in
tranquility.

~ James Thurber

RICHARD DU TOIT
South Africa
Two distinctively patterned zebras
cross paths.

168

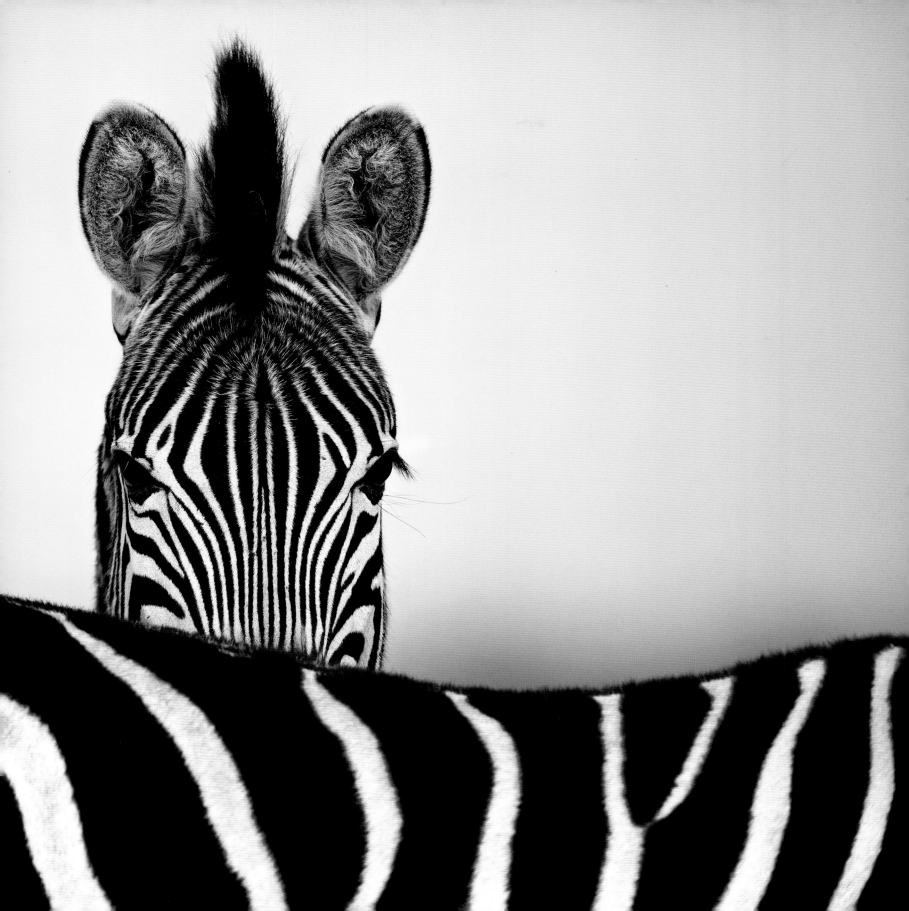

Melissa Farlow

When I photograph I sincerely want to know who they are and what they feel. It's a conversation, not an interview. A level of energy had been building all day as this couple prepared to marry atop a glacier in Alaska. Their love was infectious. When the bride heard "You may now kiss the bride," she lifted the groom off his feet and kissed him. Photographers try to anticipate key moments, but there is luck in timing that is better than anything we could imagine.

MELISSA FARLOW
Juneau, Alaska
A bride embraces the groom for the wedding ceremony kiss.

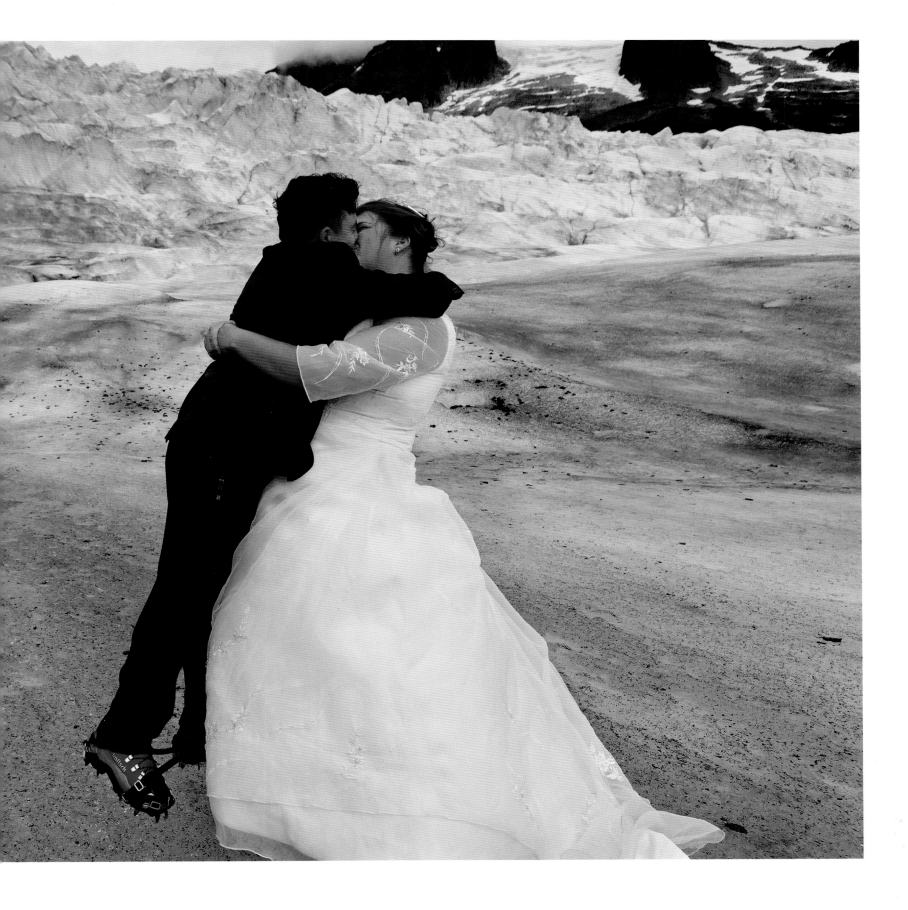

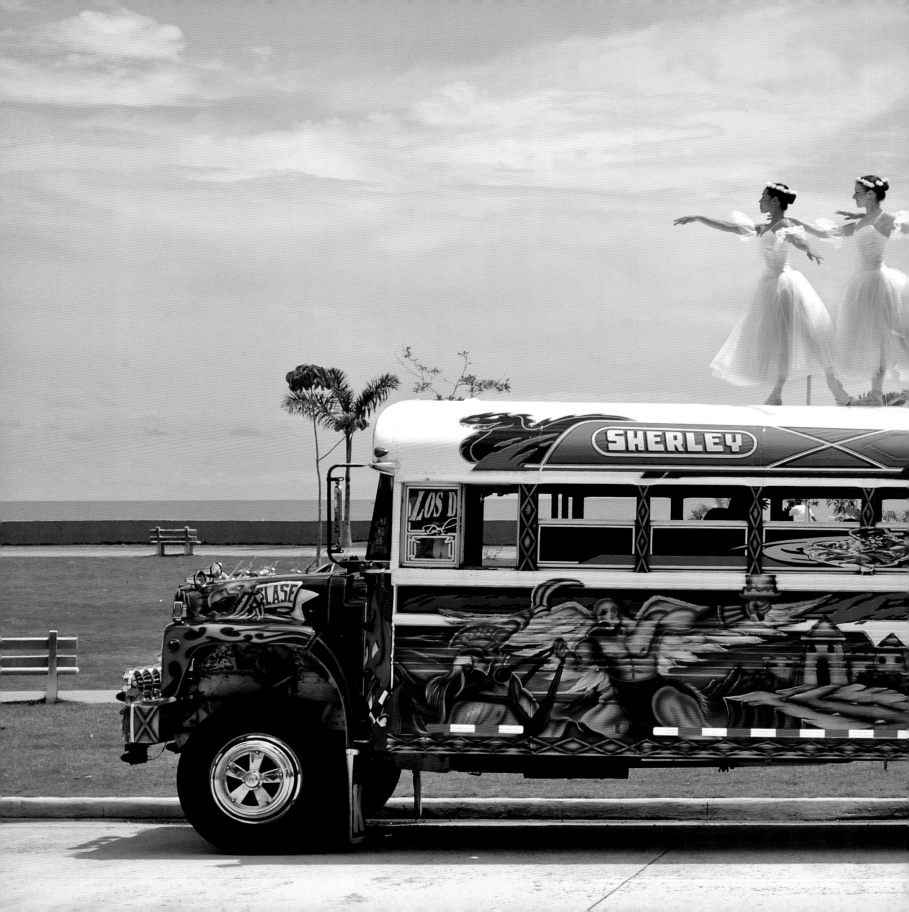

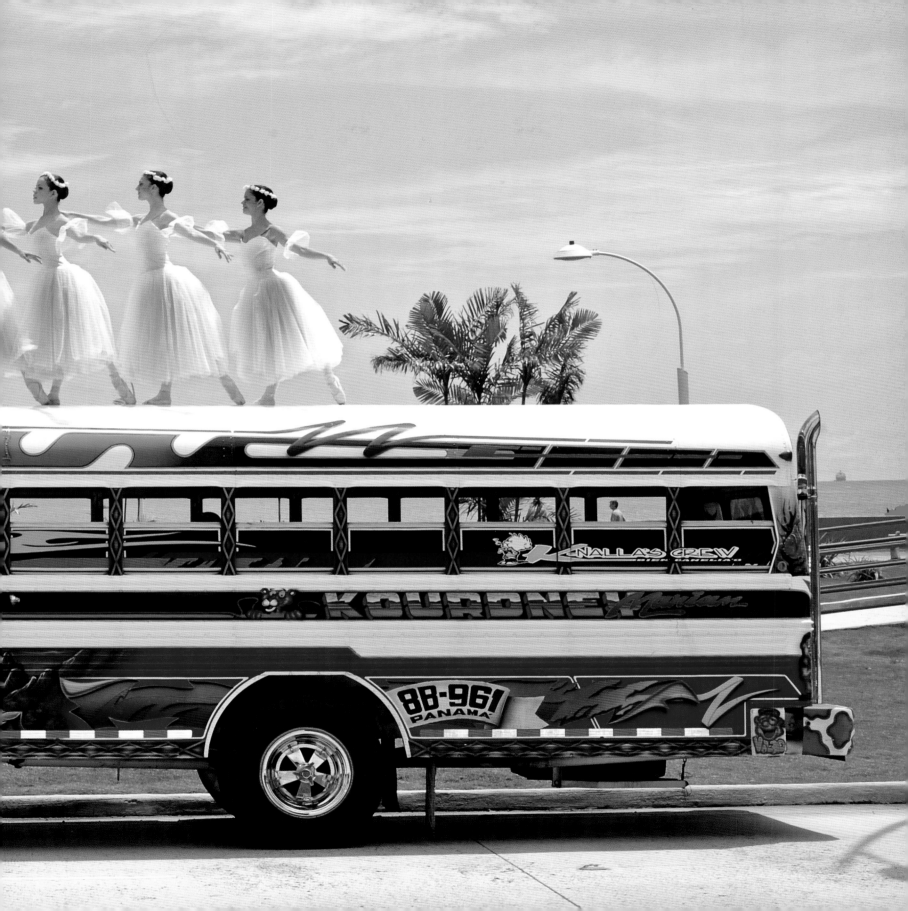

JEREMY PHAN
Ninh Binh, Vietnam
A douc langur monkey in a primate
sanctuary gazes at the camera.

preceding pages
KIKE CALVO
La Cinta Costera, Panama
Ballerinas dance on the roof of a
painted bus on the coastal highway.

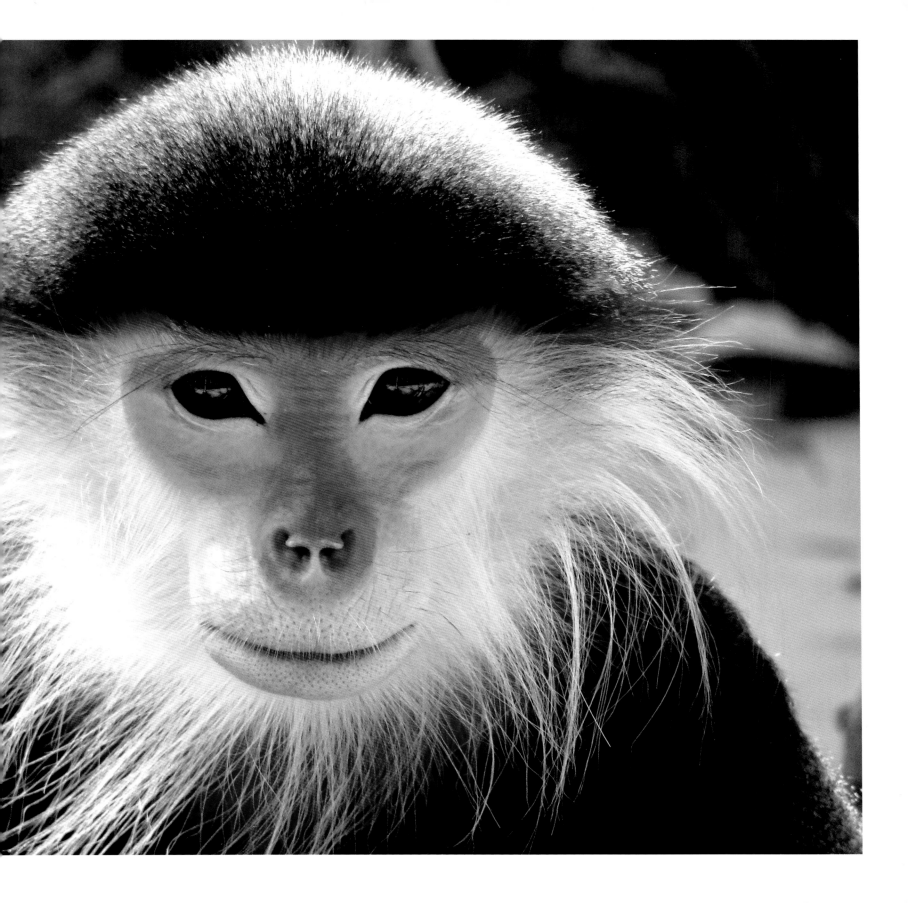

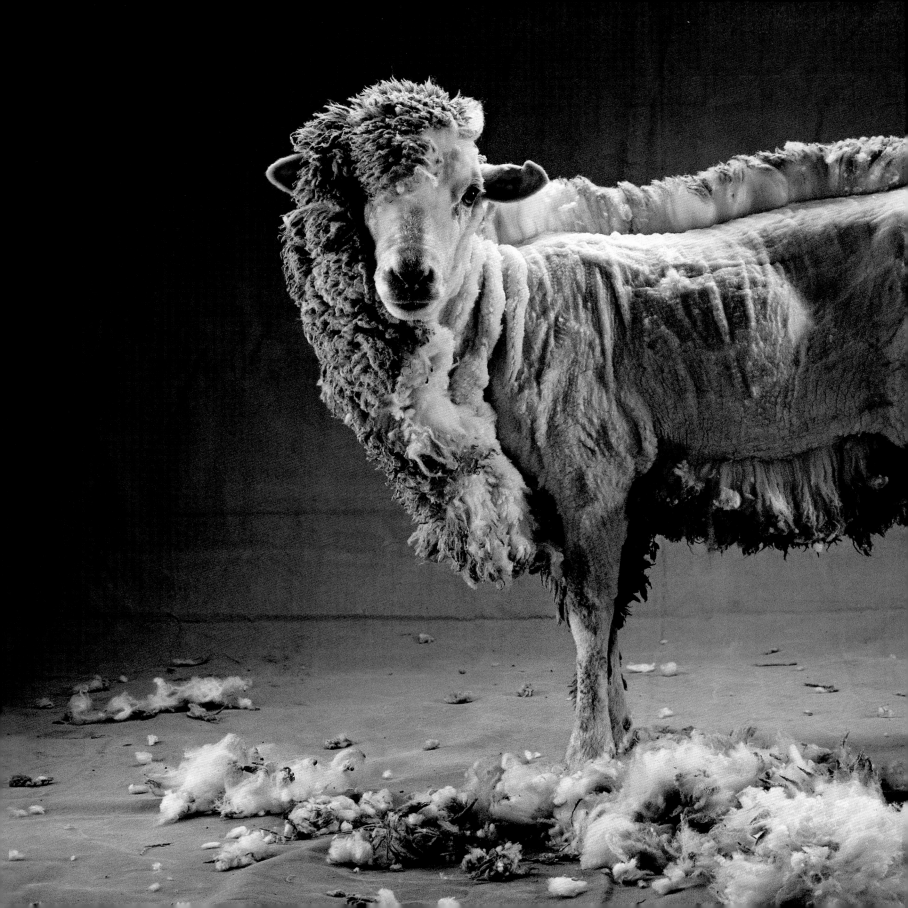

Cary Wolinsky

It seemed easy enough: To show how much wool a sheep grows in a season, just shear off half the wool and have the sheep stand sideways. I figured I'd have this picture done in an afternoon.

The first sheep never achieved stardom. After shearing, it swayed a bit and toppled toward the woolly side. The unbalanced sheep lay helpless, feet bicycling in the air. Nor was there success with the 2nd, the 19th, or the 27th. It was sheep number 30 that finally became a star.

CARY WOLINSKY
Victoria, Australia
A half-shorn sheep stands hoof-deep
in fleece.

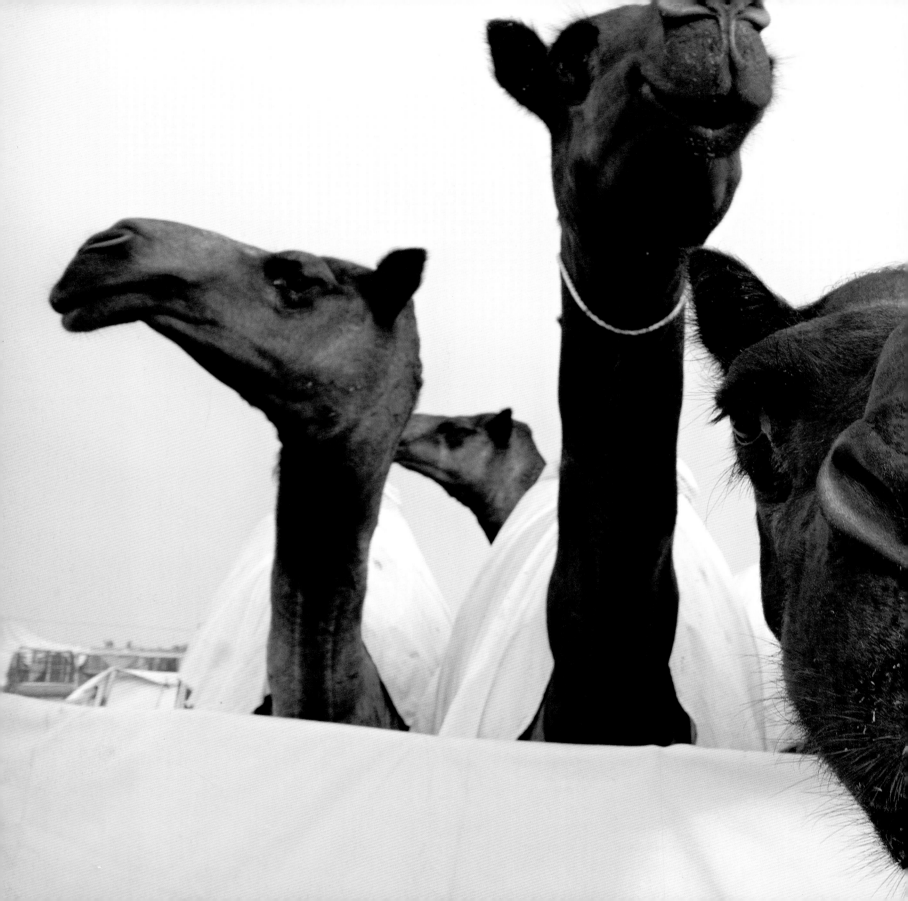

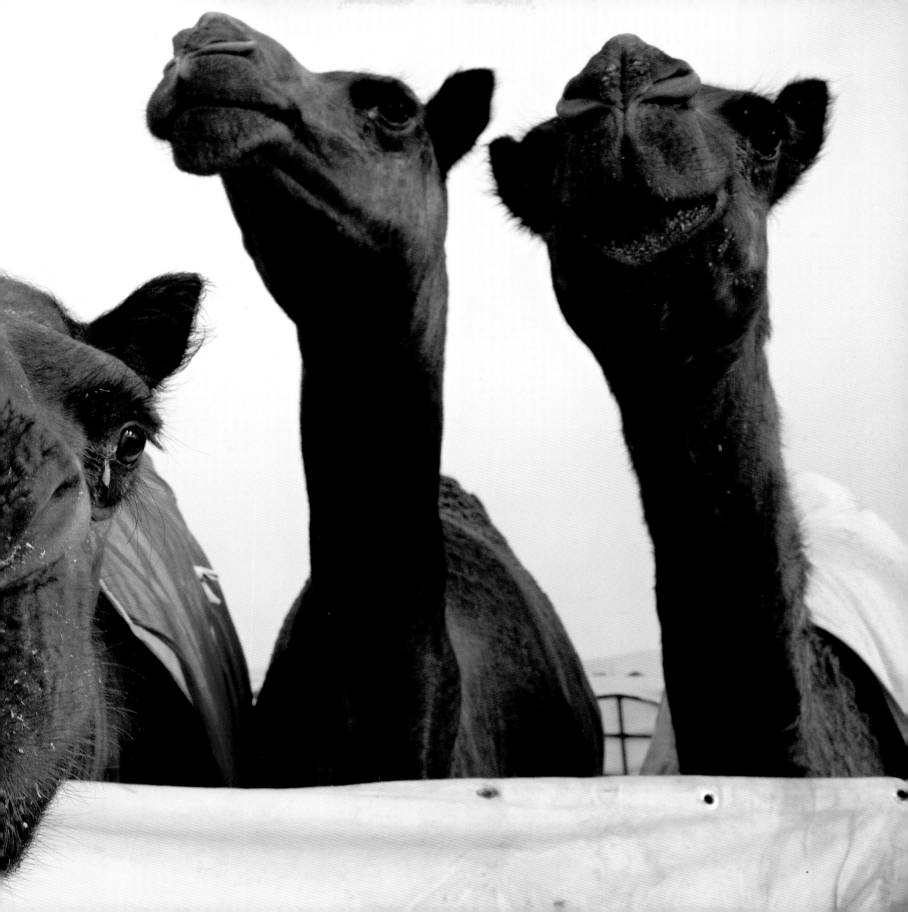

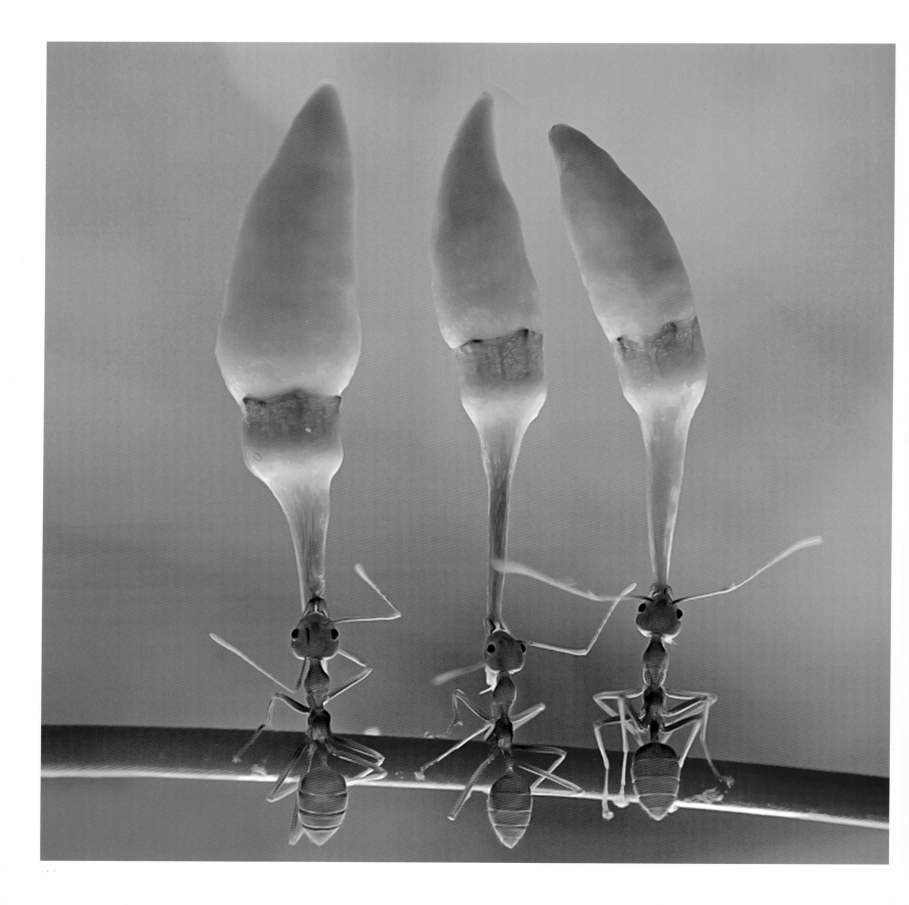

DONCRY

South Kalimantan, Indonesia

Industrious ants tote chili peppers to their nest.

preceding pages

RANDY OLSON

Abu Dhabi, United Arab Emirates

Contestants in a camel beauty pageant await the judges' decision.

KIERAN DOHERTY

London, England

Competitors in the U.K. Cold Water
Swimming Championship head for
the water.

following page

THERON HUMPHREY

Indiana

Rescued coonhound Maddie balances
on the feet of a human.

182

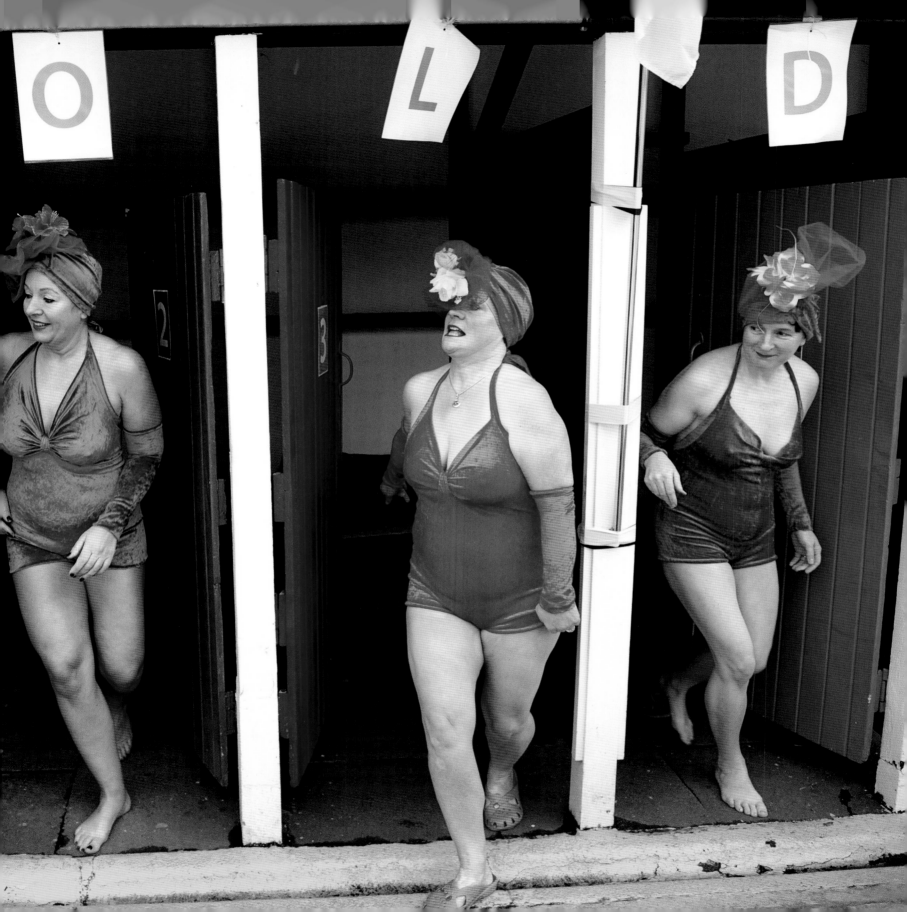

Perhaps the world's second-worst crime is boredom; the first is being a bore.

~ Cecil Beaton

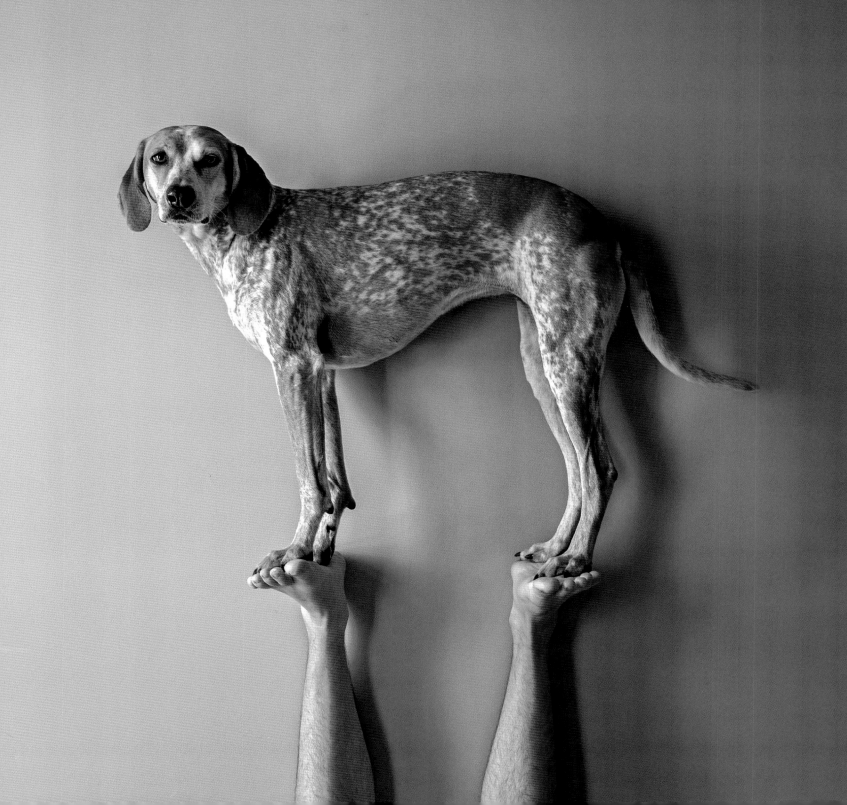

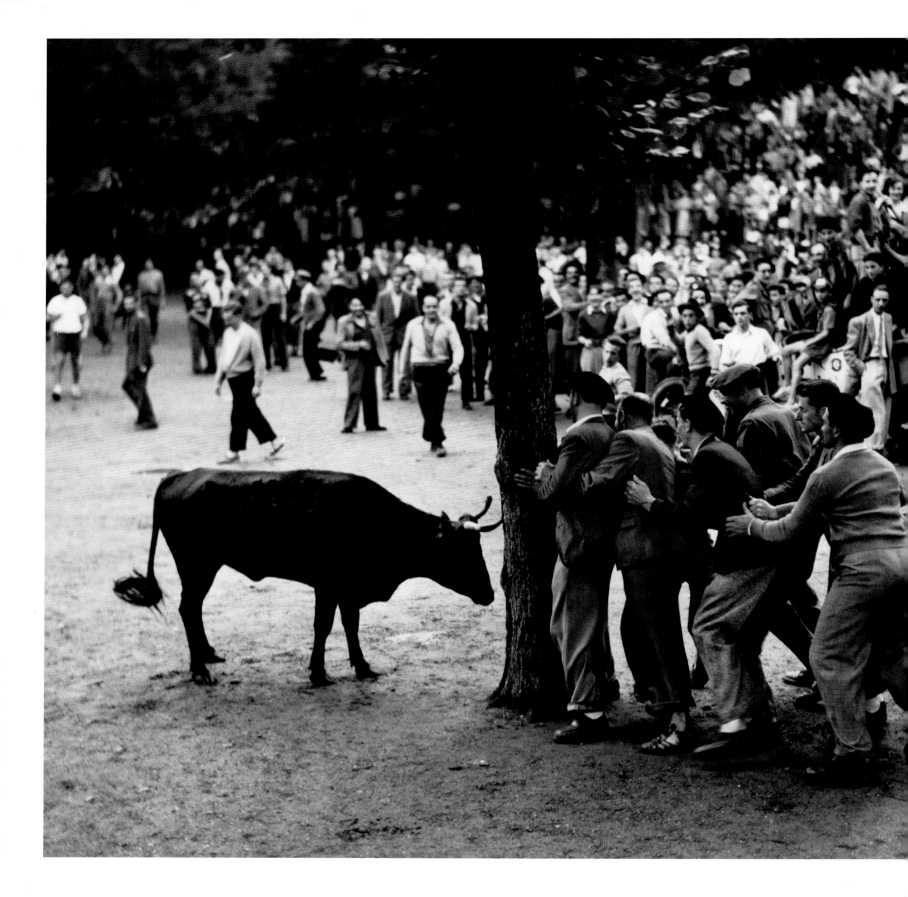

JUSTIN LOCKE
Bayonne, France
Young daredevils provoke a bull during a Basque festival event.

following pages
CHADDEN HUNTER
South Georgia and the South Sandwich Islands
An elephant seal savors his sleep.

187

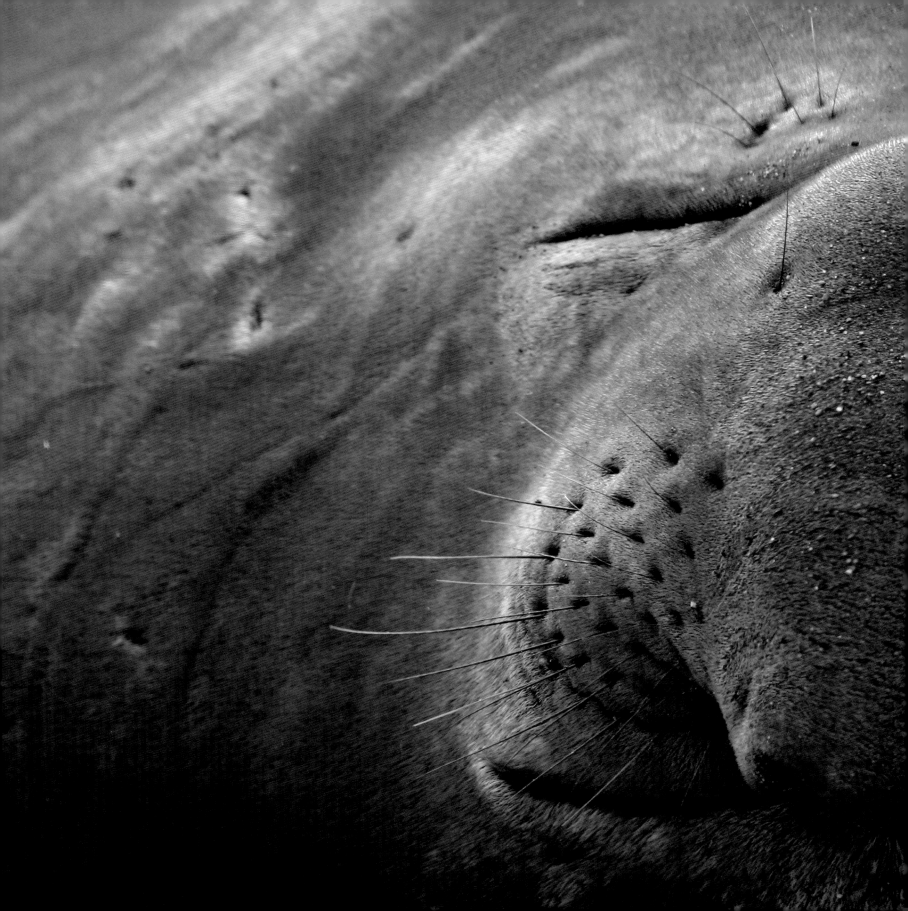

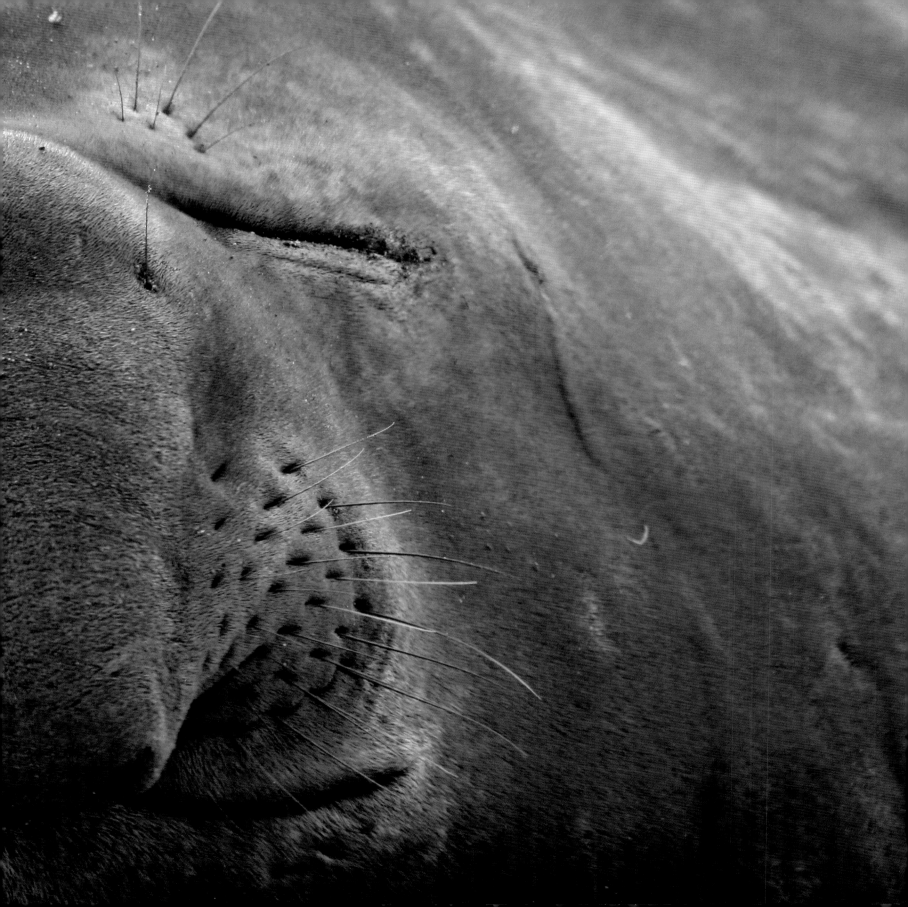

ANKIT MAVCHI
India
An insect crawls across a student's
exam notes.

TINO SORIANO
Barcelona, Spain
A museum worker carries a reproduction
of the "Mona Lisa."

following pages
TIM CHONG
Singapore
A Youth Olympic Games diver shares air
space with a military transport plane.

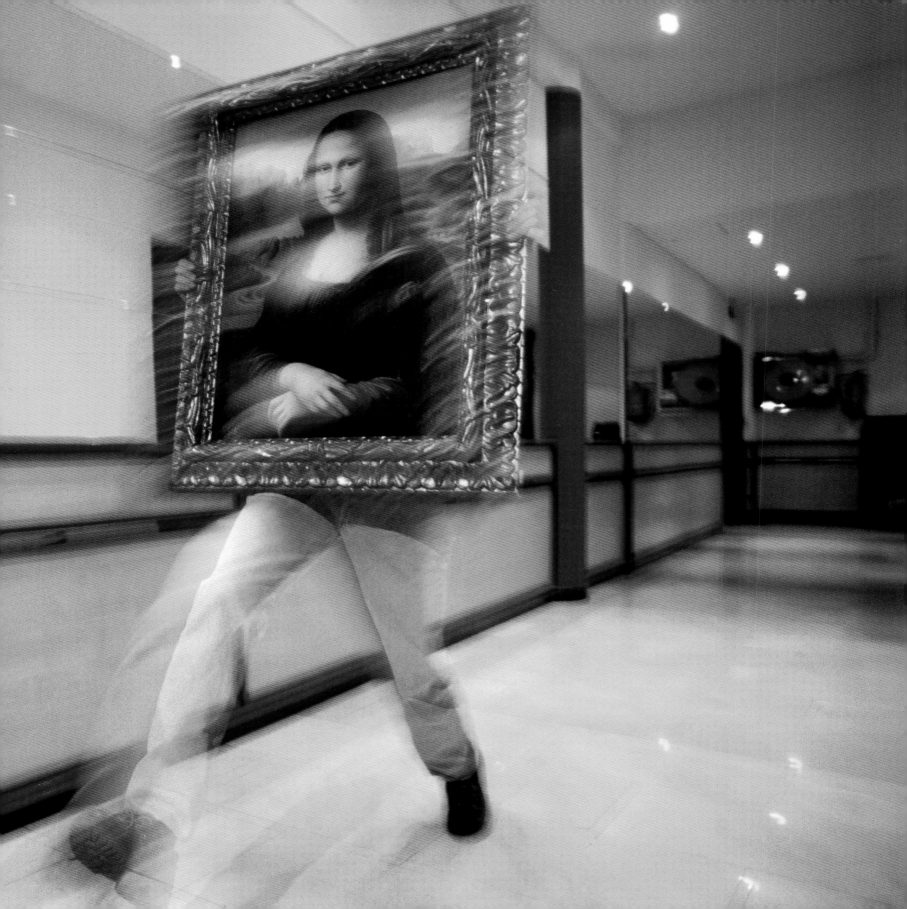

Life is not
significant details,
illuminated by
a flash, fixed forever.
Photographs are.

~ Susan Sontag

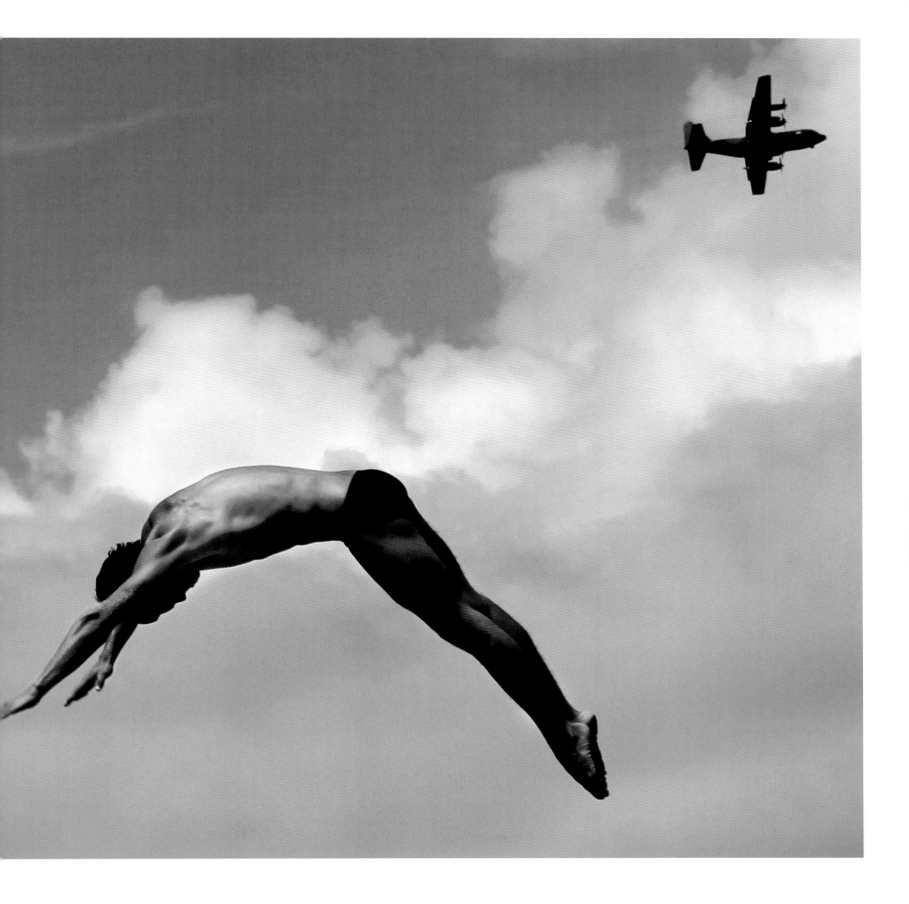

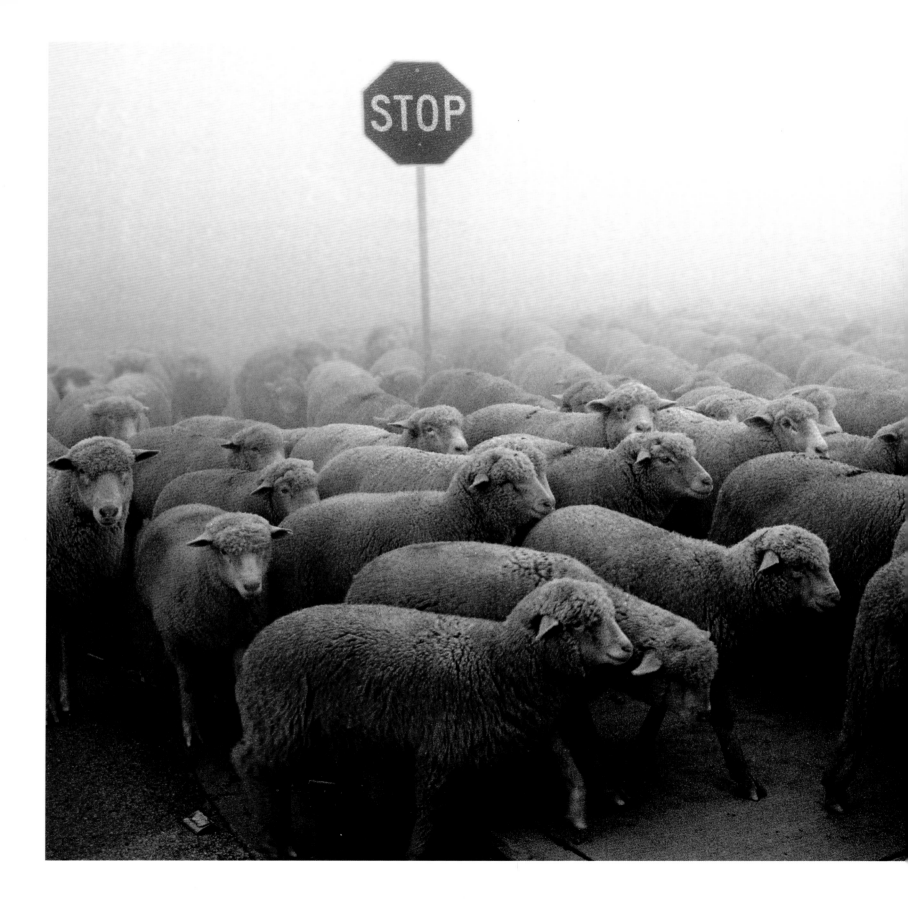

DICK SELBY
Boise, Idaho
Hundreds of sheep jam Main Street
during the annual migration.

Annie Griffiths

Photographers need an inner radar that can detect when something that is merely interesting might become wonderful. I was shooting a yacht parade in Australia when I saw these men who had decorated their boat as *Swan Lake.*

As the day progressed and the beer flowed, an inner ballerina seemed to come out in both men. At one point, they crossed their ankles and curved their toes in unison. Suddenly, an entertaining scene became a memorable moment.

ANNIE GRIFFITHS
Sydney, Australia
Jolly crewmates wear matching tutus during a boat race.

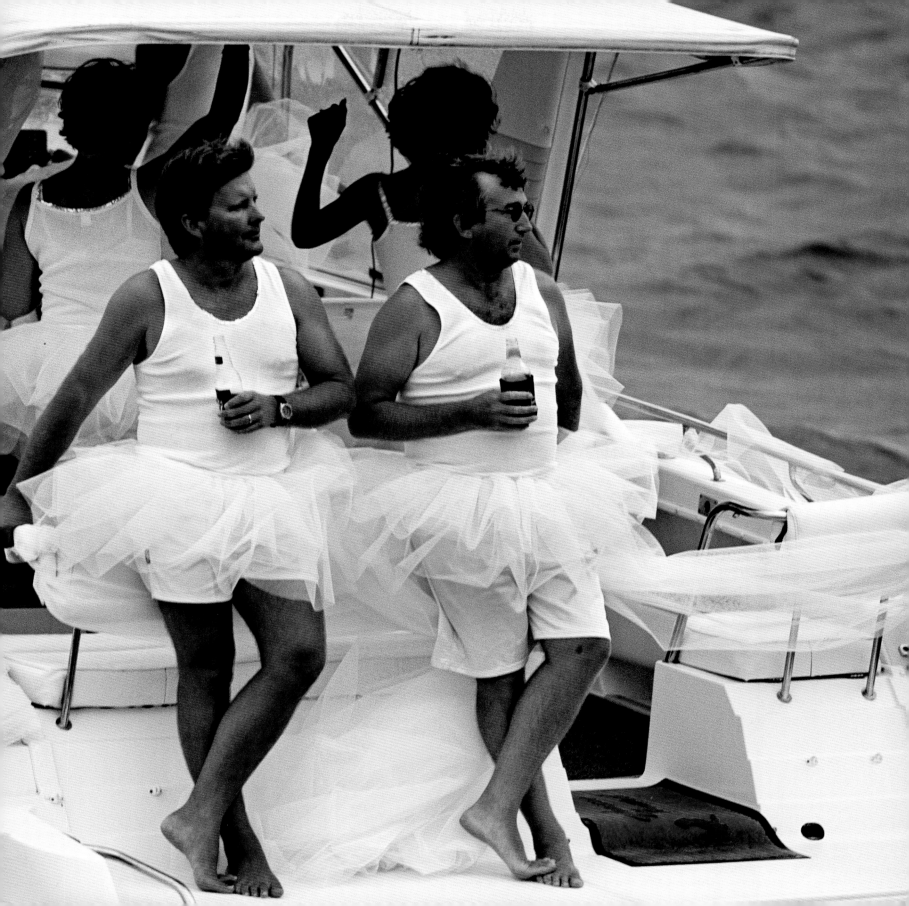

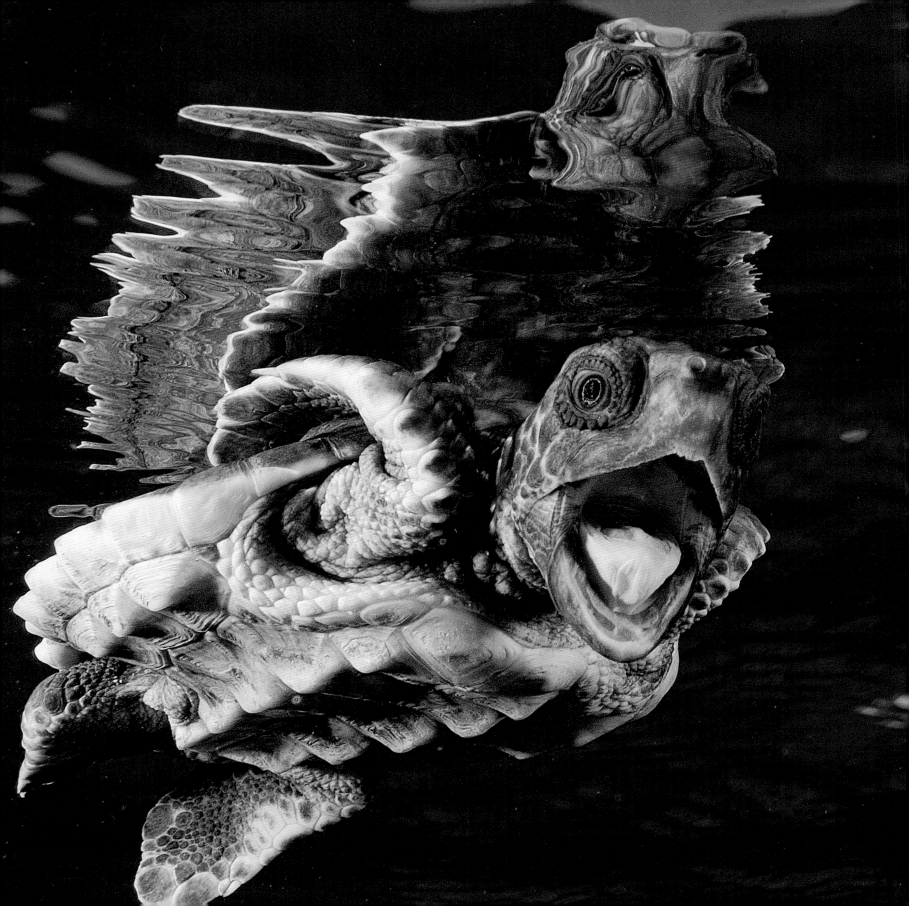

STEVE ROSENBERG
Bahamas
A juvenile loggerhead turtle challenges
its own reflection.

following pages
DMITRI MARKINE
Havana, Cuba
A bride and family members wait for
a photography session.

DIGITAL VISION
United States
Chickens roost on a fence rail.

The capacity
for delight is the
gift of paying
attention.

~ Julia Margaret Cameron

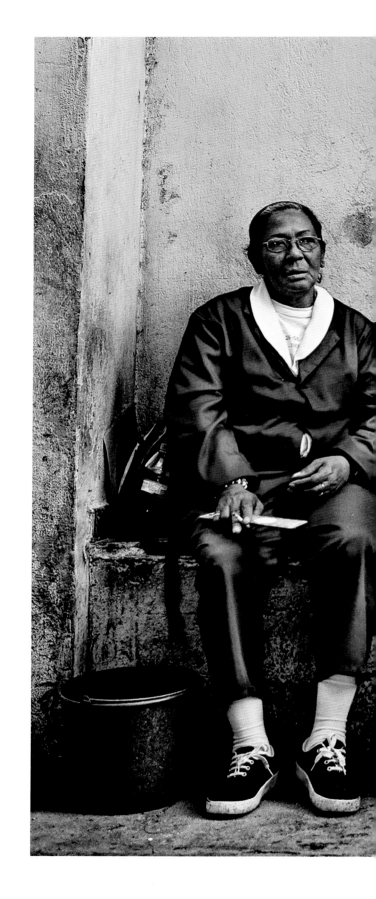

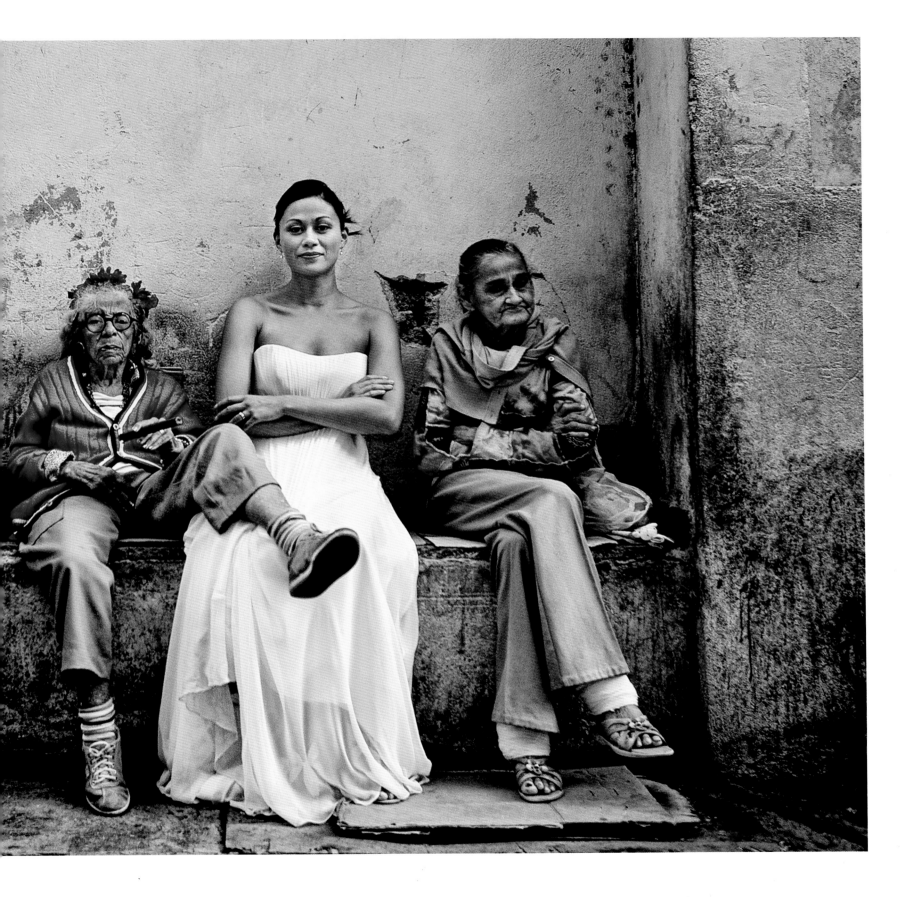

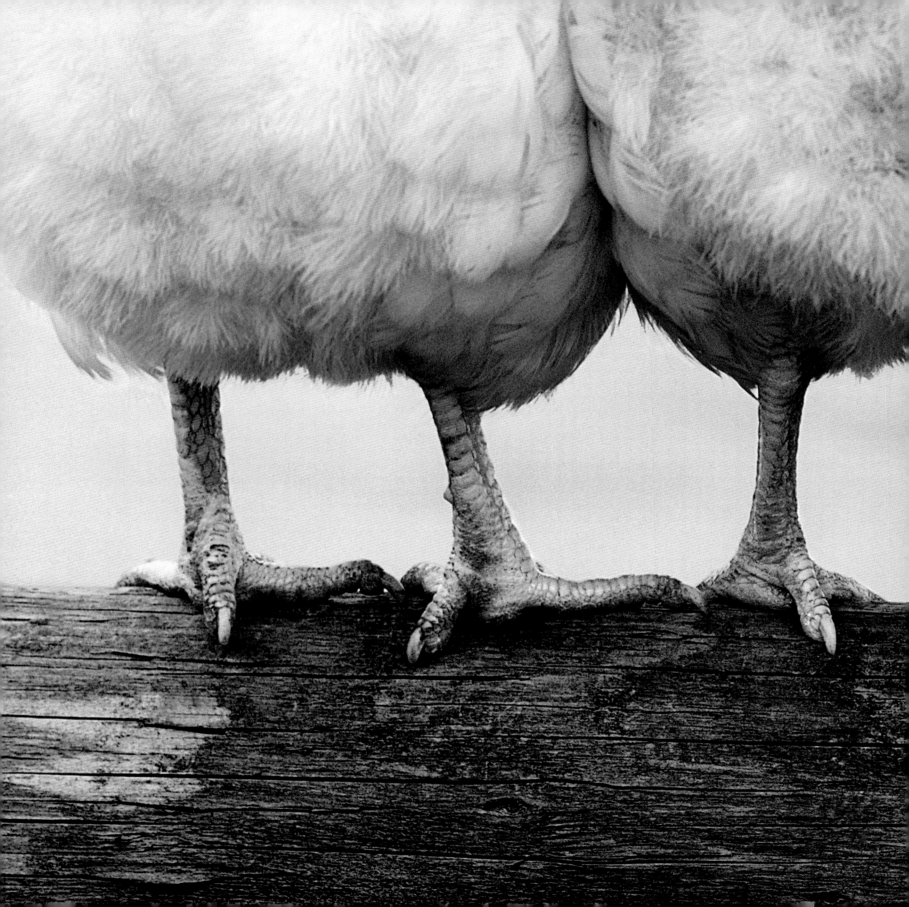

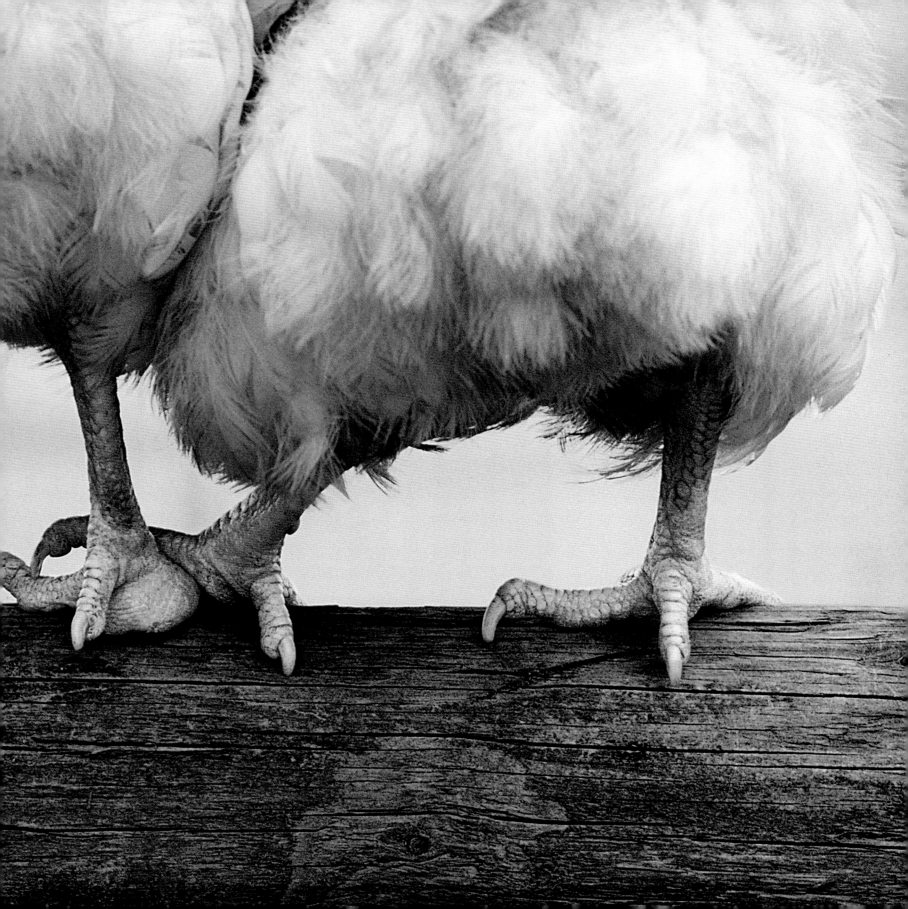

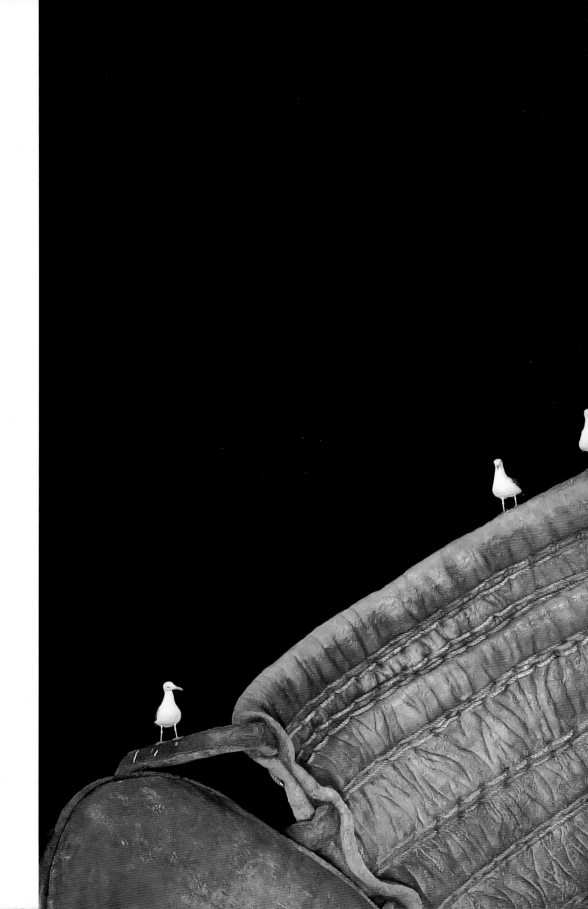

MARCIO JOSE SANCHEZ
San Francisco, California
Seagulls perch on a stadium's giant
steel-and-fiberglass baseball glove.

following pages
JASON EDWARDS
Coral Sea Islands Territory, Australia
A strawberry land hermit crab peers out
from its shell.

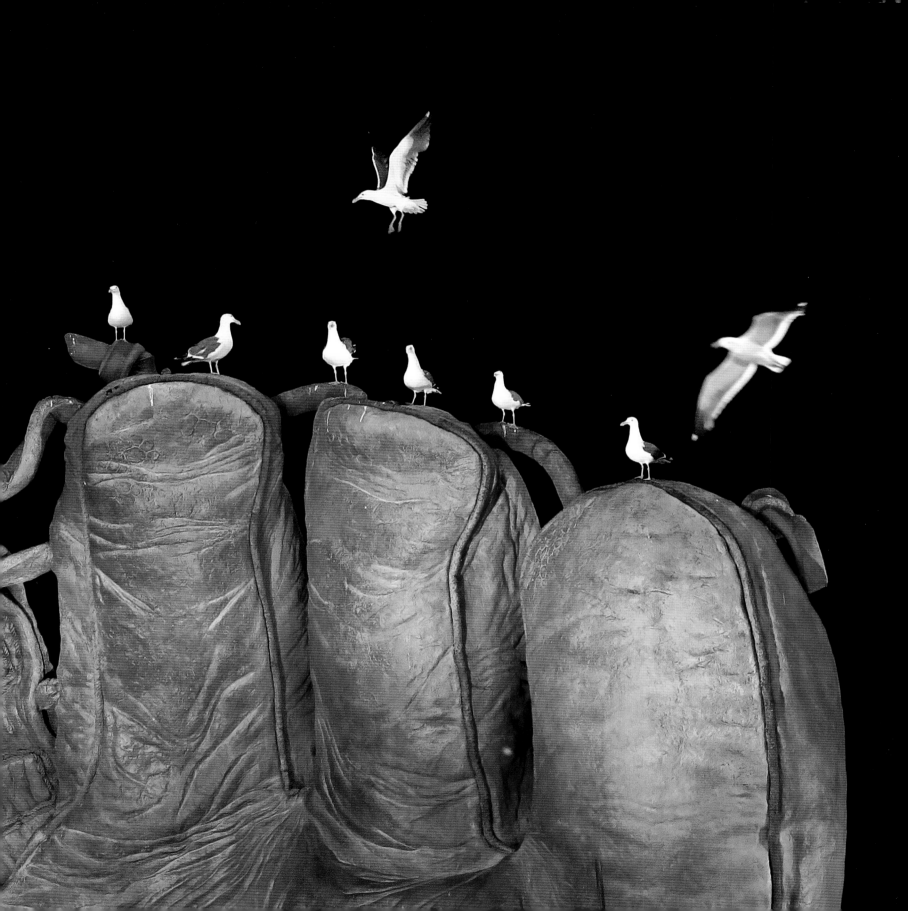

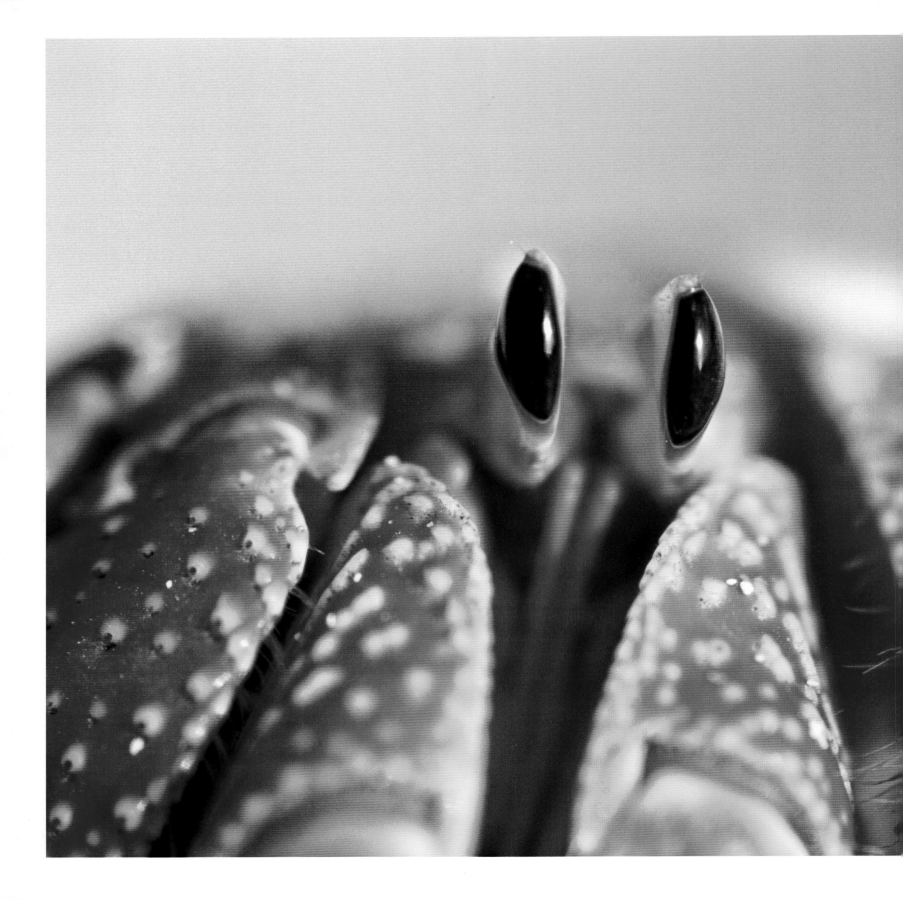

The secret
to humor is
surprise.

~ Aristotle

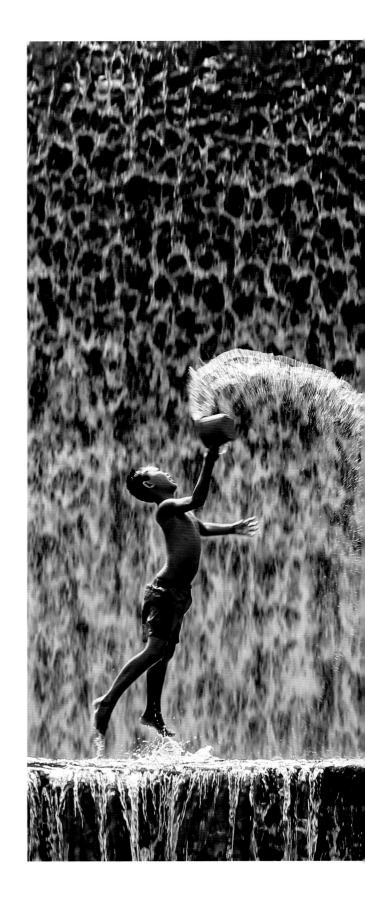

AGOES ANTARA

Indonesia

Boys delight in spirited water play at
a river.

following pages

HIROYA MINAKUCHI

Shimane, Japan

A trio of beluga whales blows ring-
shaped bubbles at an aquarium.

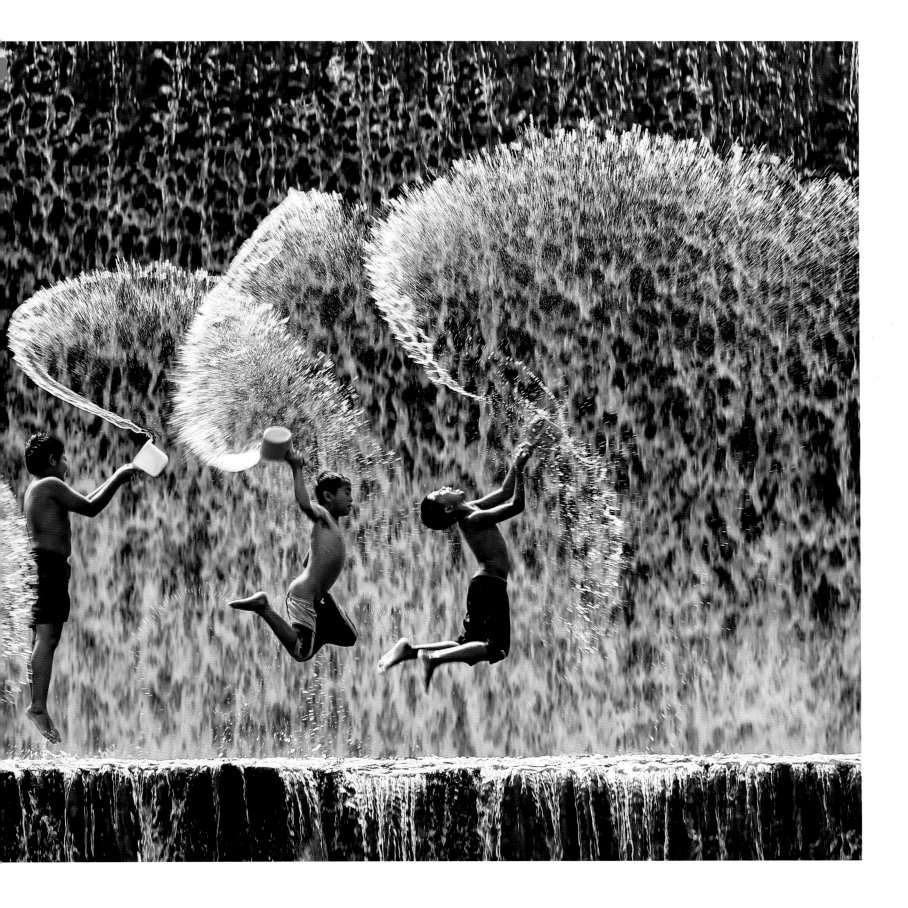

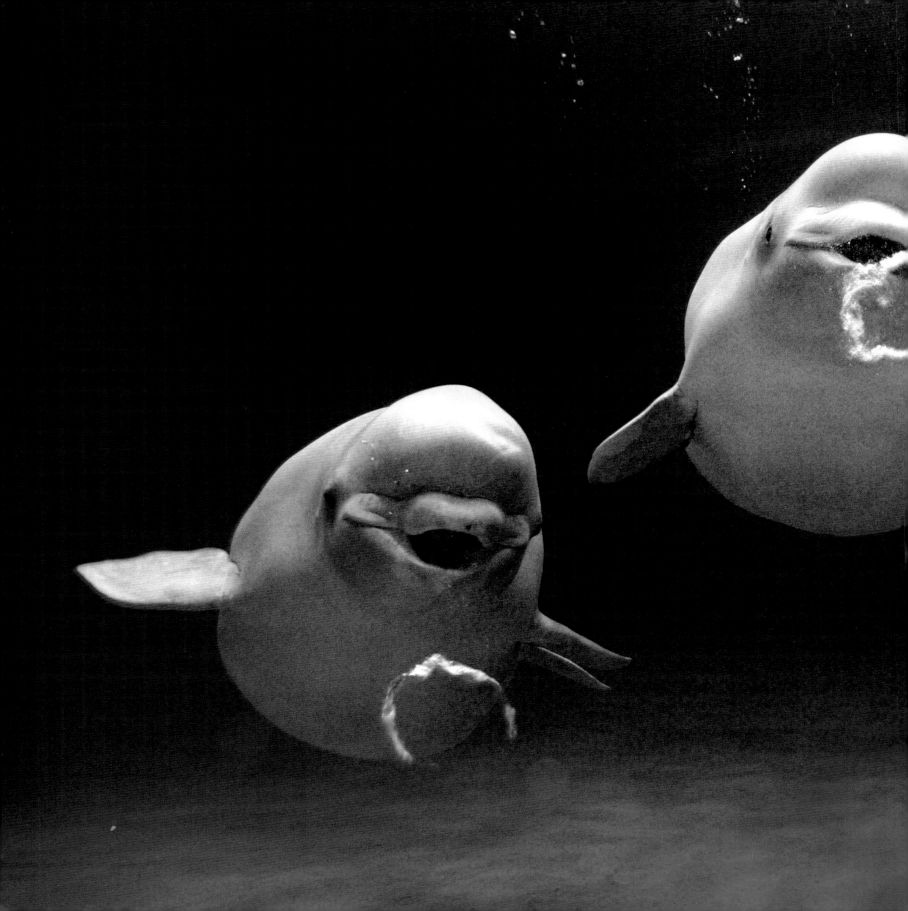

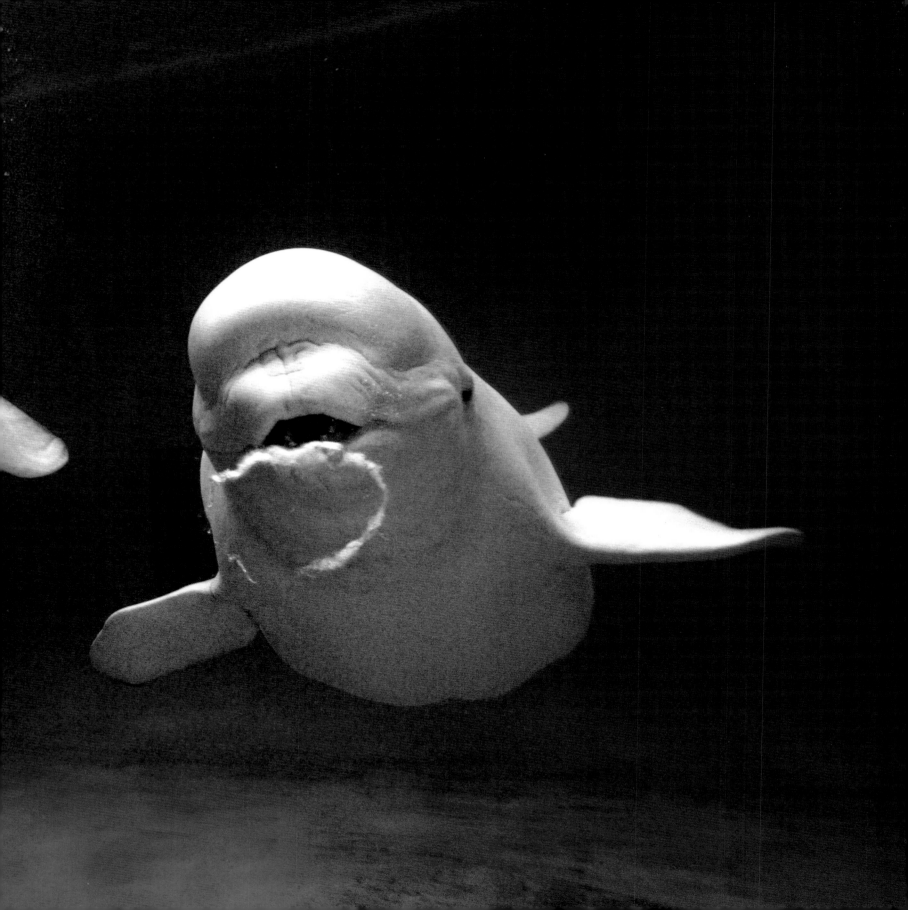

Discovery

Photography is an art of observation . . . I've found that it has little do with the things you see and everything to do with the way you see them.

~ Elliott Erwitt

Discovery

Discovery is one part curiosity, one part genius, and two parts tenacity. Those who seek it, find it, and bring it back as visual proof are more than photographers. They are scientists, geologists, ethnologists, and pioneers. They have carried the mission of National Geographic on their shoulders and in their camera bags for more than 100 years. These are the Tintins of our time, restlessly pursuing the highest, the lowest, the deepest, the farthest. Their cameras are trained on the most remote places and people on Earth . . . and beyond. ❧ This elite group is neither swashbuckling nor flamboyant. Renowned oceanographer Sylvia Earle stands barely five feet tall, but is affectionately called "Her Deepness." Other explorers are simply called crazy. Their collective talents and travails have profoundly changed what we know about our world. They are courageous, committed, and fascinating. One of the unsung perks of working at National Geographic is that you rarely have a dull lunch. The collective energy of our explorers, writers, cartographers, and photographers keeps hope afloat. ❧ These are people who have discovered species and named stars. Irrepressible visionaries, they dream about what it feels like to summit a mountain without air, what it looks like deep inside a tornado, and whether there is life beyond our galaxy. Impatient on the edge, they prefer to parachute into the unknown. Fortunately for the rest of the world, they bring cameras along. ❧ It's easy to underestimate the resourcefulness and technical skills of photo pioneers. They plant camera traps at watering holes and lash mini-cams to lions and tigers and bears (Oh my!). Through brilliant engineering, they somehow place cameras on robots and missiles, or float them through the arteries of the human body. Their images make us sweat. ❧ So does their

work ethic. Years ago I recall helping brilliant underwater photographer David Doubilet load five taxis with equipment as he headed to the airport and on to another deep-sea exploration. "This is nothing," he told me as we stuffed the last duffel bag in. "You should see what's on the boat!"

❧ The hardship and logistics of documenting glacial retreat, or navigating the world of vipers, or retracing the steps of early man on foot for seven years would cause most journalists to turn in their press passes and head for the nearest pub. It's an uncomfortable business, as dangerous as it is uplifting. We photographers count among our heroes those we have lost to the mountain, the sea, the avalanche, or the wrath of a tornado. Countless others have endured frostbite, tropical diseases, and roaring seasickness. ❧ But, oh, the photographs they bring back! The world now has visual proof of the flight of a falcon. We have seen the summit of Everest and the depths of the Mariana Trench. Magma flies. Stars collide. A whale the size of a bus gently nudges a lone diver. We have witnessed the beating of the human heart in real time; the sight of an infant star, broadcast from its birth dozens of years ago, but only arriving now as an image. ❧ Other explorations are subtler. We enter the den of a sleeping grizzly or are introduced to the hidden habitat of an ancient tree. My friend and master of photographic innovation Jim Balog once said, "When I worked with wildlife a lot in the eighties and nineties, I learnt the meaning of patience. And when I worked with trees, I learned the meaning of humility." ❧ It is a humbling world these photographers deliver. On a planet that seems to teem with humans, it is quite something to be shown a vision that nobody has seen before, or a new view of something most of us thought we knew. These images convert doubters and confirm believers. The astounding is delivered with a flourish. The unimaginable is made certifiable. We see and believe and crave more.

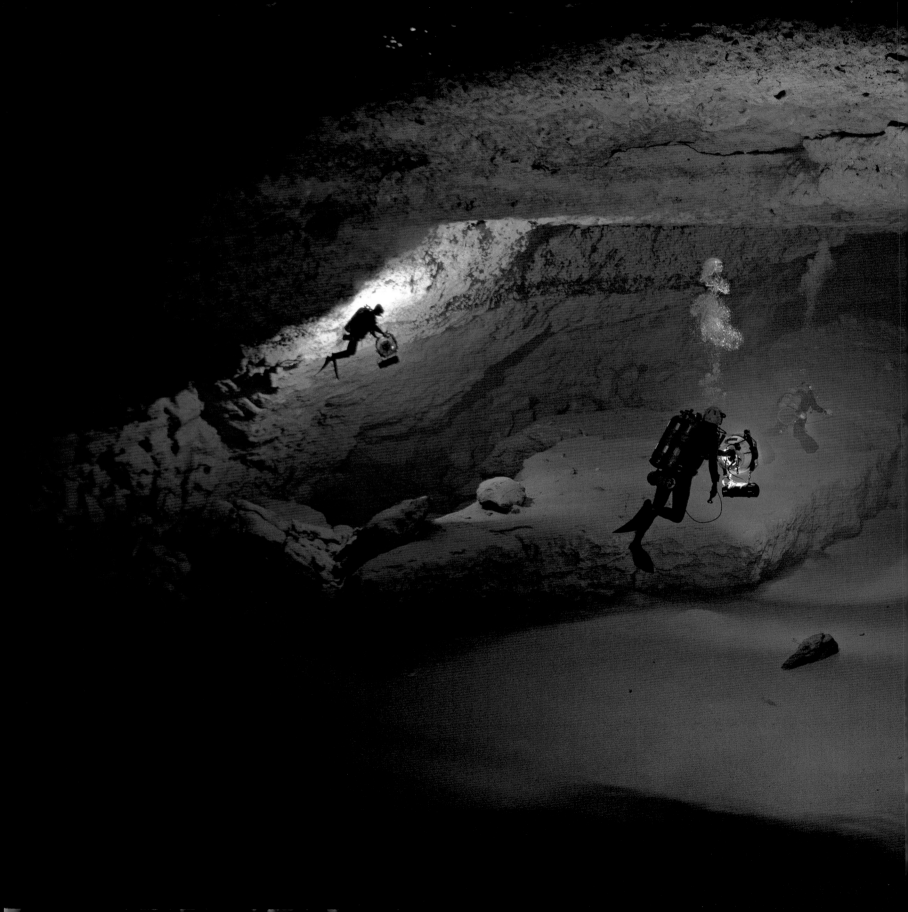

VICTOR TROYANOV
Pennine Alps, border of Switzerland
and Italy
Climbers crest Western Breithorn,
a 13,600-foot Alpine peak.

preceding pages
GEORGE STEINMETZ
Sahara desert, Niger
A pilot soars over a wind-carved
dunescape in a powered paraglider.

WES C. SKILES
Brooksville, Florida
Divers explore a flooded chamber of
Diepolder Cave, 250 feet belowground.

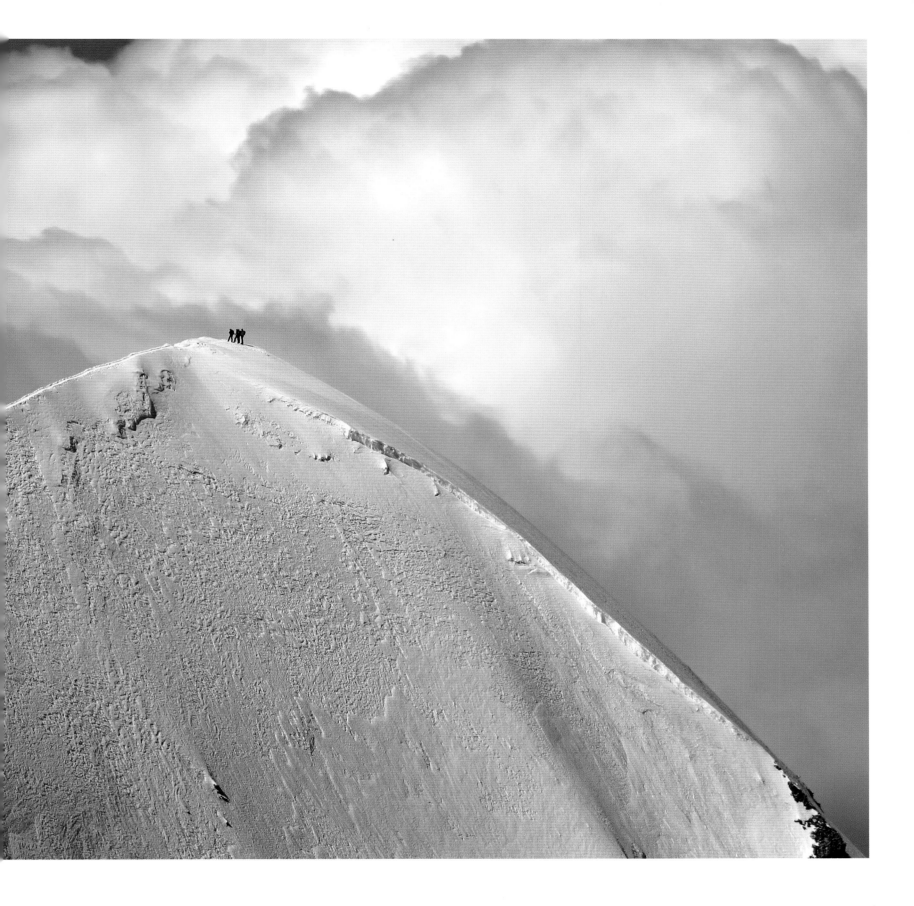

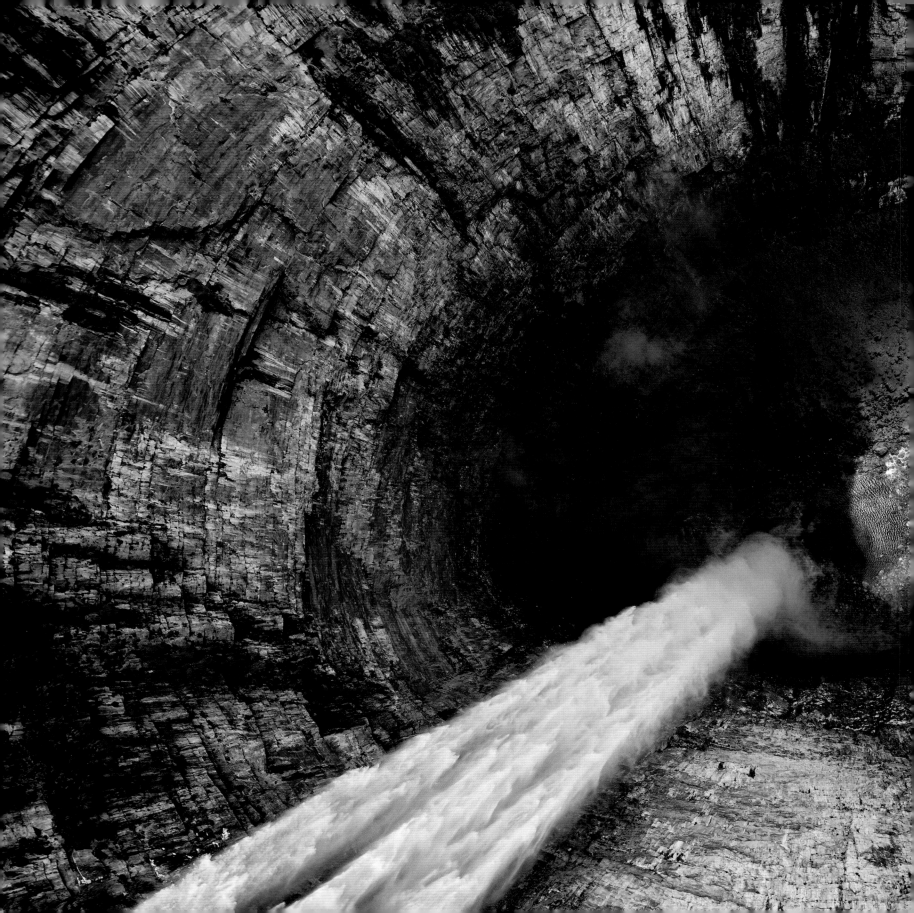

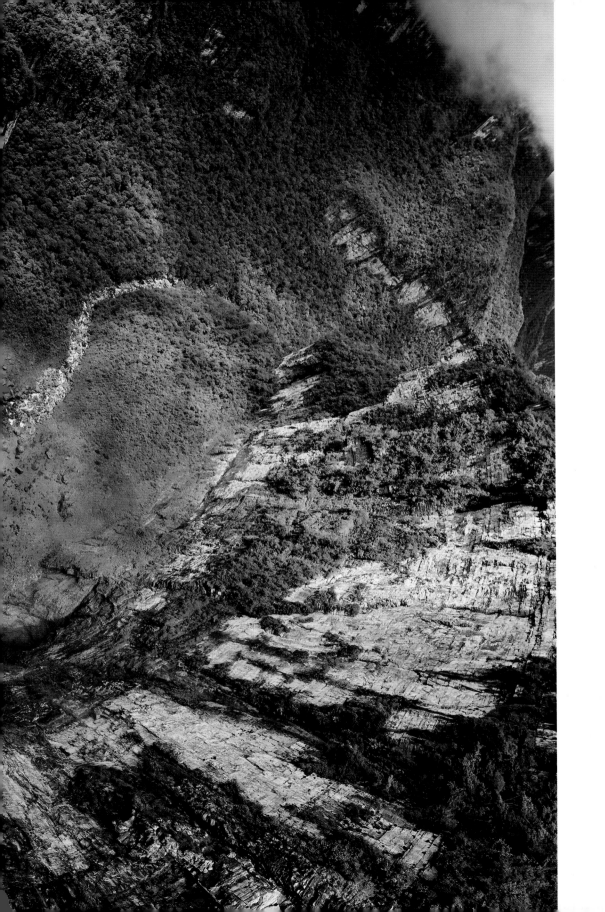

AIRPANO
Venezuela
Churún-Merú Falls (Angel Falls) drops
dramatically from a mountain plateau.

following pages
BRET WEBSTER
Grand Canyon National Park, Arizona
A blazing sunset penetrates storm
clouds over a dormant volcano.

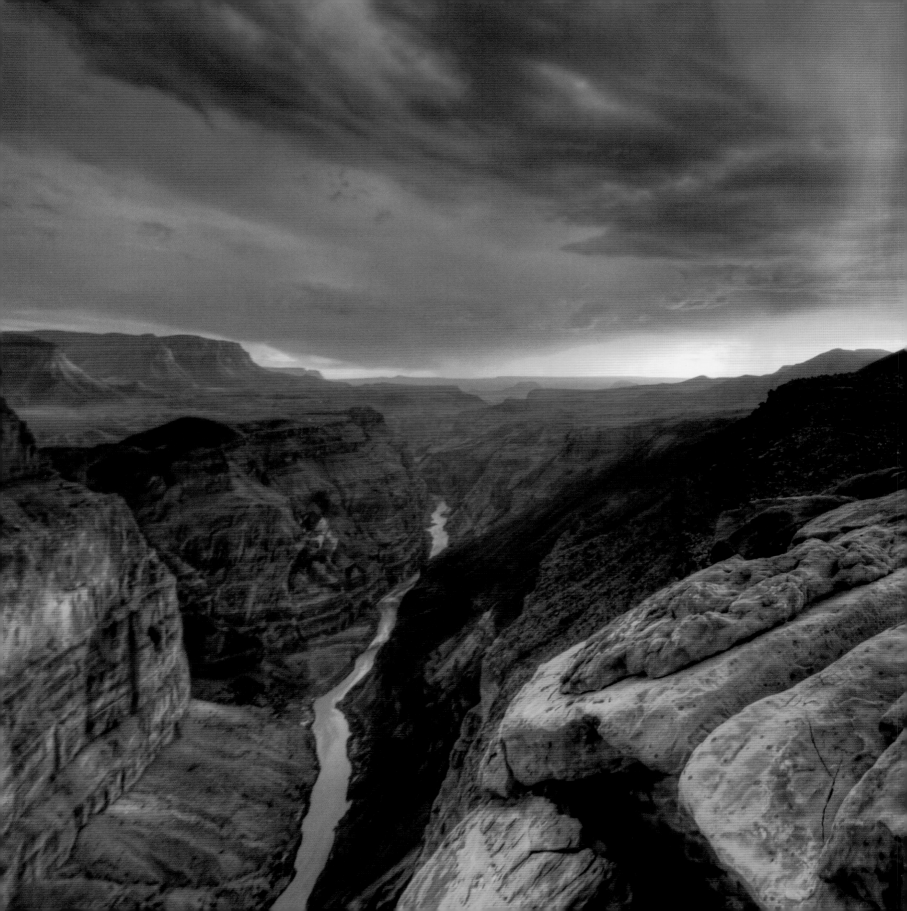

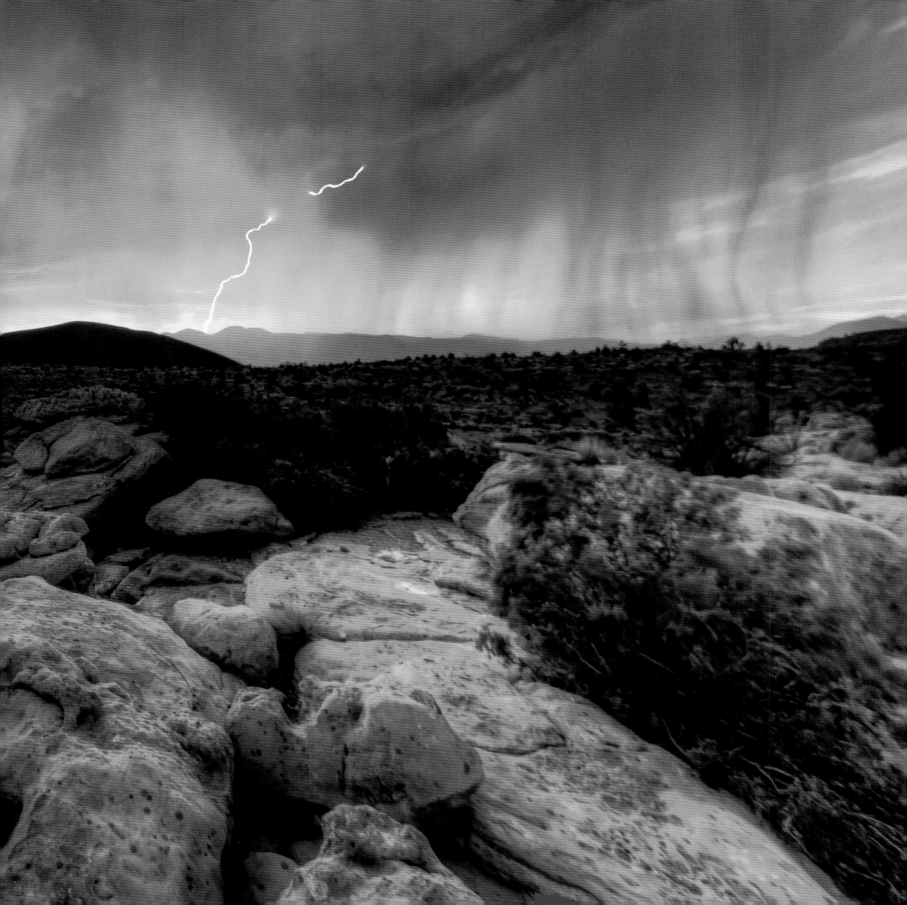

John Burcham

There's a famous triple spire near Sedona, Arizona, known as the Mace. Climbers ascend the tallest pinnacle, composed of 300 feet of sandstone. To descend, they must leap from the top of the tallest spire to the next shortest. It's quite a leap. Only then can they rappel down. On this evening it all came together— the light, the clouds, and the climber. I'm always looking for moments of discovery in nature, and when it happens, I say to myself: "This is it. Don't blow it!"

JOHN BURCHAM
Sedona, Arizona
A climber rappels down a steep
sandstone cliff.

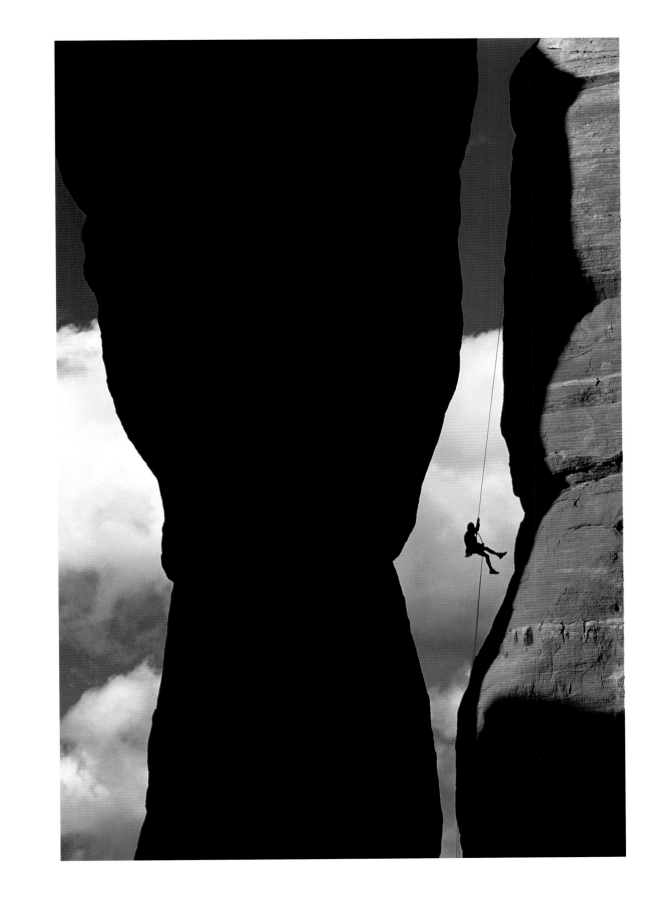

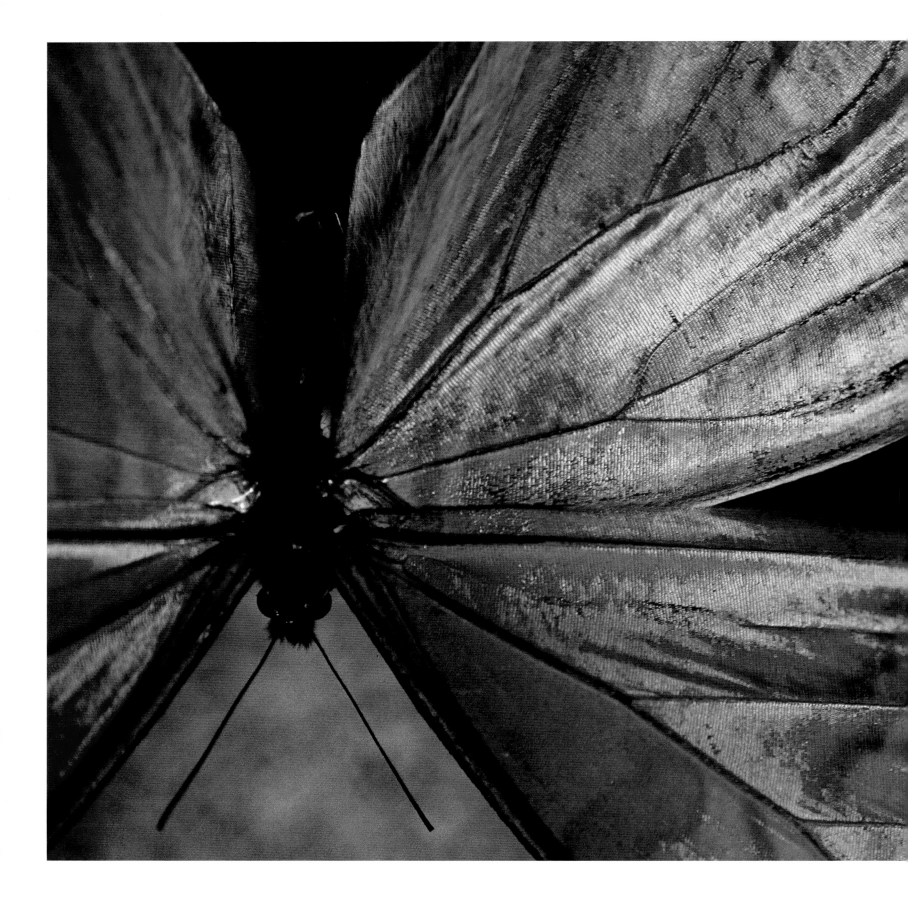

CARY WOLINSKY
Massachusetts
A morpho butterfly spreads its iridescent
blue wings.

following pages
MARC ADAMUS
Cape Kiwanda, Oregon
Water streams toward the sunlight at
the end of a sea tunnel.

WILD WONDERS OF EUROPE LTD
Oulu, Finland
A great gray owl scours a snowy
landscape for prey.

Nature is so powerful, so strong. Capturing its essence is not easy . . . It takes you to a place within yourself.

~ Annie Leibovitz

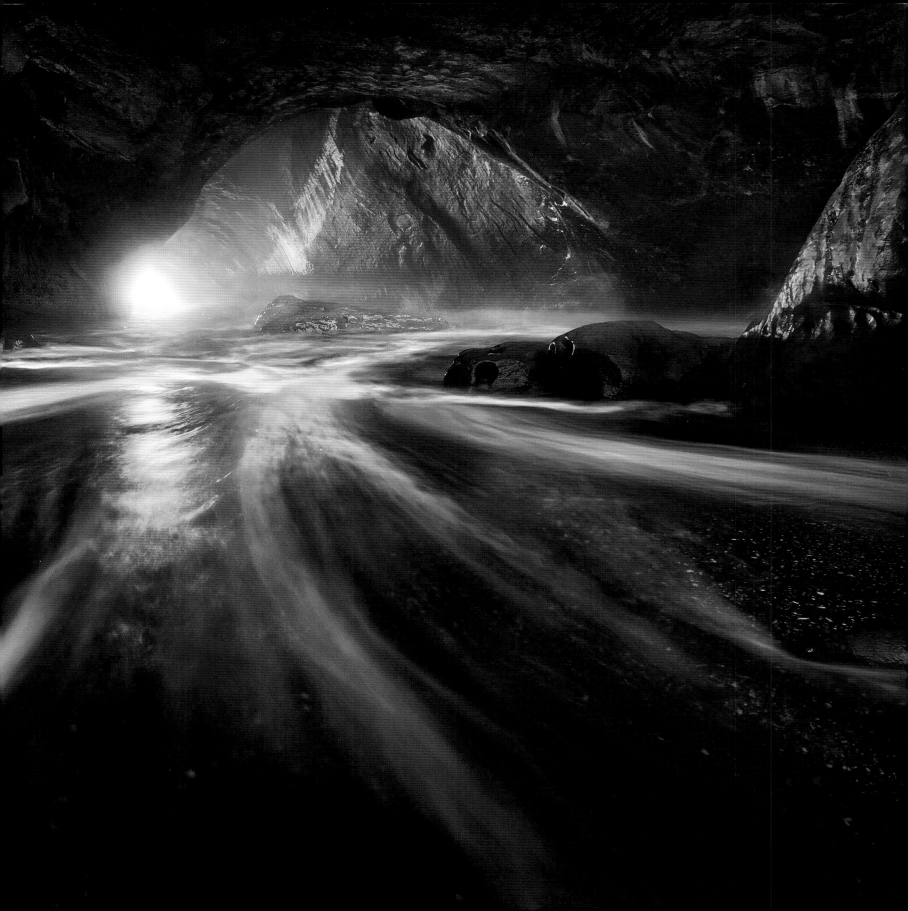

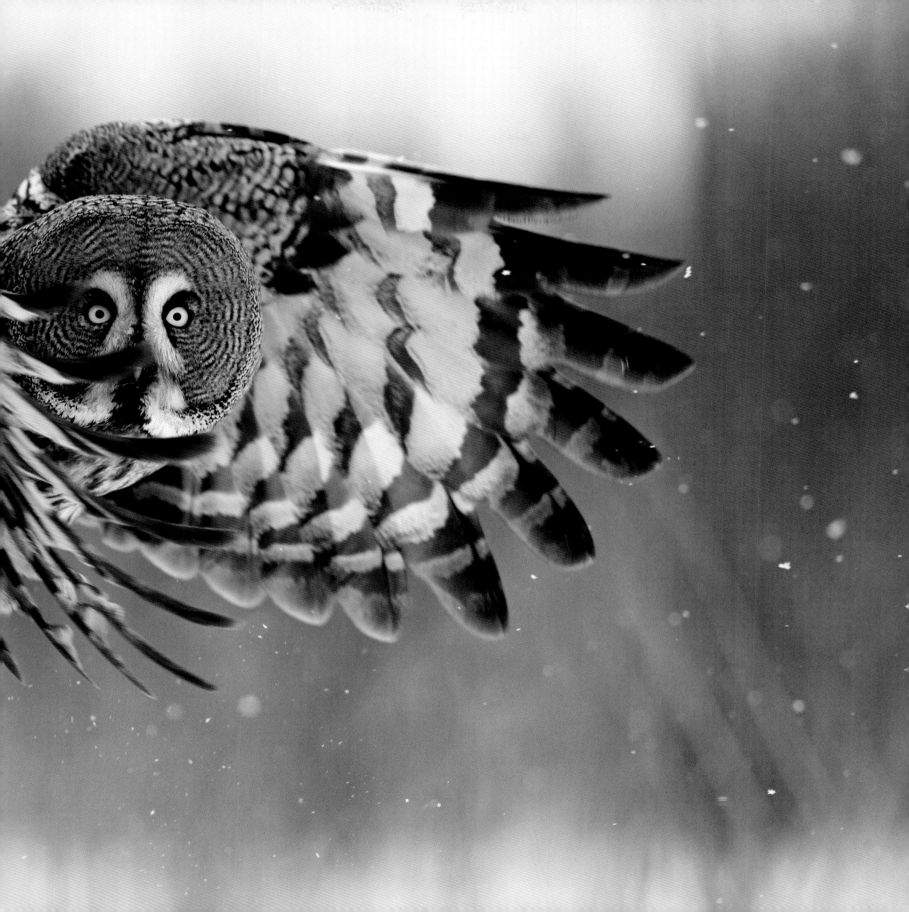

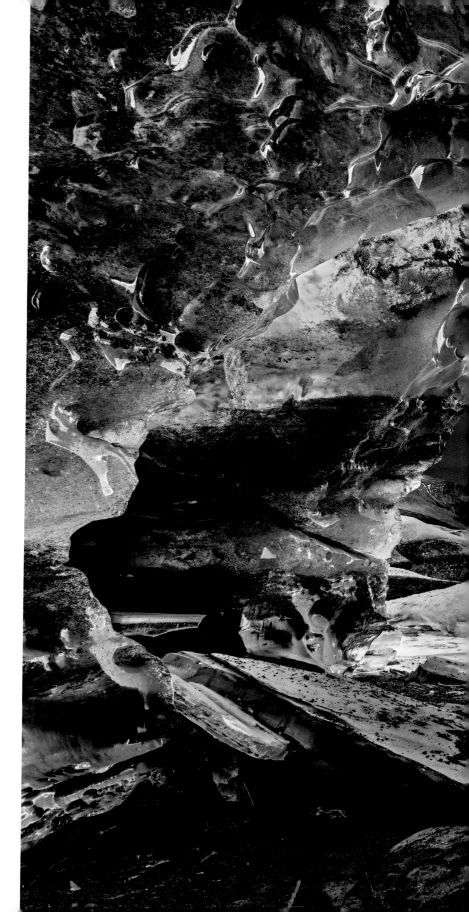

CHRISTIAN KLEPP
Svínafellsjökull glacier, Skaftafell,
Iceland
The mouth of an ice cave frames the
day's fading sun.

following pages
JOHN PEZZENTI, JR.
Kenai Peninsula Borough, Alaska
A cloud of volcanic gases billows
skyward.

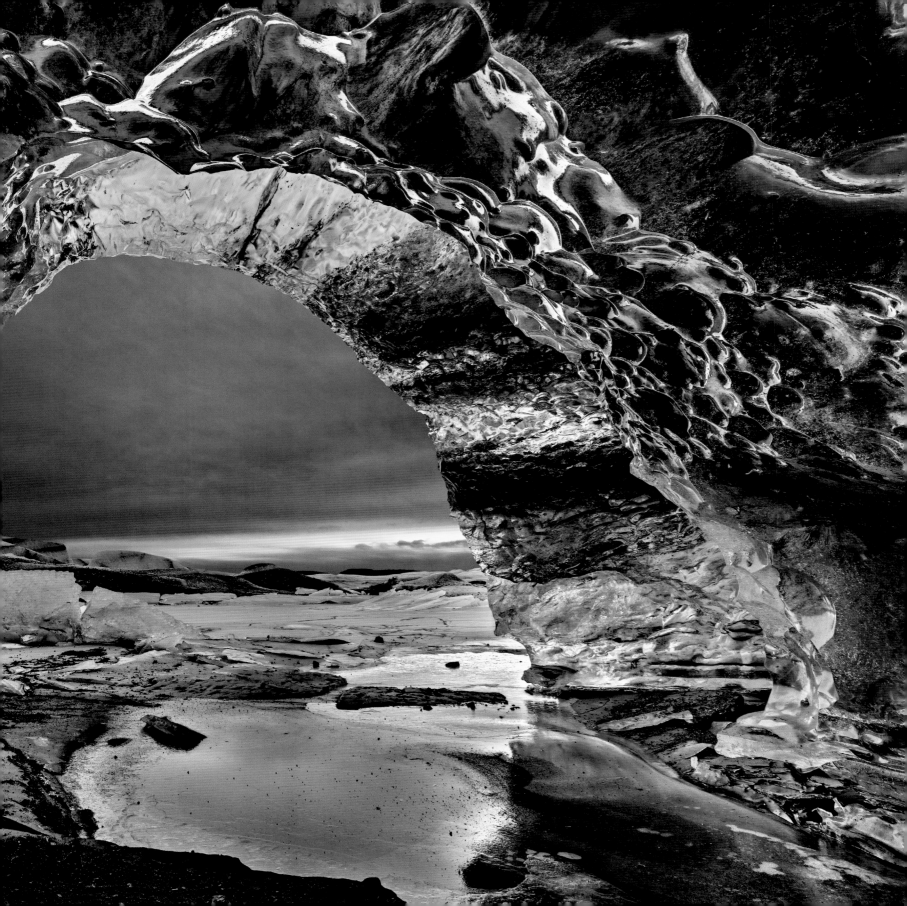

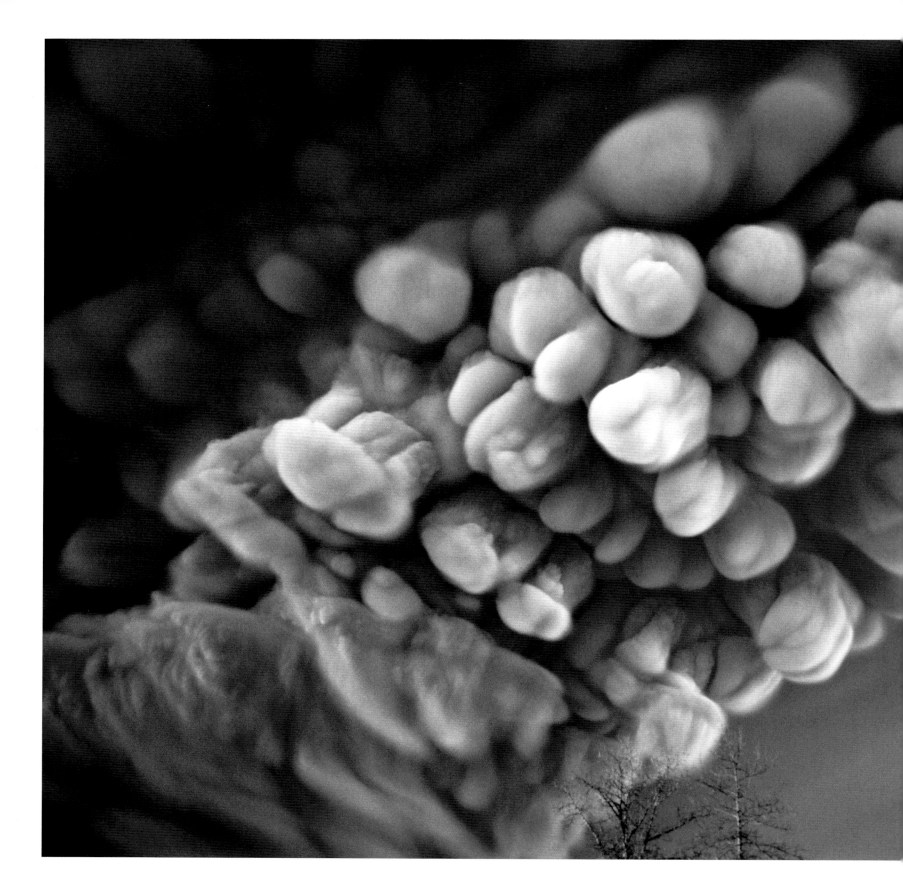

The process of scientific discovery is, in effect, a con-tinual flight from wonder.

~ Albert Einstein

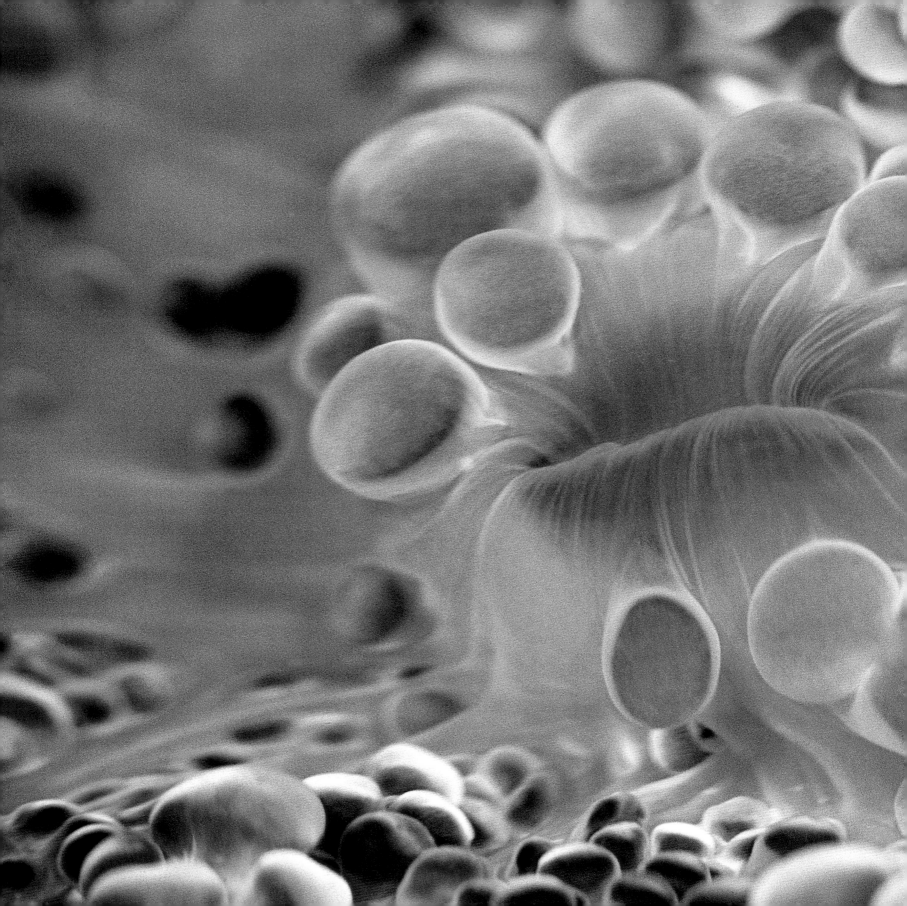

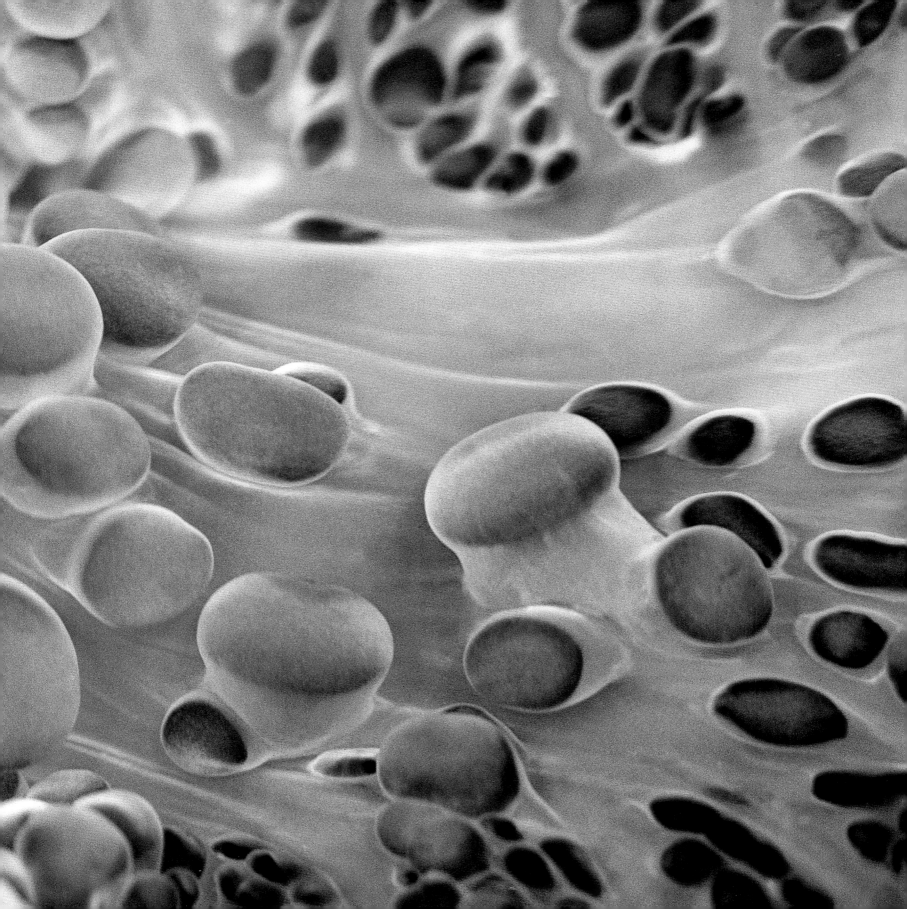

TONY HEFF
Haleiwa, Hawaii
Surfer Coco Ho swims to the surface
after diving beneath a crashing wave.

preceding pages
CHRIS NEWBERT
Solomon Islands
Short tentacles with bubble-like tips
distinguish mushroom corals.

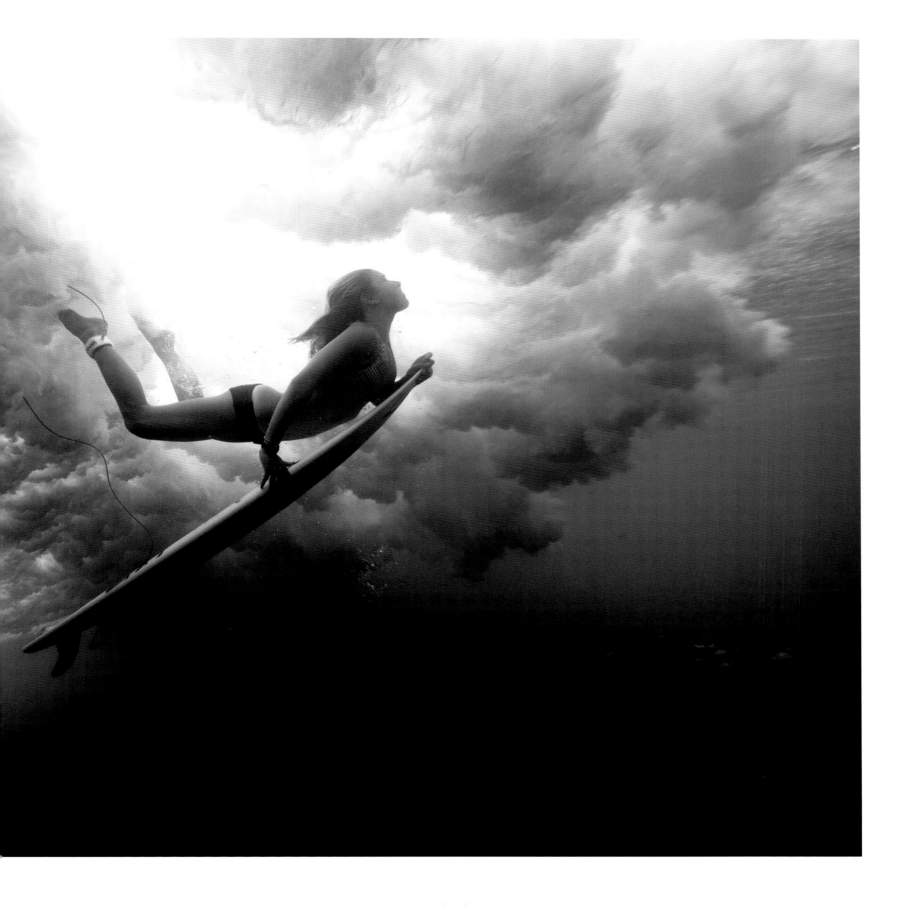

Paul Souders

Searching for polar bears on the sea ice is insanely difficult. For this shot, I kept a healthy distance, allowing the bear to relax a bit. Then I slowly worked my way closer, photographing her as she climbed up onto the ice, and staying with her when she slipped back into the water. Gradually her curiosity began to kick in, and I was able to bring the boat a bit closer. By sunset, she was swimming beside me and I was able to lower my underwater camera right beside her.

PAUL SOUDERS
Manitoba, Canada
A submerged polar bear peers from the edge of a melting ice floe.

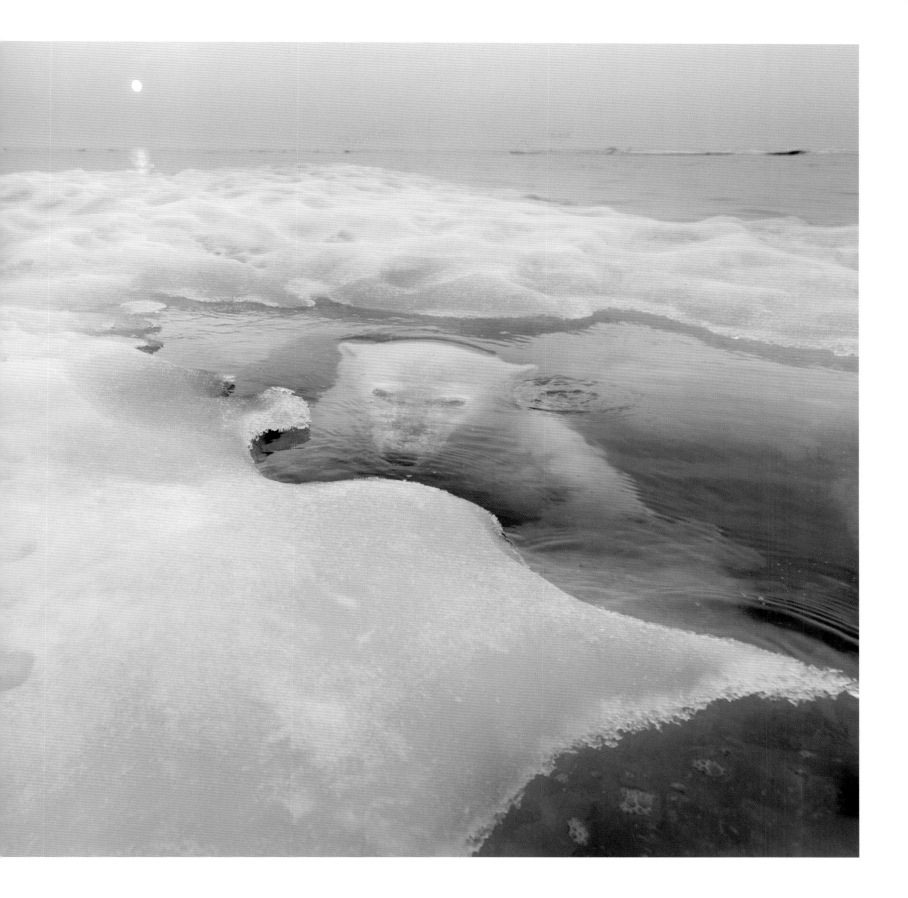

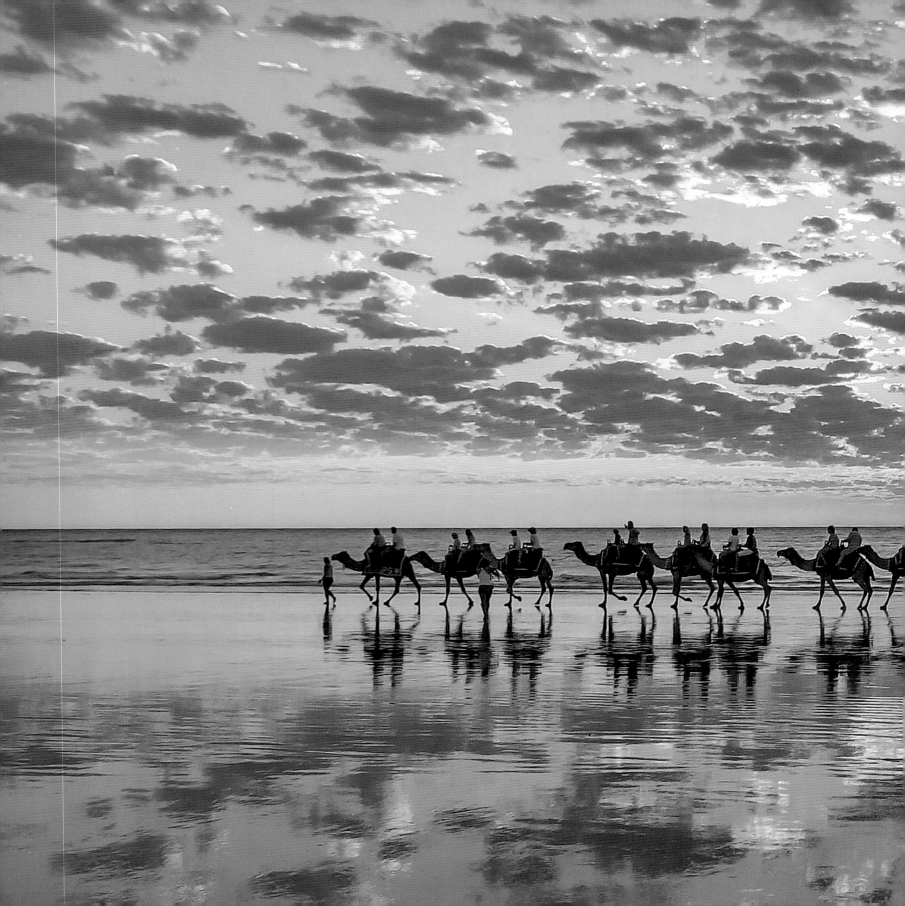

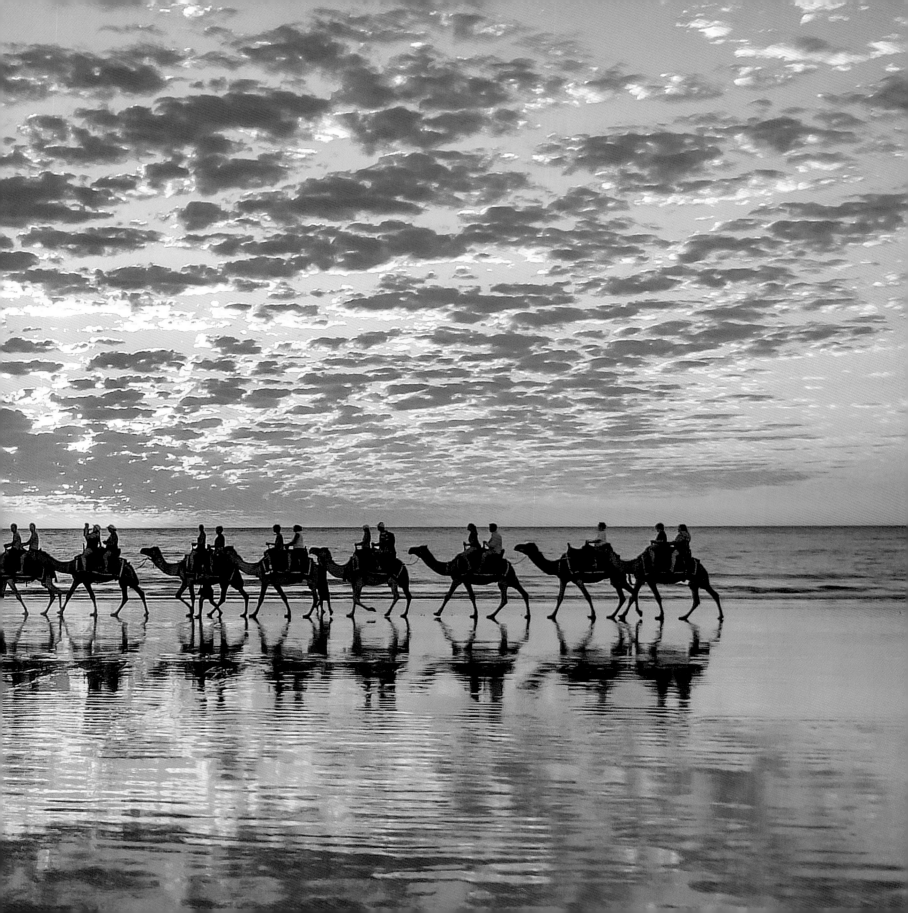

MARTIN OEGGERLI
Switzerland
Under an electron microscope,
streptococcus bacteria resemble
a string of beads.

preceding pages
SHAHAR KEREN
Broome, Australia
A caravan of camels and riders treks
along a beach at sunset.

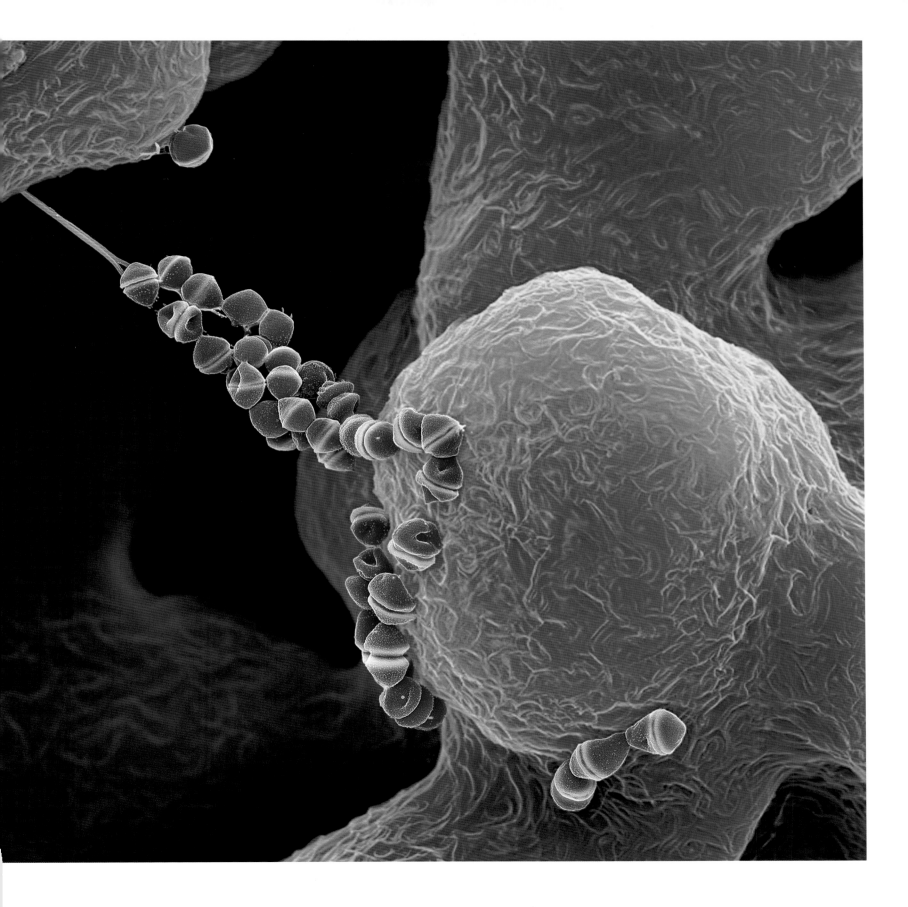

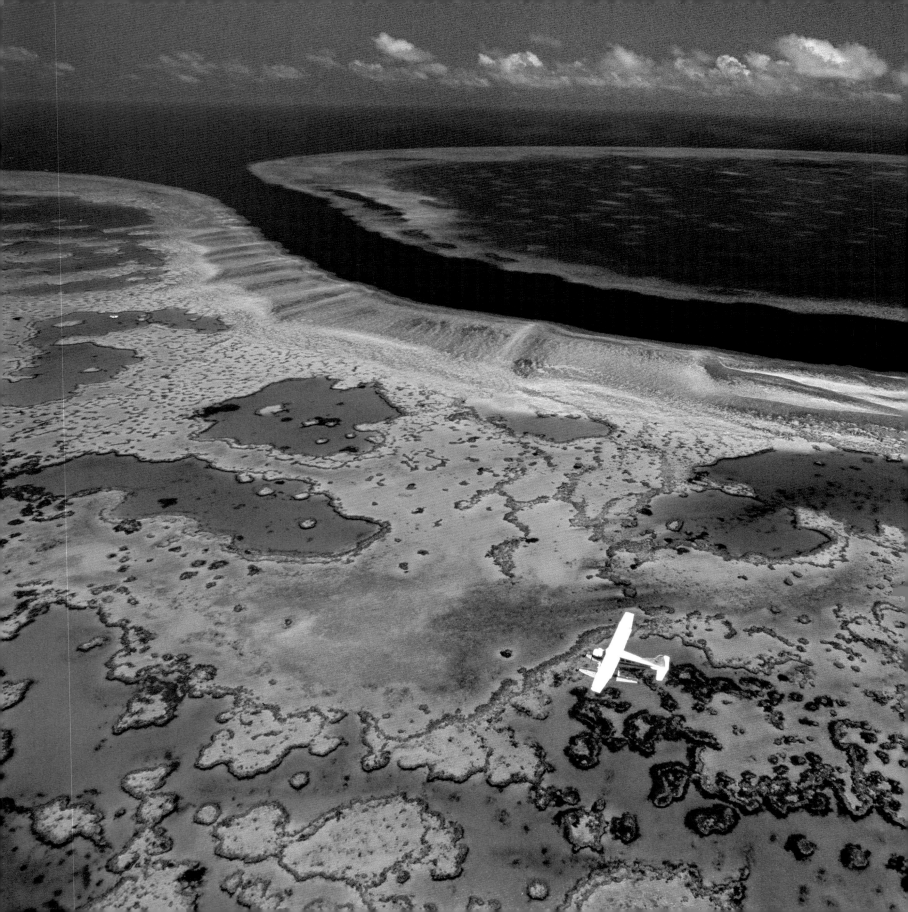

David Doubilet

The only way to really understand a coral reef is to see it from the air. A coral reef is a living carpet of coral polyps, creatures half the size of an infant's pinkie nail.

This photo was taken over the Great Barrier Reef, whose future is cloudy at best. Rising sea temperatures are causing coral bleaching, increasing the sea's acidity to the point that coral polyps can no longer build their homes. That's why I make these pictures. So people understand. You can't save something that you don't understand.

DAVID DOUBILET
Great Barrier Reef, Australia
A plane glides above islands that make up part of the world's largest reef system.

ANNIE GRIFFITHS
North Yorkshire, England
Visitors to a limestone cave observe
a cascading waterfall.

following pages
JOHN EASTCOTT AND
YVA MOMATIUK
Patagonia, Chile
Craggy granite peaks of the Andes
Mountains pierce the clouds.

ALEXEY TROFIMOV
Lake Baikal, Russia
Jewel-colored chunks of ice, created by
fractures, glint on the frozen lake.

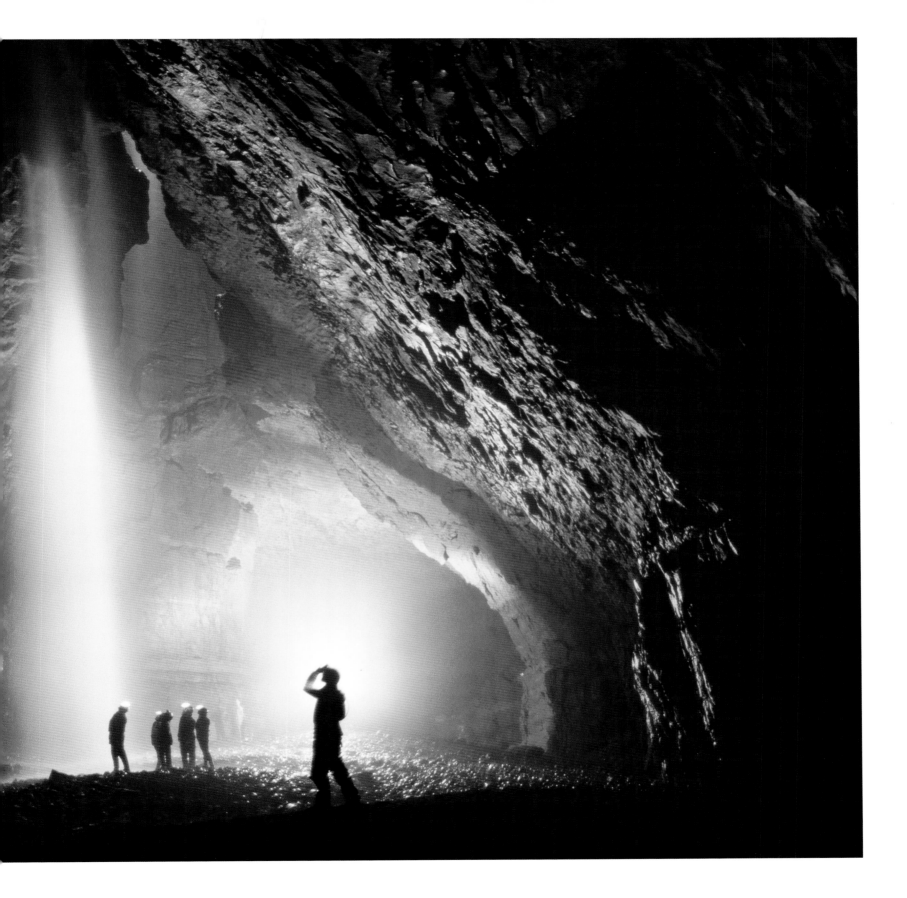

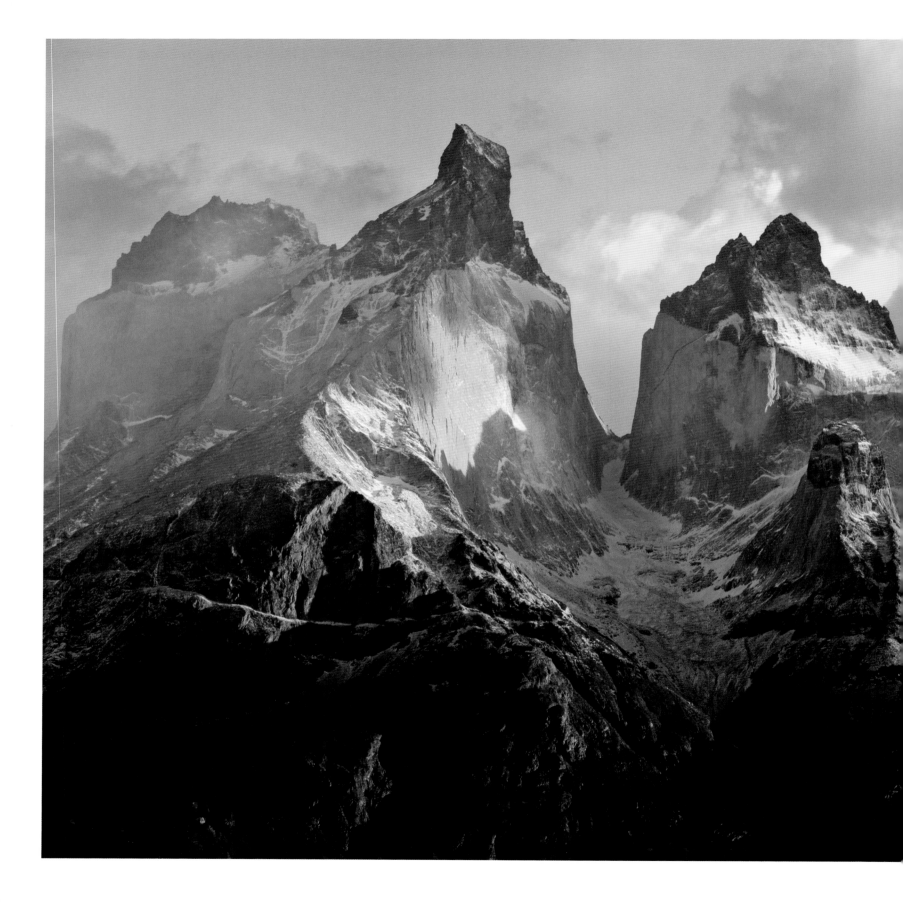

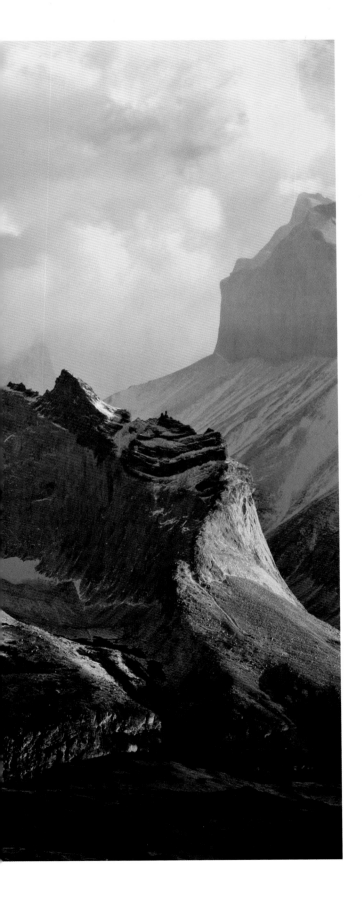

In wisdom gathered over time I have found that every experi-ence is a form of exploration.

~ Ansel Adams

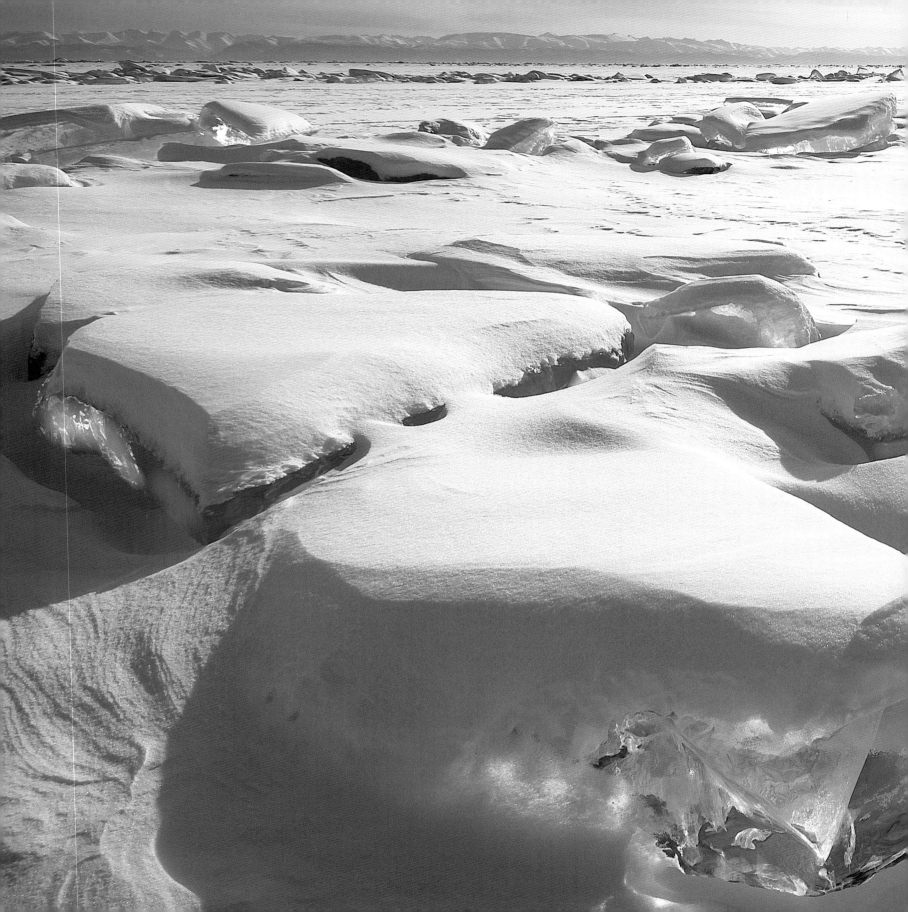

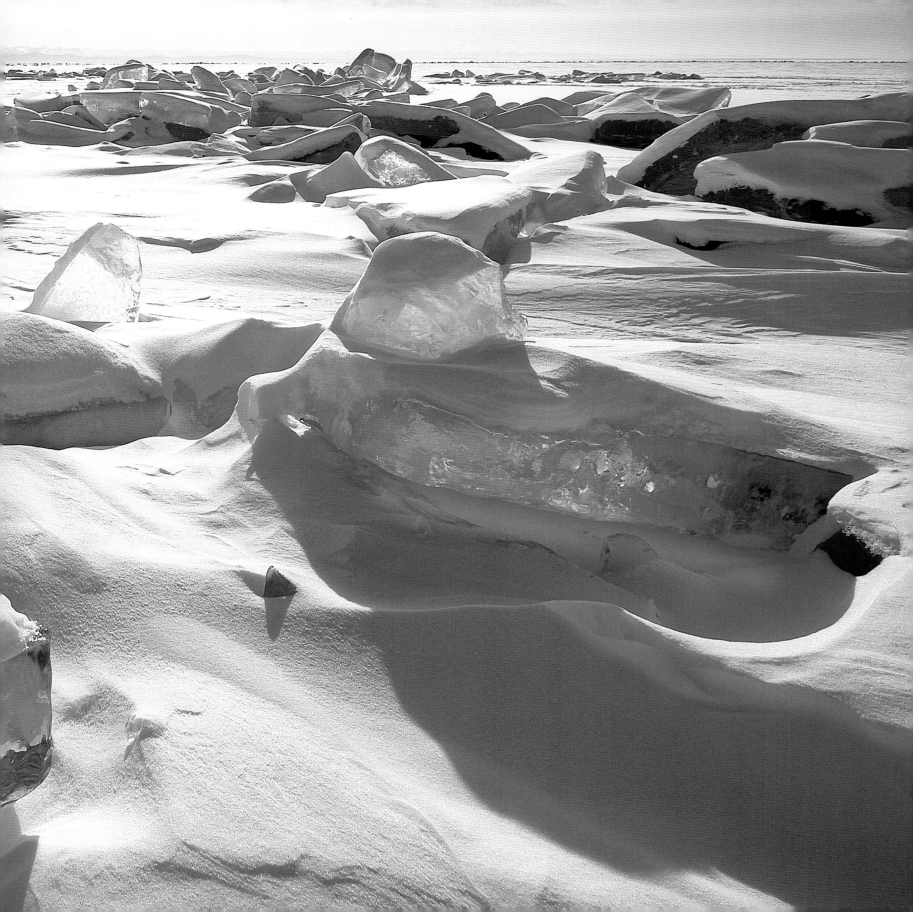

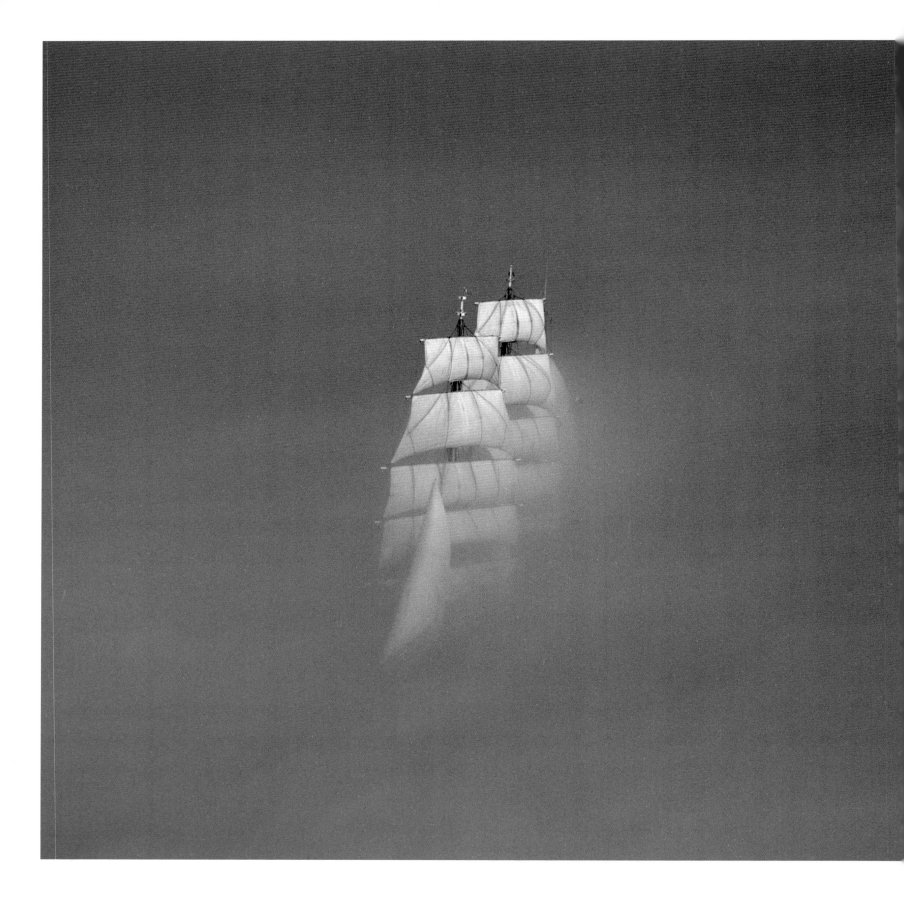

JAMES P. BLAIR
Cape Cod, Massachusetts
Fog envelops the U.S. Coast Guard
training ship *Eagle.*

following page
CHRISTIAN ZIEGLER
Barro Colorado Island, Panama
An infrared camera image renders
a fruit-eating bat ghostly white.

The greatest obstacle
to discovery is not
ignorance—it is the
illusion of knowledge.

~ Daniel J. Boorstin

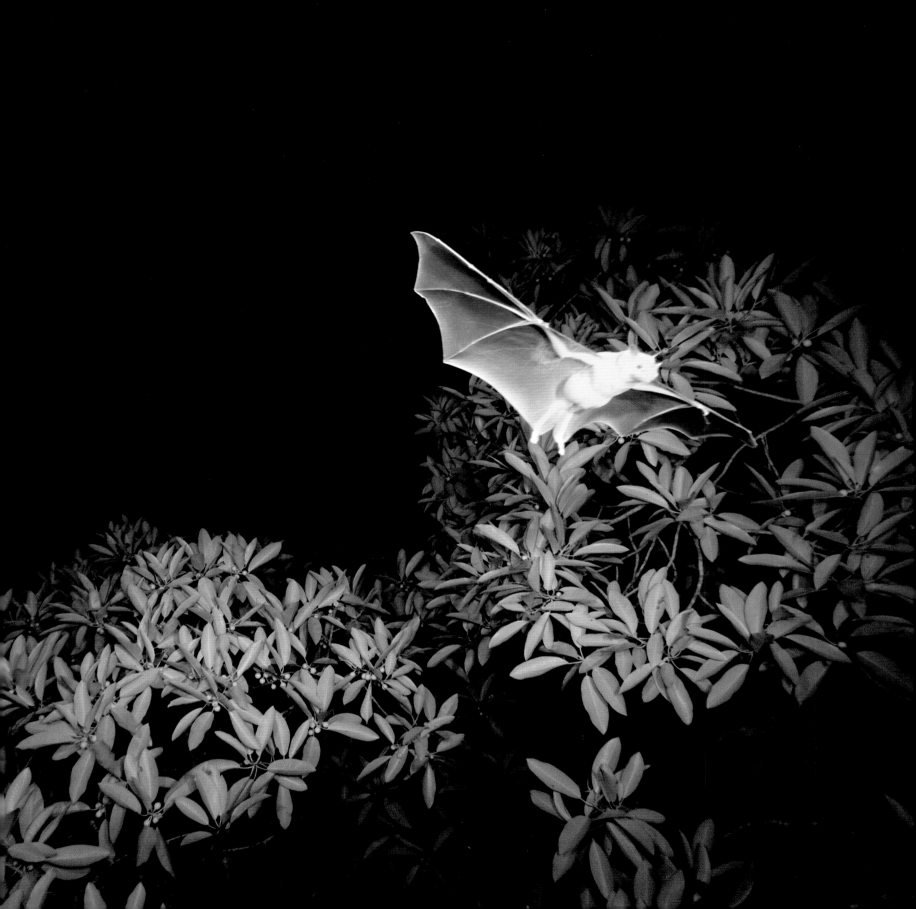

FRED K. SMITH
Lake Okeechobee, Florida
Lightning illuminates a parallel water-
spout to produce a night-sky spectacle.

following pages
CARSTEN PETER
Ambrym, Vanuatu
A scientist on a distant ridge monitors
a fiery volcanic eruption.

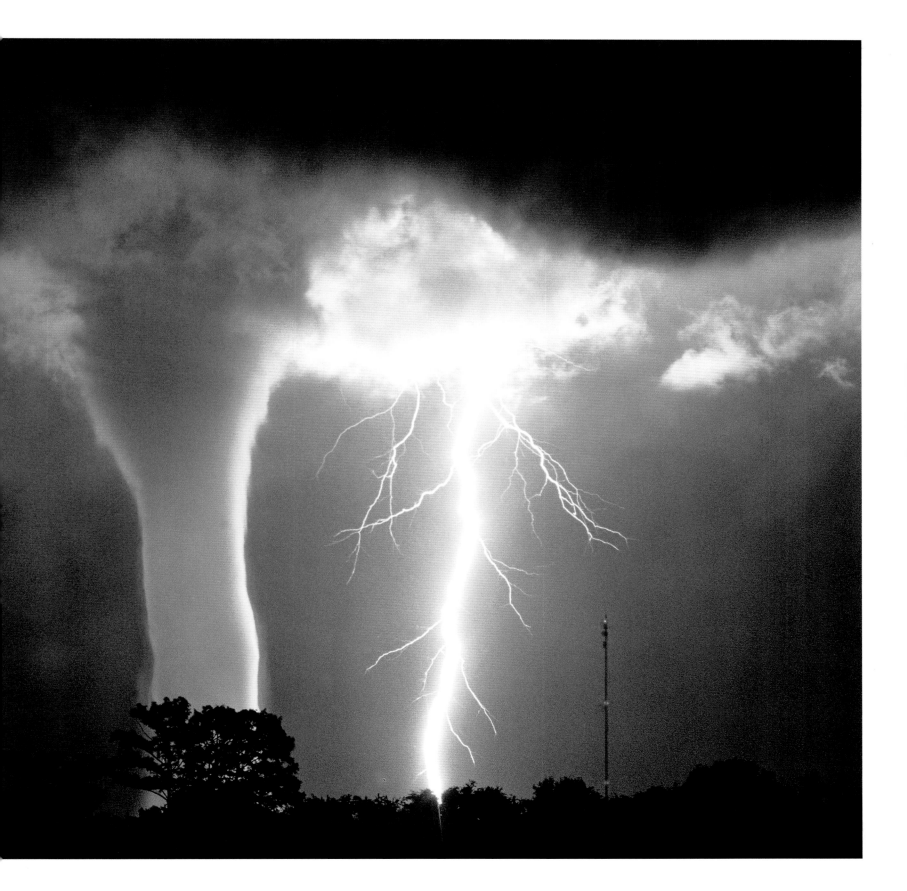

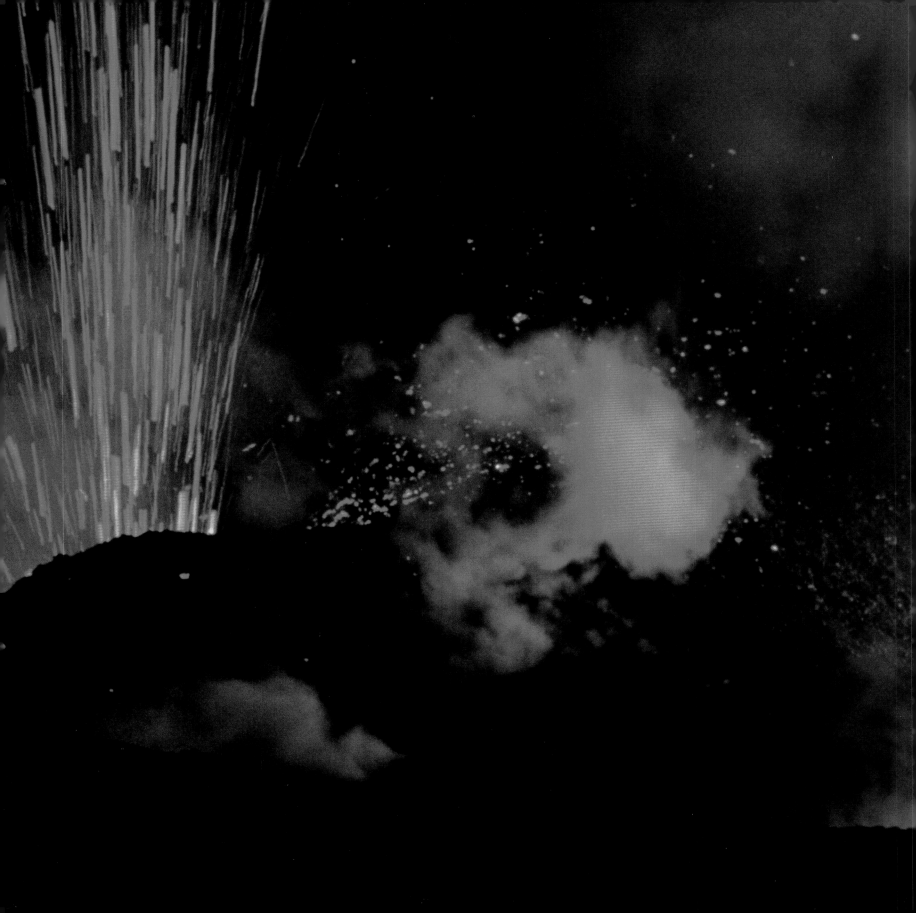

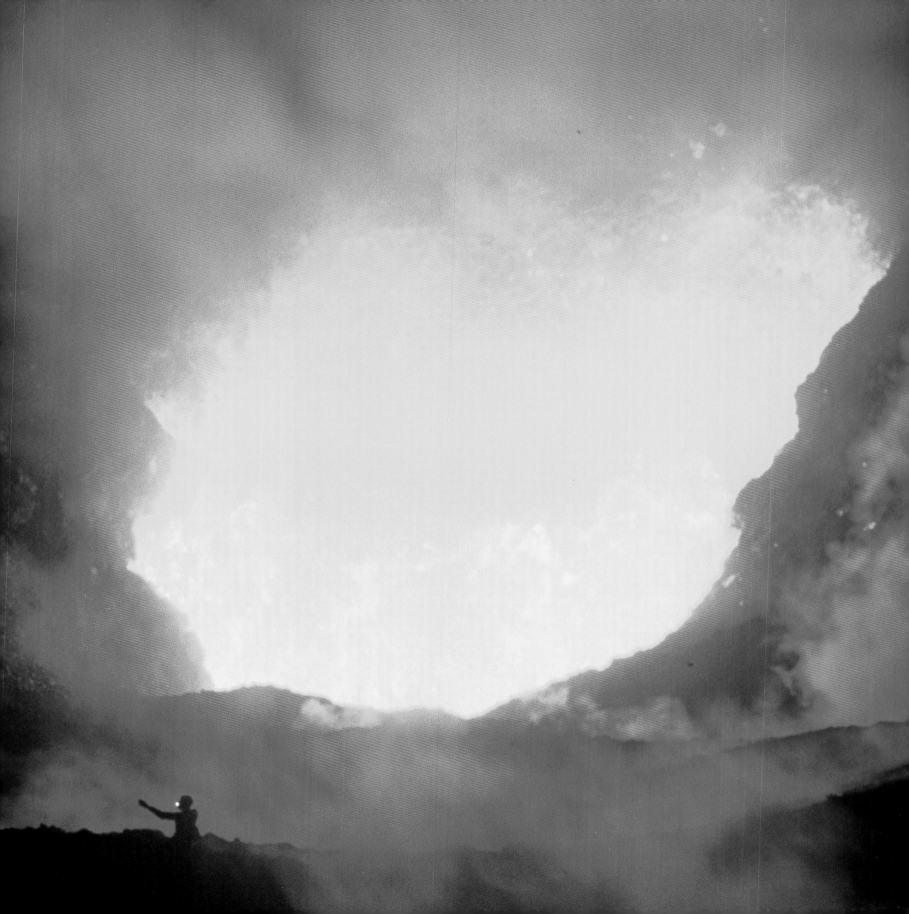

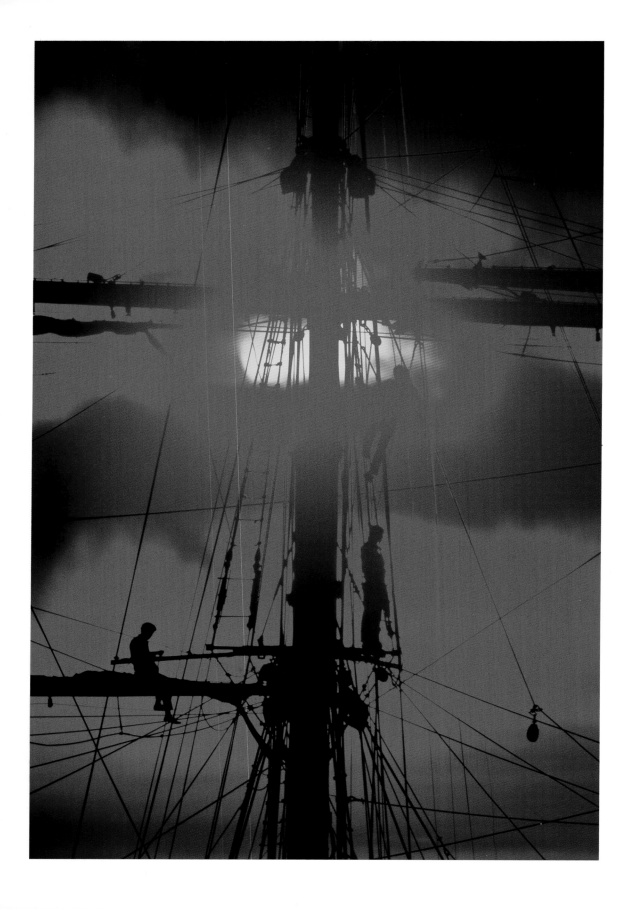

Bruce Dale

This shot was done for a *National Geographic* magazine story on Ferdinand Magellan. I wanted to evoke feelings that the crew may have had on this incredible journey. In a contemporary journal, I read about a celestial phenomenon called St. Elmo's fire that had occurred after an electrical storm and terrified the crew. The light after the storm appeared like fire at the top of the mast. To illustrate this story, I arranged to shoot at sunrise through the mast of a ship in Buenos Aires.

BRUCE DALE
Buenos Aires, Argentina
Silhouetted against a vermilion sky, naval cadets rig the training ship *Libertad.*

265

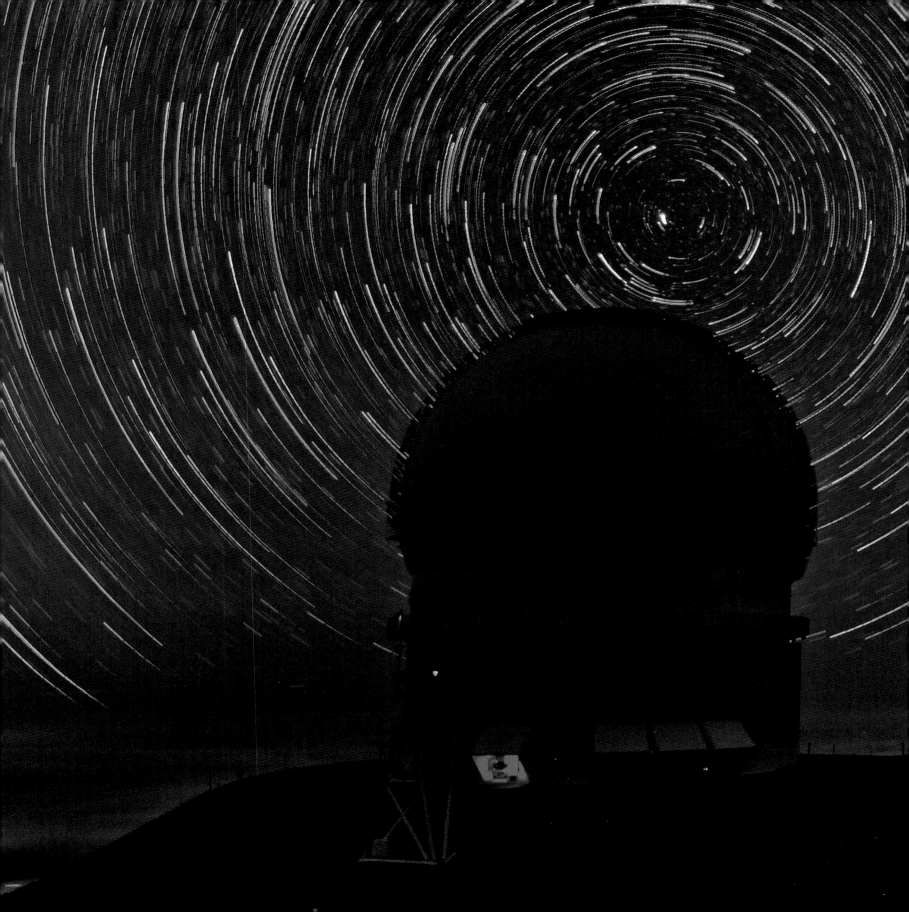

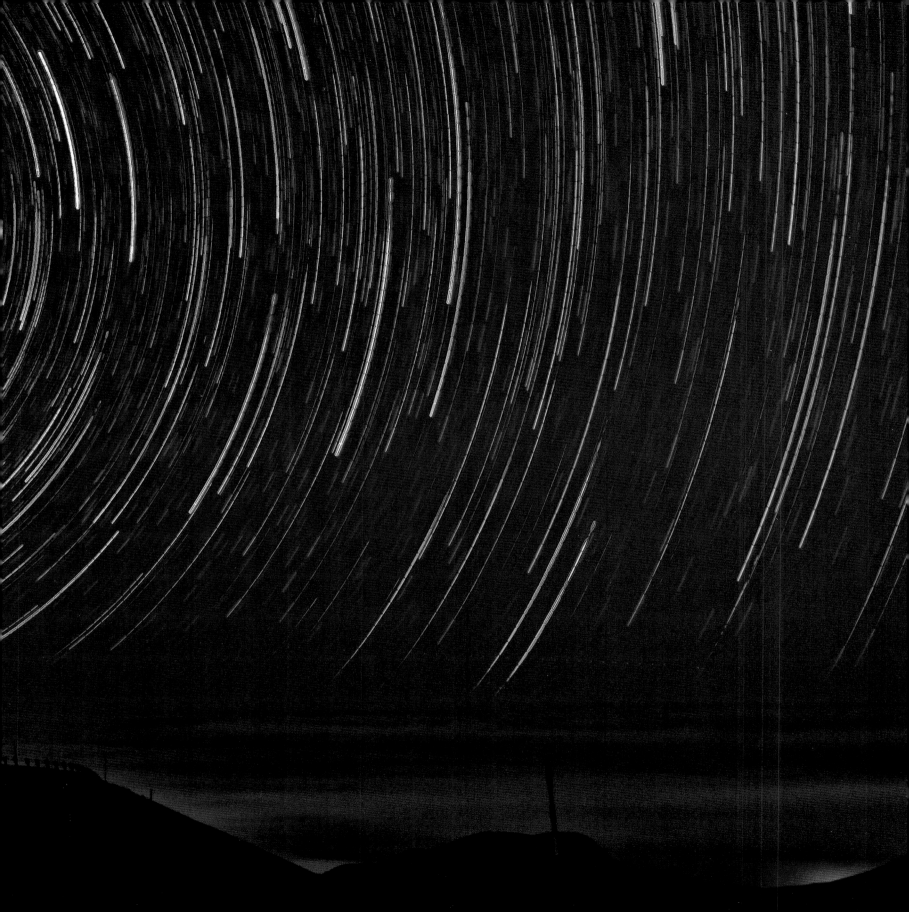

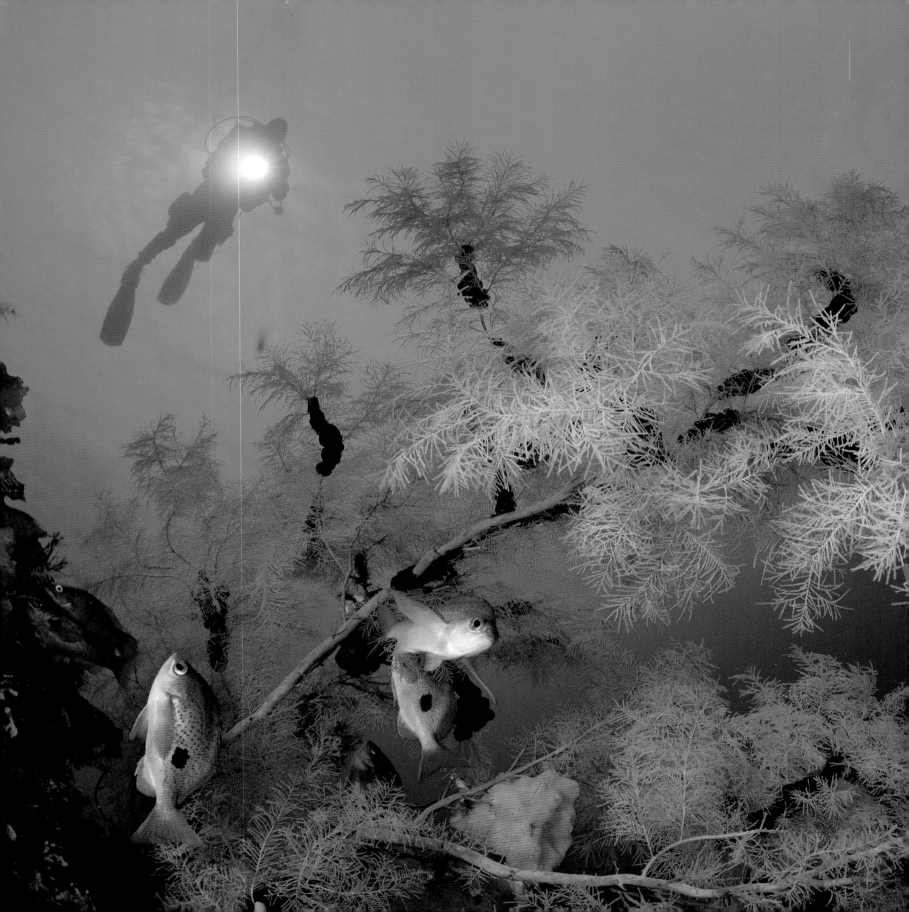

BRIAN SKERRY
Fiordland National Park, New Zealand
A diver shines his light on treelike black
corals, startling curious fish.

preceding pages
ANDREAS KOEBERL
Mauna Kea, Hawaii
Stars accentuated by time exposure
paint the night sky over Mauna
Kea's summit.

following pages
VICTOR AMOR SANZ
Brothers Islands, Red Sea
A crown jellyfish pulsates through
dark waters.

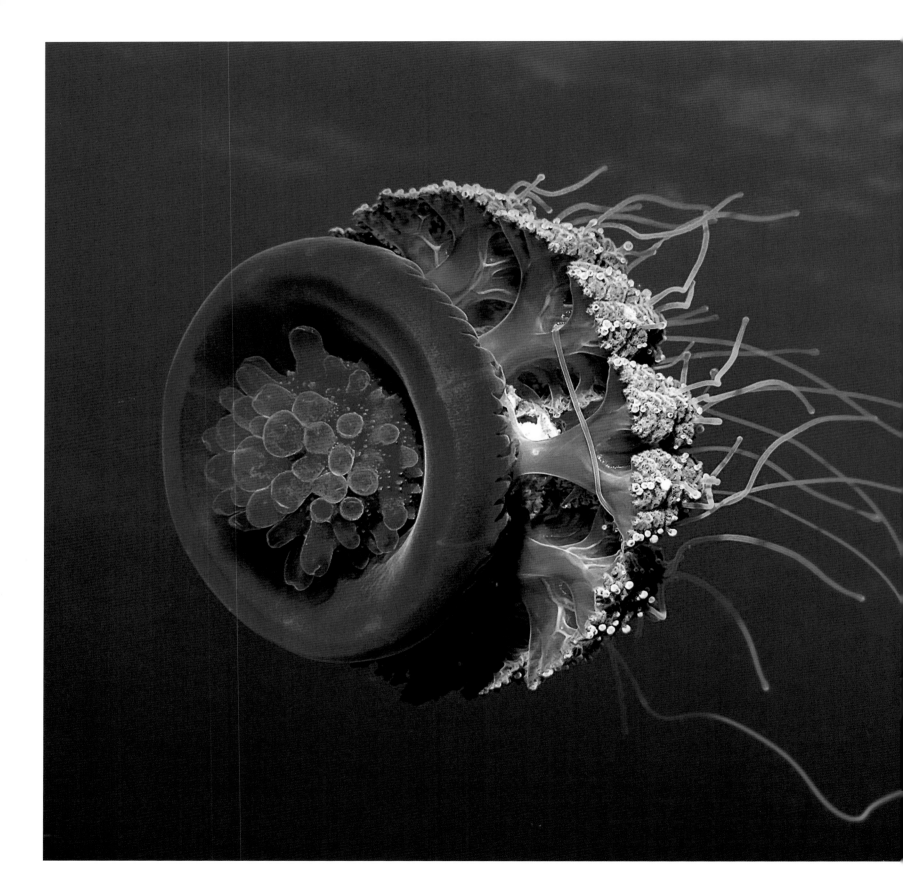

The real voyage
of discovery consists
not in seeking new
landscapes, but in
having new eyes.

~ Marcel Proust

MANISH MAMTANI
Joshua Tree National Park, California
A glowing Milky Way arcs above a
Joshua tree.

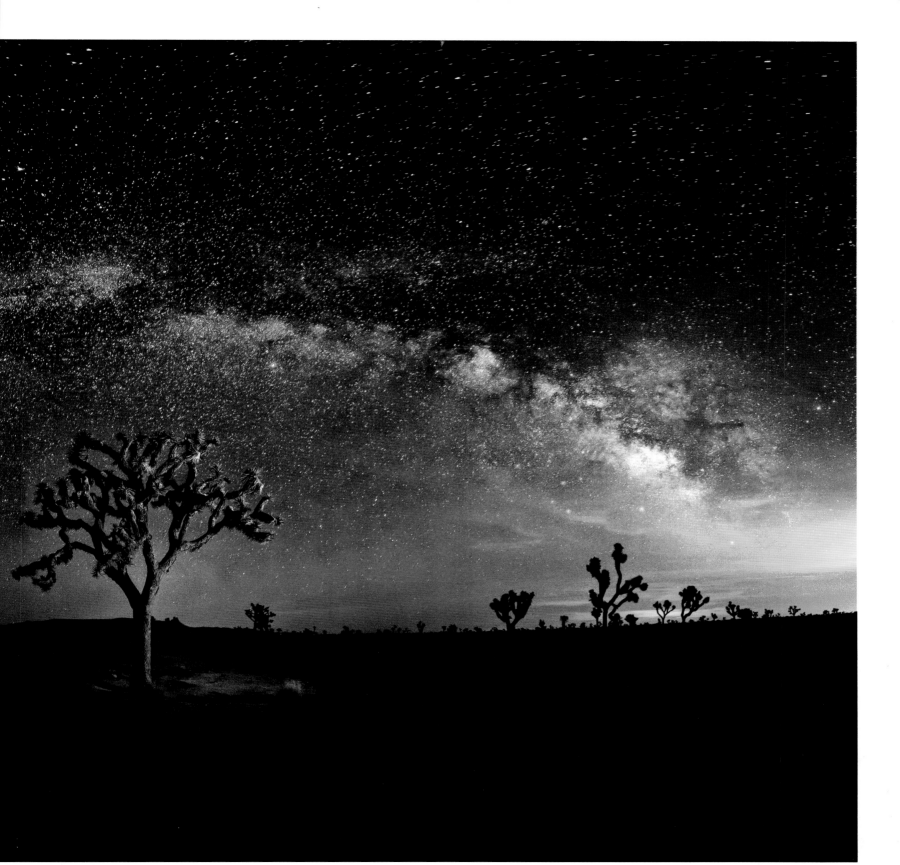

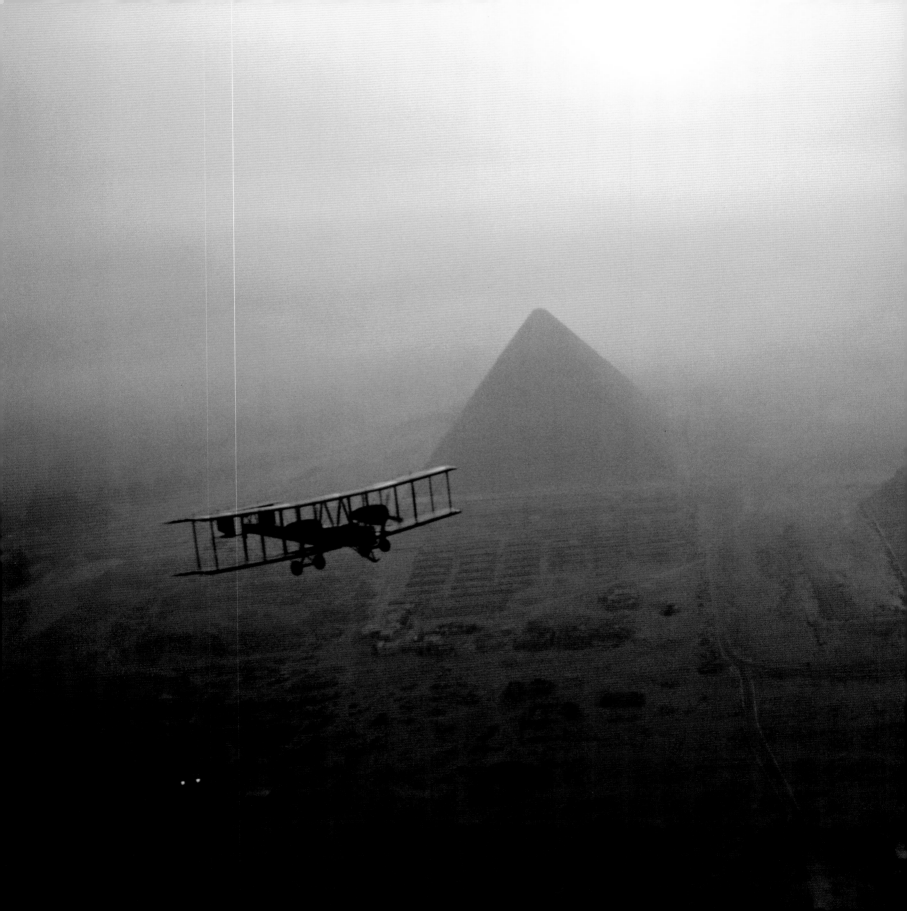

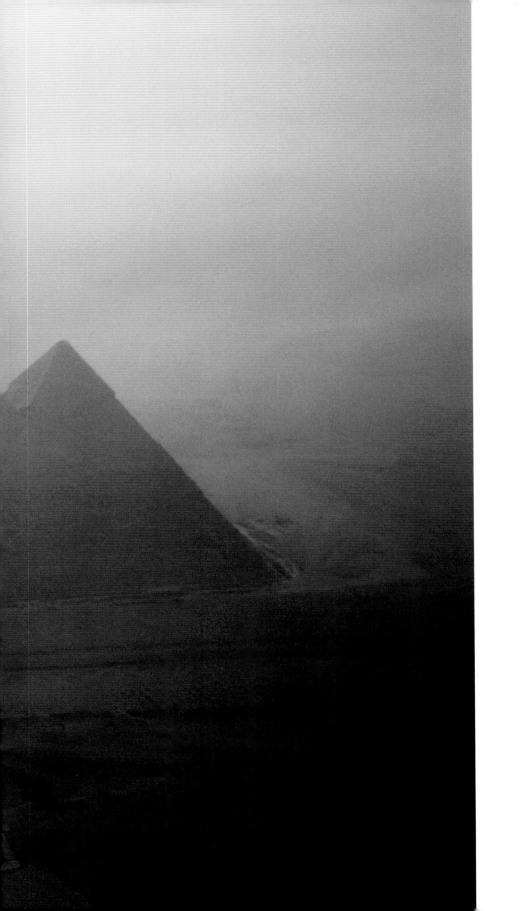

JAMES L. STANFIELD
Giza, Egypt
A model of the Vickers Vimy biplane
circles fog-cloaked pyramids at dawn.

following pages
KEN KAMINESKY
Iceland
Grundarfjordur Falls spills onto
a rocky landscape.

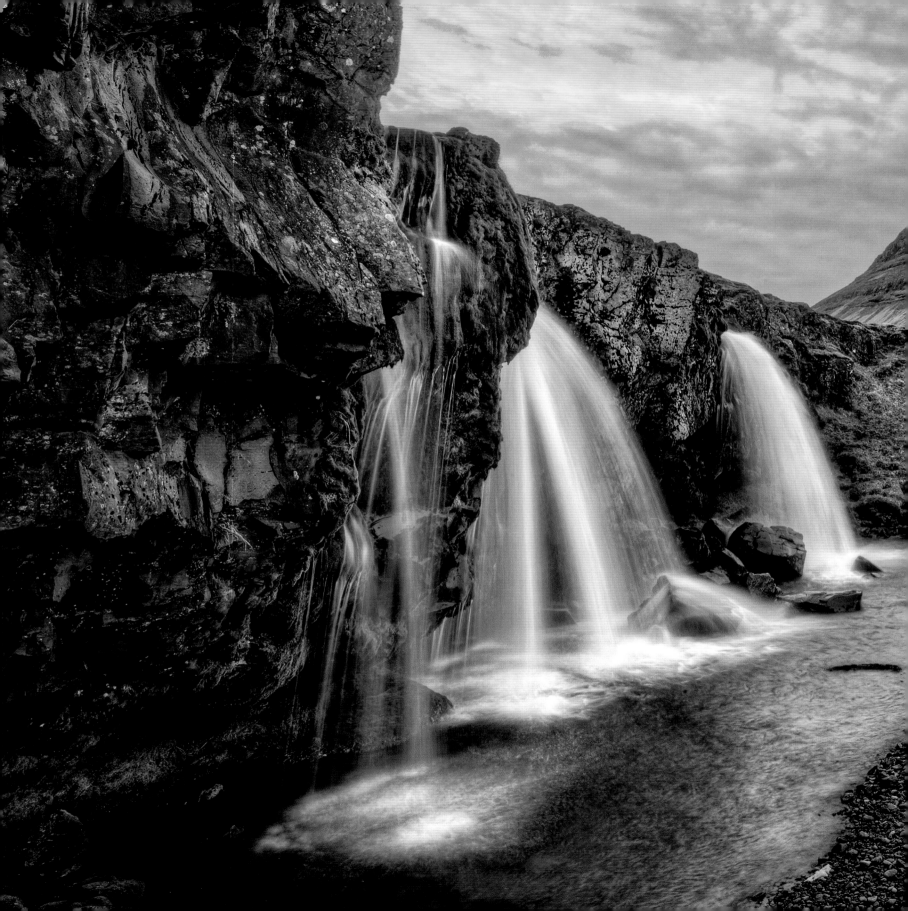

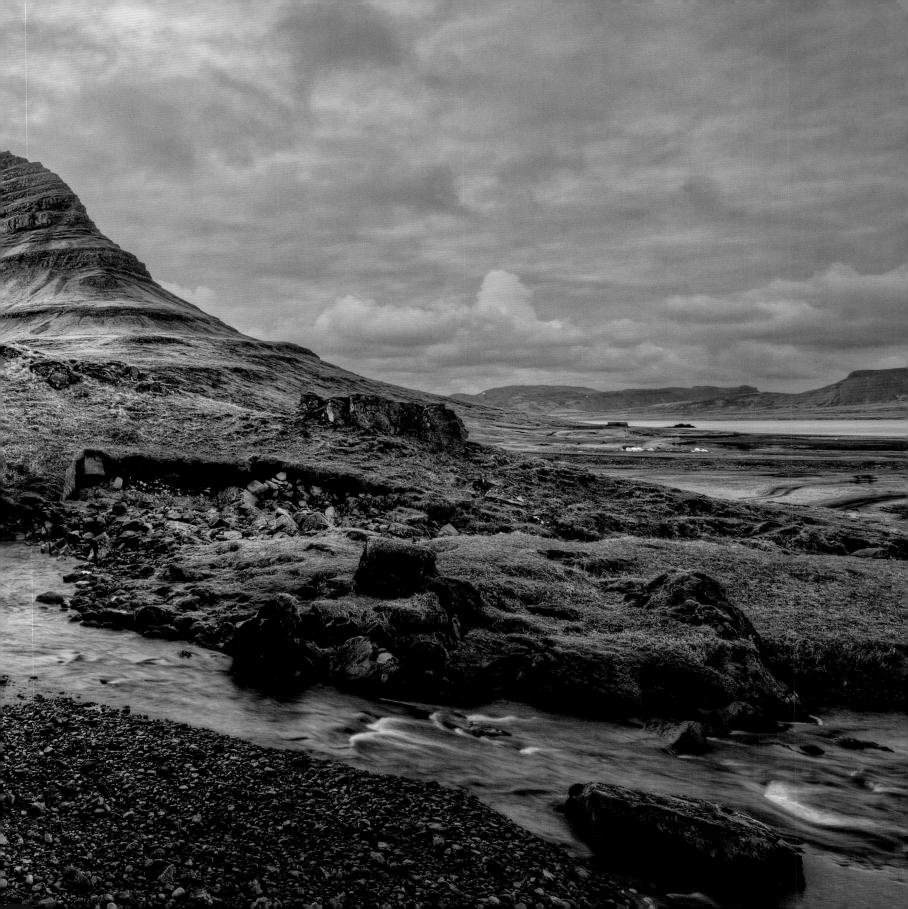

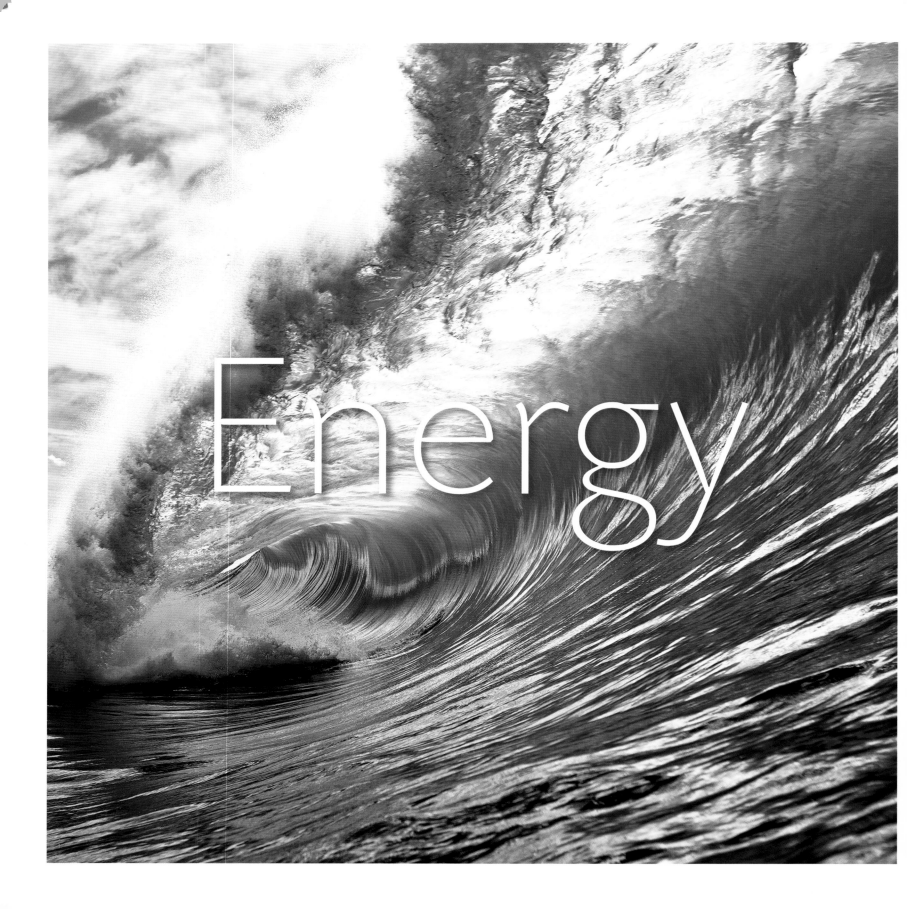

The ground we walk on,
the clouds above . . . each
gift of nature possessing
its own radiant energy,
bound together
by cosmic harmony.

~ Ruth Bernhard

Energy

Some photographs simply explode off the page. They contain an energy that grabs the viewer and refuses to let him go. These are the OMG images that quicken the pulse with the physics of fantastic. ☙ At times, pictures seem to have sounds and even smells embedded within them: thunder, sulfur, salt, roar. It seems counterintuitive that a two-dimensional image could deliver in such a multidimensional way, but some photographs just knock our socks off. ☙ All photographs are time exposures, and the length of time that the shutter is open will deliver the magic of energy in a variety of ways. The photographer may choose a long exposure, allowing the scene to twirl or surge to abstraction. Lightning quick exposures can freeze the energy of an eagle, or a bullet, in flight. Capturing these pictures requires photographers who are innovative and talented—a little bit lucky and a little bit mad. ☙ Sometimes the subject itself contains such an abundance of energy that the photographer has to be fortunate or just crazy enough to go for it. Storms fascinate because they arrive in so many disguises. Volcanoes thrill in volatile bursts. The aurora borealis pulses and undulates like a dragon in the sky. The photographer's job is to capture the wind, the lightning, the heat. ☙ Sports photographers go to amazing lengths to reveal both the muscular and the mental exertion of athletes. Intensity and great technical skill are required to bring such energy to life in a still image. They are endlessly inventive, placing cameras beneath the hooves, above the hoop, and on the helmets of skydivers, surfers, and snowboarders. ☙ Human energy is contagious. One happy, leaping child propels us back to our own carefree days. A single dancer, whirling in a world of billowing fabric, makes us swoon and sigh. Bodies hurling themselves into the water fill us with longing to join the fray. ☙ We respond to the energy

of a crowd with special fascination. Seen from a distance, humanity becomes a river of color and motion. The individual disappears and the whole takes on a vitality of its own. When a photograph takes us within the crowd, we feel the music and laughter and freedom of the moment. We are guests at life in midair. ❮ The ultimate energy belongs to Mother Nature. Forces beyond our comprehension seduce us with fear and amazement in equal parts. Even the words associated with natural energy are fraught with tension: tsunami, tornado, avalanche, quake, vortex, eye, caldera, fault. ❮ Years ago I had a humbling assignment for *National Geographic* magazine to document natural disasters. That year, Mount St. Helens erupted in Washington State, and I arrived just eight hours after it blew. The next few days were a master class on nature's extraordinary power. We took off by helicopter to search for survivors, falling into stunned silence as we approached the mountain and realized that every tree was felled in the same direction, uphill and down. As we got closer, it became clear that each had also been stripped of branch and bark. They were laid out like toothpicks. In an instant, the sheer force of the eruption had sandblasted a mighty forest. ❮ There are photographers who risk their lives getting as close as possible to extraordinary natural events. The work is grueling, dangerous, and also addictive. The most gifted photographers have profound respect for nature and are experts at preparedness and survival. My colleague Carsten Peter has spent his life chasing tornadoes, clawing through ice caves, and inching to within feet of active volcanoes. He is smart, talented, and incredibly brave. Every time I see him I am grateful for the warmth of his smile and the fact that he seems to have nine lives. ❮ Whatever its form, energy in a photograph depends upon awe, because, as Norman Vincent Peale said, "The more you lose yourself in something bigger than yourself, the more energy you will have."

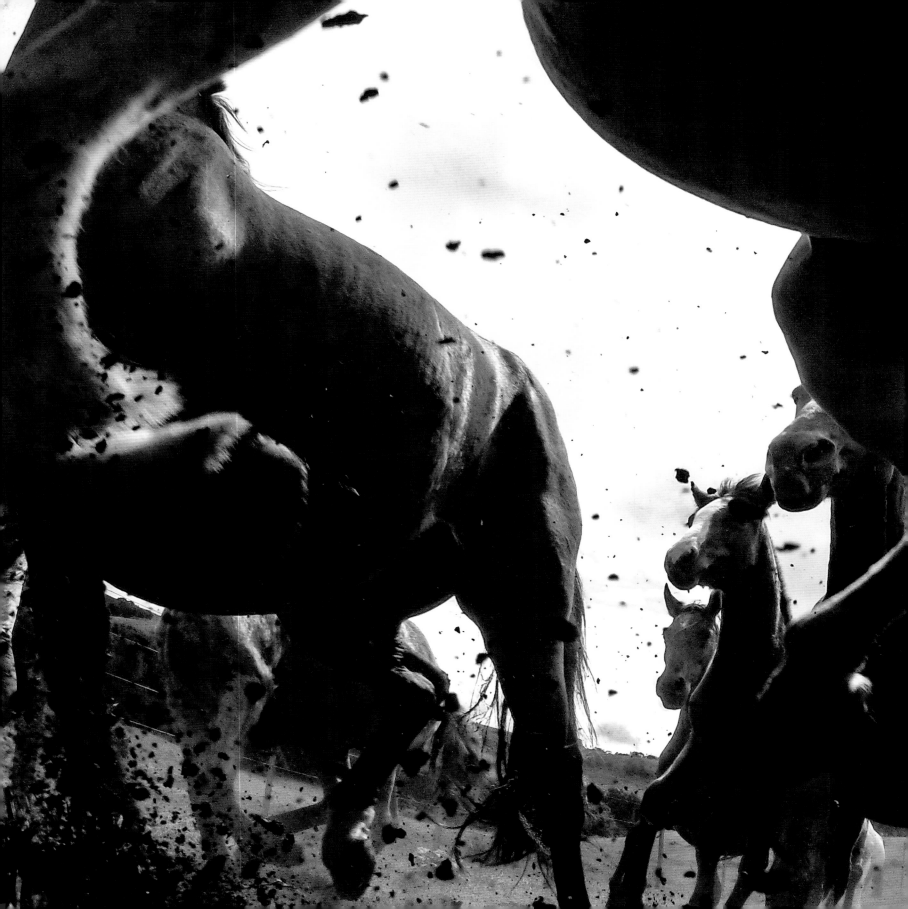

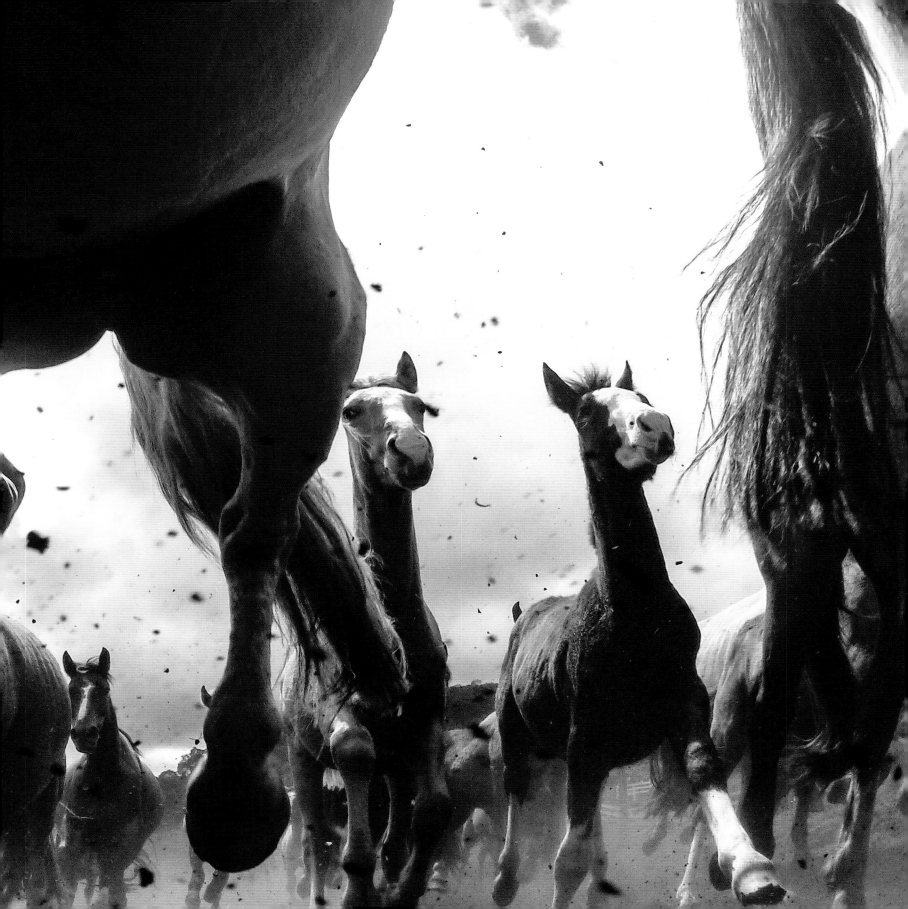

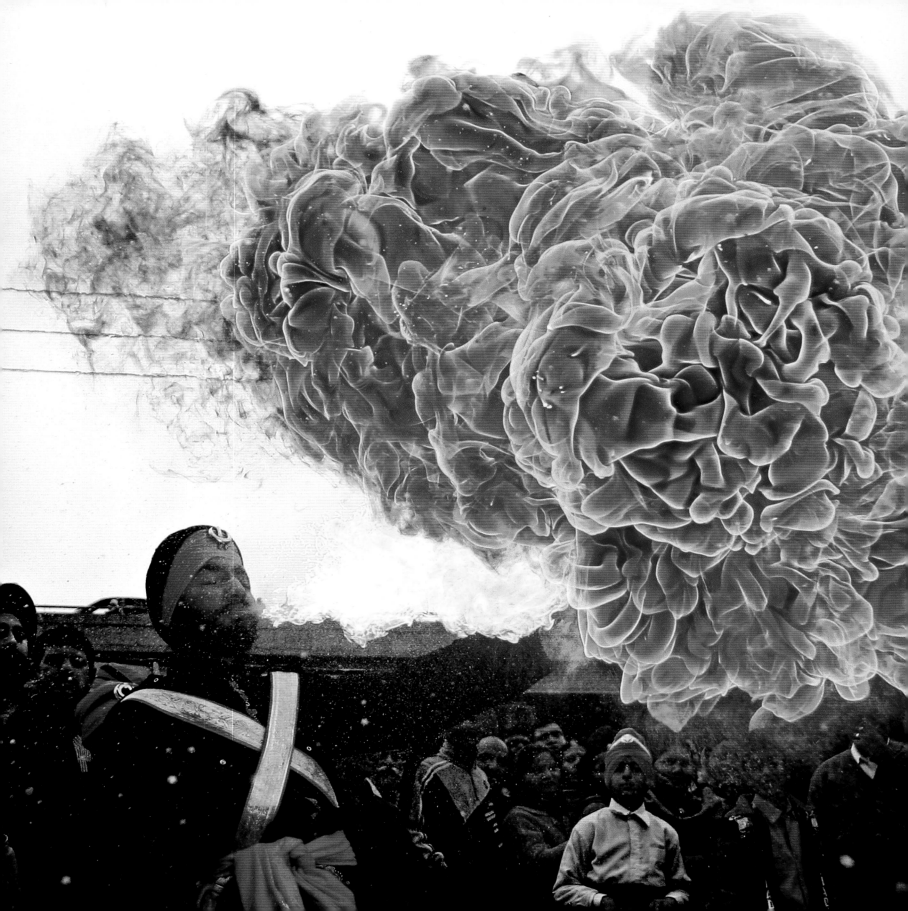

JAIPAL SINGH
Jammu and Kashmir, India
Spraying a mouthful of fuel over a flame, a Sikh blows a gigantic fireball during a religious procession.

preceding pages
PHILIP THURSTON
Bawley Point, New South Wales, Australia
A powerful groundswell crashes toward a reef ledge.

CHRIS SCHMID
Paraná, Brazil
Powerful Criollo horses thunder across a field.

following pages
ANDREW NEWTON
Possum Kingdom Lake, Texas
Thick smoke darkens the sky as a wildfire rages.

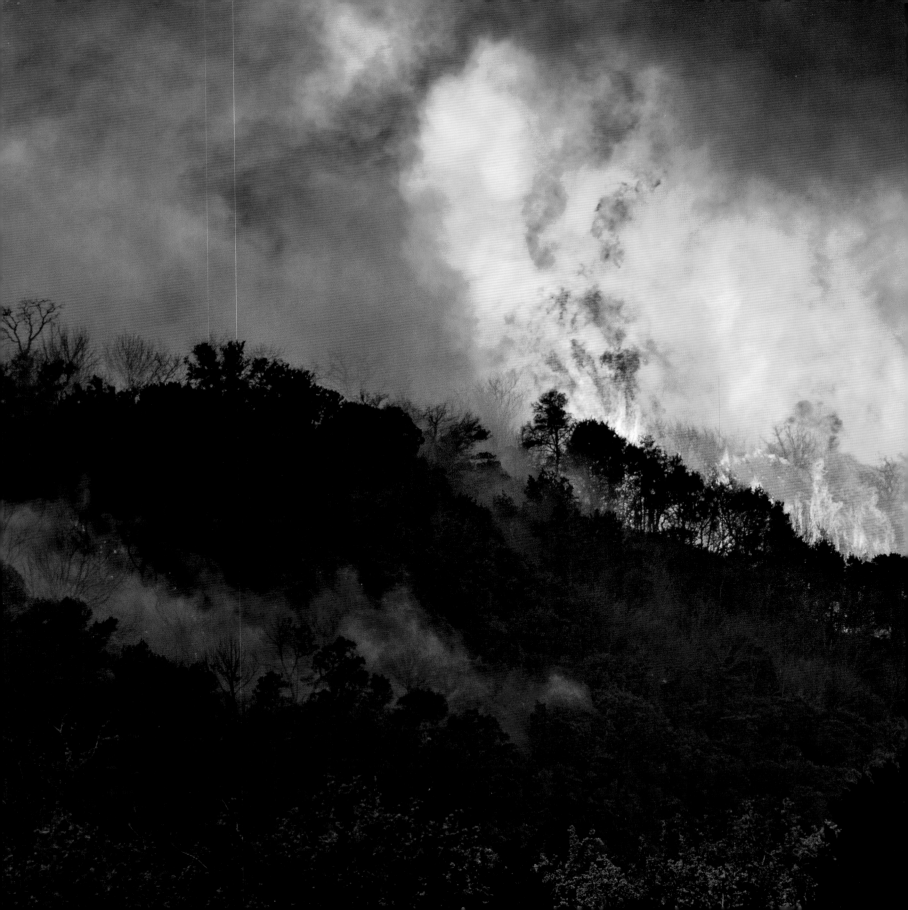

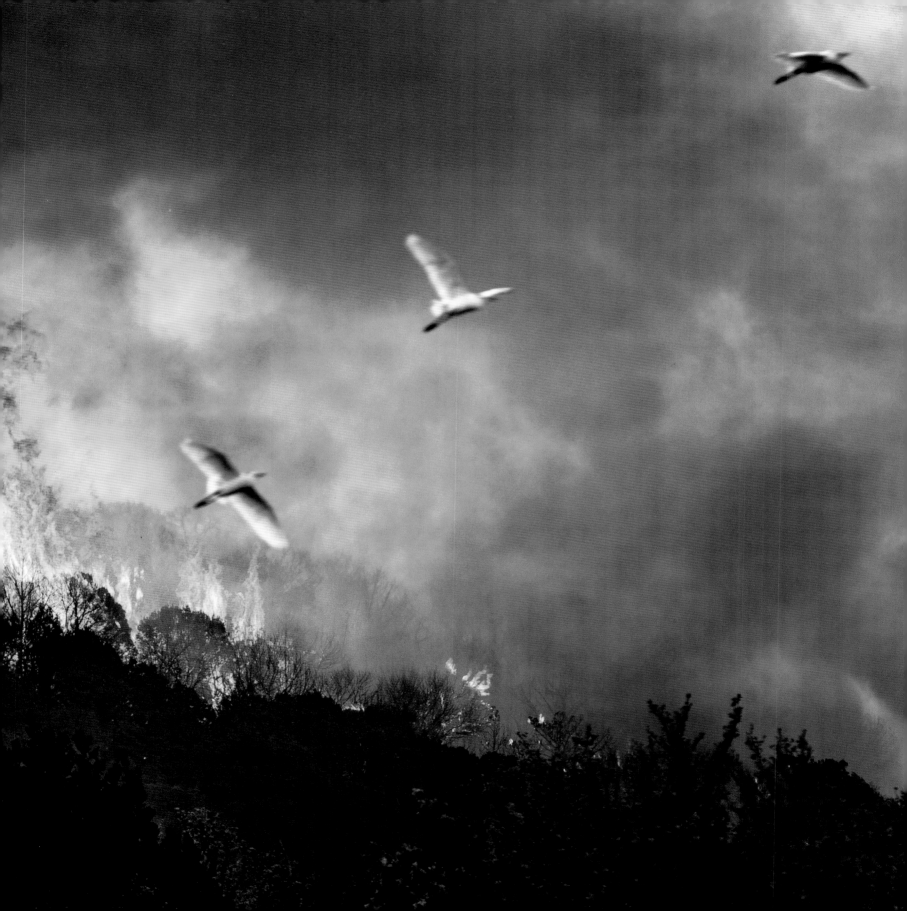

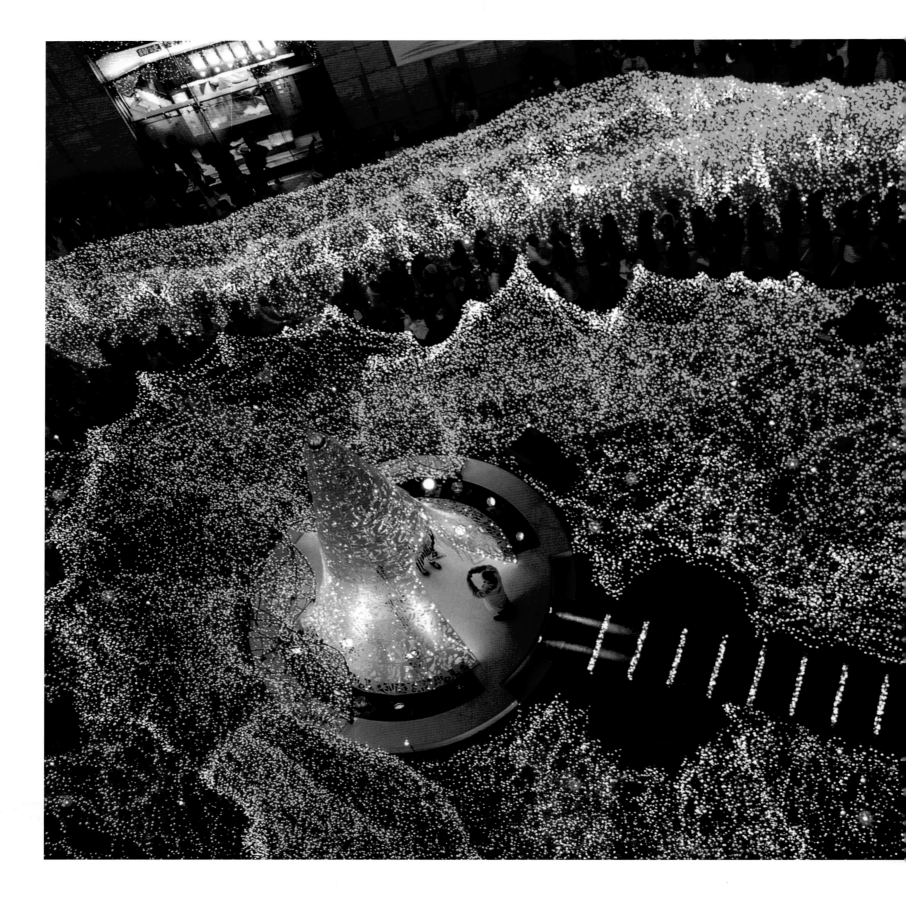

HIRO KURASHINA
Tokyo, Japan
People walk through an illumination display
of millions of LED Christmas lights.

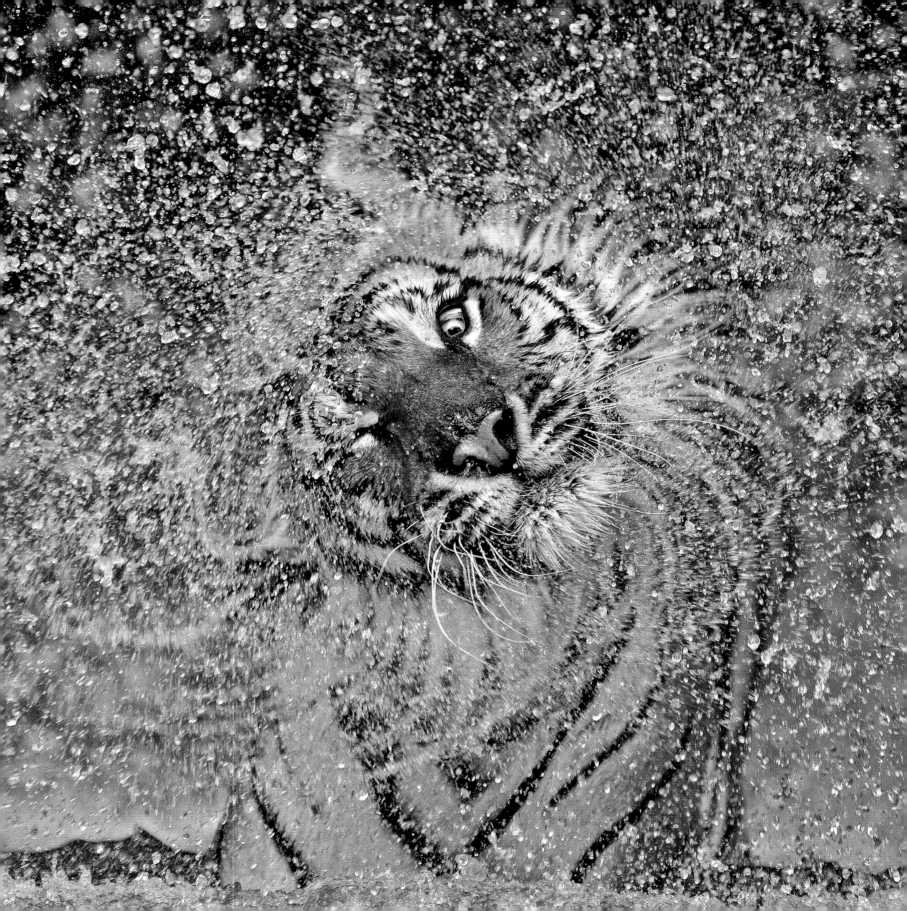

Ashley Vincent

My main focus as a photographer has been to capture the personality of each animal I portray. I love dynamic and compelling portraits that help viewers connect with the subject, if only momentarily. This shot was taken at a zoo, but I was able to freeze the energy and power of the tiger as she shook water off her body. High-impact imagery of this sort simply takes my breath away.

ASHLEY VINCENT
Chonburi, Thailand
A tiger flings off a shower of water as she shakes herself dry.

MITCH DOBROWNER
Regan, North Dakota
A weakening tornado "ropes out" into
a tubular shape.

following pages
FRANS LANTING
Botswana
Zebras huddle together in a holding pen.

292

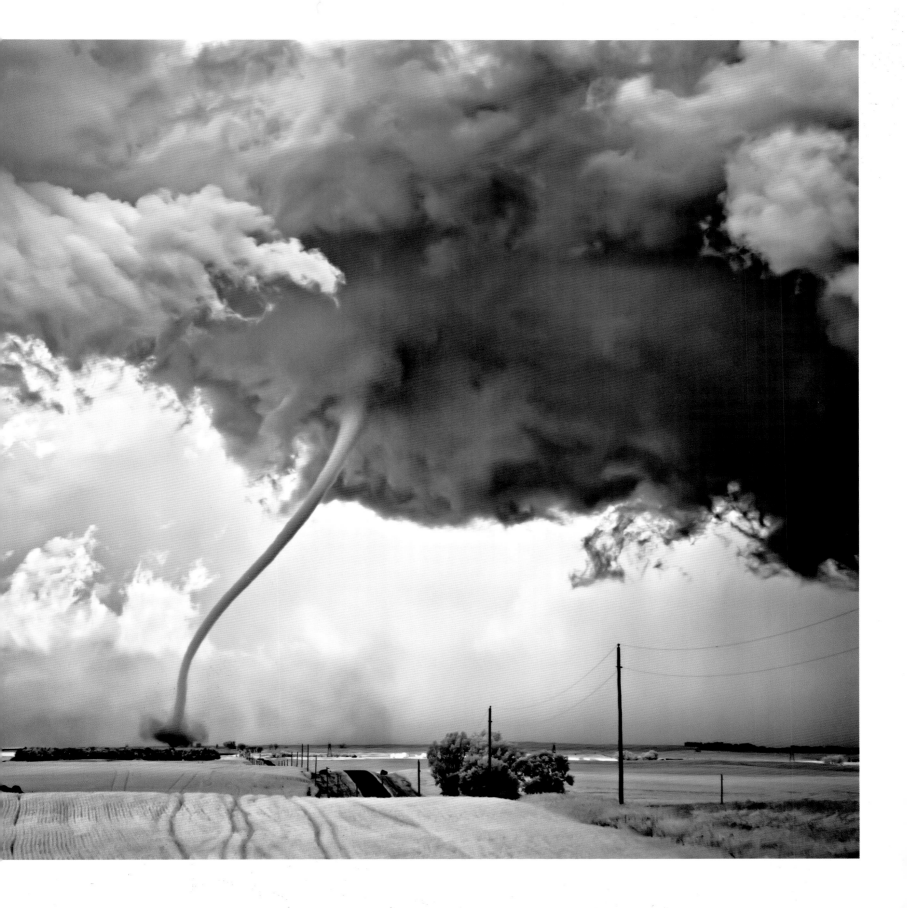

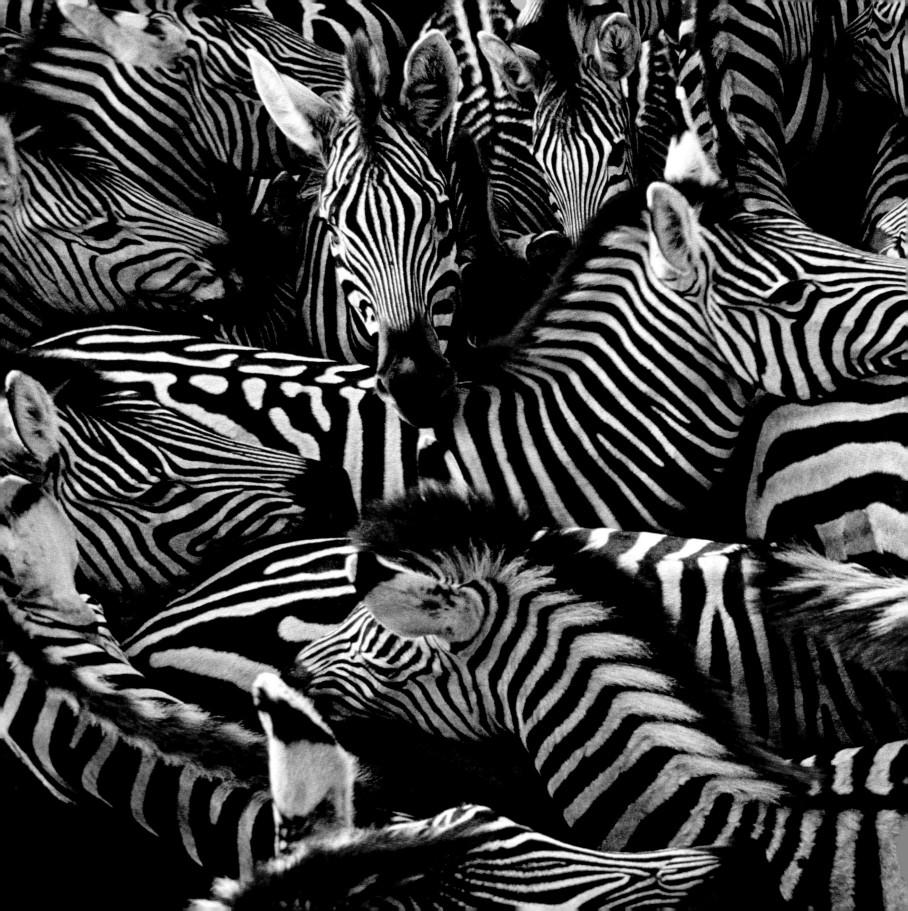

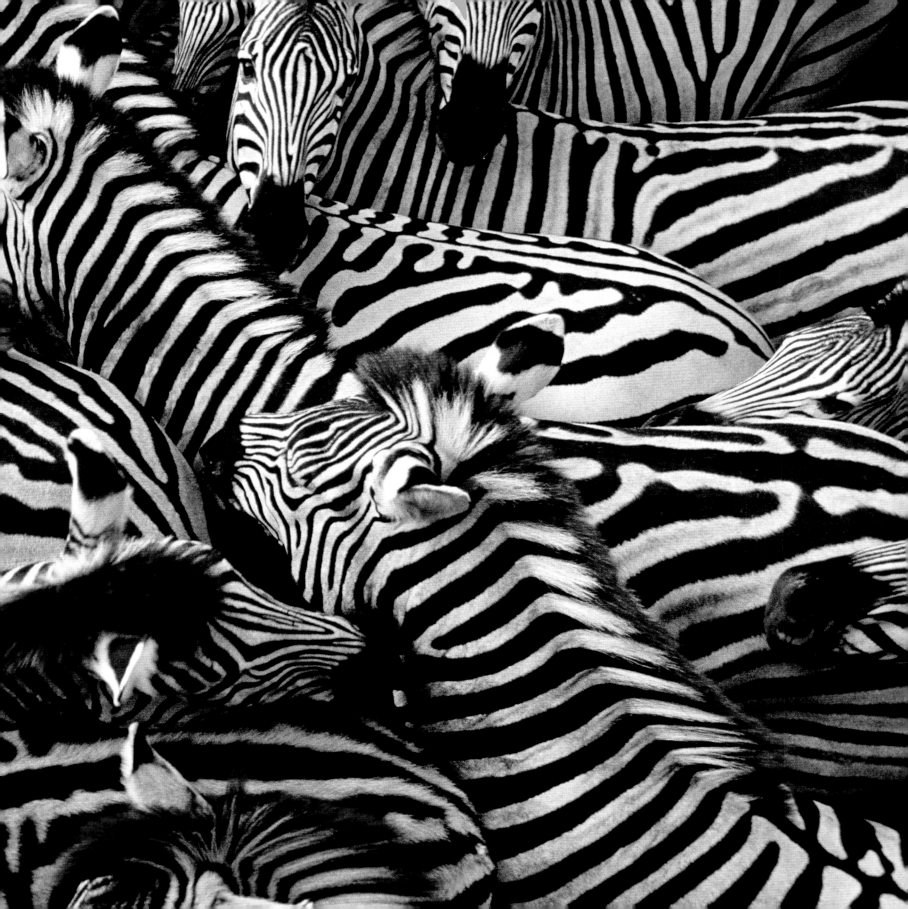

Frans Lanting

I became interested in photography during my first visit to the United States; I was overwhelmed by the beauty of the American West. I photographed this geyser at dawn in the Great Basin. A geyser is the perfect expression of Earth's energy; it has all the ingredients of life: light, water, minerals. When a geyser goes off, it gives you a sense that there is a whole different world just below the surface of our planet.

FRANS LANTING
Black Rock Desert, Nevada
A geyser spews boiling water six feet high from a multihued, algae-covered cone formation.

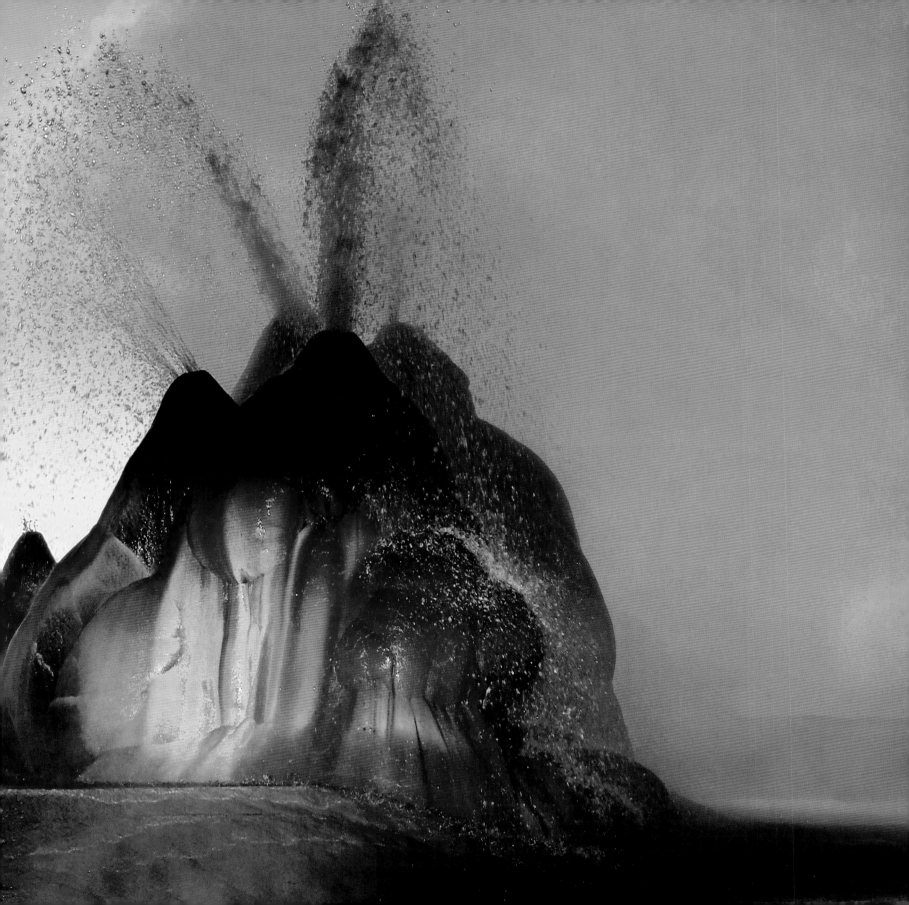

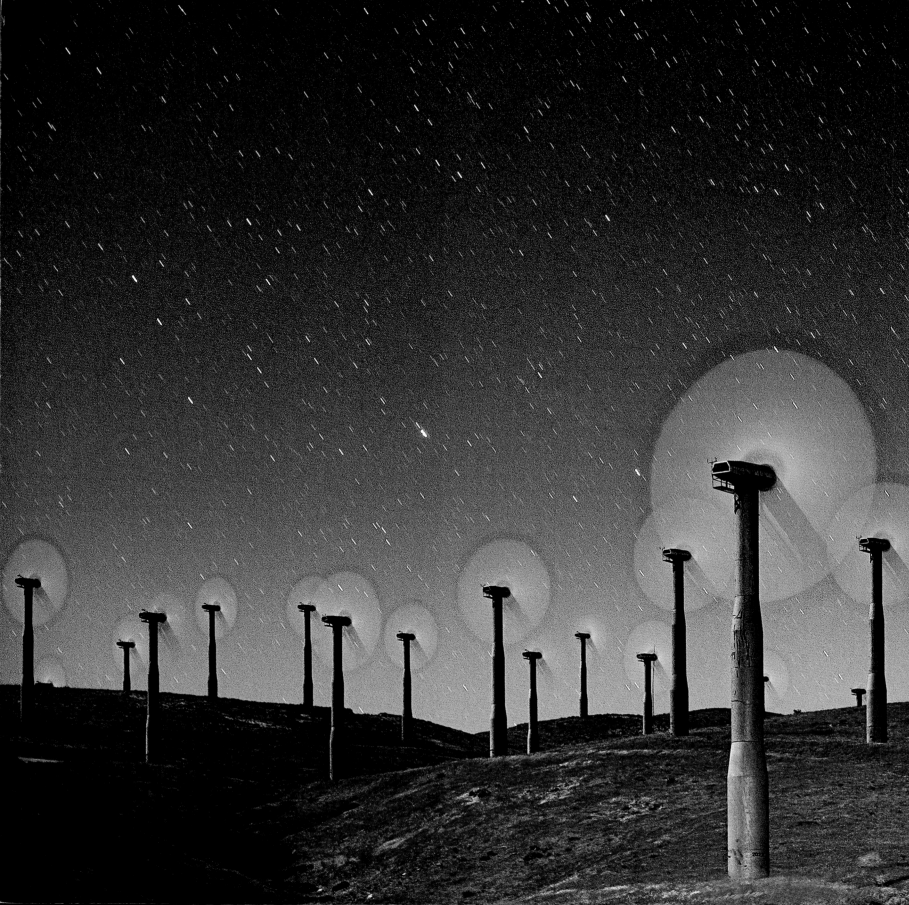

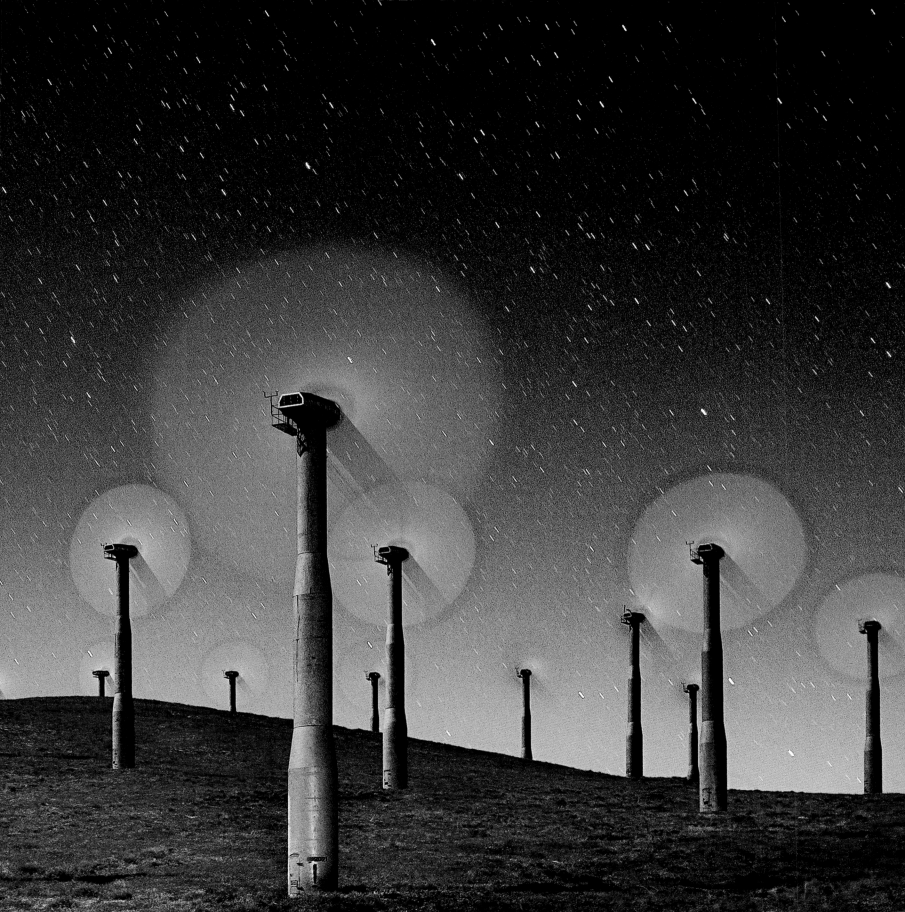

The energy
of the mind is the
essence of life.

~ Aristotle

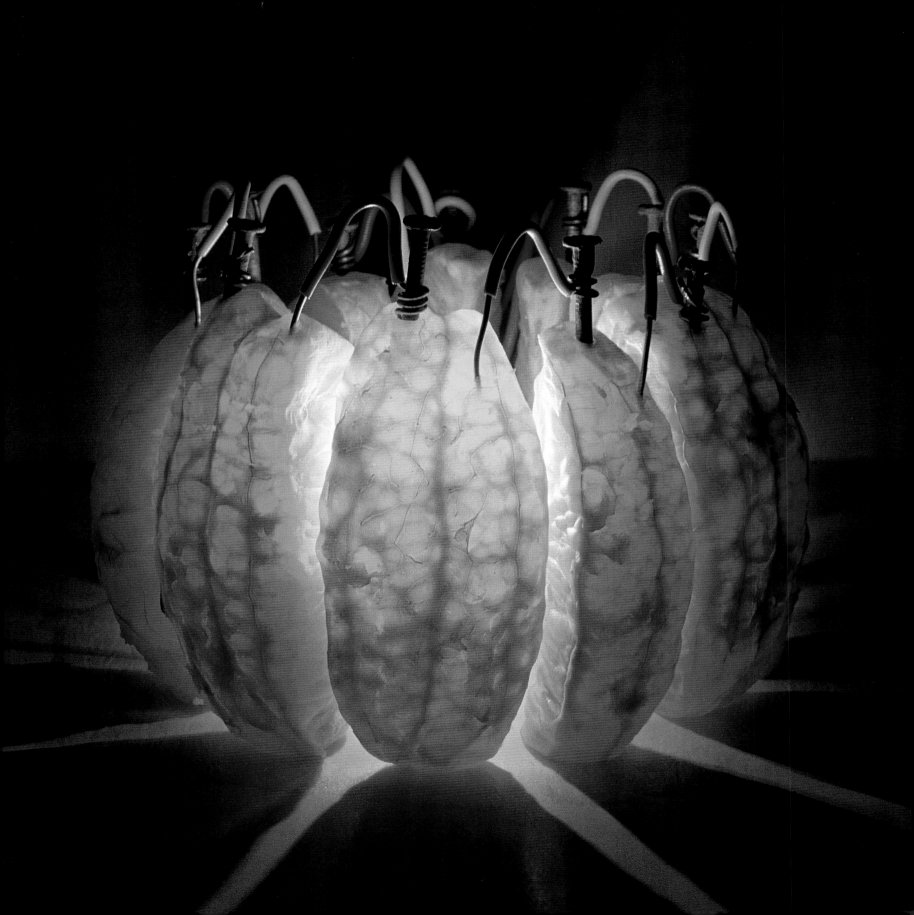

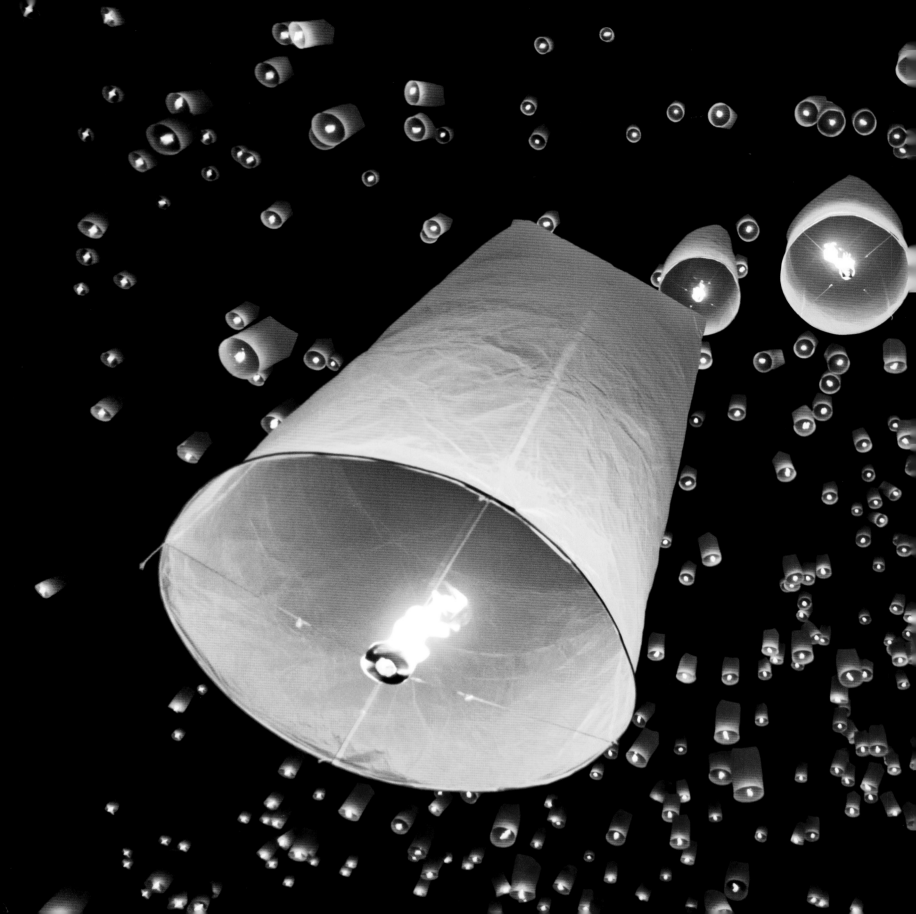

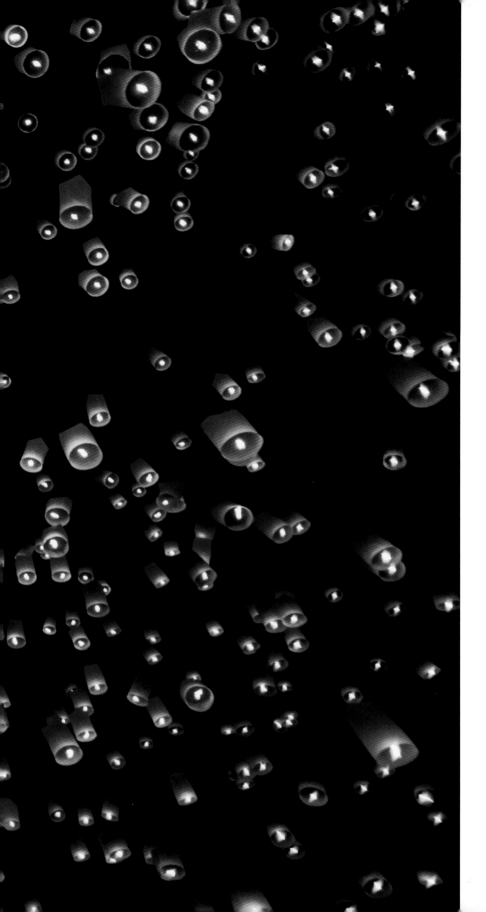

KLJ PHOTOGRAPHIC
Chiang Mai, Thailand
Thousands of rice paper lanterns float
in the night sky during a Yi Peng festival.

preceding pages
JEFF KROEZE
Tehachapi Pass, California
The spinning blades of wind farm
turbines dissolve into circles of light.

CALEB CHARLAND
Maine
Orange wedges, nails, and wire
generate enough electricity to light
an LED bulb.

303

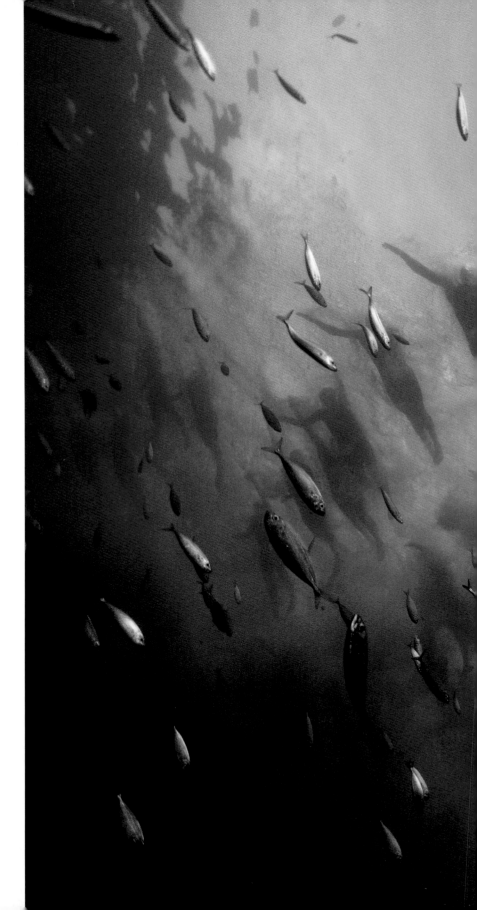

DONALD MIRALLE
Kona, Hawaii
Fish scatter as a throng of triathletes
swims through the ocean.

following pages
DAVID CLAPP
Cornwall, England
Storm waves batter the Cornish coast.

SUDEEP MEHTA
Mumbai, India
Youths link arms to form a human pyramid
in celebration of a Hindu tradition.

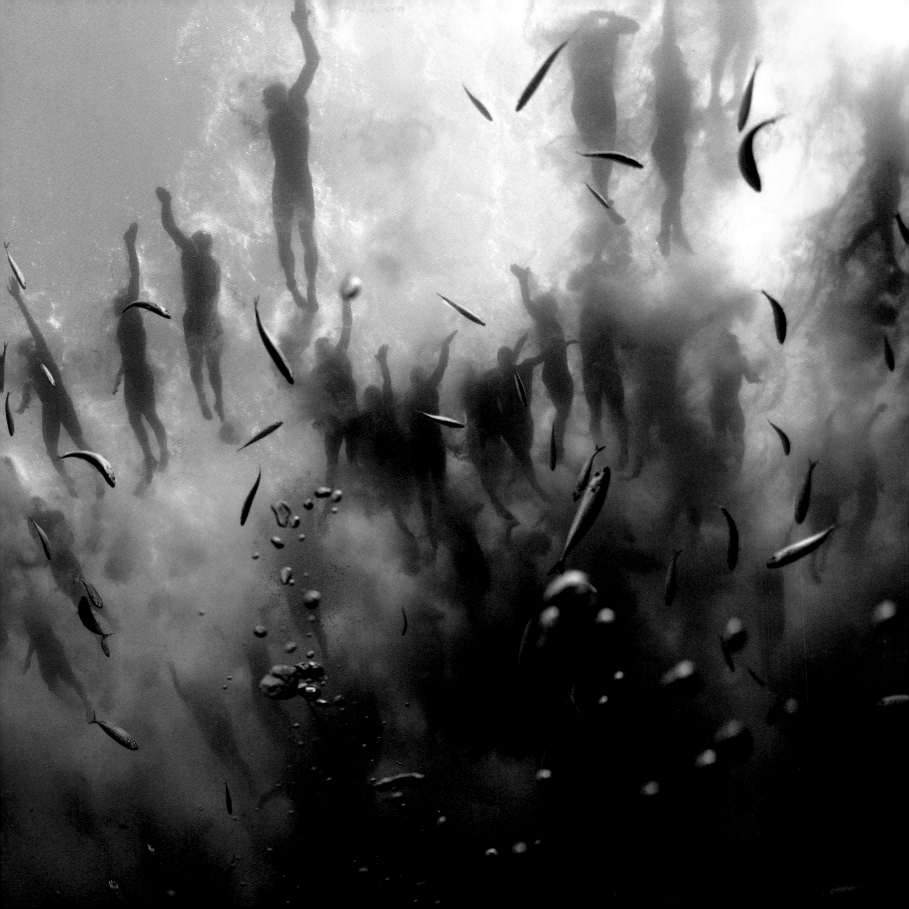

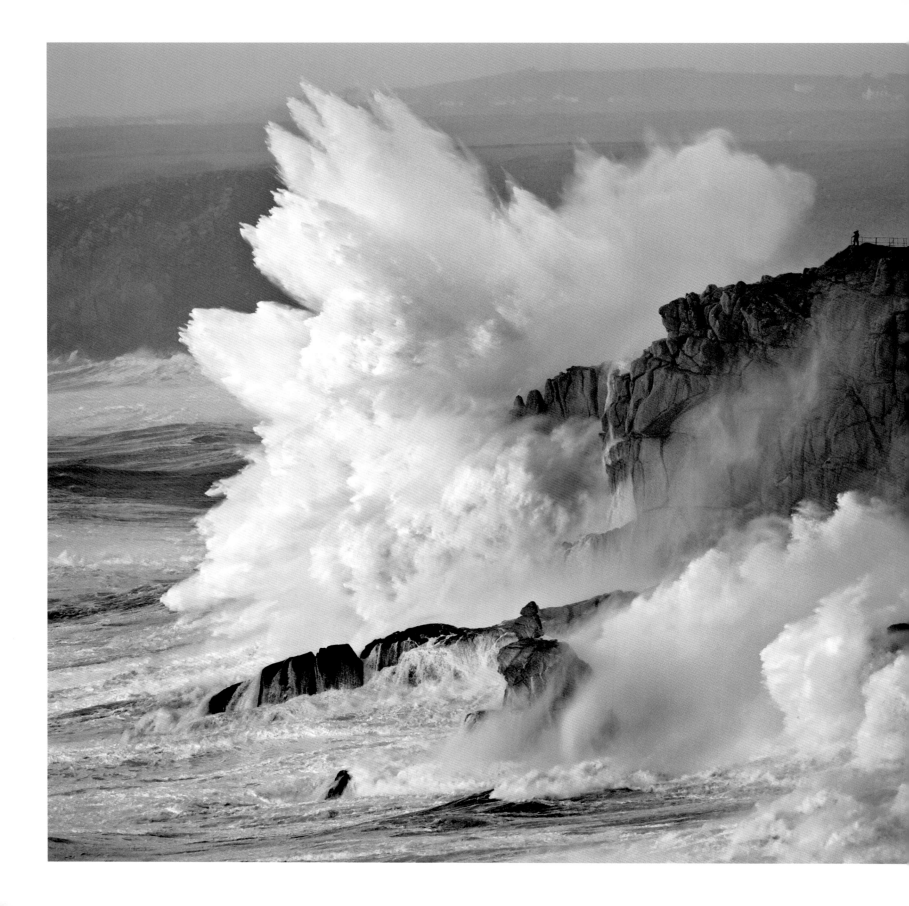

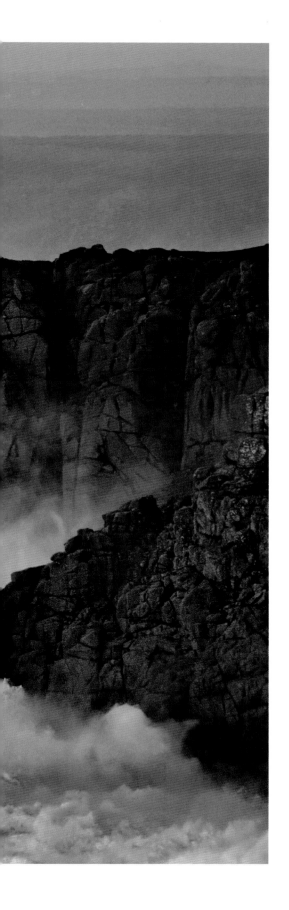

Every other
artist begins with
a blank canvas,
a piece of paper.
The photographer
begins with the
finished product.

~ Edward Steichen

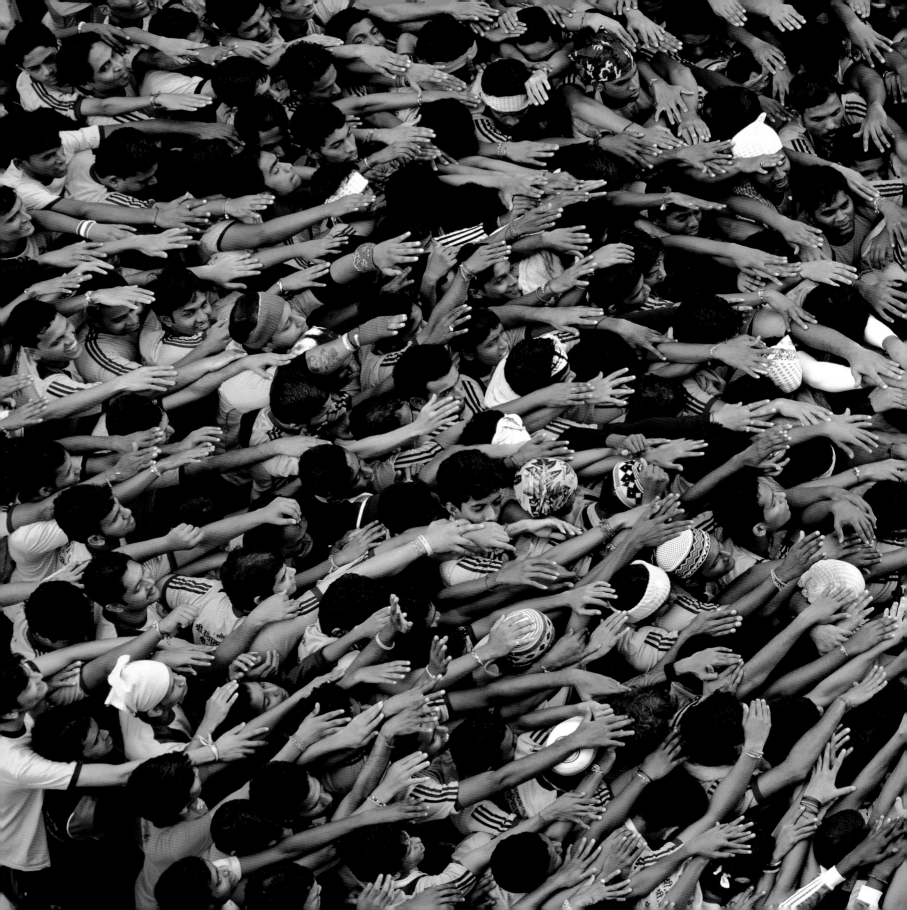

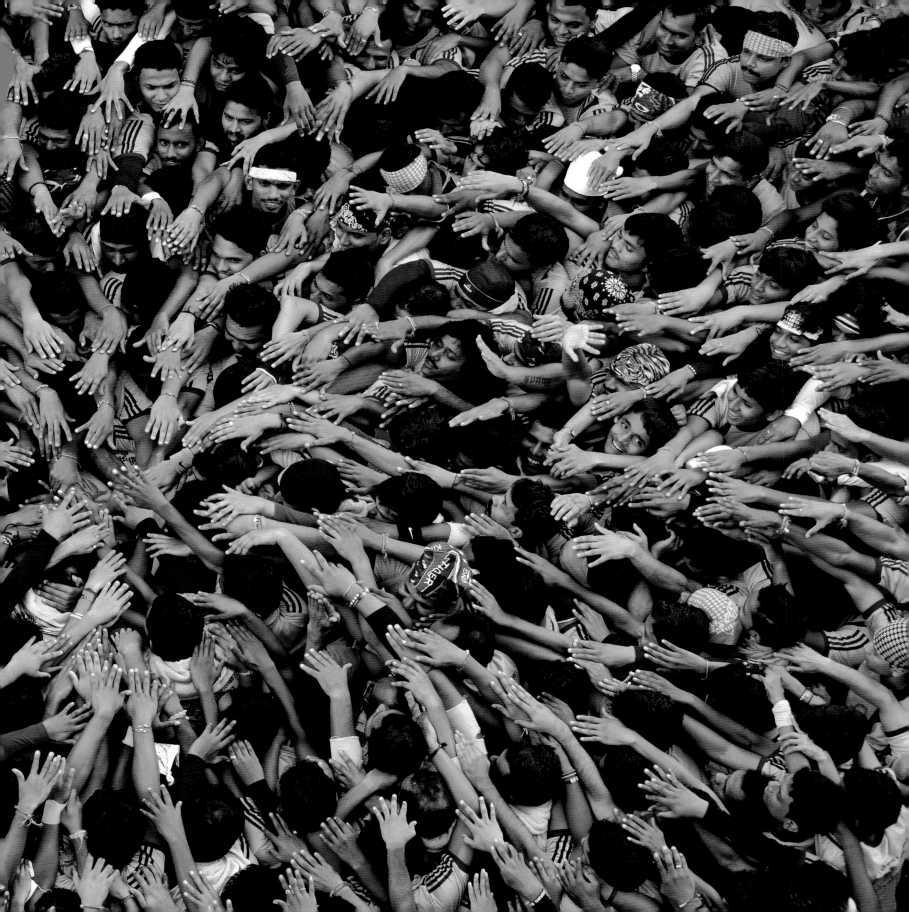

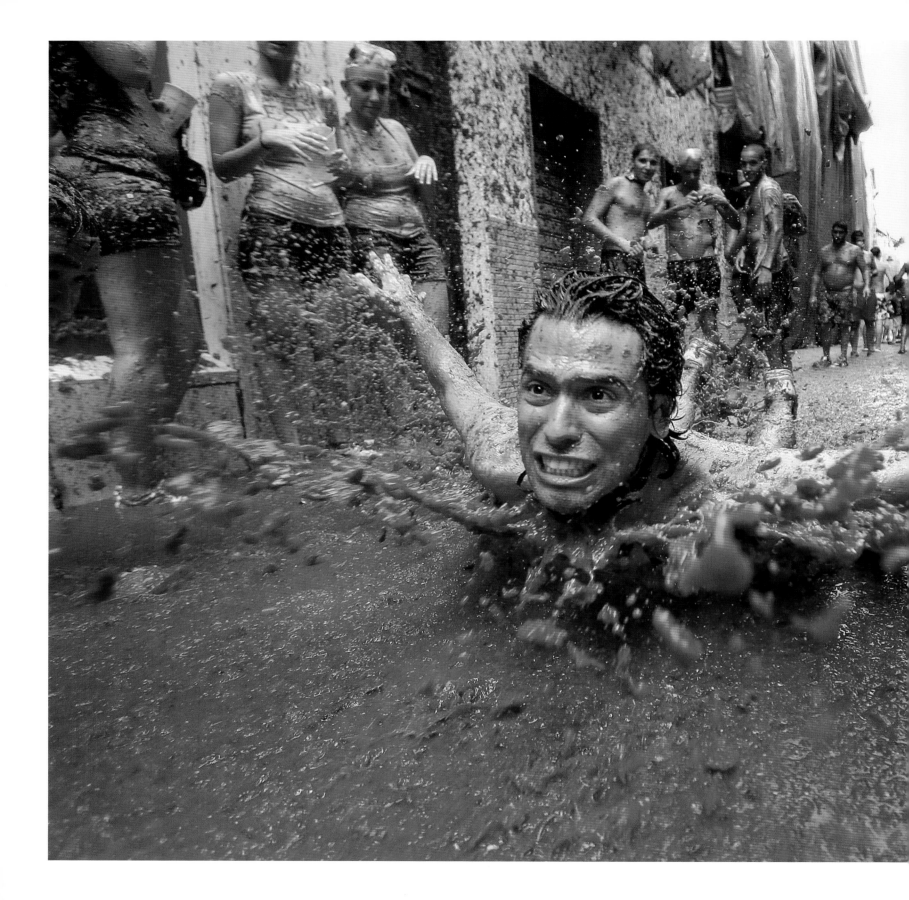

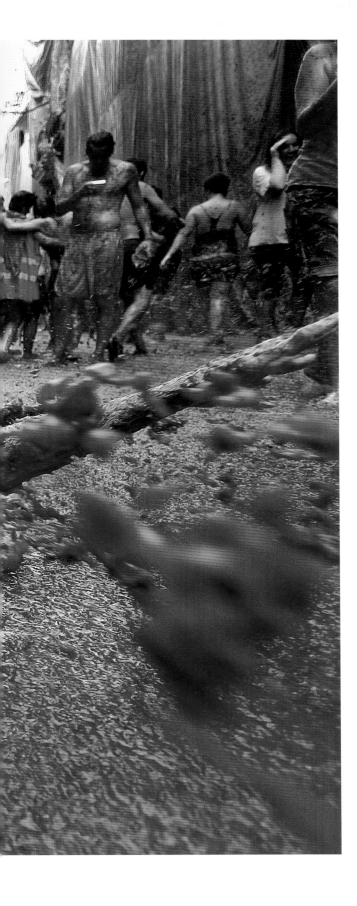

BIEL ALIÑO
Buñol, Spain
A young man slides through a stream of pulp during his city's annual tomato festival.

following pages
DON ROBERTS
Paro, Bhutan
A composite of seven photographs captures a young Buddhist monk's haste.

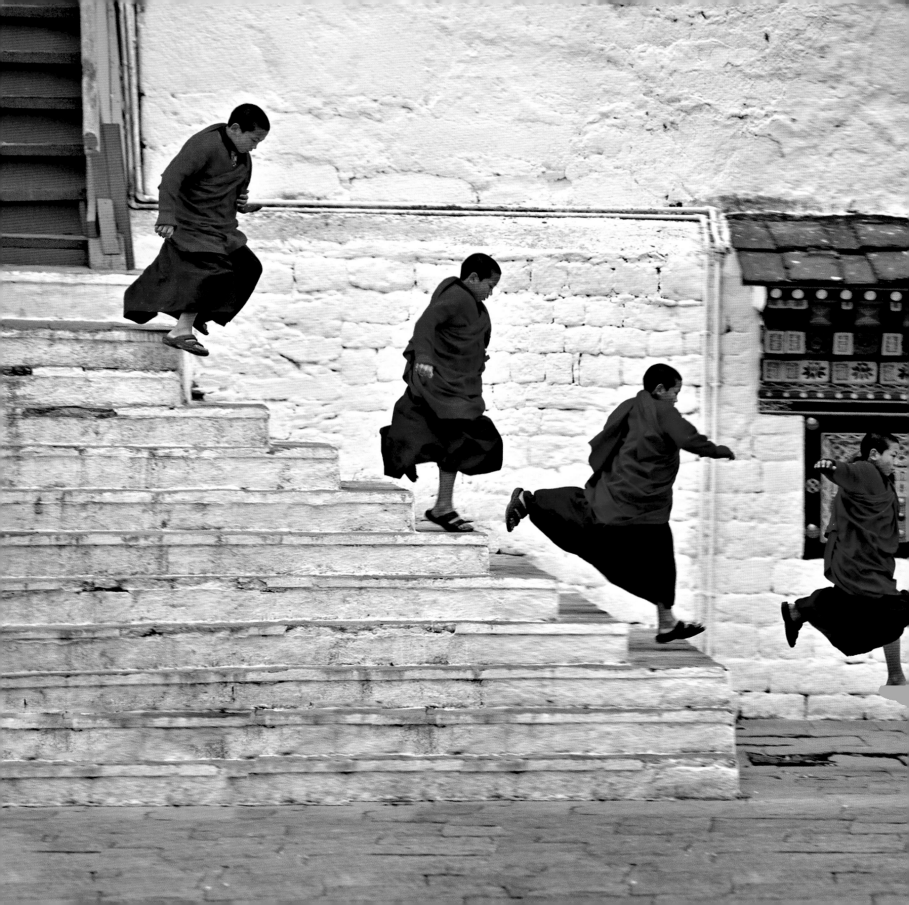

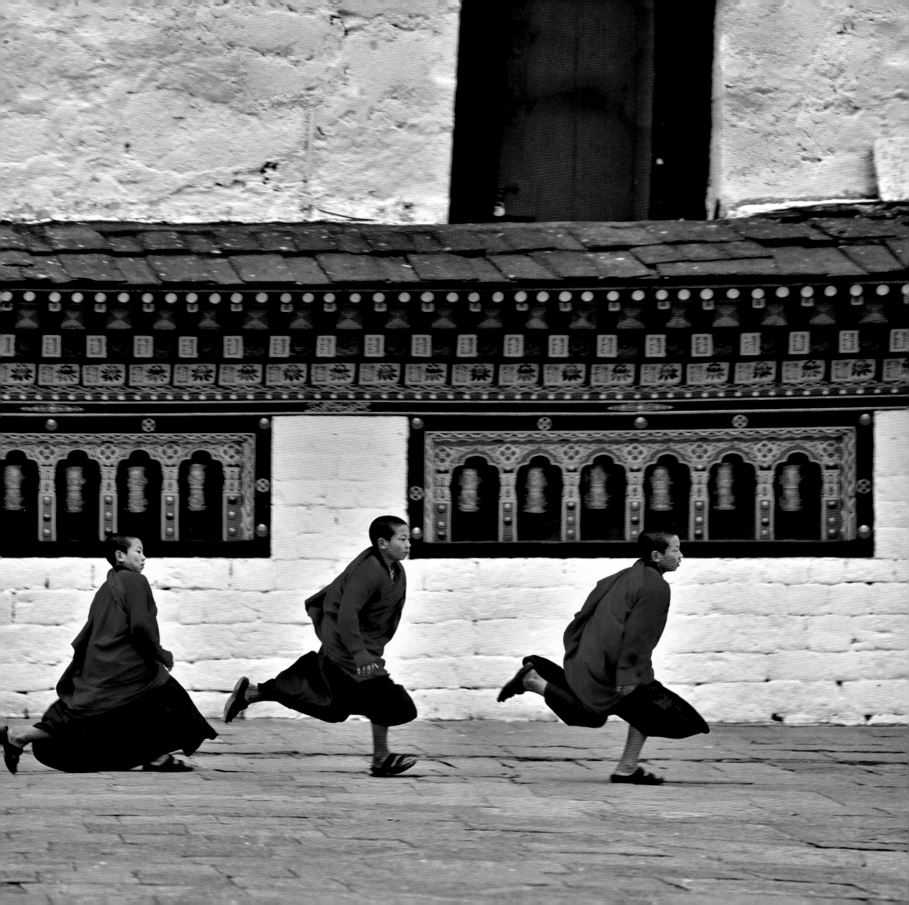

Annie Griffiths

Sometimes a photograph that looks fairly straightforward is actually the result of careful planning. Such was the case for this shot of the millennium fireworks in Sydney Harbour.

I knew the harbor would be filled with boats, so the challenge was to shoot from high enough to clear them. It took two days of scouting and twelve hours sitting in one spot to get the location right for when the fireworks began. Voilà! The image was used on the cover of *National Geographic*.

ANNIE GRIFFITHS
Sydney, Australia
Fireworks light up Sydney Harbour during a New Year's celebration.

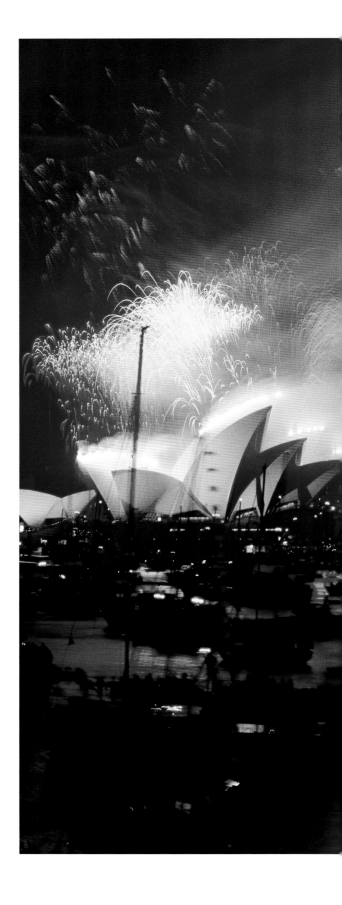

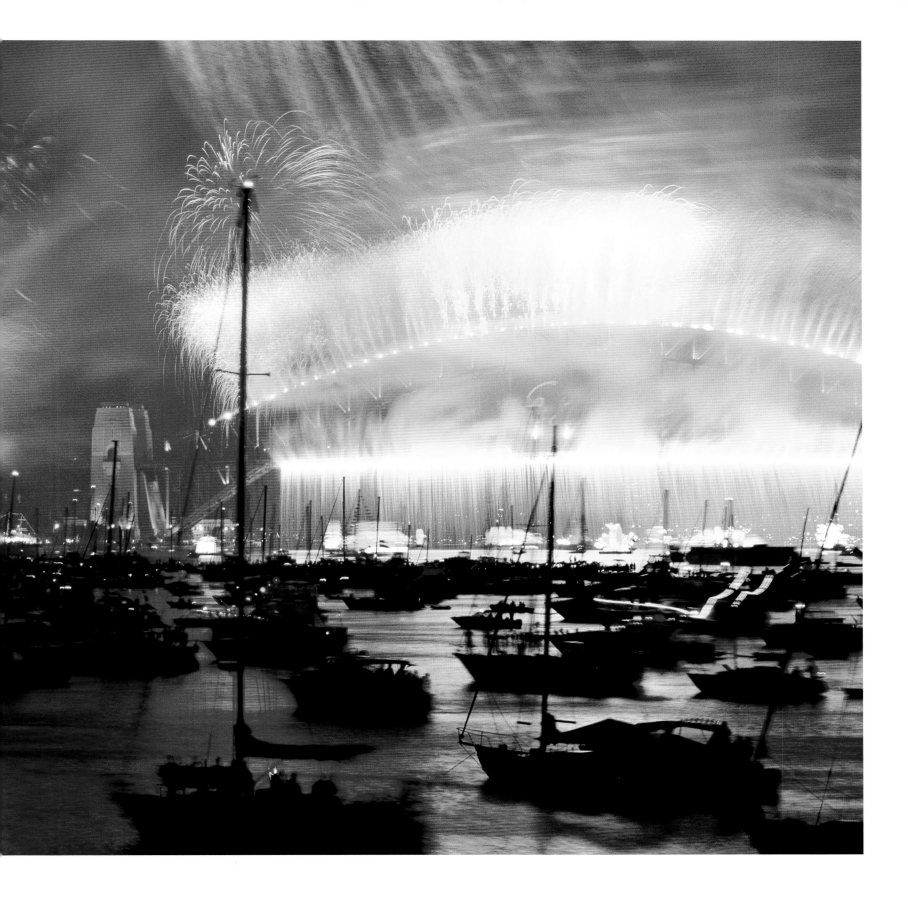

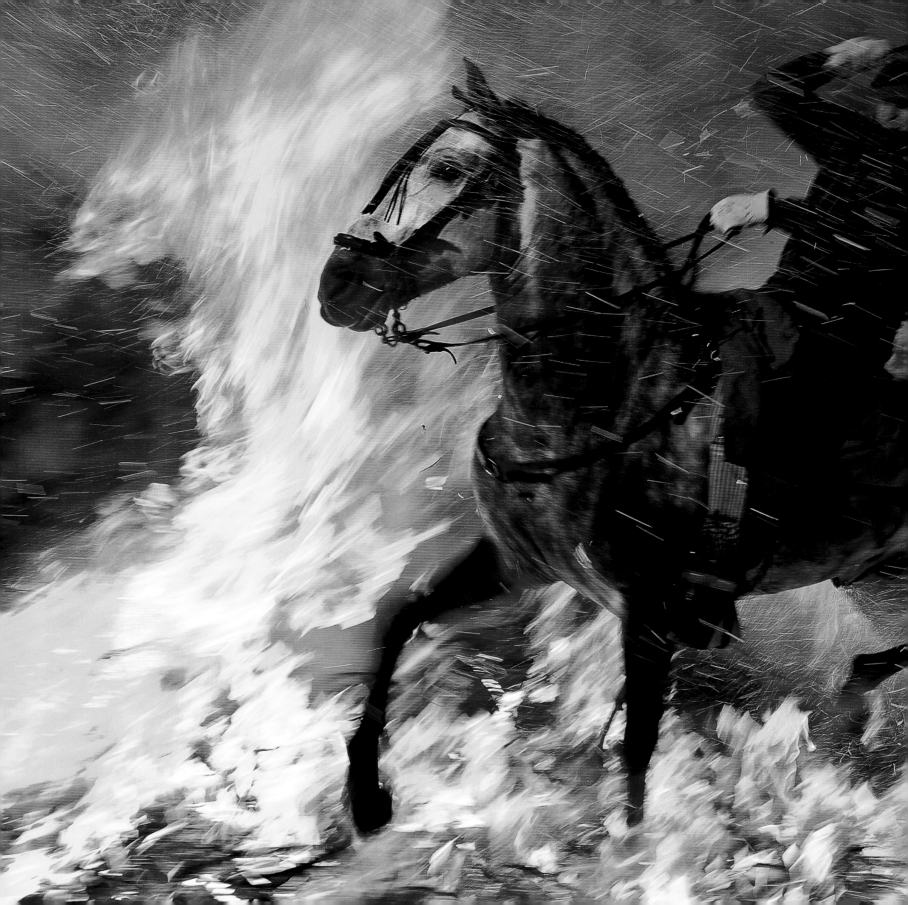

JASPER JUINEN
San Bartolomé de Pinares, Spain
A horse and rider hurtle through a bonfire in a centuries-old ritual believed to purify the animals.

following pages
ANURAG KUMAR
Uttar Pradesh, India
Holi festival celebrants douse each other with colored powder to welcome spring.

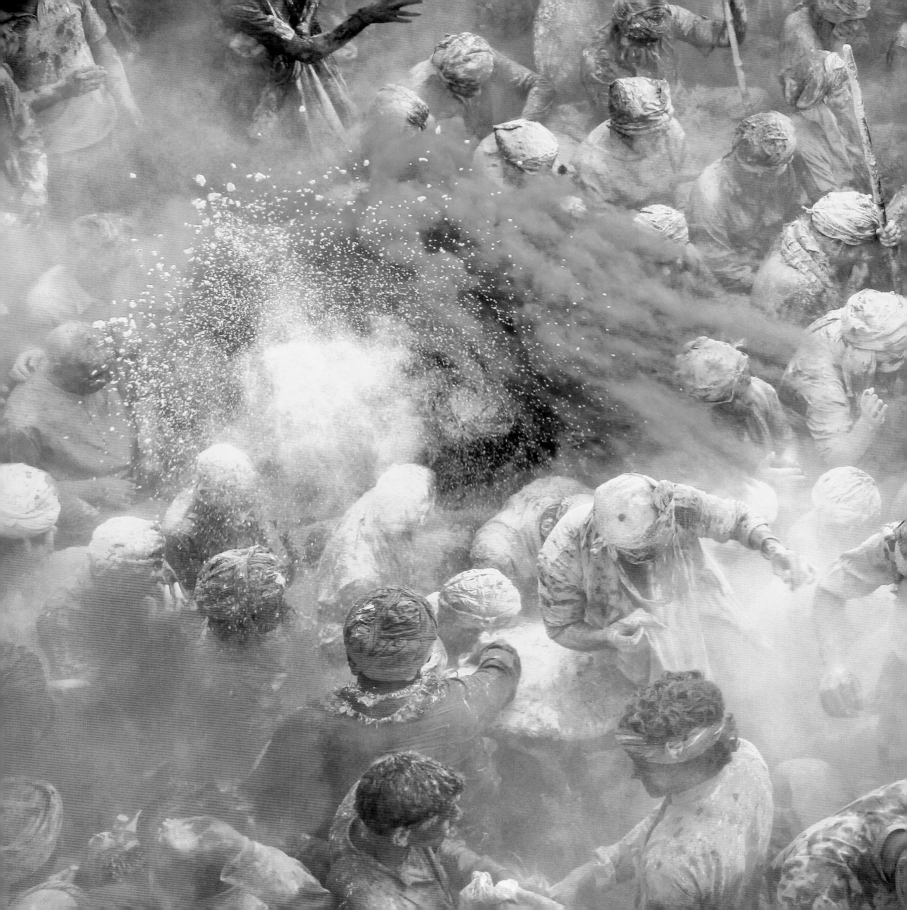

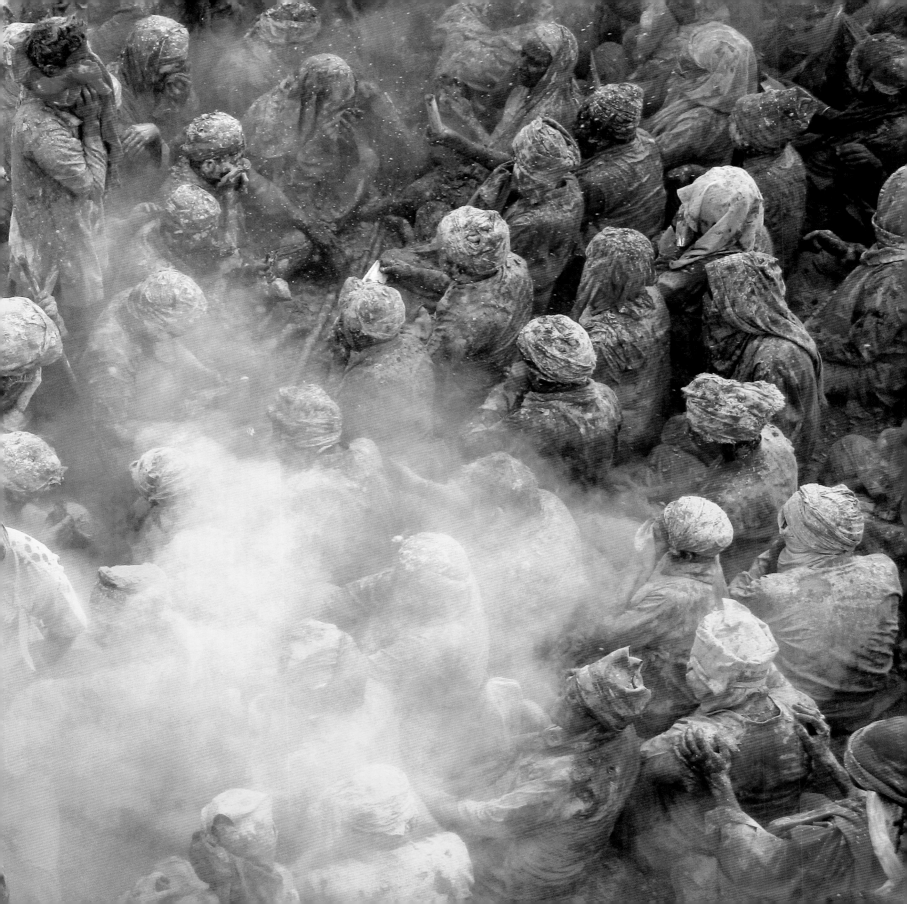

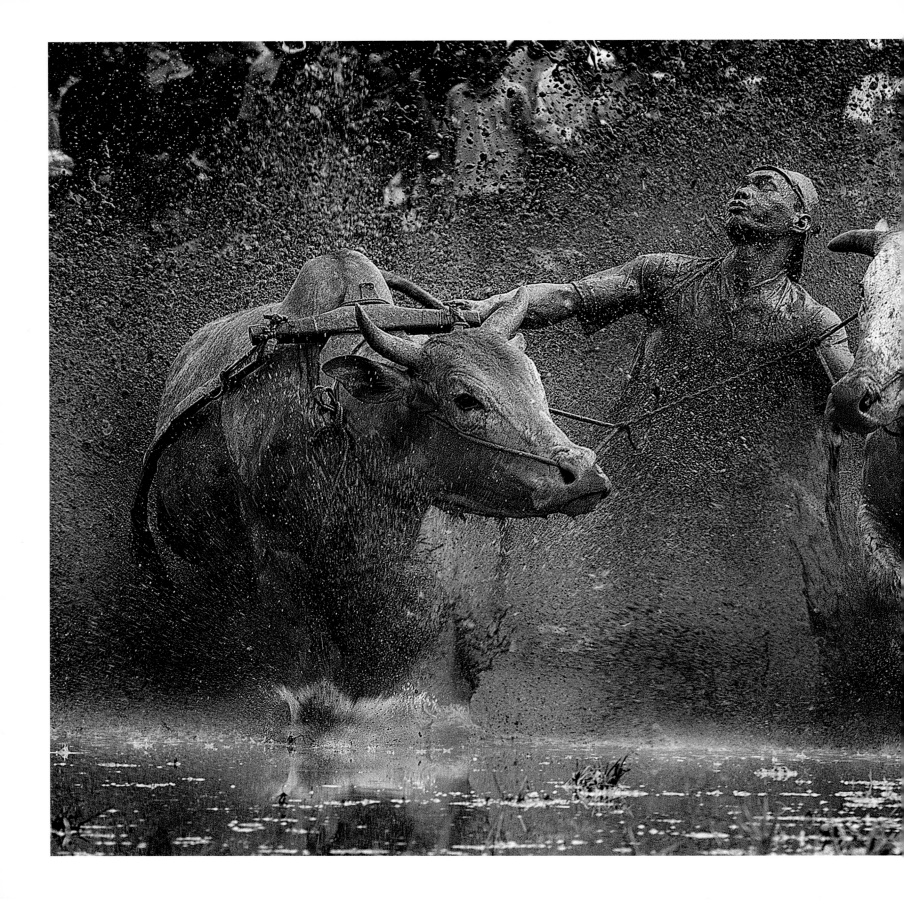

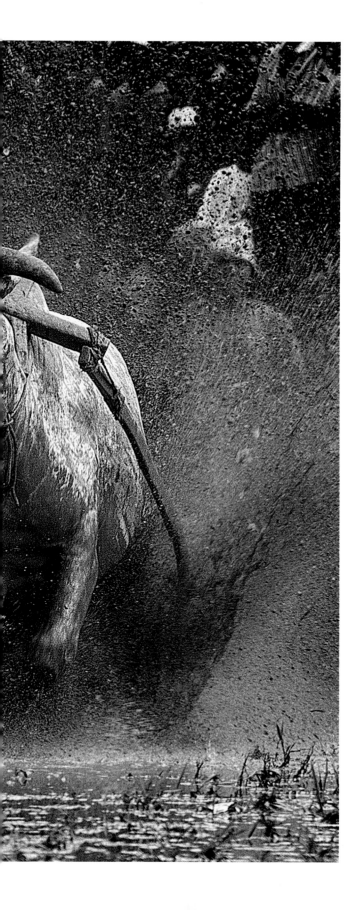

FAUZAN MAUDUDDIN
West Sumatra, Indonesia
A jockey drives two galloping bovines through a muddy rice paddy during a cow race.

following pages
TOMMY SCHULTZ
Bali, Indonesia
A local surfer rides a majestic wave.

MAXIM SHATROV
Dubai, United Arab Emirates
Lightning flashes above the sail-shaped Burj Al Arab Hotel.

FABRICIO JIMENEZ
San José, Costa Rica
An airliner breaks through dark clouds on its descent.

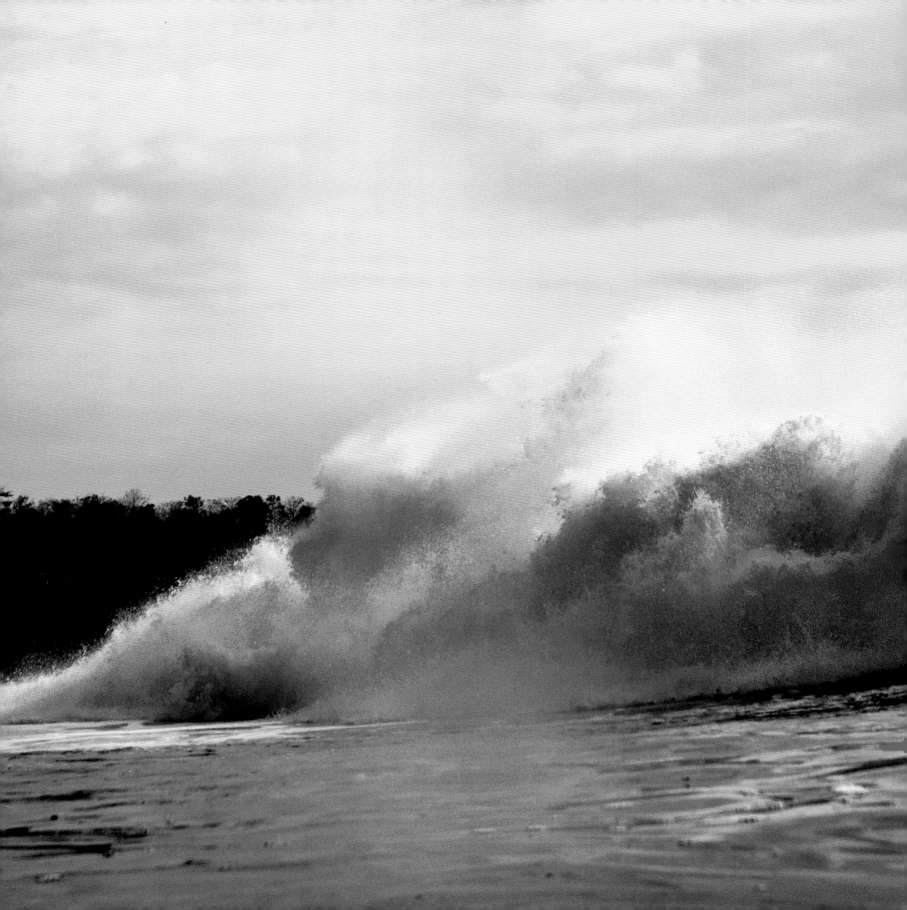

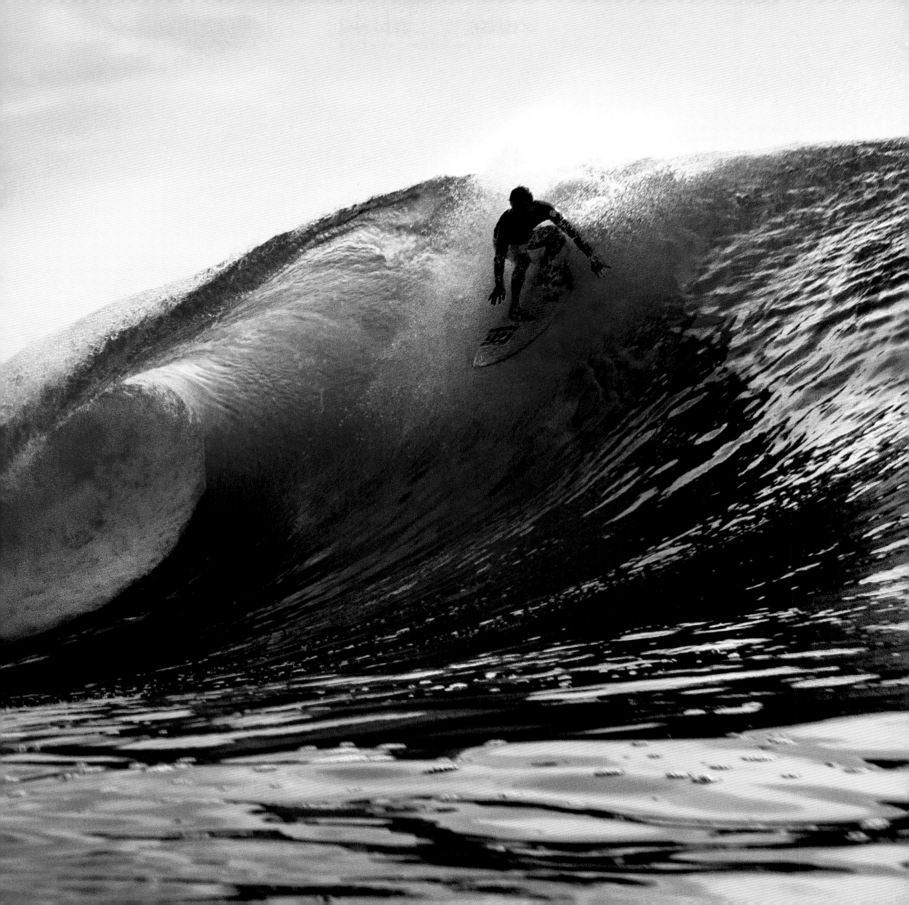

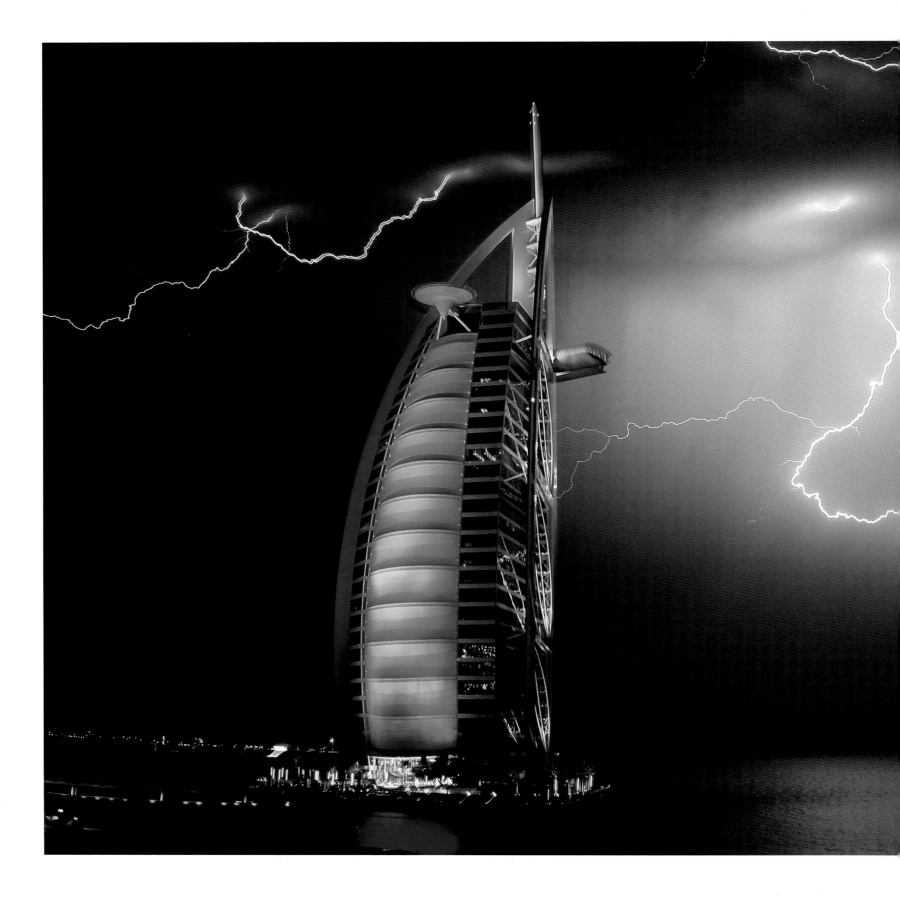

The image
is more than
an idea. It is a
vortex or cluster
of fused ideas
and is endowed
with energy.

~ Ezra Pound

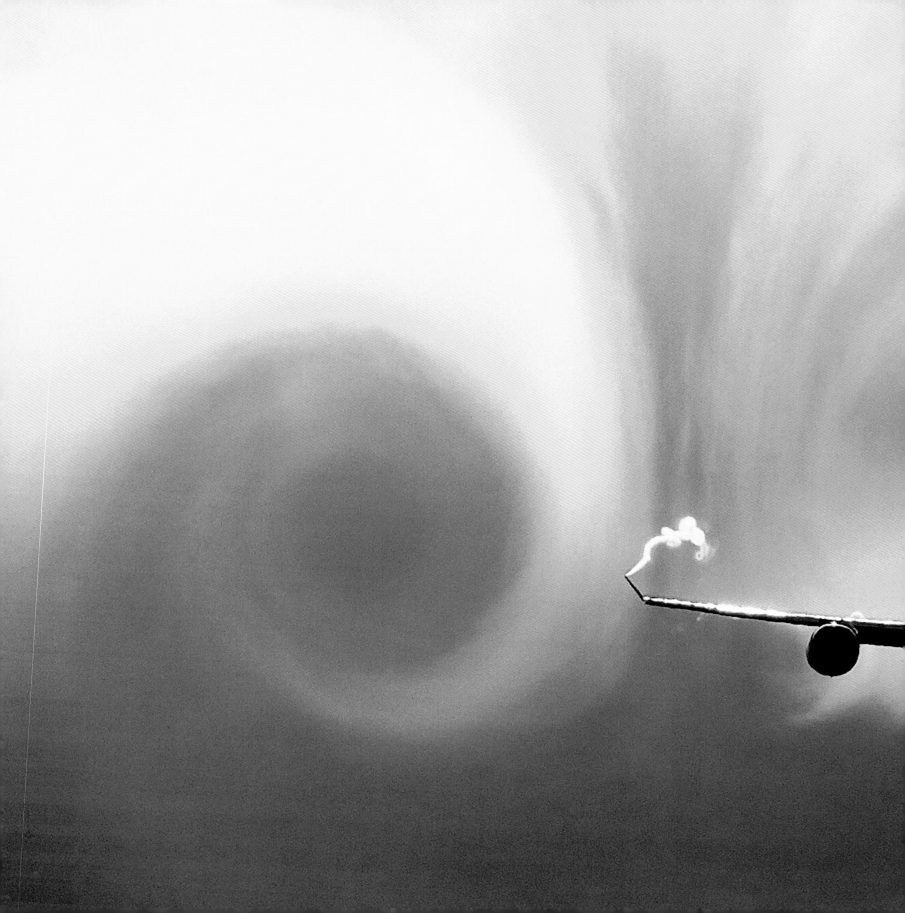

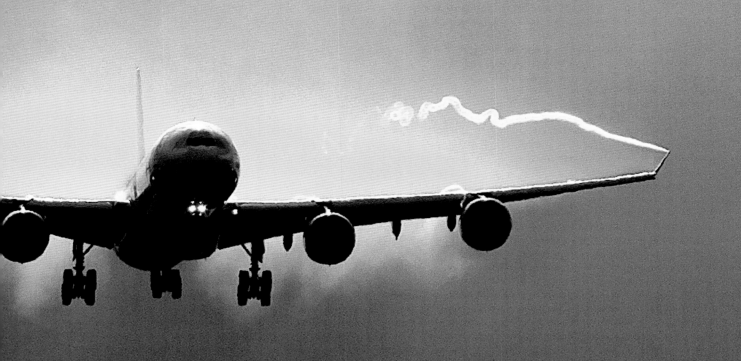

BRIAN LANKER
San Francisco, California
A dancer performs draped in swaths
of sheer fabric.

following pages
WAGNER ARAUJO
Manaus, Brazil
Contestants in a swimming and
running competition dash through
the Rio Negro.

329

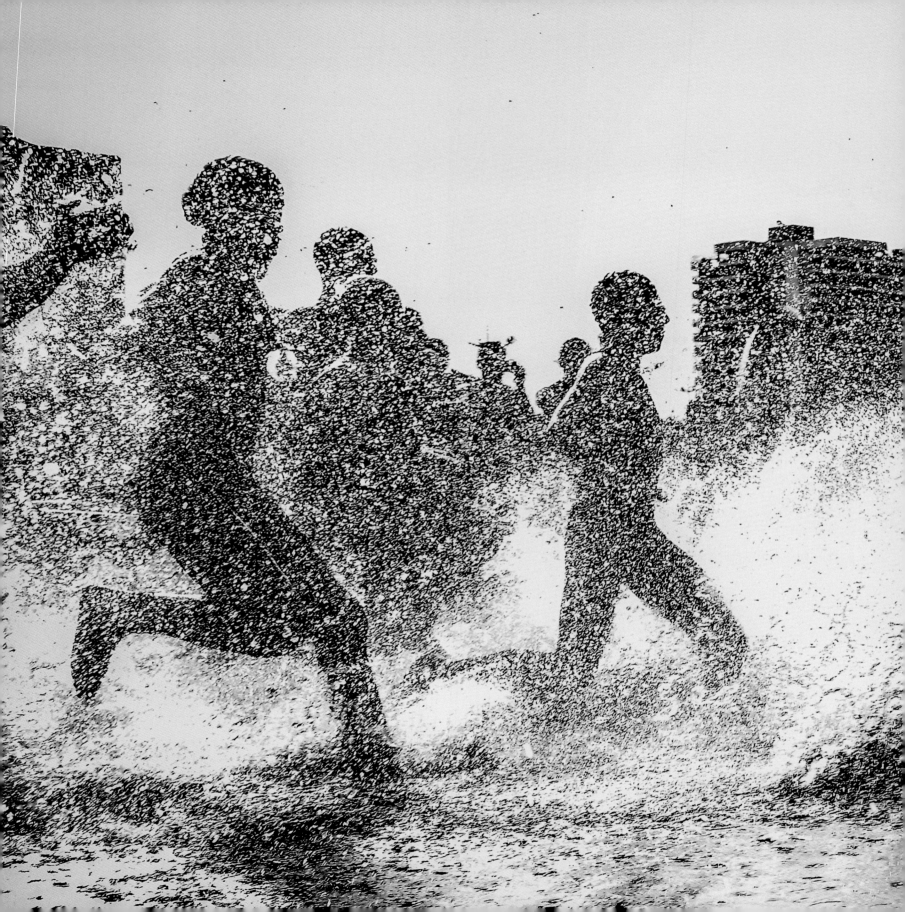

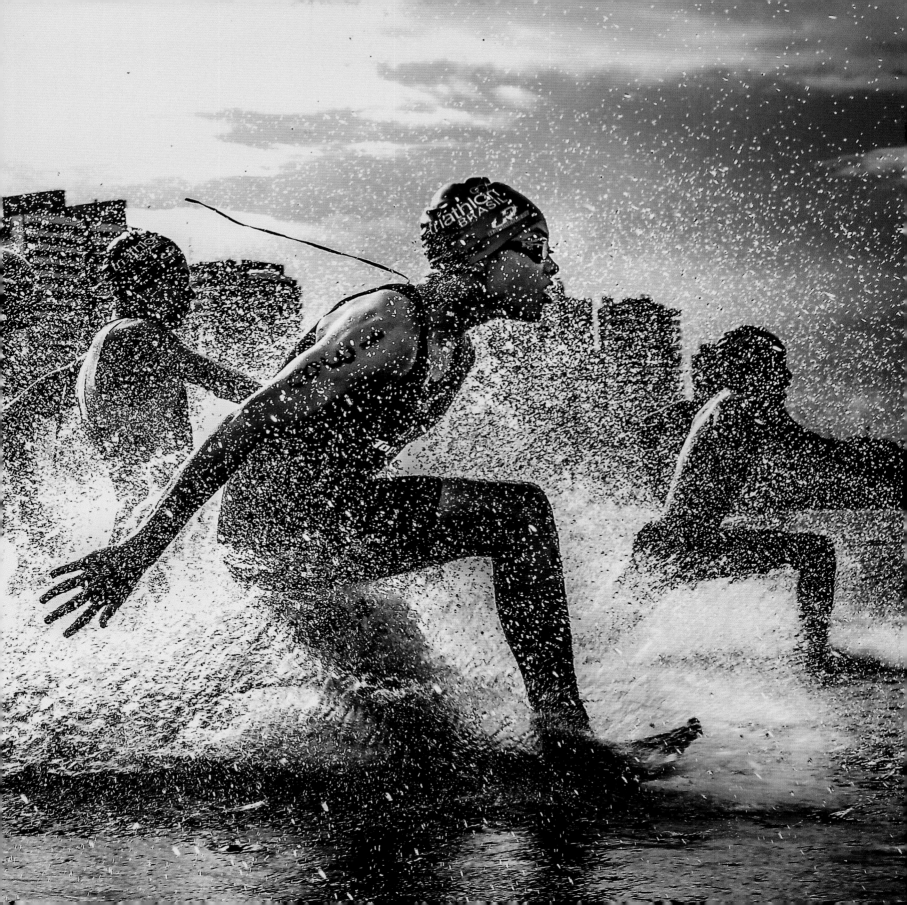

Intimacy

Whether he is an artist or not, the photographer is a joyous sensualist, for the simple reason that the eye traffics in feelings, not in thoughts.

~ Walker Evans

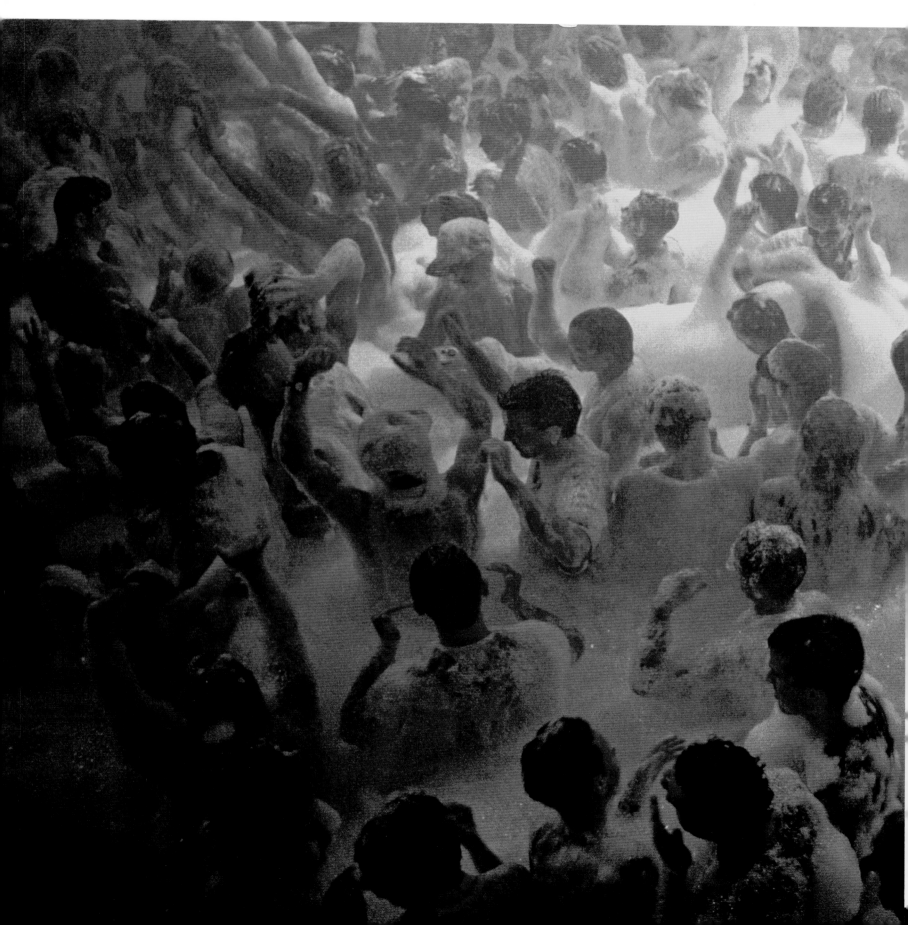

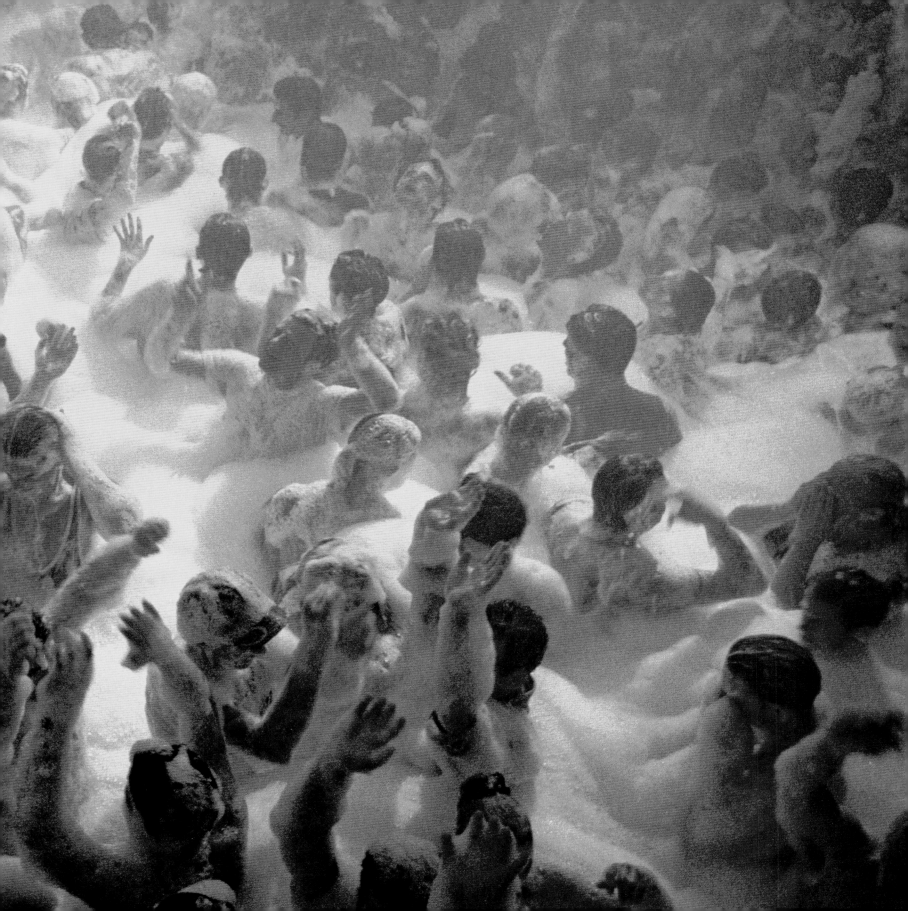

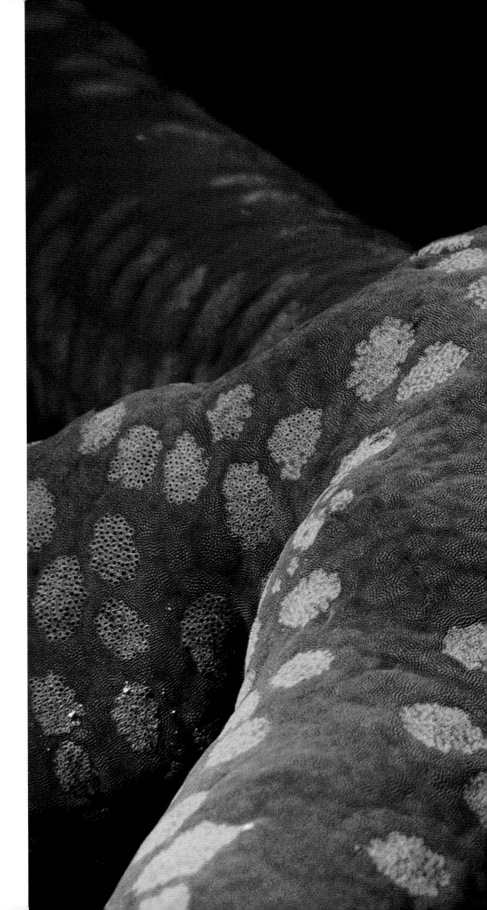

BIRGITTE WILMS
Solomon Islands
A young brittle star clings to a blue sea star.

preceding pages
TSUNEO YAMAMOTO
Antelope Canyon, Arizona
A shaft of light penetrates the interior of a slot canyon.

DAVID ALAN HARVEY
Ibiza, Spain
Dancers revel in soapsuds at a popular disco.

following page
KATHLIN BAKOS
Felcsút, Hungary
A baby and kitten share a nap.

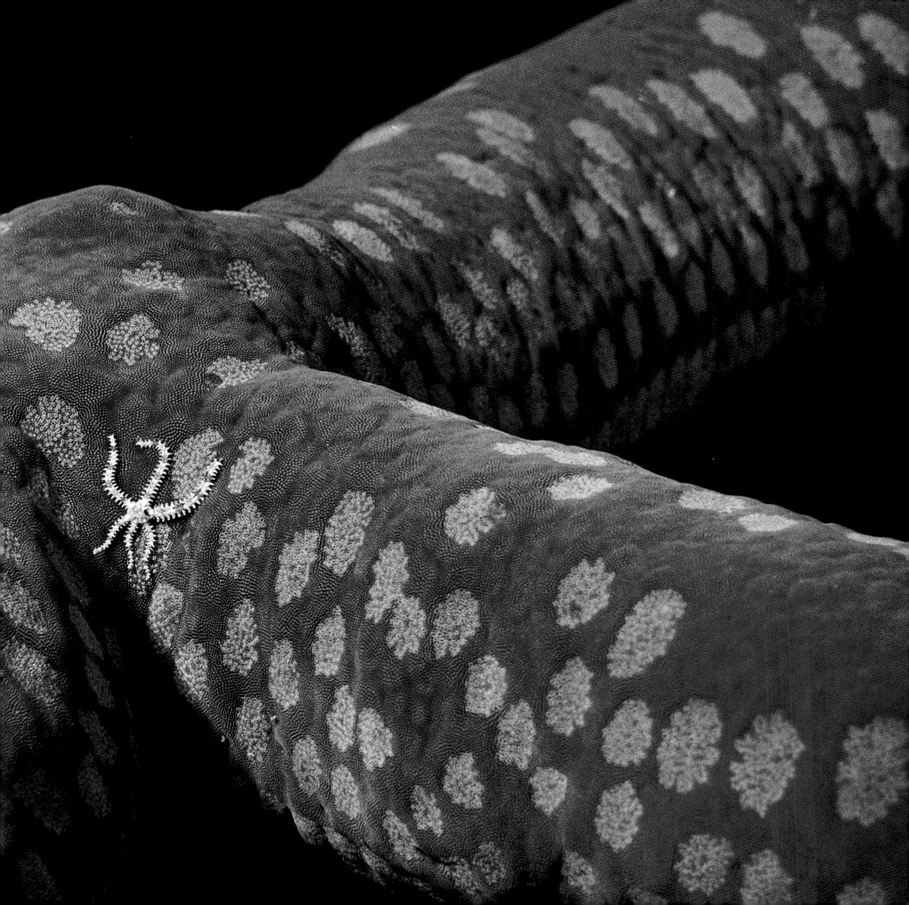

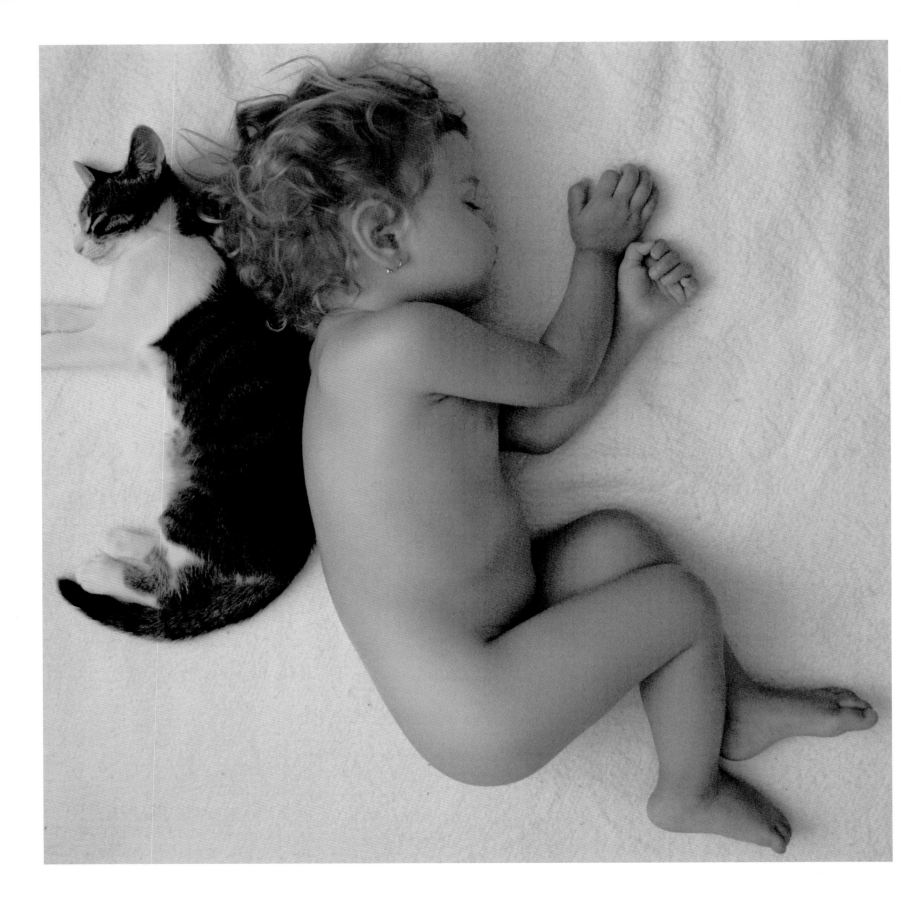

If a photographer cares about the people before the lens and is compassionate, much is given.

~ Eve Arnold

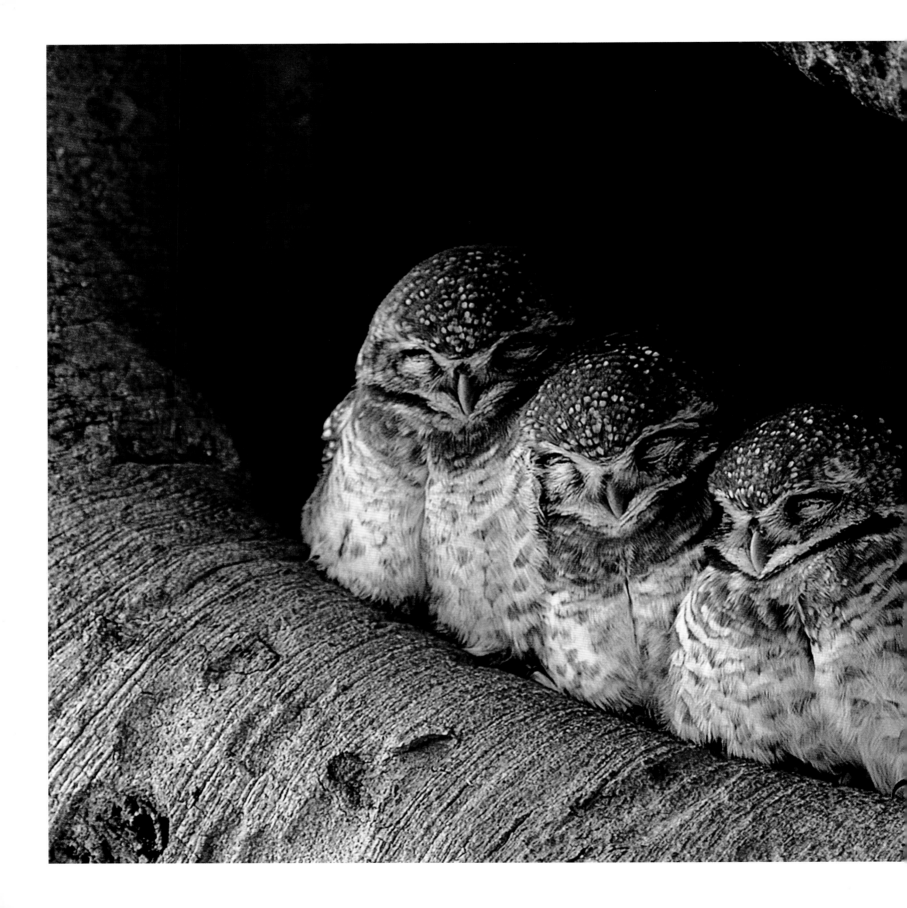

CHANDRABHAL SINGH
Maharashtra, India
Three owlets doze in a tree hollow.

following pages
UTPAL DAS
Ladakh, India
A lake catches the sky's ethereal reflection.

LESLIE ALSHEIMER
Uganda
Girls laugh and play in a dirt yard in their village.

BRIAN SKERRY
Auckland Islands, New Zealand
A pair of southern right whales frolics in a marine reserve.

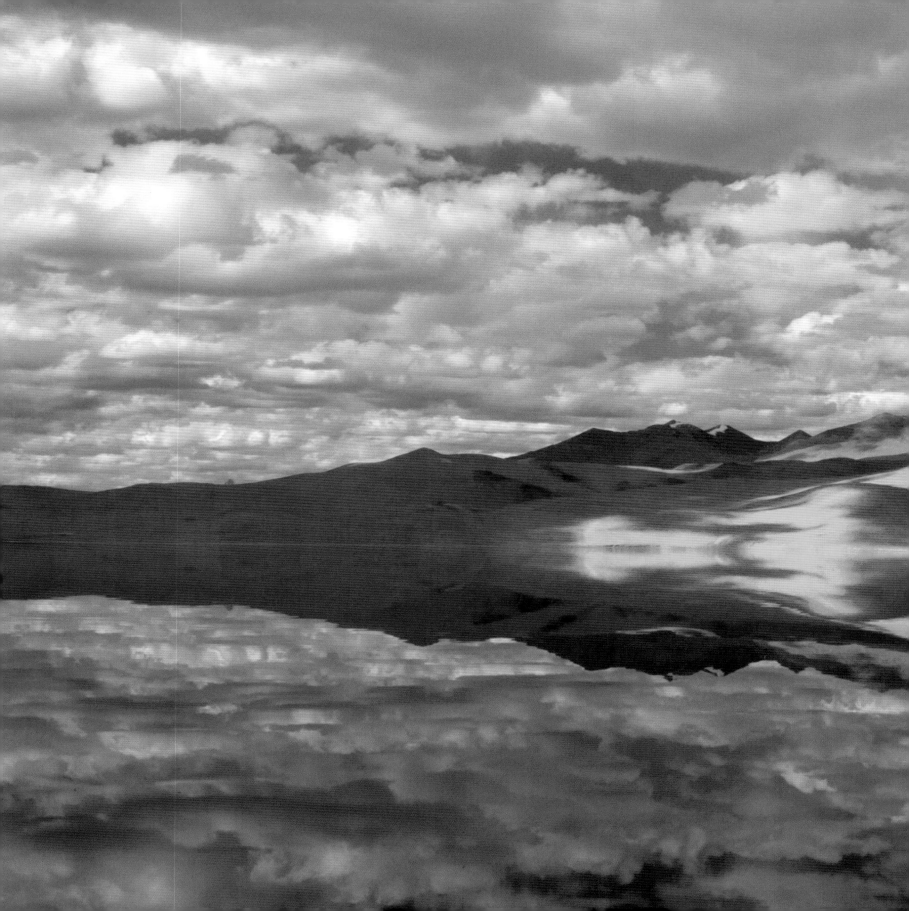

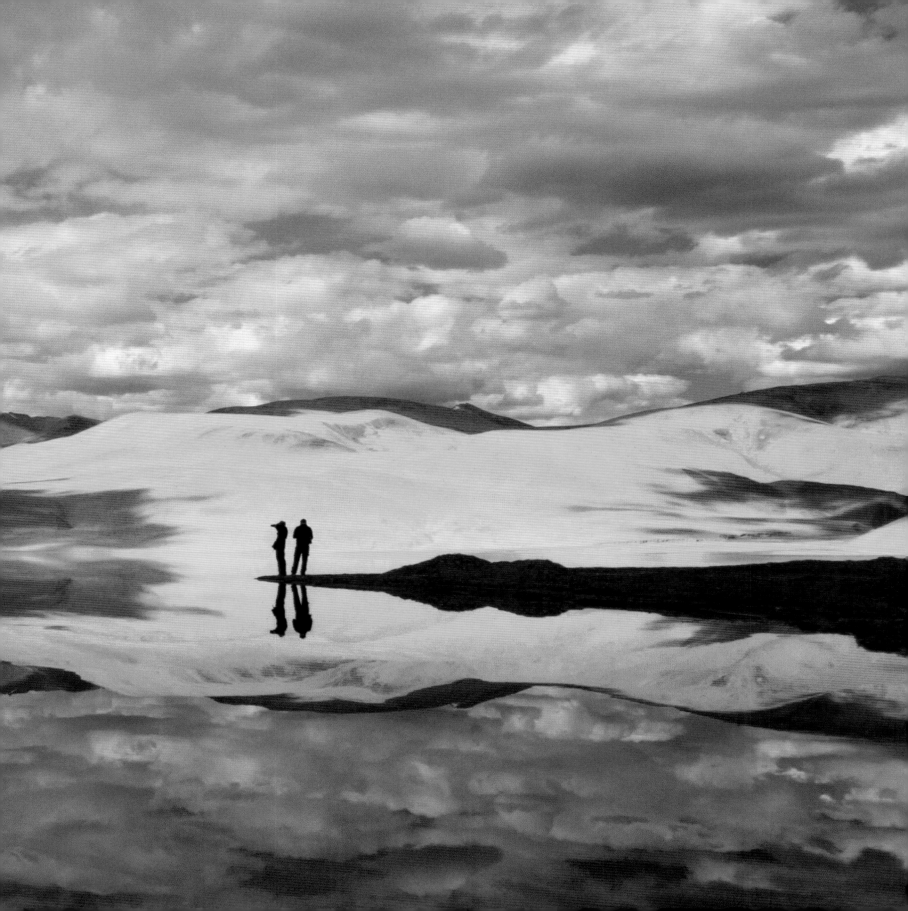

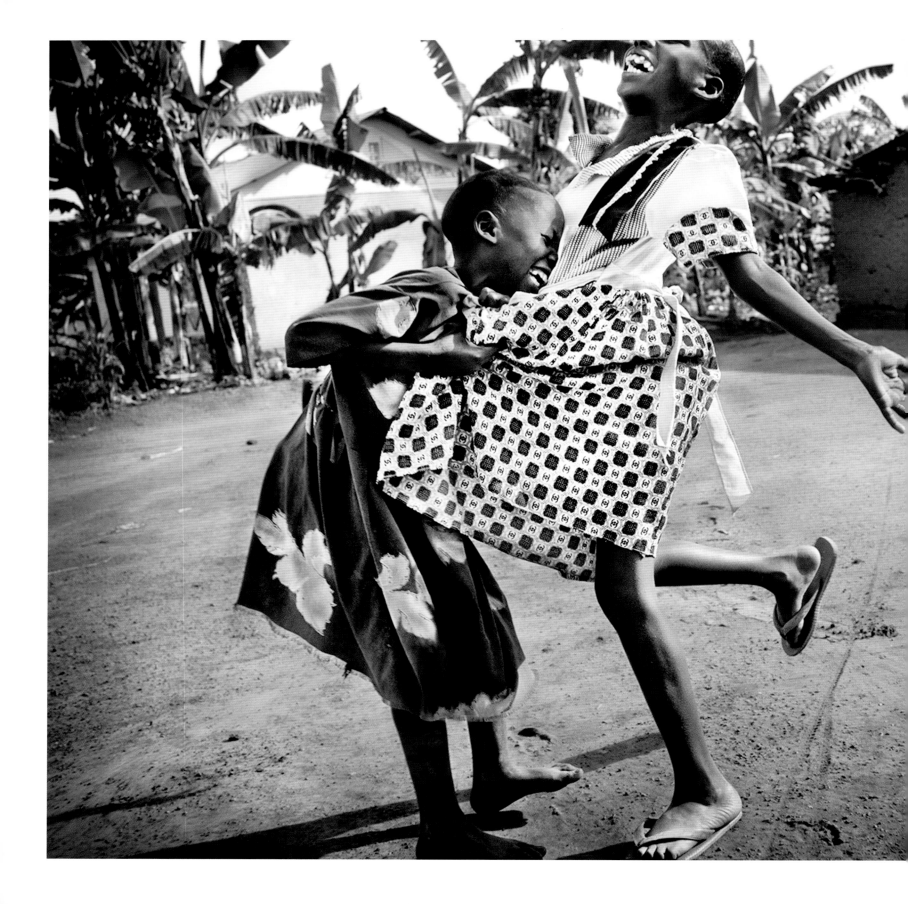

The need for love and intimacy is a fundamental human need, as primal as the need for food, water, and air.

~ Dean Ornish

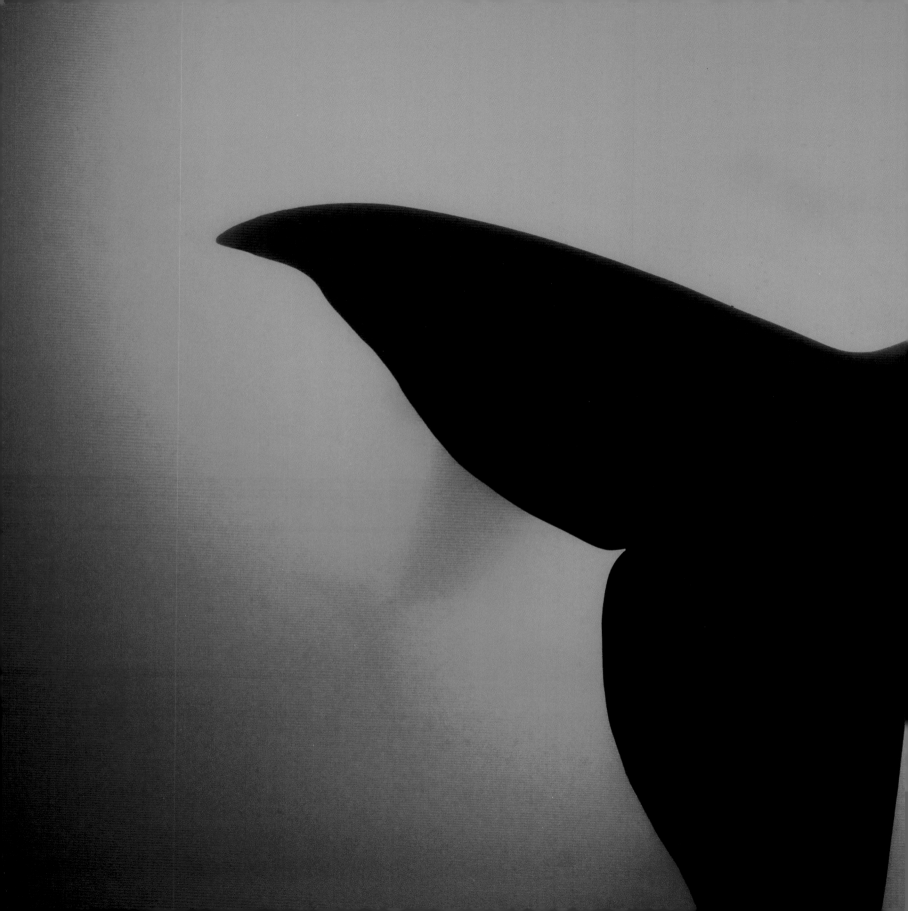

LOURIE ZIPF
Livermore, Colorado
A woman embraces her mustang
mare, Bella.

following page
MARC ADAMUS
Alberta, Canada
An unfrozen stream snakes toward
the setting sun.

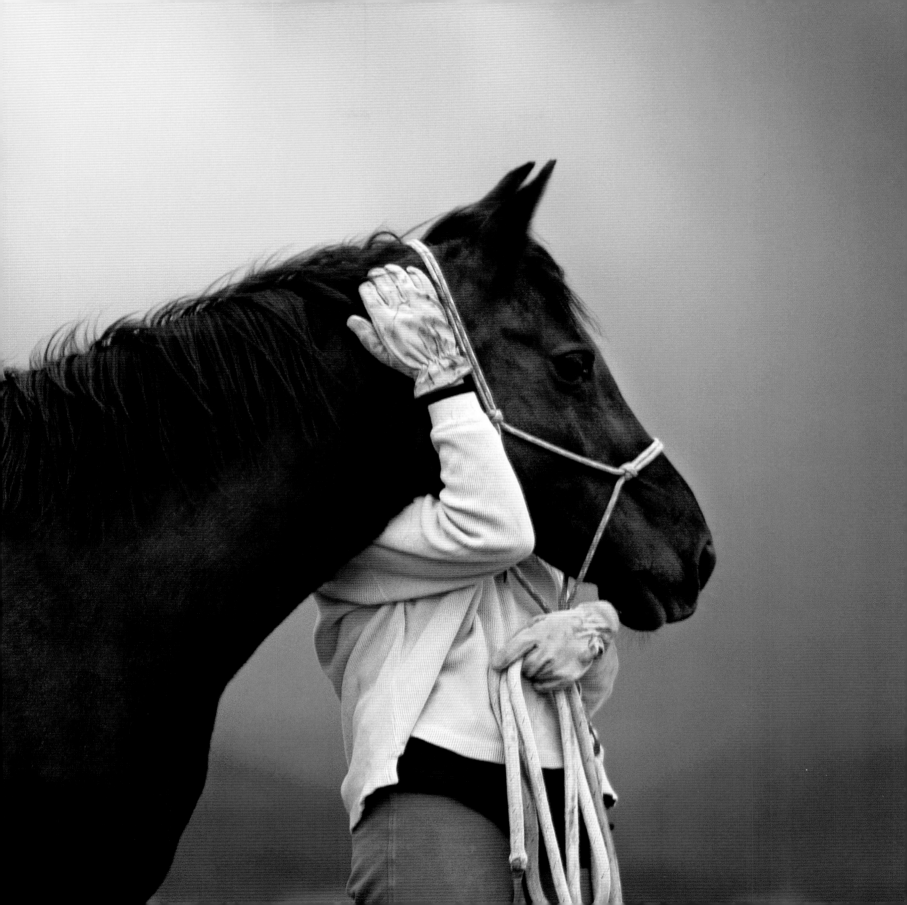

A picture is
the expression
of an impression.
If the beautiful
were not in us,
how would we
ever recognize it?

~ Ernst Haas

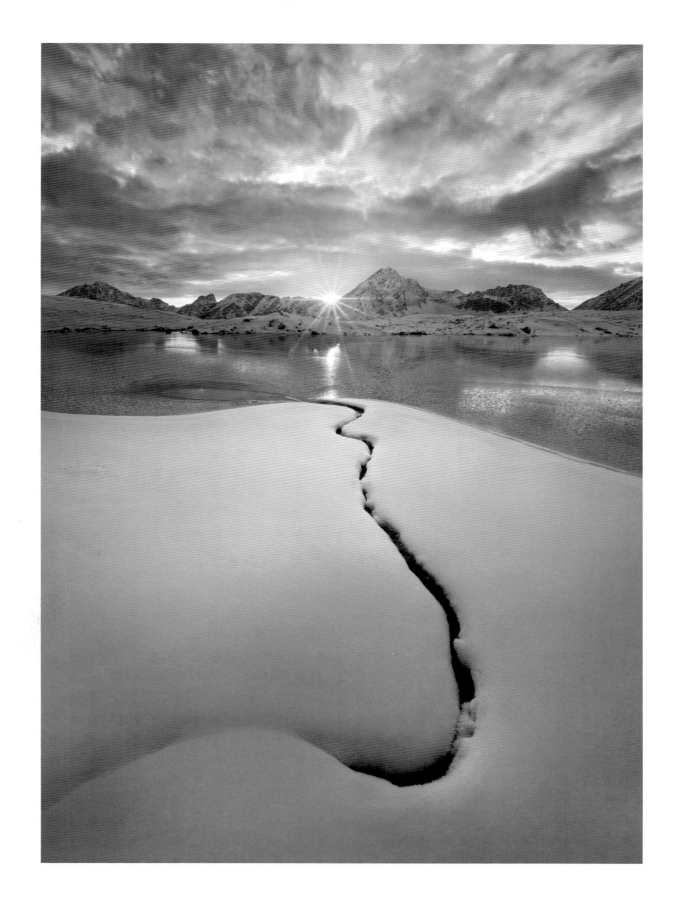

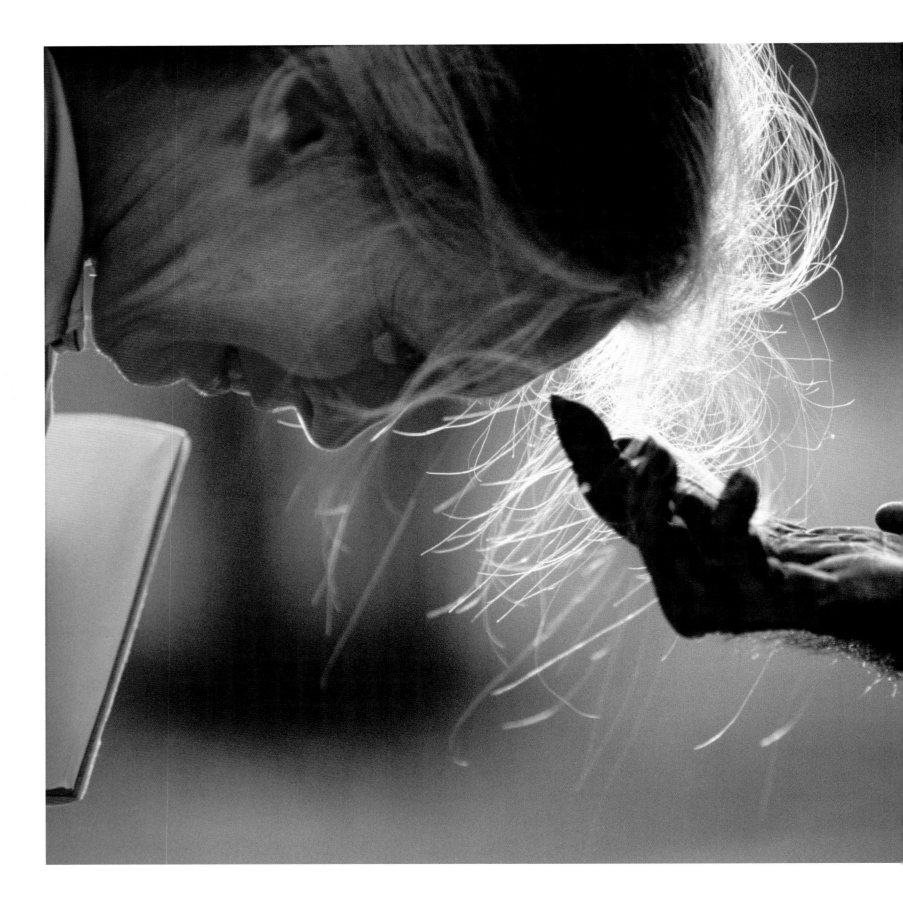

MICHAEL NICHOLS
Brazzaville, Republic of the Congo

Primatologist Jane Goodall lowers her head as Jou Jou, a chimpanzee, reaches out to touch her.

following pages
JED WEINGARTEN
British Columbia, Canada

A Kermode bear sleeps on a bed of moss in the Great Bear Rainforest.

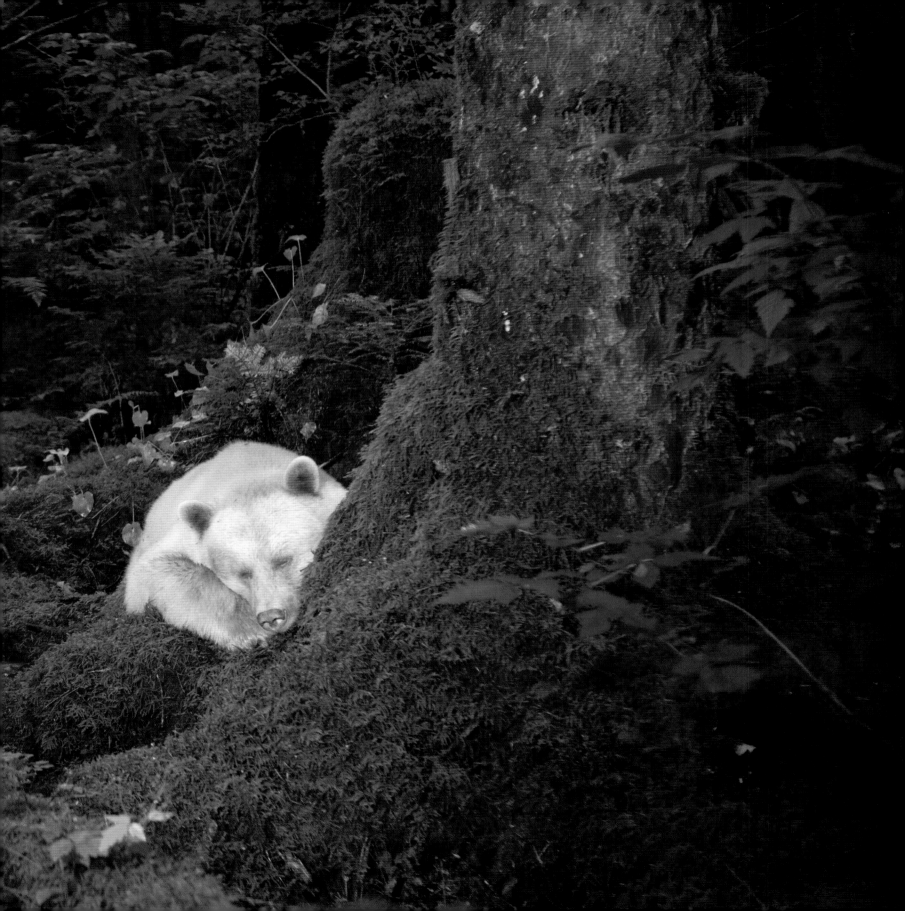

LUKE TRAUTWEIN

Battambang, Cambodia

Two young Buddhist monks snooze
through a bus ride.

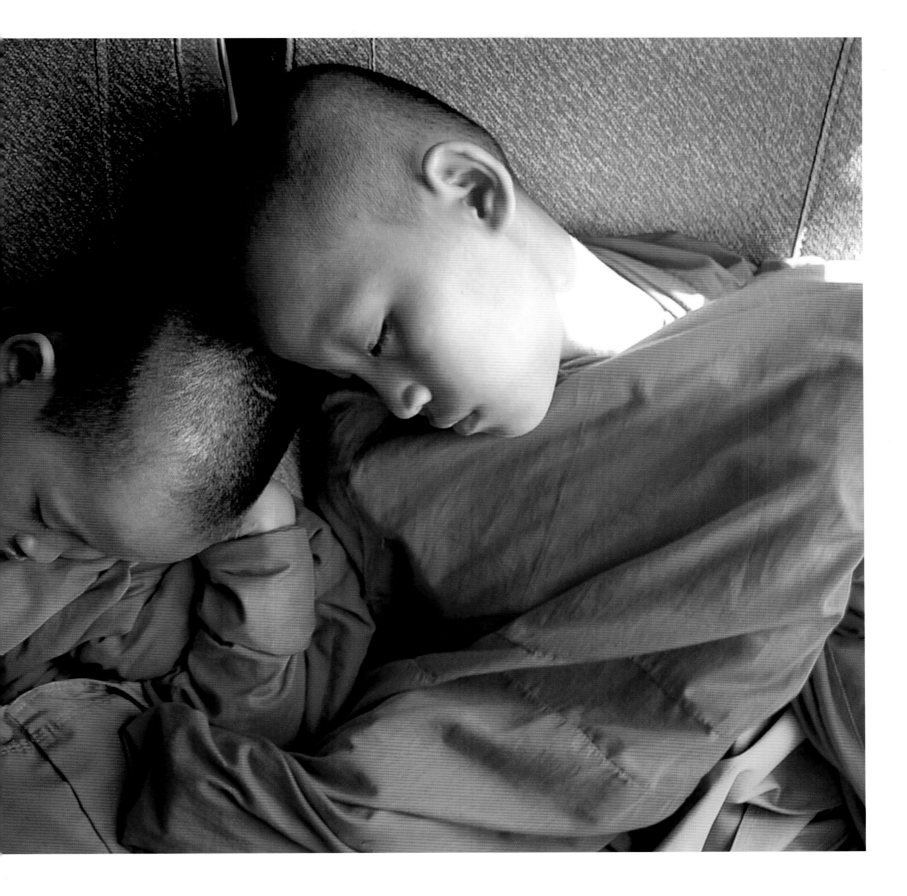

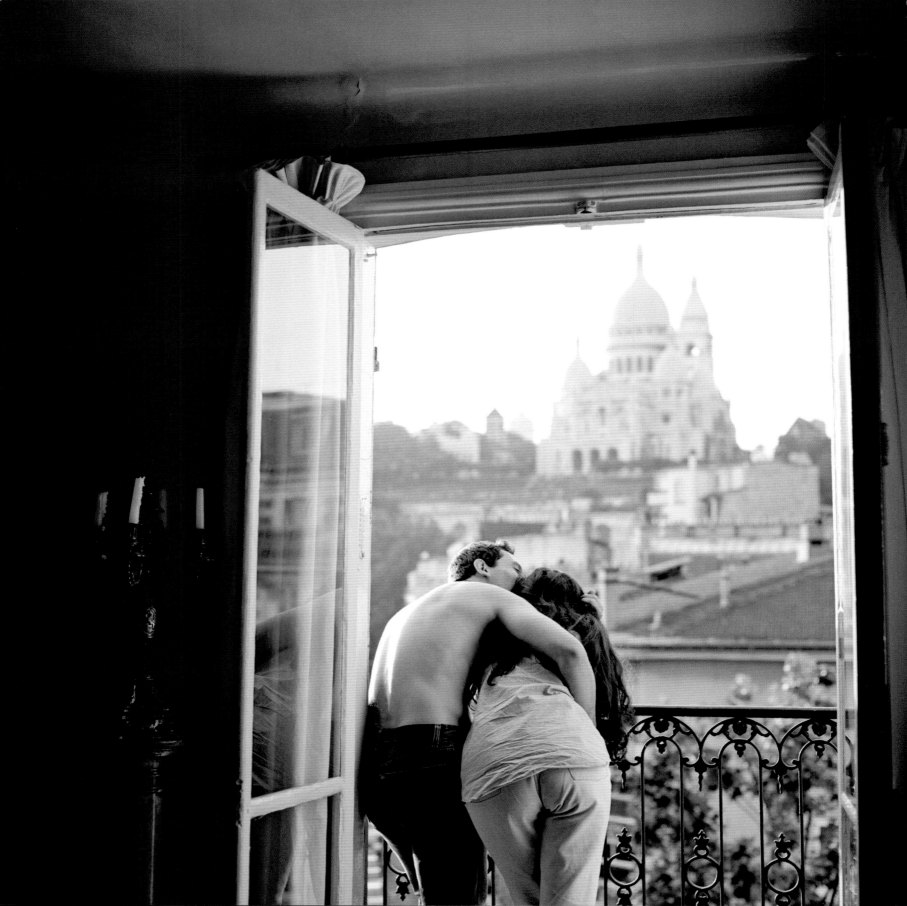

Lynn Johnson

This photograph was shot for a *National Geographic* magazine story about Vincent van Gogh, who was a man constantly in search of love, especially during his time in Paris. I was looking for scenes of lovers that felt timeless. Intimacy in a photograph is about being patient and being quiet. It is so important that the photographer disappear . . . allow honest moments to begin, unimpeded by courtesy. Intimacy must come to you. You can invite it. You can make space for it. But you cannot schedule or control it.

LYNN JOHNSON
Paris, France
Lovers cuddle on a balcony opposite
Sacré-Coeur Basilica.

JAN VERMEER
Snow Hill Island, Antarctica
Emperor penguins lean in to touch
beaks as a display of affection.

following pages
ALBENA MARKOVA
Bulgaria
Poppies bloom in a sun-drenched field.

SREERAJ UNNITHAN
Bangalore, India
A mother feeds a fish to a juvenile egret.

LAUREN DEBELL
Bend, Oregon
A woman relaxes in a hot soaking tub.

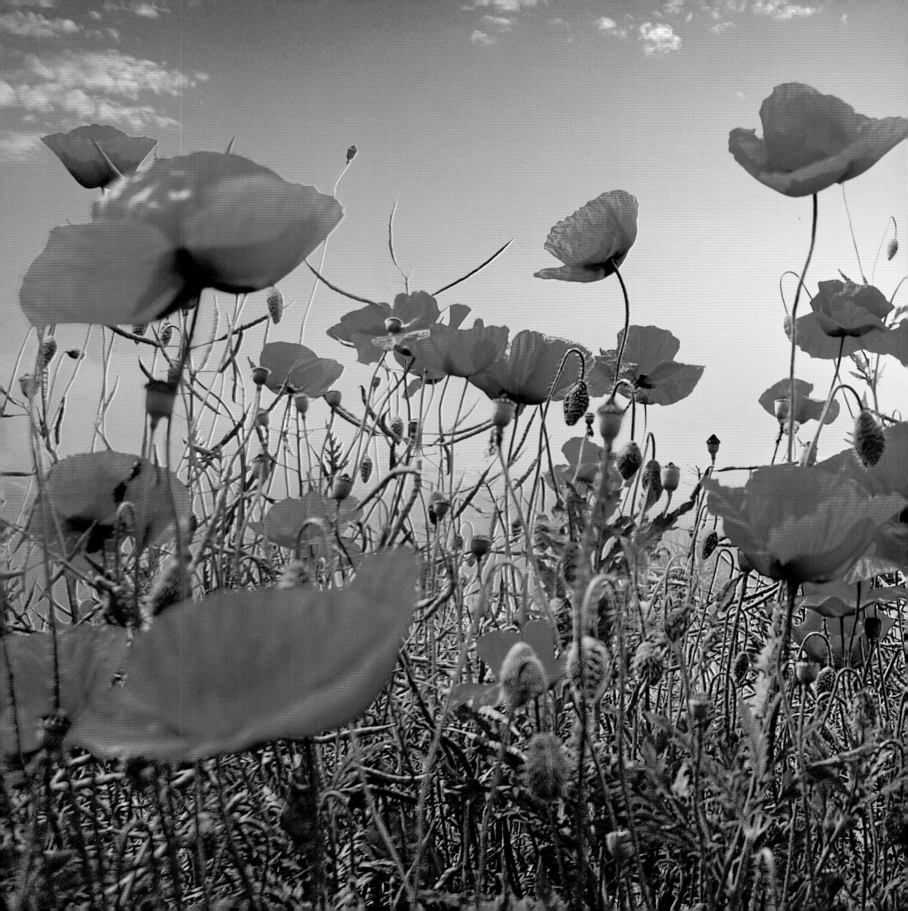

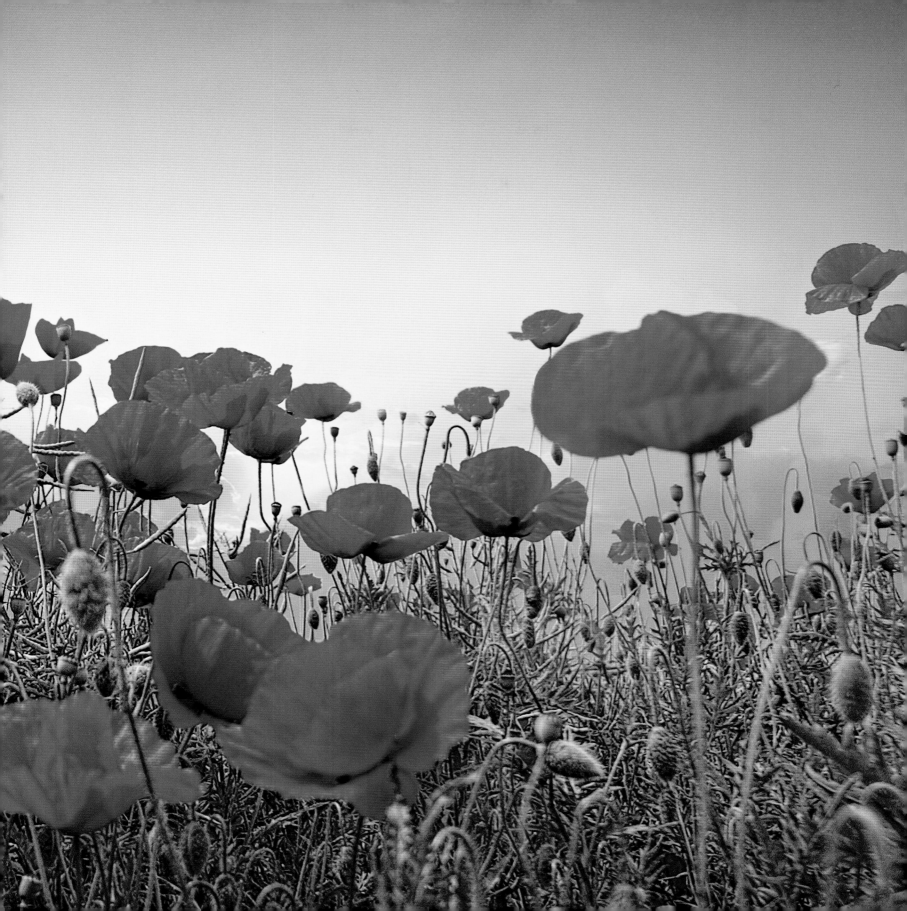

The painter constructs, the photographer discloses.

~ Susan Sontag

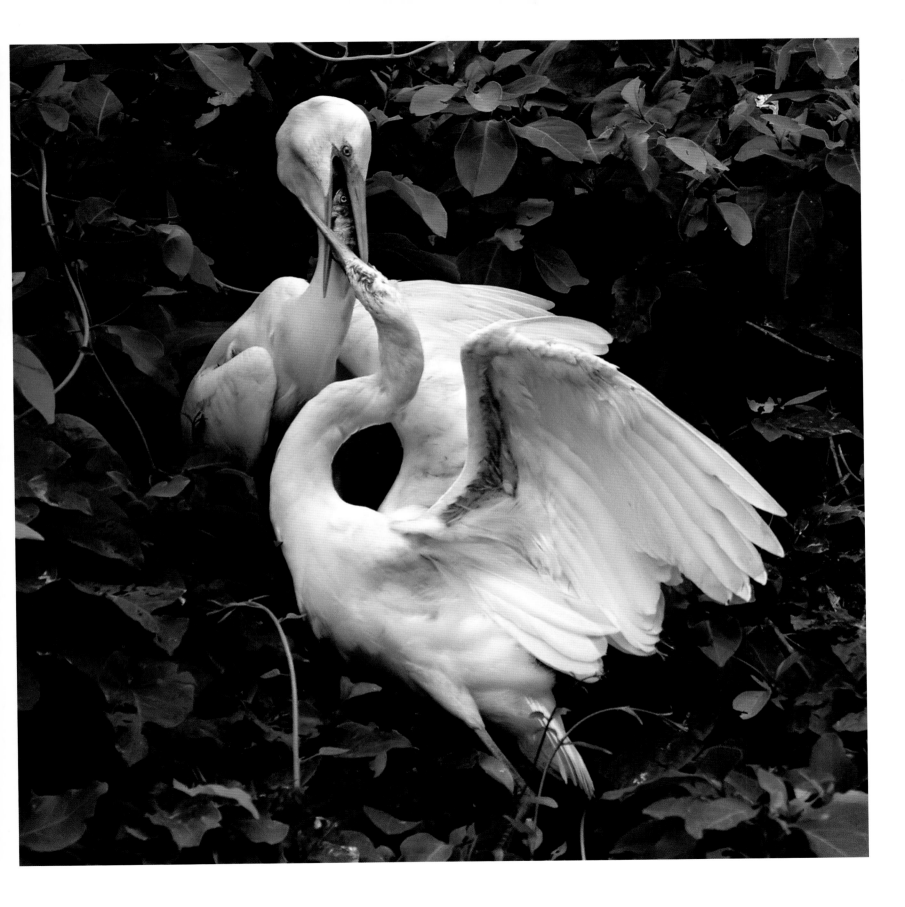

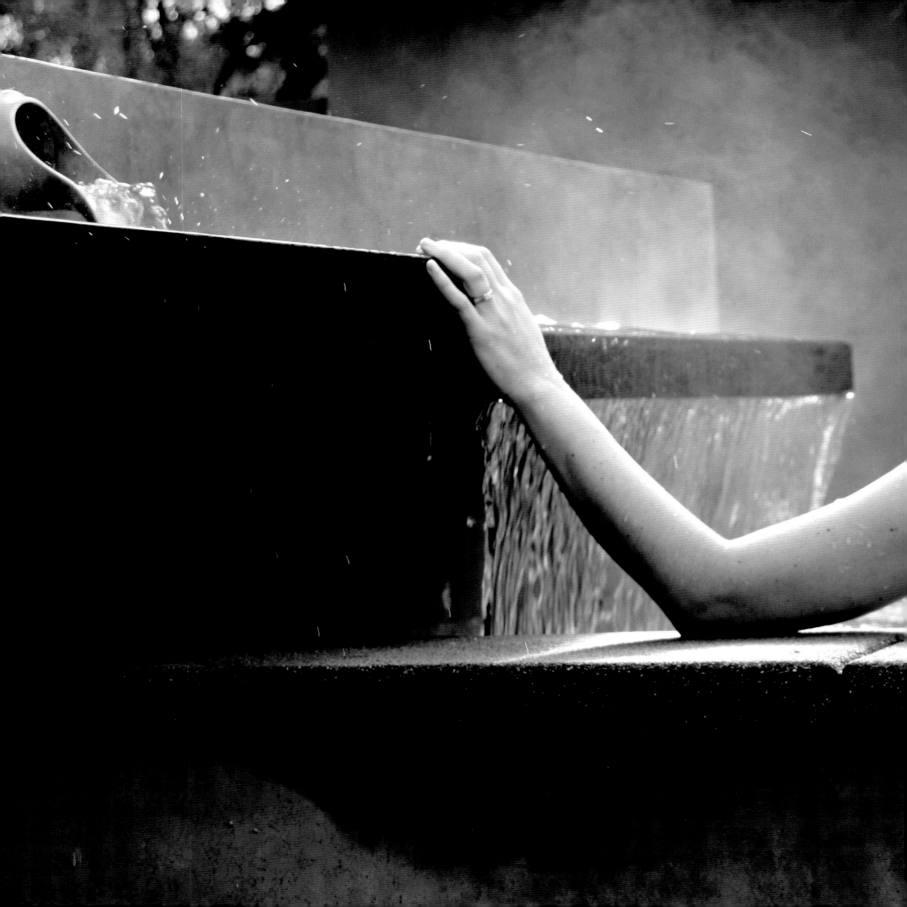

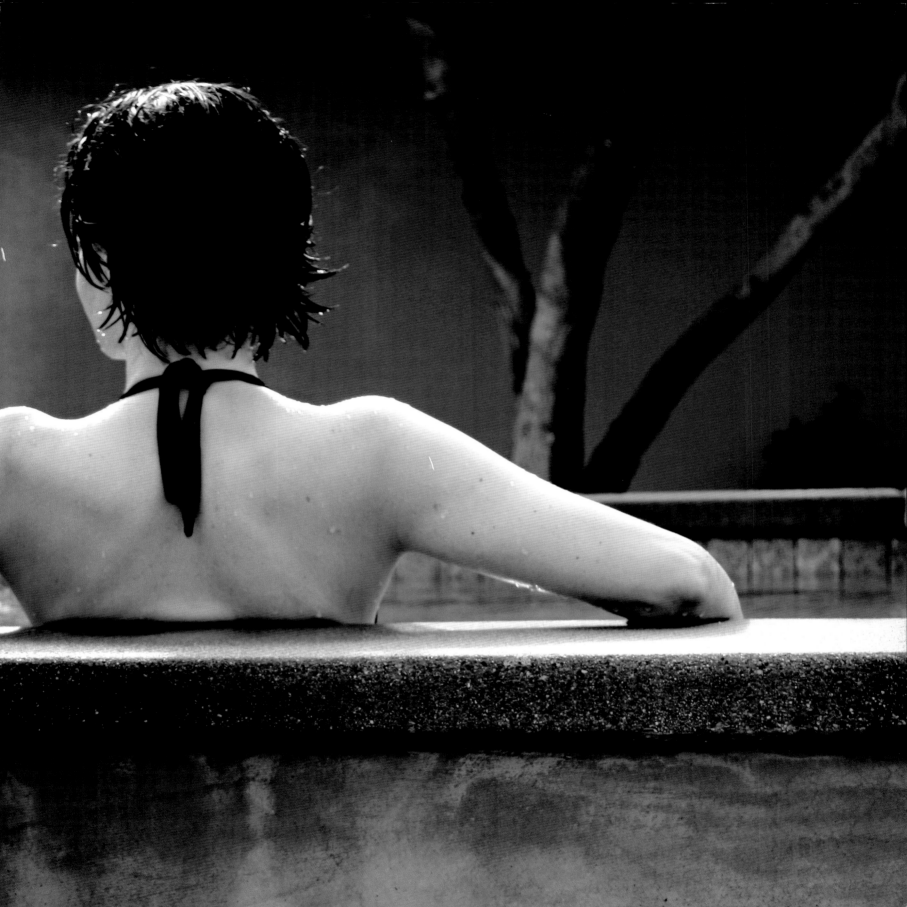

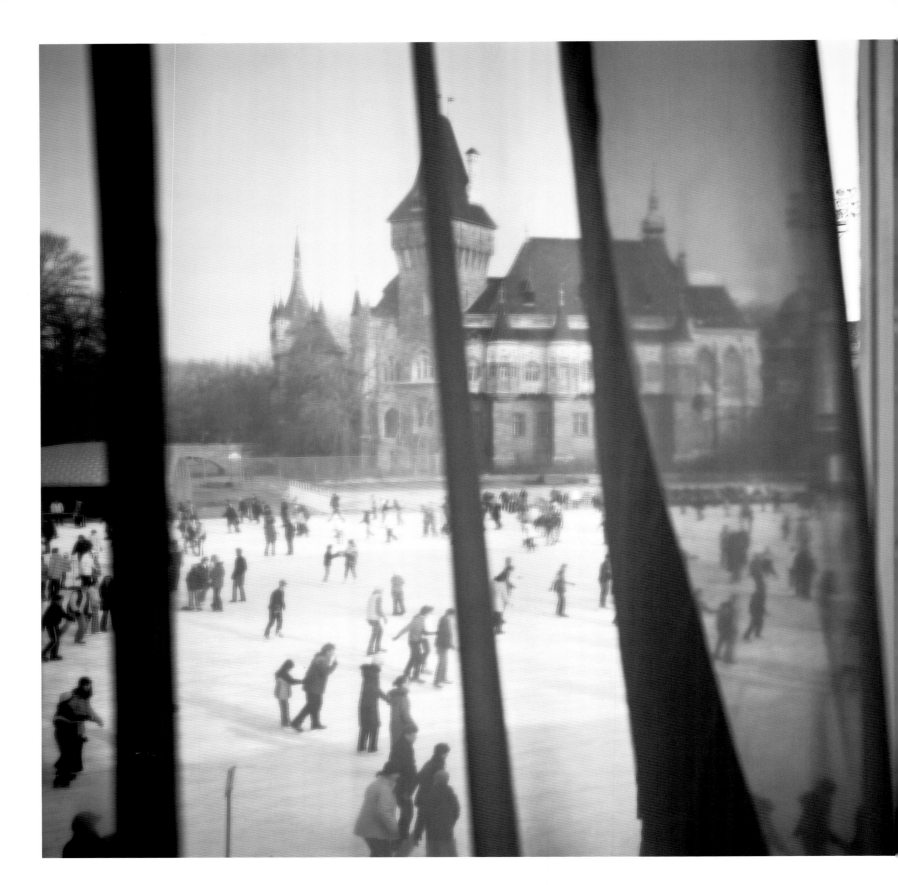

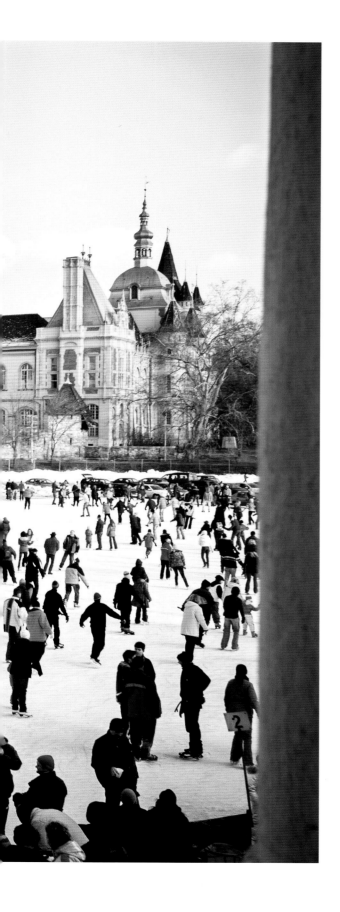

AMI VITALE
Budapest, Hungary
Sheer curtains veil skaters on an ice rink opposite historic Vajdahunyad Castle.

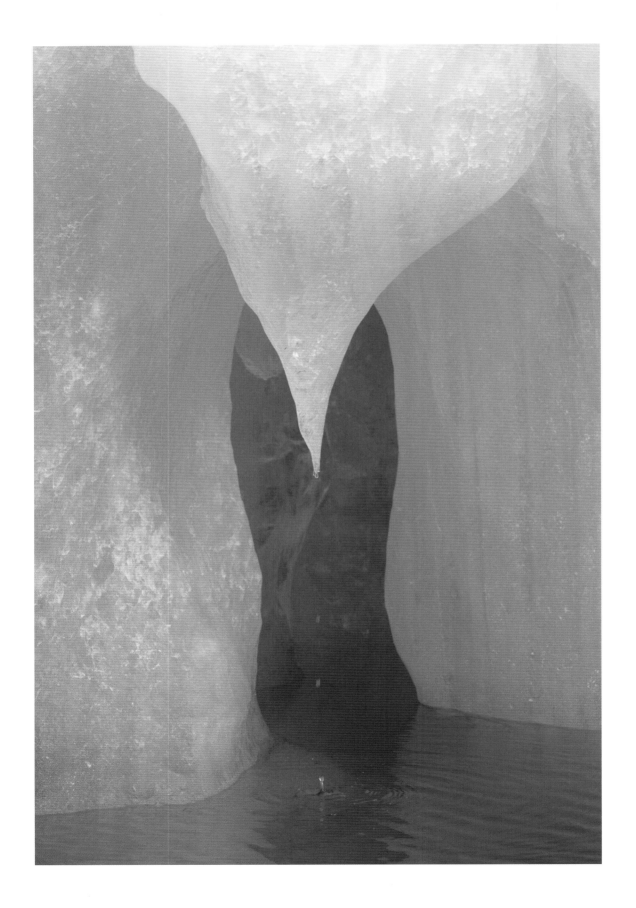

Ralph Lee Hopkins

I dream of ice. Arctic landscapes can look cold and featureless, but there's magic in the details. I look for microcosms in the grand landscape that reveal a delicate balance.

Each iceberg is a unique work of art. There's nothing more magical to me than the way light is absorbed and retransmitted in an intense blue, as if lit from within. Both glacial and pack ice is disappearing at an alarming rate. Each drop freezes a timeless moment, creating an intimate connection with what is being lost.

RALPH LEE HOPKINS
Hornsund, Norway
Melting glaciers transform a fjord.

TOMASZ TOMASZEWSKI
Moldavia, Romania

A couple kisses in a lace-curtained doorway.

following page
SARAH RUPP
Senoia, Georgia

A young woman covers her face to stifle a laugh.

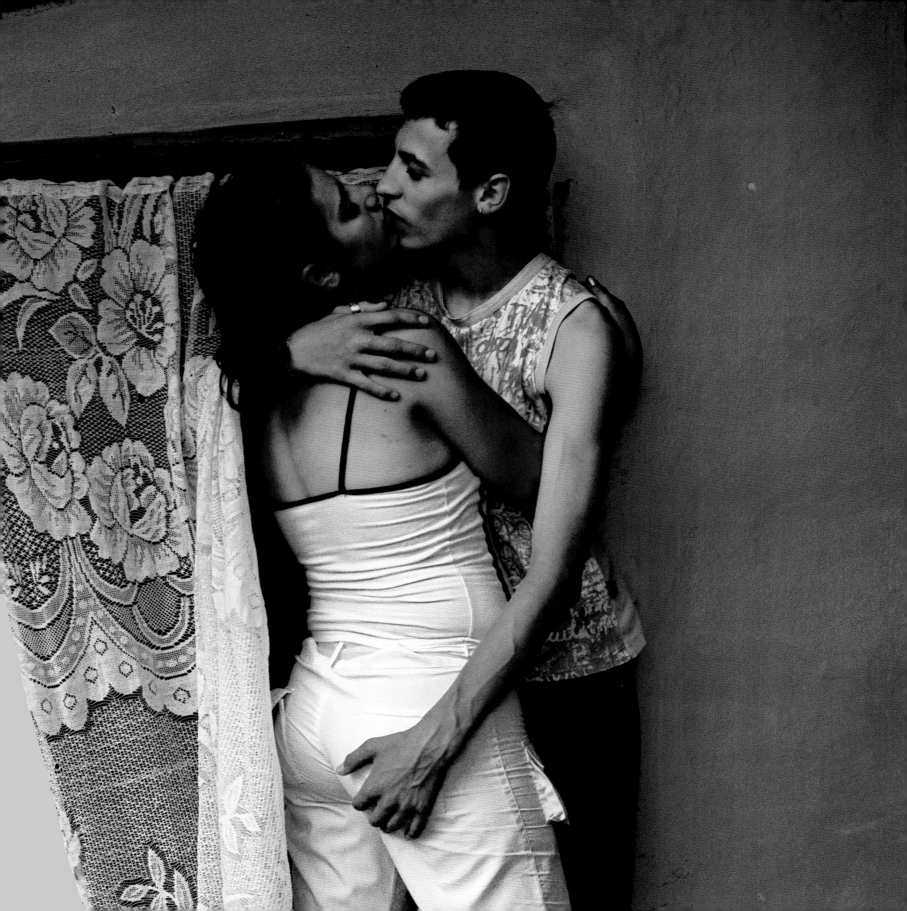

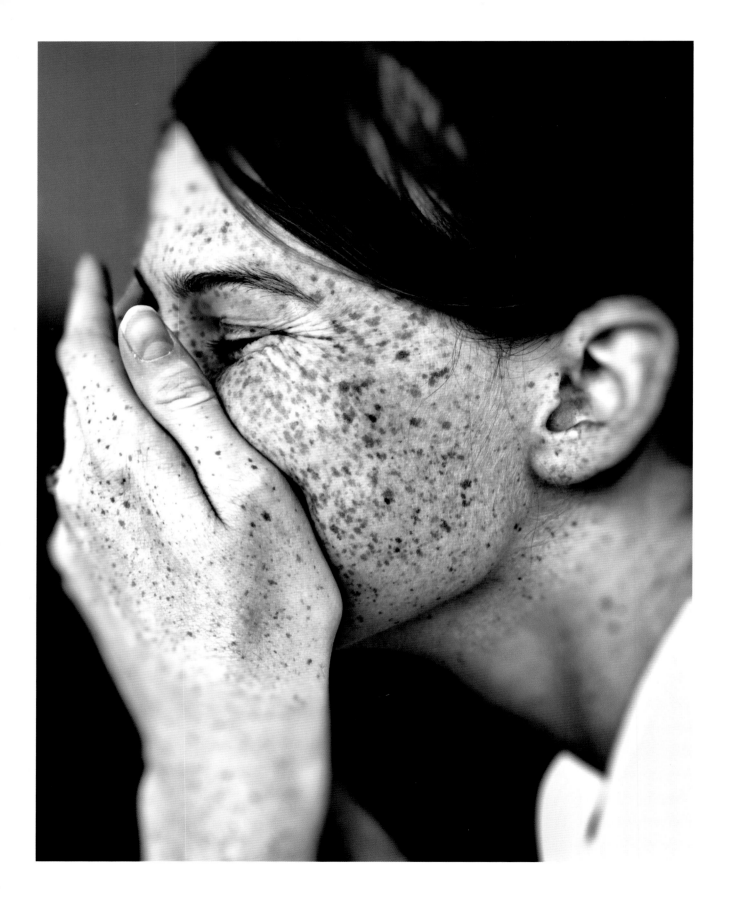

It is one thing to photograph people. It is another to make others care about them by revealing the core of their humanness.

~ Paul Strand

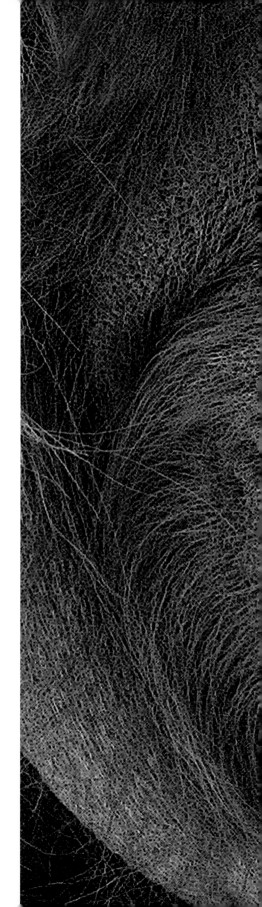

CHERYL ARENA MOLENNOR

Tampa, Florida

A baby orangutan's kiss elicits a smile
from her mother.

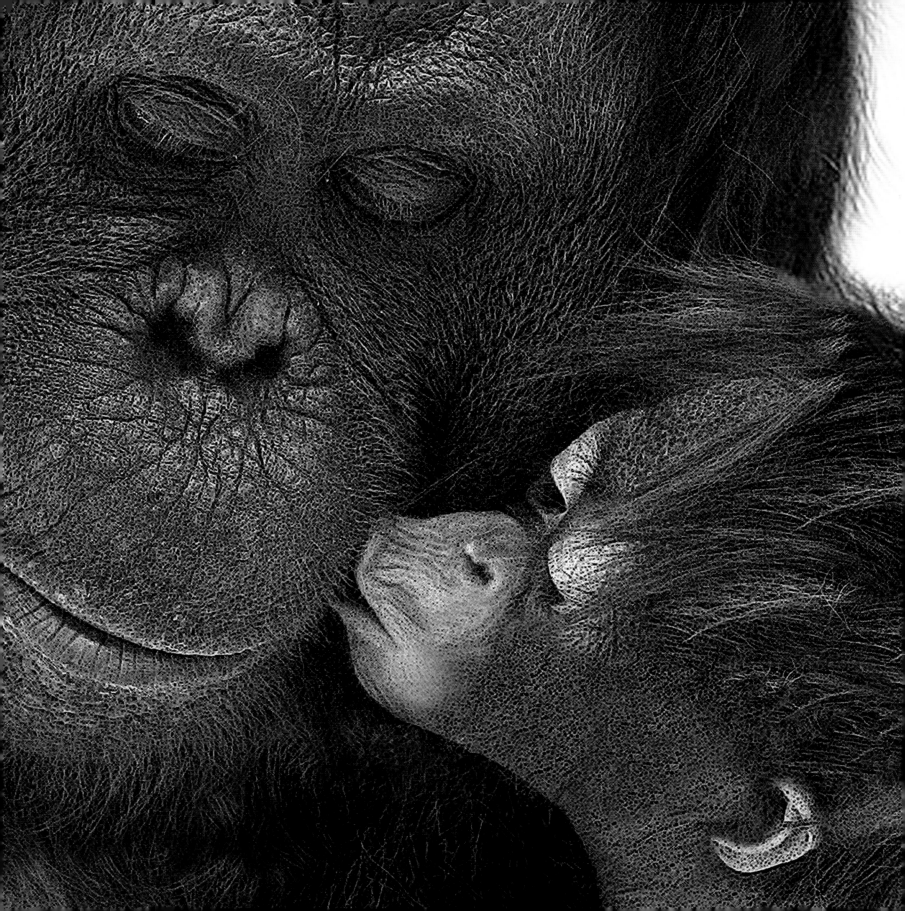

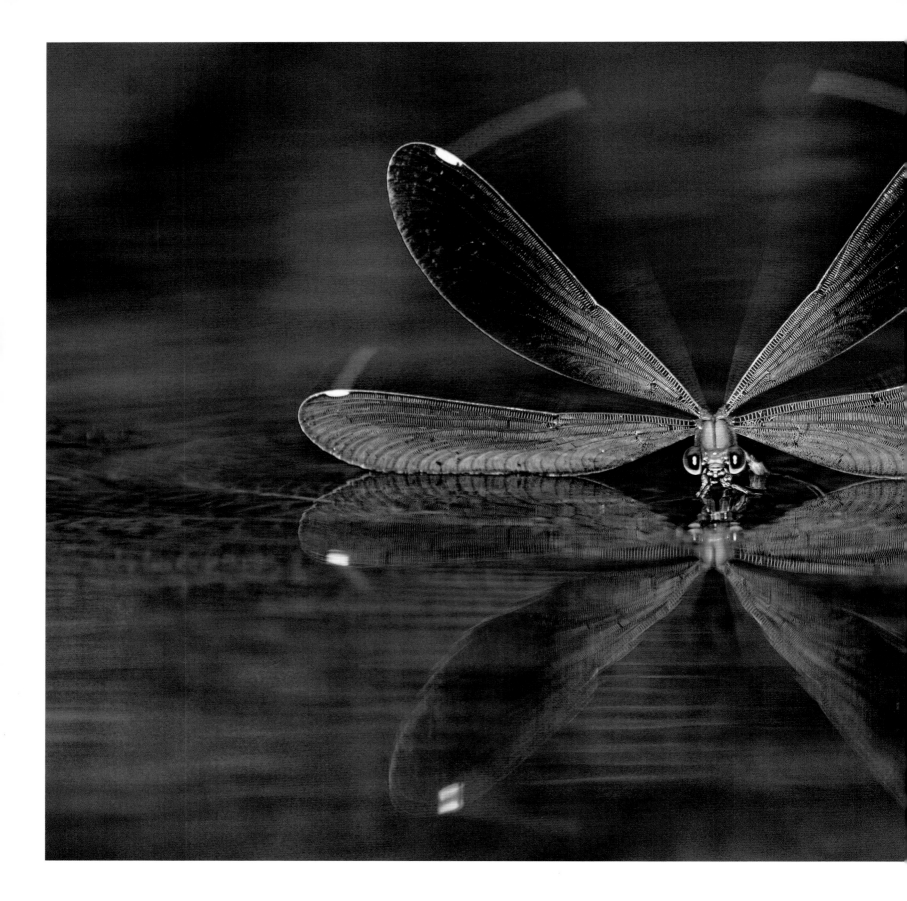

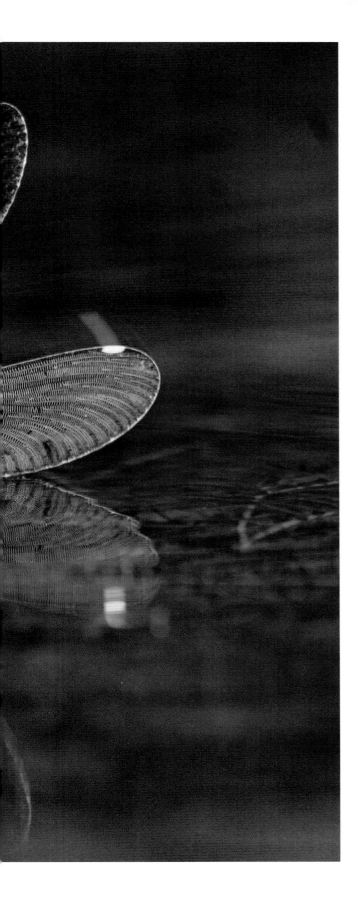

JOE PETERSBURGER
Taiwan
A pond mirrors a Formosan jewelwing
damselfly perched at the water's edge.

following pages
CHRIS ARCHINET
Jura Mountains Regional Natural Park,
France
Winter fog blankets a rural church.

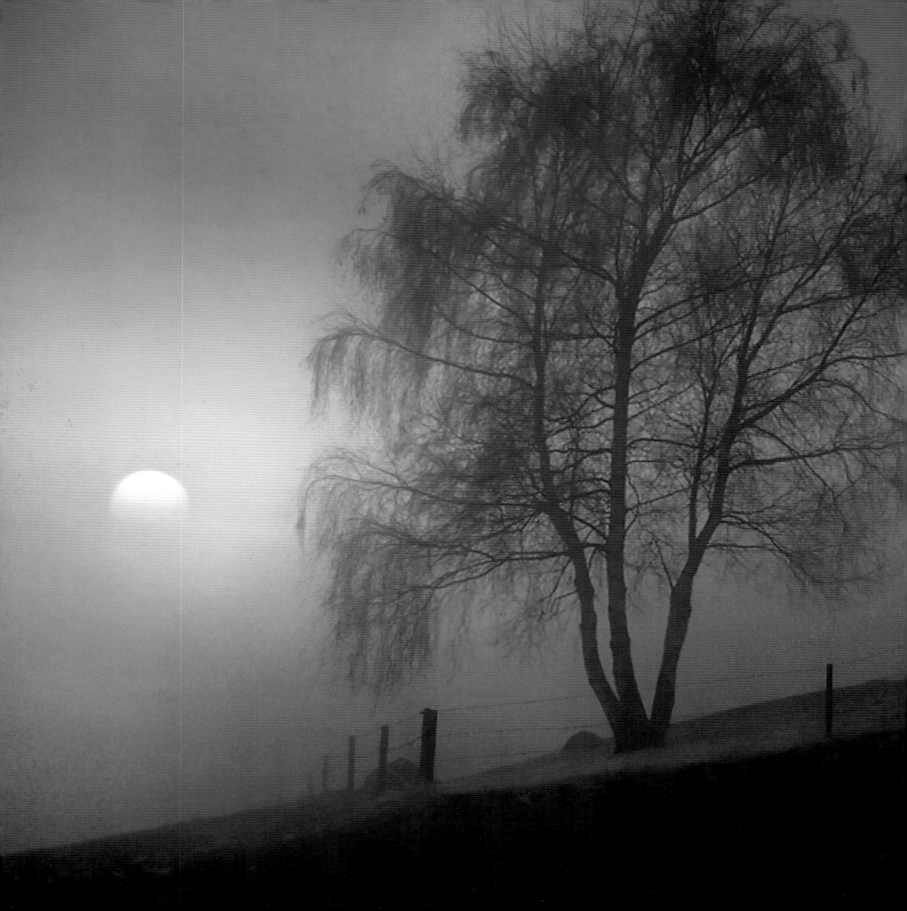

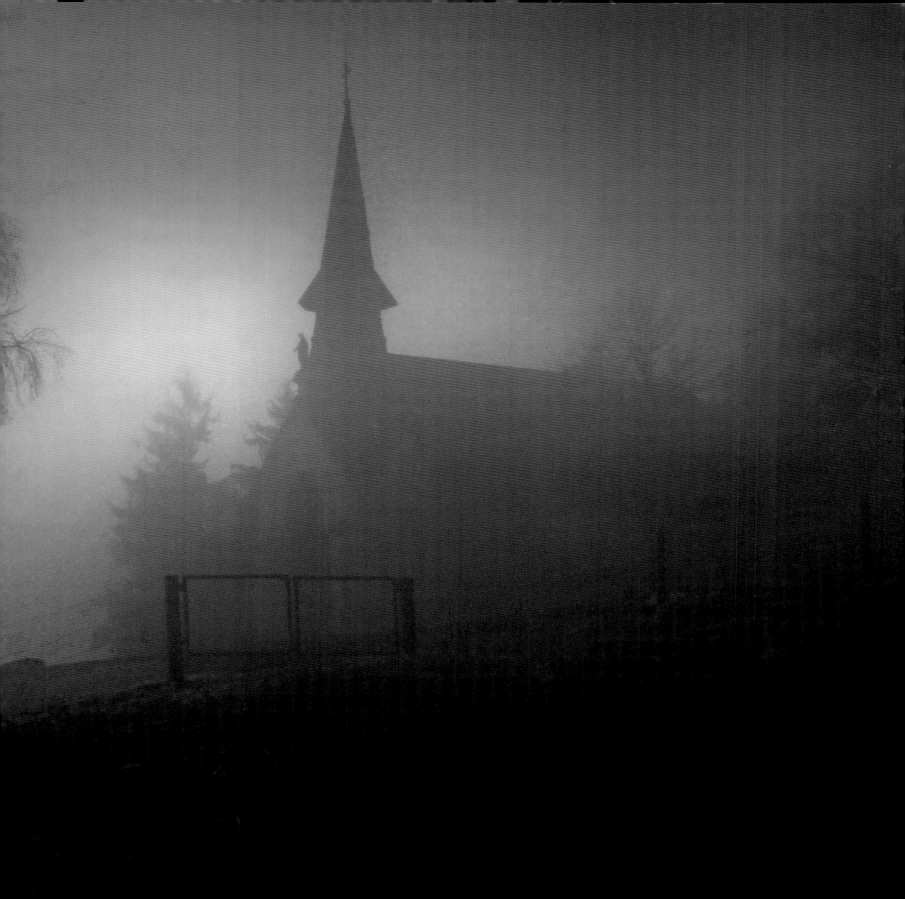

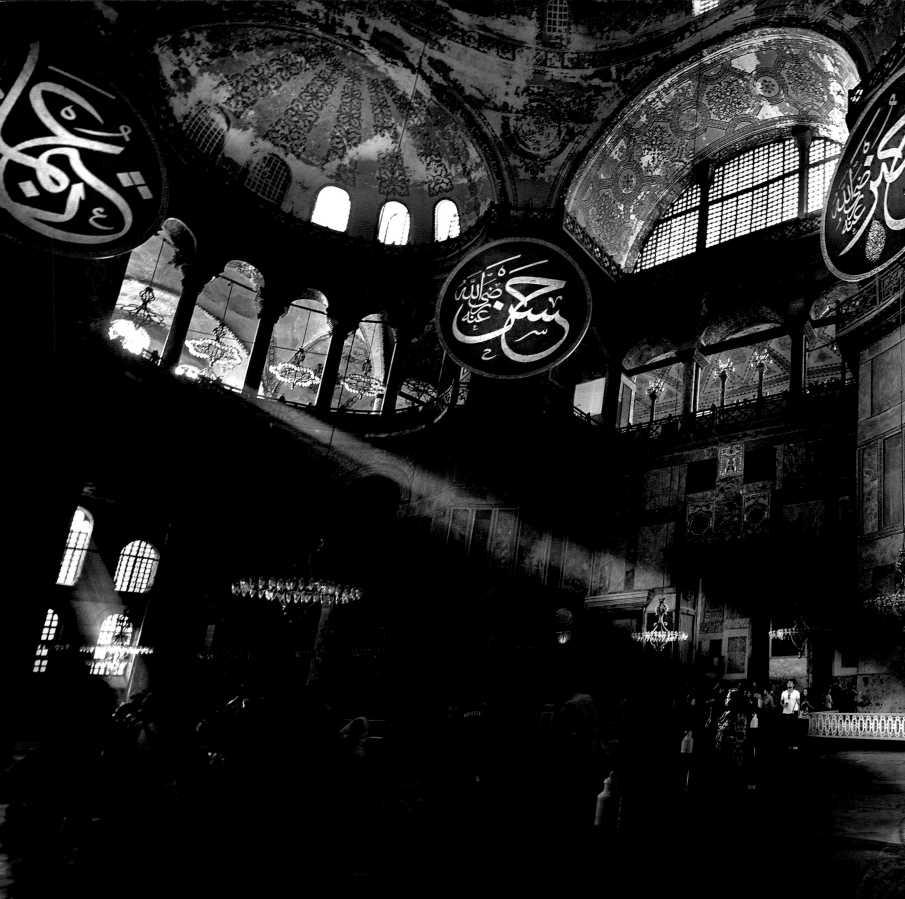

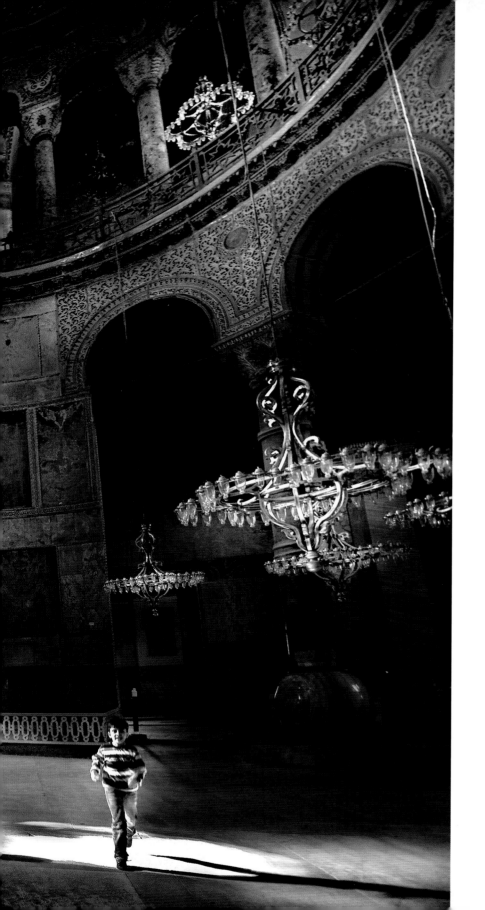

MELIH SULAR
Istanbul, Turkey
A boy steps into a beam of sunlight in Hagia Sophia museum.

RANDY OLSON

Tutuila Island, American Samoa

A parishioner amuses a child
snuggled in his mother's arms
during church service.

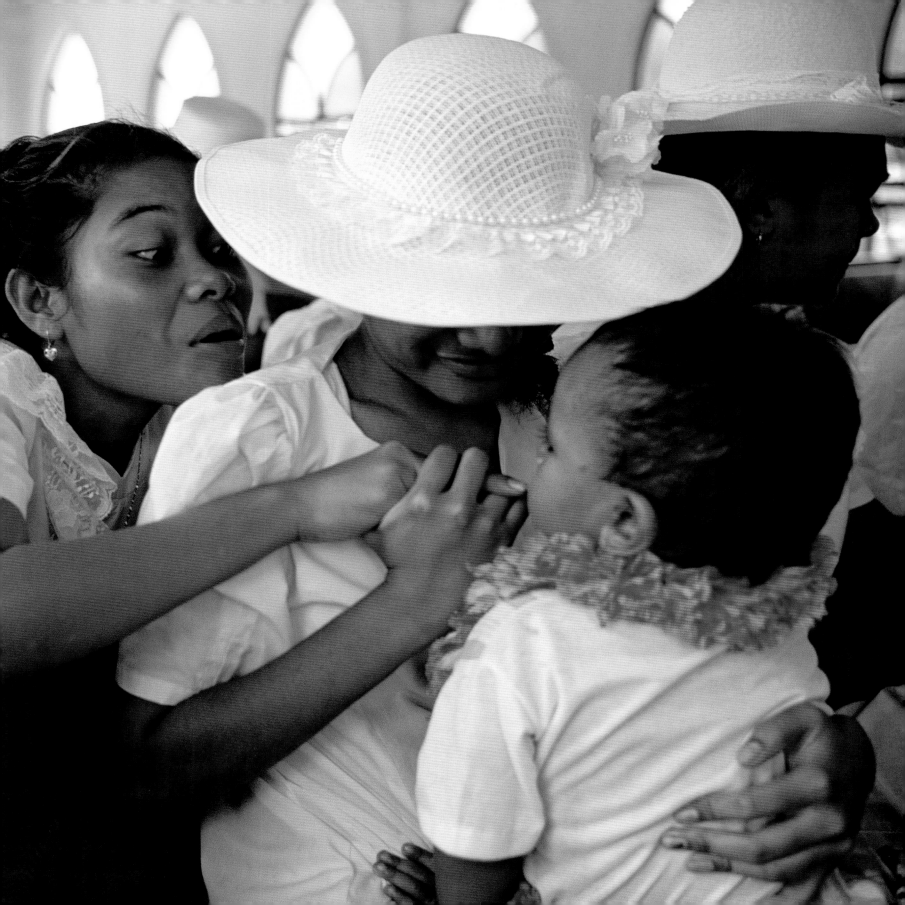

Maggie Steber

Meaningful photographs require an investment of time and heart. The photographer must create a safe place for the subject. If we ask them to be vulnerable, we must also be vulnerable.

I spent more than a year visiting this family. They had lost their home and were being helped by neighbors. One afternoon after church, the four little girls lay down for their nap. I tiptoed in and took a few pictures. I was touched by the way they curled up together in a single bed. Even in the innocence of sleep, you can find intimacy.

MAGGIE STEBER
Miami, Florida
Four sleeping sisters nestle in
a shared bed.

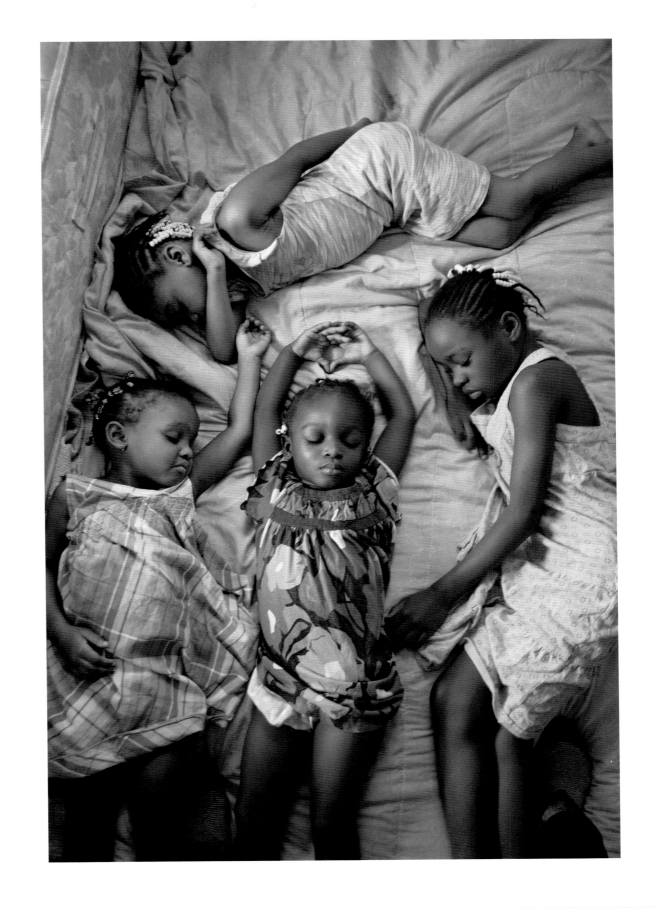

MARIA-HELENA BUCKLEY
Berlin, Germany
A dancer leaps with grace and agility.

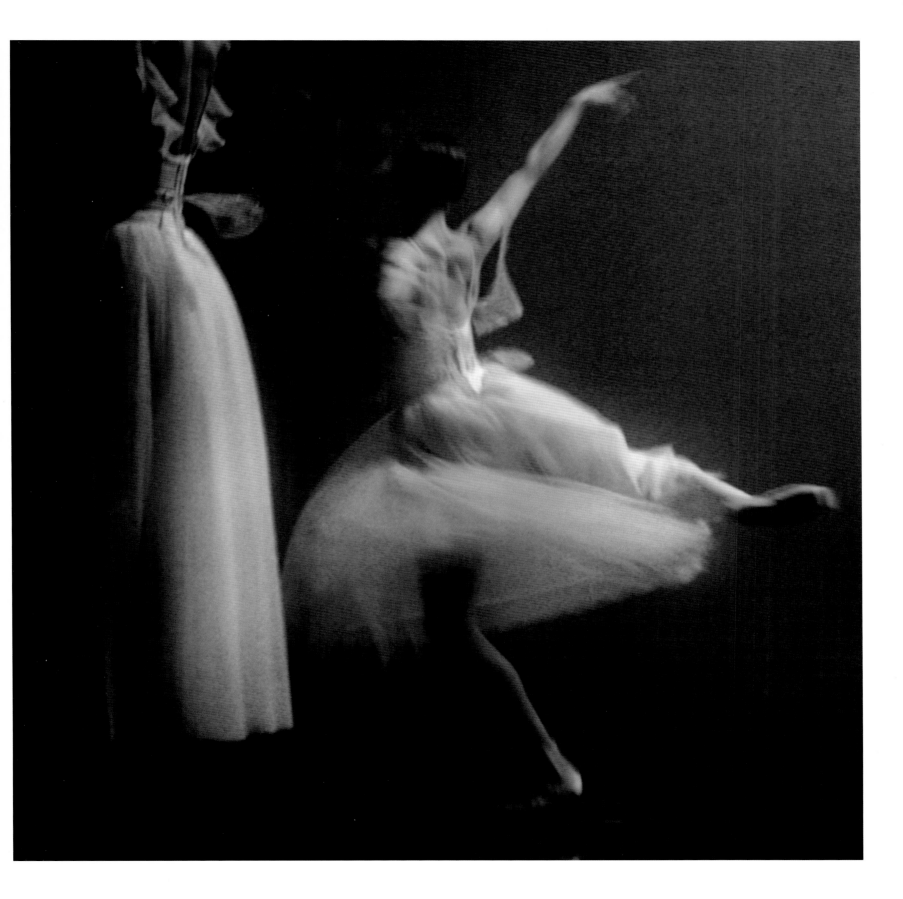

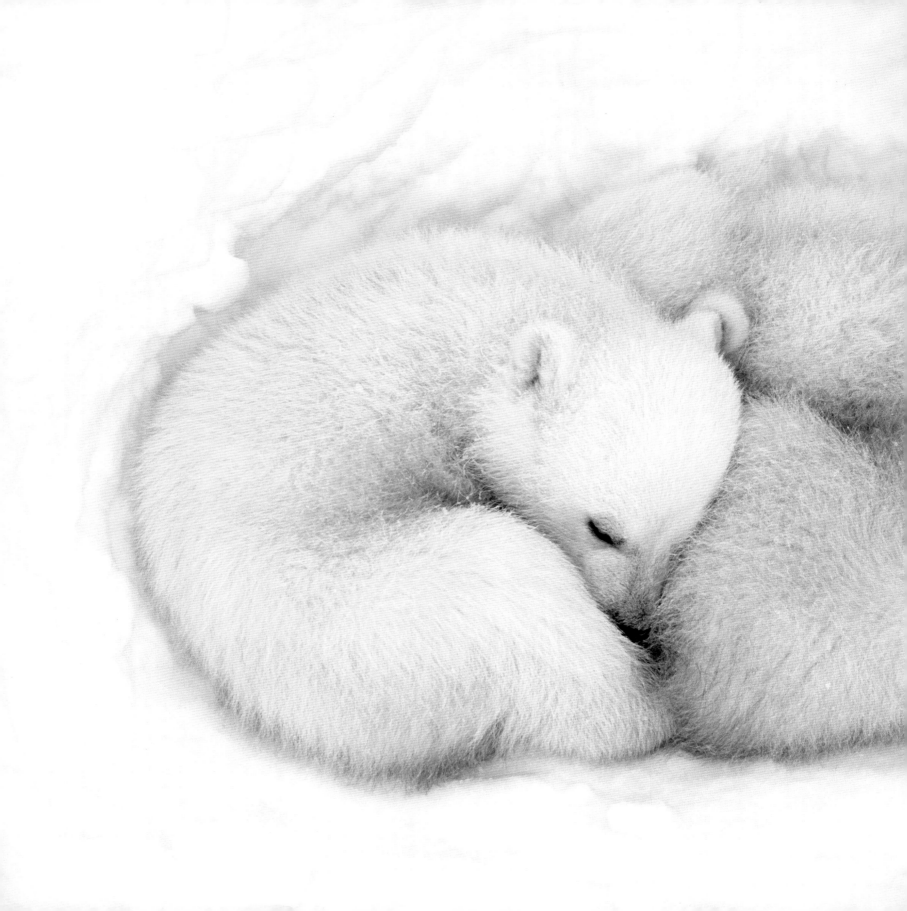

Each situation,
each moment,
is of infinite worth;
for each represents
a whole eternity.

~ Johann Wolfgang von Goethe

BRIAN SKERRY
Swallow Caye Wildlife Sanctuary, Belize
A manatee mother and calf graze on
turtle grass in an underwater habitat.

preceding pages
JENNY E. ROSS
Wapusk National Park, Canada
Twin polar bear cubs sleep curled
together in a snow den.

following pages
MICHAEL NICHOLS
Serengeti National Park, Tanzania
Lionesses and cubs rest on a rocky
outcrop near a water hole.

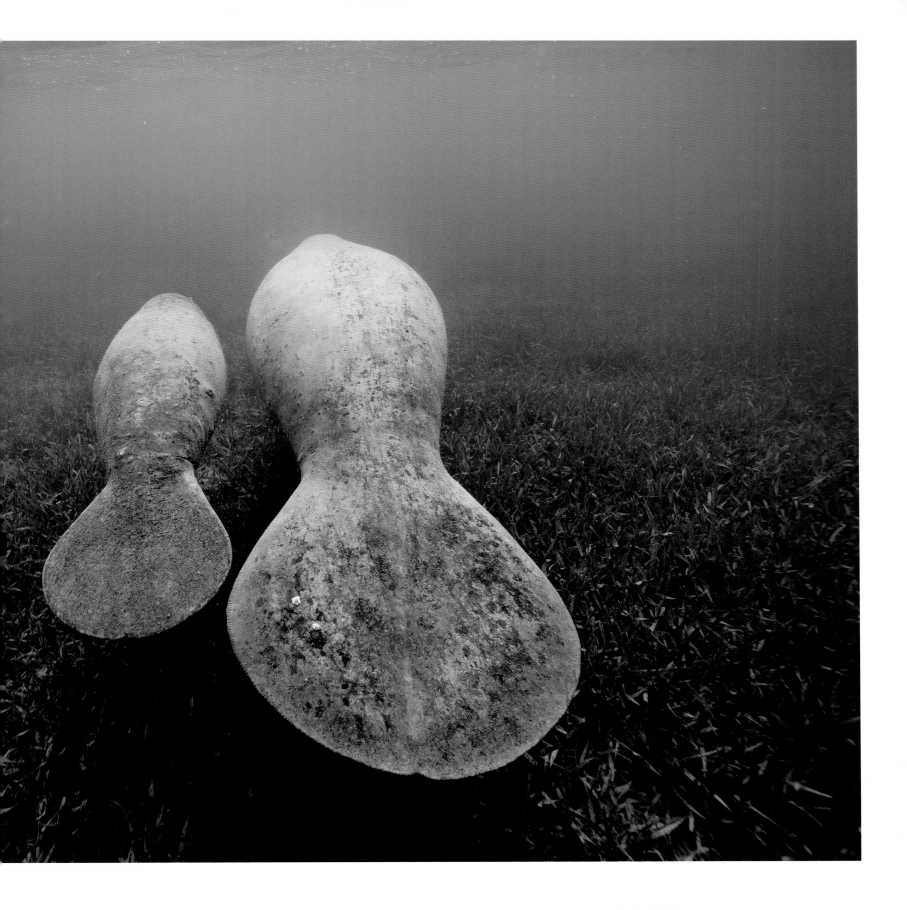

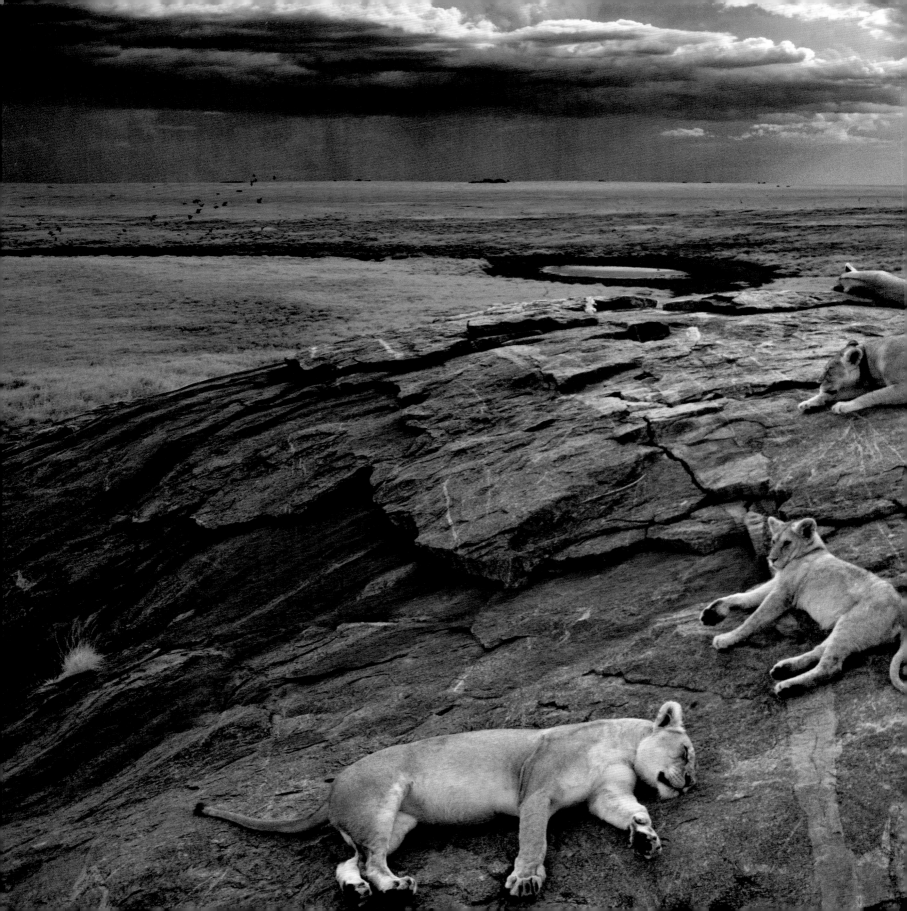

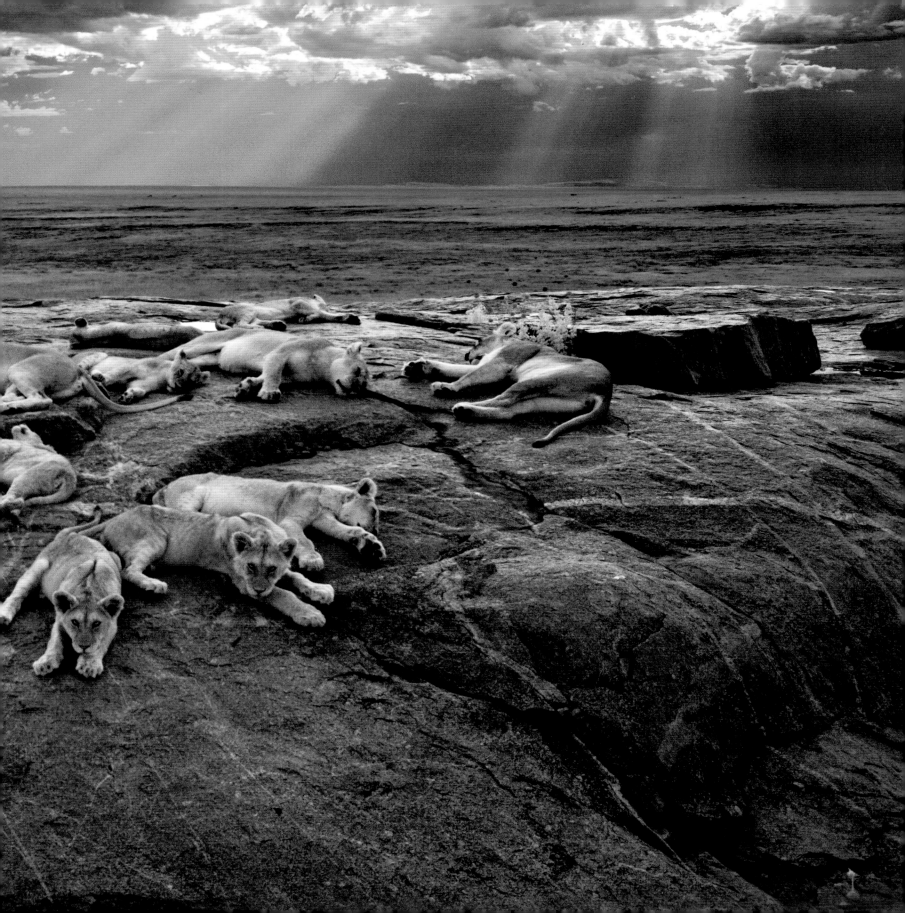

National Geographic Stunning Photographs
Annie Griffiths

Published by the National Geographic Society
Gary E. Knell, *President and Chief Executive Officer*
John M. Fahey, *Chairman of the Board*
Declan Moore, *Executive Vice President; President, Publishing and Travel*
Melina Gerosa Bellows, *Executive Vice President; Publisher and Chief Creative Officer, Books, Kids, and Family*

Prepared by the Book Division
Hector Sierra, *Senior Vice President and General Manager*
Janet Goldstein, *Senior Vice President and Editorial Director*
Jonathan Halling, *Creative Director*
Marianne R. Koszorus, *Design Director*
Hilary Black, *Senior Editor*
R. Gary Colbert, *Production Director*
Jennifer A. Thornton, *Director of Managing Editorial*
Susan S. Blair, *Director of Photography*
Meredith C. Wilcox, *Director, Administration and Rights Clearance*

Staff for This Book
Anne Smyth, *Assistant Editor*
Kristina Heitkamp, *Researcher*
Marian Smith Holmes, *Picture Legends Writer*
Marshall Kiker, *Associate Managing Editor*
Judith Klein, *Production Editor*
Mike Horenstein, *Production Manager*
Galen Young, *Rights Clearance Specialist*
Katie Olsen, *Production Design Assistant*

Production Services
Phillip L. Schlosser, *Senior Vice President*
Chris Brown, *Vice President, NG Book Manufacturing*
Robert L. Barr, *Manager*
Rahsaan Jackson, *Imaging*

The National Geographic Society is one of the world's largest nonprofit scientific and educational organizations. Founded in 1888 to "increase and diffuse geographic knowledge," the member-supported Society works to inspire people to care about the planet. Through its online community, members can get closer to explorers and photographers, connect with other members around the world, and help make a difference. National Geographic reflects the world through its magazines, television programs, films, music and radio, books, DVDs, maps, exhibitions, live events, school publishing programs, interactive media, and merchandise. *National Geographic* magazine, the Society's official journal, published in English and 38 local-language editions, is read by more than 60 million people each month. The National Geographic Channel reaches 440 million households in 171 countries in 38 languages. National Geographic Digital Media receives more than 25 million visitors a month. National Geographic has funded more than 10,000 scientific research, conservation, and exploration projects and supports an education program promoting geography literacy. For more information, visit www.nationalgeographic.com.

For more information, please call 1-800-NGS LINE (647-5463) or write to the following address:

National Geographic Society
1145 17th Street N.W.
Washington, D.C. 20036-4688 U.S.A.

For information about special discounts for bulk purchases, please contact National Geographic Books Special Sales: ngspecsales@ngs.org

For rights or permissions inquiries, please contact National Geographic Books Subsidiary Rights: ngbookrights@ngs.org

Copyright © 2014 National Geographic Society

ISBN: 978-1-4262-1392-2

Printed in China

14/PPS/1